Embroidery in Religion and Ceremonial

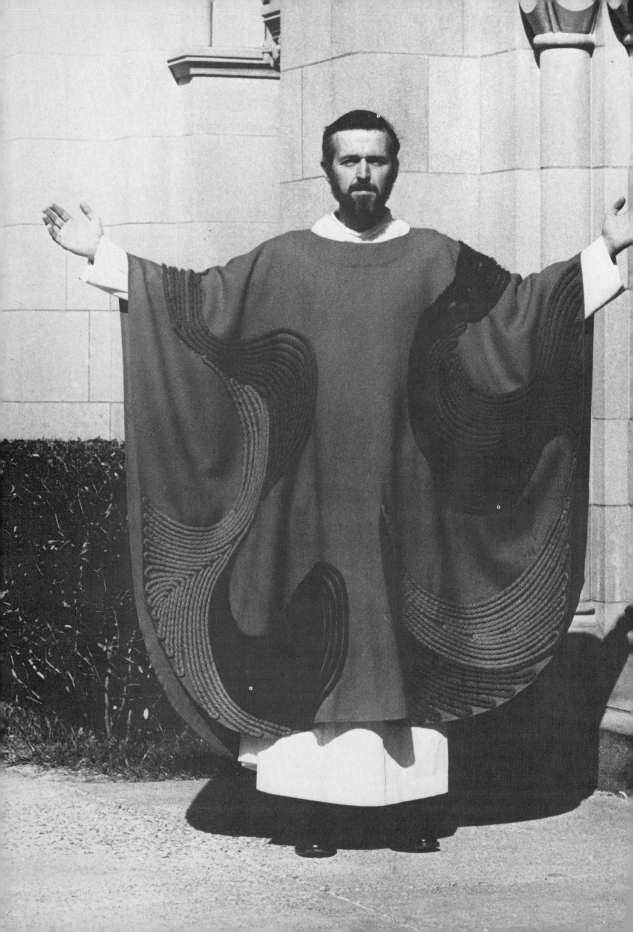

Embroidery in Religion and Ceremonial

Beryl Dean

B T Batsford Limited
London

Frontispiece. Chasuble, created by
Marjorie Coffey, Washington DC; green,
with hand-stitched couching in purple,
orange and fuschia; worn at the National
Conference on Liturgy
Marjorie Coffey

© Beryl Dean 1981
First published 1981

ISBN 0 7134 3325 6

Filmset in Monophoto Ehrhardt by
Servis Filmsetting Limited, Manchester
Printed in Great Britain by
The Anchor Press Ltd.
Tiptree, Essex
for the publishers
B T Batsford Limited
4 Fitzhardinge Street
London W1H 0AH

Contents

Acknowledgment

To the Reverend Peter Delaney I owe a great debt of gratitude for all his help. I have quoted (but not always ascribed to him) his words extensively. I also want to thank the Reverend Leonard Childs who took infinite trouble to organise the photography for many interesting examples of embroidery as illustrations for this book.

I am also grateful to the following photographers for providing illustrations: Michèle Ditson (194); John Gay (115, 147, 298, 299); Sandra Hildreth Brown, Penna Press Ltd (85); Terry Radloff (190, 191); Mary Alice B Rich (245, 247); Edward Whitfeld (125a); Stephen Yates (73, 95, 120a, 120d, 133, 134, 150, 177, 259, 260, 262, 264, 265, 266, 279).

Much of the information in the section devoted to Ceremonial embroidery was contributed by Margaret Forbes, from her valuable practical experience – to her my very grateful thanks are due. I want also to express special gratitude to Judy Barry, whose contribution has so greatly enhanced the value of this book.

The help which Mrs Walter P White, Jr, of Pasadena, C A so generously gave to me was invaluable; as was all the information and assistance given by Rabbi Abraham Levy and Mrs Estelle Levy of St John's Wood, London.

I would also like to thank Marylin Bitcon, Florence Hind and my long suffering husband for their assistance, and the many people who have helped.

I wish to acknowledge my indebtedness to Pauline Johnstone and Lillian Freehof with Bucky King, for the information I derived from their books.

Beryl Dean *London 1981*

Introduction

The purpose of this book is to set down the information necessary for the practical realisation of embroidery projects for the church. Upon this foundation, the design (which is all important) can be created in the idiom of the day, and is therefore transient in style.

Recognising that those requiring help will have reached every stage of achievement, the subject has been dealt with at different levels.

This being a period of change in the liturgy, even the wearing and use of vesture is in a state of transition. For this reason both the traditional and the new forms of Eucharistic vestments are dealt with. The photographs have been selected to illustrate points made in the text, and in most instances have not been published before.

Red frontal, designed and executed by Conni Eggers, Oakton, VA. Satin, silks, wools and kid, hand and machine appliqué on hand-woven wool ground.
Washington Cathedral, Washington DC

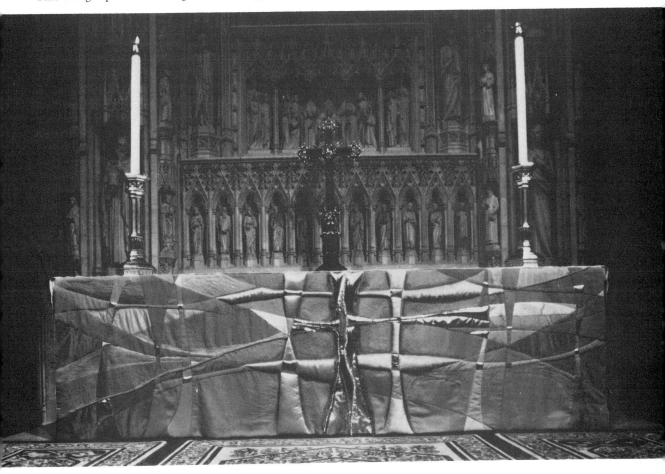

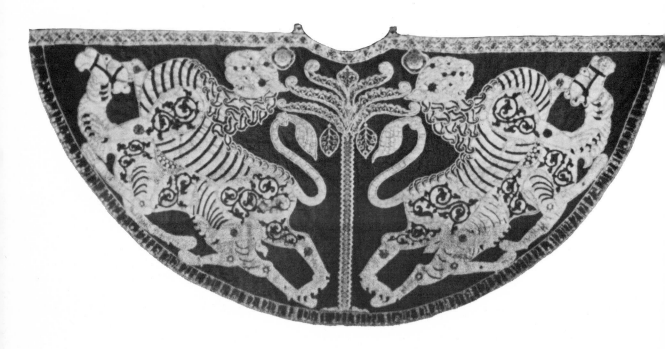

1 The Imperial Mantle made in Sicily for the coronation of Roger II in 1133
Kunsthistorisches Museum Vienna

CHAPTER I
A brief historical sequence of church embroidery

It is both interesting and stimulating to extend one's knowledge of the decorative styles which have formed the background to design for religious purposes in the past, and to trace the more recent development in Britain, the United States and other countries. This necessarily brief survey cannot hope to deal exhaustively with such a vast subject, but something of the continuity of the basic symbolism common to most religions can be discovered. And the influence of contemporary secular embroidery upon the approach to the designing of vestments and furnishings becomes evident. This study leads to a clearer understanding of the necessary adaptations to the changes resulting from the present ecumenical movement.

From earliest times man has incorporated signs and symbols in his decoration; it was natural that the early Christians should adapt many of the existing pagan symbols, such as the circle, triangle, zigzag for water, wheat, etc. They also served a practical purpose, as in the first three centuries AD there was persecution, but those who held the new faith, secretly, could recognise each other by the signs incorporated in the decoration upon their tunics, for example the fish which denoted a Christian. Similar tunics have been depicted in the Byzantine Mosaics, and in many museums there can be seen Coptic linen tunics with the tapestry woven roundels and two vertical bands of decoration. When, in the early fourth century Constantine secured for the Christians toleration, another symbol was added, the Chi-Rho, the sign seen in his vision.

During the first centuries of the Christian era there was no distinction between ecclesiastical and civil dress. With modifications this has continued until the present time, as instanced in the clavi of the dalmatic and tunicle which developed from the two stripes on the linen tunics. But with the great schism there were certain differences in vesture between the West (Rome) and the East (Constantinople), and the Eastern Orthodox Church.

Early vestments can be seen portrayed in the Ravenna Mosaics and in manuscripts. An example of Byzantine embroidery (eighth century or later) is the magnificent so-called Dalmatic of Charlemagne (actually a saccos), silk thread and gold work on blue silk, which can be seen in the Treasury of St Peter's, Rome (**198, 199**). There are rare silk embroidered roundels in the Victoria and Albert Museum, London, which are Byzantine, of Egyptian origin, sixth century. Most interesting gold work, of splendid refinement and design, can be found in several museums, including the Benaki Museum, Athens (**197**) the Museum of Art, Bucharest, and the Victoria and Albert Museum, London which also possesses an Epitaphios Sindon. Byzantine embroideries ceased to be produced upon the fall of Constantinople in 1453. See page 173 *et seq.*

In Vienna is to be seen the coronation robe of the Holy Roman Emperor, a mantle of distinctive design woven and made for Roger II in 1134 in the Imperial workshops at Palermo. The large-scale design is gold-embroidered on a ground of red velvet (**1**).

Between 1200 and 1500 from the convents of Germany – Altenberg on the Lahn, in particular – have come altar cloths and frontals in white-work on linen, perfect in the variety and skill of execution. The techniques in which they were carried out, and the scale of the conception of the designs result in a uniquely powerful composition (**2, 3**). Other cloths from Switzerland and the Scandinavian countries tend more towards outline with the introduction of a little coloured thread. Characteristic of early coloured embroidery from Germany are **5, 6**.

There are embroideries with a religious theme of great interest, whose origin has been traced to Iceland; they are of the early twelfth century. The pattern of circles which covers the background in each piece shows yet again the influence of Byzantine woven fabrics. **Figure 7** is a part of the St Martin embroidery which is in the Cluny Museum Paris.

Somewhat earlier is the Bayeux Tapestry (which is stitchery and not woven). It is outstanding as a source of historical information, including early

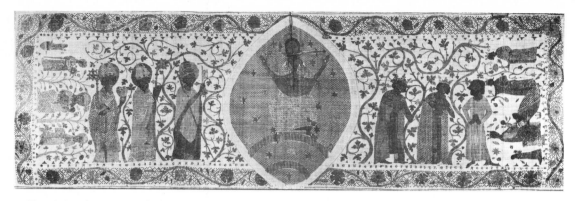

2 Altar cloth – Germany early fourteenth century. Unbleached linen, embroidered in white linen thread
Metropolitan Museum of Art, New York

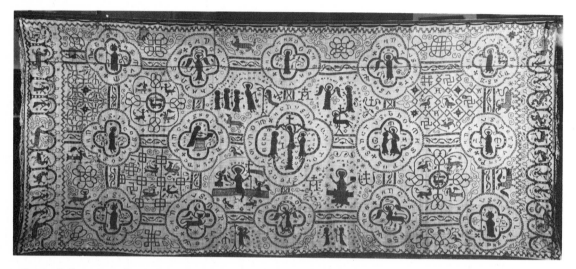

3 Lenten cloth 1.52 m × 3.65 m (5 ft × 12 ft), Altenberg on the Lahn, thirteenth century. White linen stitchery on linen
The Cleveland Museum of Art, Ohio USA

4 *Below* St Peter, detail

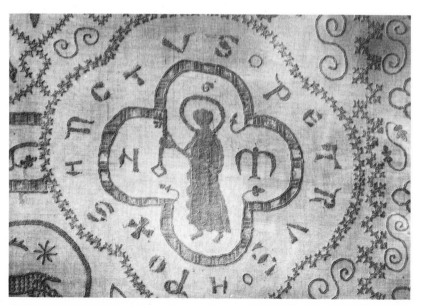

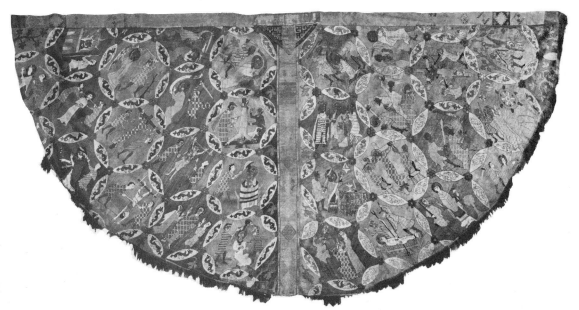

5 *Above* Hildesheim cope, early fourteenth century. Linen embroidered with silk and gold, mainly blue and green
Victoria and Albert Museum, London

6 Altar hanging (detail), Germany (Lower Saxony), late fourteenth century. Linen embroidered with silk, red, blue, green, yellow and natural
Metropolitan Museum of Art, New York (Gift of Mrs M Crane)

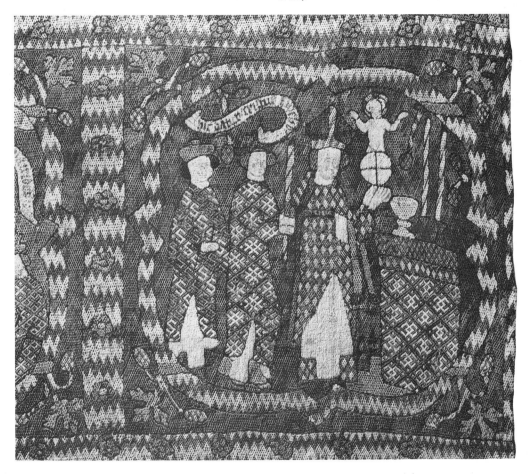

7 Life of St Martin, embroidered antipodium. Icelandic, early thirteenth century
Cluny Museum, Paris

heraldry and church vestments. A parallel can be drawn between this and the Icelandic embroideries, because the stitch treatment on the linen background is almost the same, the solid areas are filled with laid work in fine wool, and the outlines are worked in couching and stemstitch.

Those embroideries which have survived were probably not isolated examples, but typical of a wealth of exquisite needlework being produced, especially at this time in England. The return of the Crusaders with lengths of sumptuous woven textiles and embroideries must have influenced the creative imagination. For instance, when the tomb of St Cuthbert was opened it was found to contain some Byzantine fabric. But much more importantly, with other pieces of embroidery was the outstand-

ingly miraculous maniple and stole. They are of the finest workmanship, the design being carried out in silks and the background with gold of such purity that it was very pliant, the stitches with which it was sewn were looped together on the reverse side. That St Cuthbert's maniple was made early in the tenth century must prove that there was an already established tradition of excellent craftsmanship in Britain (8). The contents of the tomb are preserved in the Treasury at Durham Cathedral.

In architecture the Romanesque had been superseded by the glories of the Gothic Cathedrals, and the arts of all kinds had attained standards of perfection.

By 1250 the highest achievements in embroidery were reached, and remained unsurpassed until 1350. The embroidery of this period was known as *Opus Anglicanum* and was recognised and desired by ecclesiastics throughout Europe.

8 St Cuthbert's maniple (part) worked in silk on background of finest gold, early tenth century
The Treasury of Durham Cathedral

9a *Opus Anglicanum*. The head of the Archangel Gabriel from the cope of Pius II at Pienza

It is only possible here to give the briefest summary of the main characteristics of this most important style of embroidered decoration for the church. The subject has been exhaustively researched by Mrs Christie in her *English Medieval Embroidery*, Oxford Press.

The design style was recognisable and fell into three types, but throughout, the figure compositions clearly illustrated incidents from the Bible, for the instruction of the unlettered laity. Single figures were identified by name. The eyes were large (9a) with round black pupils, the foreheads high and broad. The faces were worked in fine split-stitch which followed the contour, and went round in spirals for the cheeks and chin. Rows of split-stitch in alternating dark and light colours, eg reddish-brown and yellow or blue and white, were used for the hair. The same fine silk split-stitch followed the direction of the folds in the draperies. On the outside the colour was dark and on the inner side light. Blues, yellowish-greens and reddish-browns were used.

The fine gold thread used was almost pure, (being wound round a core of silk) it was pliant, the method

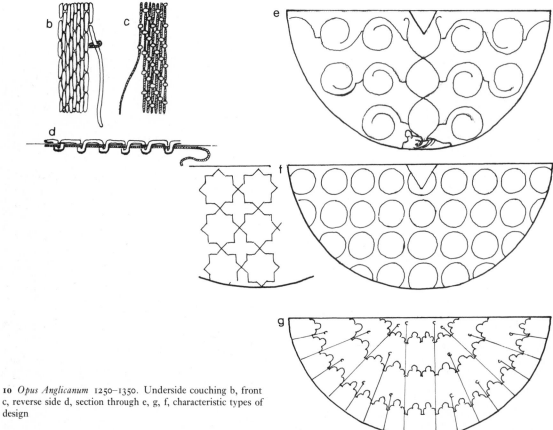

10 *Opus Anglicanum* 1250–1350. Underside couching b, front c, reverse side d, section through e, g, f, characteristic types of design

of stitching was known as 'underside couching' (10b,c,d). For this technique there was a linen backing which was framed-up, covered by blue, old-gold or crimson silk, twill or velvet; when the background was to be of solid gold a second loosely woven finer linen was placed over the first. To work the areas of gold, the metal thread was laid on the surface; and the needle, threaded with a fine linen thread, was pushed up from underneath, then passed over the gold and taken down through the same hole, thus drawing a tiny loop of gold through to the underside. Because of its pliancy this method has outlasted the later surface couching. The sewing-down stitches might be so spaced that an all-over pattern in the gold could be formed. The background of the cope which was from the Basilica of St John Lateran, and is now in the Vatican Museum Rome, is worked in patterned gold.

The earliest type of design was based upon the

11 *Opus Anglicanum*. Details from early fourteenth-century chasuble showing the Enthronement. Silk and metal threads on red velvet
The Metropolitan Museum of Art, New York

tree of Jesse, and single figures of saints were enclosed by the spiralling vine. See the cope in the Victoria and Albert Museum, London (10e). The designs for all this work resemble the drawings made by the monks for the Psalters and manuscripts of the time. There is a page in Queen Mary's Psalter almost exactly like a 'Tree of Jesse' orphrey for a chasuble. The copes usually had an orphrey, and sometimes a small triangular hood.

Towards the end of the thirteenth century for about forty years, the type of design (10f) changed, the field of the cope being divided into quatre foils (the Syon cope, Victoria and Albert Museum, London), circles (Ascoli-Piceno) (12) or squares (Steeple Aston, Victoria and Albert Museum, London). In these shapes were placed saints and six-winged angels, etc.

Then and until about 1350 the background was formed into foliated architectural arcading (10g) framing figure subjects. This all-over design treatment of a vestment is shown on the chasuble in the Metropolitan Museum, New York, which is typical (11). It is so similar to the Butler-Bowdon cope in

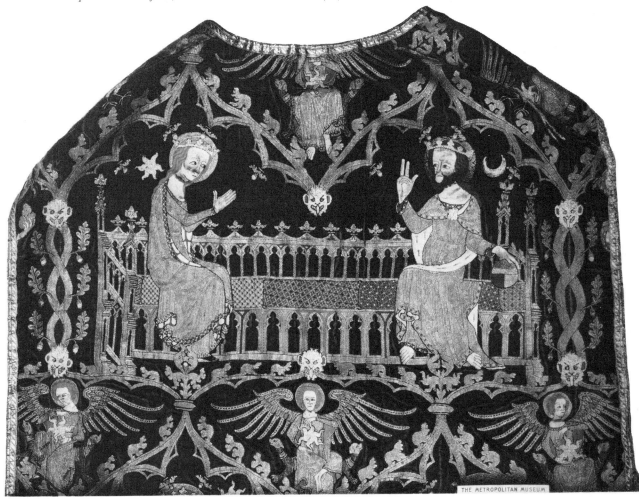

the Victoria and Albert Museum that they must surely have had a common origin. To execute such fine stitchery on the crimson velvet ground an openly woven gauze-like linen was laid over the whole, and on this the design was traced. When the embroidery was complete this linen would have been cut away around the outlines.

In these medieval works it will be noticed that the drawing of animals and birds is both fantastic and meticulous, frequently based upon the Bestiaries of the time. Note the delightful little apes' heads on the Steeple Aston cope (now cut into a dossal and frontal which is on loan to the Victoria and Albert Museum). There is evidence from other examples that details were entirely covered with little seed pearls. It is known that the Ascoli Piceno cope (1275) was stripped of its pearls (12).

To study this subject in greater depth will be found to be of the utmost interest and very rewarding. It should be related to the highest achievements in contemporary Gothic architecture, ornament, and sculpture, enamelling, jewellery and silversmithing, etc.

In the Cluny Museum, Paris, is an embroidery which was made into a chasuble. Originally a thirteenth-century horse trapper, it shows the three

great Leopards or Lions of England on each side, and is worked with very narrow strips of gold sewn down upon a deep crimson velvet ground, with the addition of some jewels and seed pearls (13).

For the decline in the standard of design and workmanship towards the end of the fourteenth century there were several contributory factors, but mainly the Black Death, the Hundred Years' War and the general unrest; also at this time the Guilds held less influence in the maintenance of high standards of technique. It is observable throughout the history of embroidery that at times, when the focus of attention is upon the introduction of some new process in the weaving of fabric, then it has led to the waning of liveliness in embroidered decoration. So now, the sumptuous velvets and brocades were used for vestments, and only the orphreys (the pillar on the front and cross on the back) of chasubles, and wider orphreys with larger flat hoods on copes were embroidered. The design was clumsy, the drawing of the architectural detail poor, and the figures of the saints 'squatty'. But it was in the technique that the great change had occurred. No longer was the fine gold underside couching used; the gold thread was now laid on the surface to be sewn down as it is today. The features and draperies were stitched with long straight stitches, and outlined in black. The rest of the ground was covered with laid-work in a coarse, untwisted silk, replacing the fine split-stitch.

12 *Opus Anglicanum*. Cope, 1272. Silk embroidery upon a gold ground; it has been stripped of its pearls. The design depicts episodes in the lives of 16 Popes
Palazzo Comunale at Ascoli Piceno

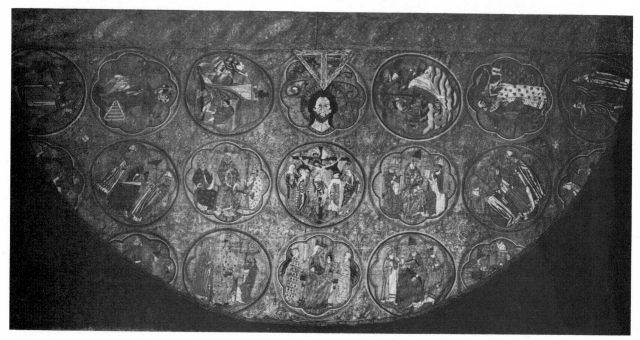

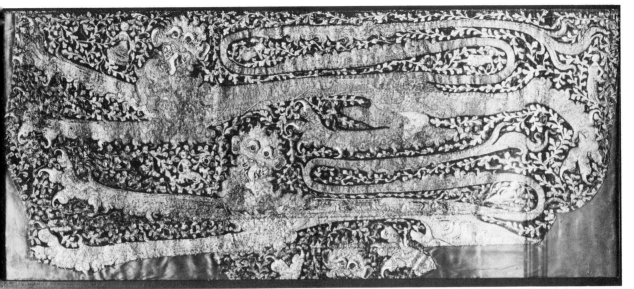

13 *Above Opus Anglicanum.* Thirteenth or fourteenth century. Originally a horse-trapper which belonged to the second son of Edward II; later made into a chasuble. Gold couched upon red deep pile velvet with details in silk and some jewels.
Cluny Museum, Paris

14 *Below* Cope (later converted into an altar frontal), English *c*1480. Silk embroidery and couched gold on linen, applied to velvet
St Peter Hungate Church Museum, Norwich, Norfolk

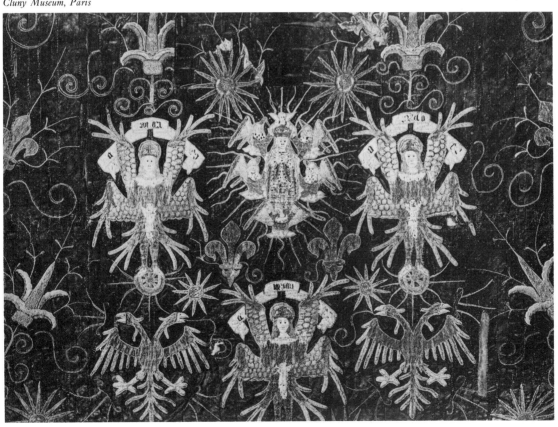

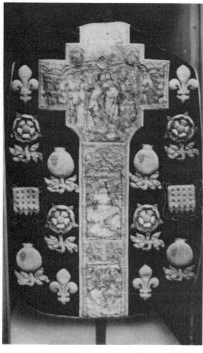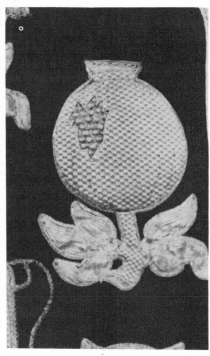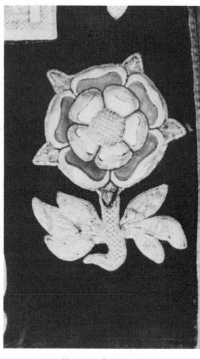

15a The Westminster Chasuble, English, 1475–1525. Red velvet-embroidered emblems applied. Orphrey, Flemish, late fifteenth century
The Arundell Trust, Tisbury, Wiltshire, Wardour Castle Chapel

15b *Centre* Pomegranate, detail. Gilt and silk couched, raised work

15c *Right* Tudor Rose, detail. Silk and metal threads. Raised work applied to later velvet ground

There was a revival of standards, and of skill in the fifteenth century, and this recovery continued until the Reformation, when a clearly identifiable type of design with its own character was produced. At this time there was a vogue for emblems and mottoes (sometimes based upon a pun of the donor's name). For example a hand in white satin appliqué, and an embroidered ER represented 'Glover'. Repeatedly used were double headed eagles, crowns, fleurs-de-lis, six-winged angels, bells, lantern flowers, pomegranates, etc. These units were worked separately with couched gold and silk, upon linen, then cut out (a photograph of a detail taken under magnification at the Boston Museum, USA, revealed that the cut edges were treated with wax) and applied, having been spaced somewhat sparsely at intervals over the velvet or silk ground fabric. They were then stitched down, and outlined with a single or double thread of gold. The whole effect was softened with rays or tendrils of gold and spangles. In the centre of the

cope or frontal there was usually the figure of the Virgin Mary or the Crucifixion surrounded by six-winged angles. On copes and chasubles there were orphreys, sometimes transferred from earlier vestments. Many of these wider orphreys and the hoods were of Flemish workmanship, and showed a high degree of skill. There was raised gold over string, large areas of *or nué*, etc. Also of the sixteenth century there is a unique set, consisting of frontal and dossal in the church at Chipping Campden, Gloucestershire. Made from a fine cope is an altar frontal at St John's College, Oxford and another (14) is in the St Peter Hungate Church Museum, Norwich. In the same museum is an interesting pall of 1517, somewhat different in style, from St Gregory's church, Norwich, which has recently been restored. Stoneyhurst College, Lancashire, and Oscott College, Sutton Coldfield, possess other fifteenth- and sixteenth-century vestments.

A treasure belonging to Wardour Castle Chapel, Tisbury, Wiltshire, is the 'Westminster Chasuble'. The superbly embroidered emblems, rose, portcullis, pomegranate and fleur-de-lis have been applied to a later velvet; they were probably on a frontal originally, and the orphreys belonged elsewhere. The date is between 1475 and 1525 (15a,b,c).

Of this period, in the Victoria and Albert Museum, London, there are many examples of which one of the most interesting is the crimson

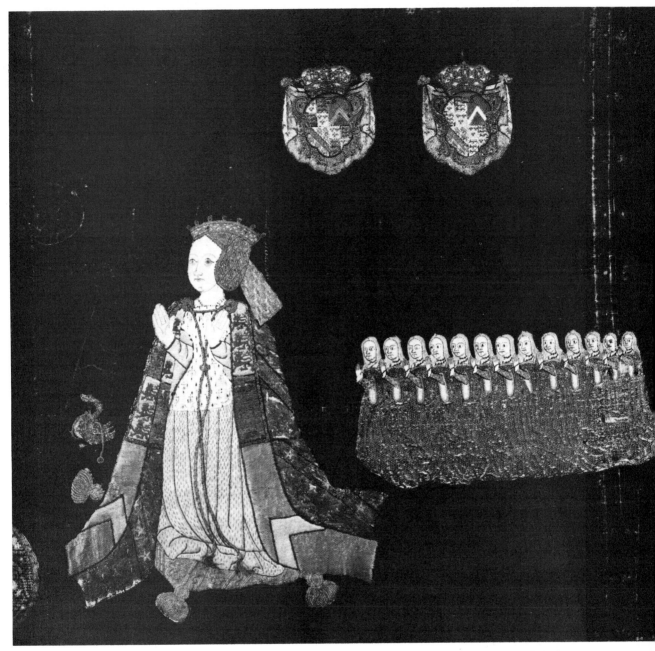

velvet frontal on which are applied decorative representations of Neville, fourth Earl of Westmorland, his wife and family. They are charmingly portrayed in silk stitchery and gold-work of more variety than is usual in this essentially English embroidery (16). But, considered as a whole there was a certain poverty of inspiration characteristic of this Pre-Reformation religious needlework.

An exception to such a generalisation must be

16 Frontal, detail showing the wife of the fourth Earl of Westmorland. Gold, silver and silk embroidery on linen, applied to a ground of red velvet. Between 1525 and 1550
Victoria and Albert Museum, London

made for the funeral palls belonging to the City of London Livery Companies, several of which have been preserved. The central panel of the Saddlers Company pall is of Florentine velvet brocade; the gold-work of the panels is typical. On each side there

17 Pall or hearse-cloth belonging to the worshipful company of saddlers. English, early sixteenth century
Victoria and Albert Museum, London

18 *Below* One corner of the Culpepper altar cloth (but probably intended as a funeral pall). Reputed to have been made by four Culpepper ladies, during the Commonwealth. It took 12 years to complete. The separately embroidered plants and cherub heads were applied to the purple velvet ground
Hollingbourne Church, Kent

are angels surrounding oval nimbi containing the sacred monogram. When repairs were being undertaken, surprisingly it was discovered that the ovals of velvet could be removed to reveal representations of the Virgin Mary (**17**).

This concealment is but one instance of the widespread damage and disfigurement done to portrayals of the Blessed Virgin Mary at the Reformation. With the dissolution of the monasteries and Abbeys, not only was the source of so much artistry ended, but their possessions, along with cartloads of vestments, were destroyed. Sometimes they were burned to melt down the gold, and the jewels were removed. The rich fabrics were plundered and converted for domestic use. Bess of Hardwick obtained several copes, pieces can be seen on a stool-covering and others were included in the appliqué of that unique set of large hangings at Hardwick Hall.

There were Catholic families in Britain who refused to change, and who continued to practise their faith secretly, keeping vestments for the celebration of Mass hidden away for the vesting of the priest in hiding. Such a set (although of much later date) is in the possession of the Bedingfeld family at Oxburgh Hall, Norfolk. The burse (**180**) shows the incorporation of part of a heraldic device carried out in bead-work.

The Pre-Reformation and other mainly Italian vestments preserved at Wardour Chapel have been mentioned. And from the Victoria and Albert Museum there is the Syon Cope treasured by the nuns who carried it around on their Continental journeyings.

That any Pre-Reformation embroideries should remain is a miracle, considering that Cromwell had so much destroyed.

With the introduction of the Laudian frontal and the draped pulpit fall, is associated a particular type of design. The sacred monogram is enclosed within a circle of rays, and the whole is worked in various golds, usually upon red or dark purple velvet. A similar design motif, stitched in canvas-work can be seen forming the top of the Axbridge frontal, a rather later example, 1702 (**181**).

No doubt the Ladies Culpepper were not the only ones to be embroidering for their churches whilst they awaited the ending of the Commonwealth in 1658. Their work is preserved in Hollingbourne church, Kent (**18**). Much ecclesiastical embroidery was produced in Edinburgh during the reigns of James IV and V, but the only remaining example is the unique Fetternear Banner which is in the Royal Scottish Museum (**19**).

19 Fettinear banner, *c*1520. Silk embroidery on linen
Royal Scottish Museum

Edmund Harrison was Court Embroiderer to James I, Charles I and II. As a professional he possessed a rare technical skill in the manipulation of all types of gold threads. The picture worked in 1637 which is in the Victoria and Albert Museum (**20**) is entitled 'Adoration of the Shepherds'.

In the Treasury of Durham Cathedral there are two of their five old copes. Although copes were not often worn at this time these are of special interest because the embroidery methods employed reflect the types of secular embroidery then popular. The modified stump-work is unusual.

At the Restoration it was realised that there were no suitable vestments, so white, red, green and purple-black sets of copes had to be made for the

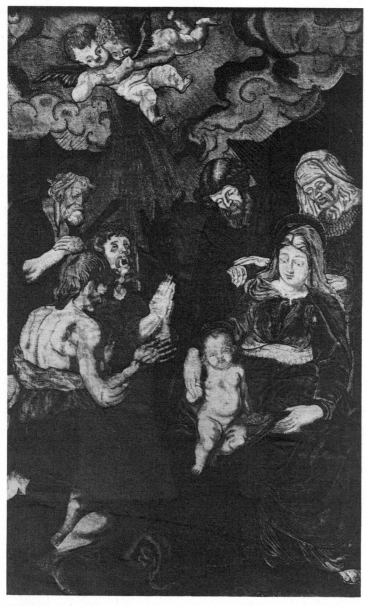

20 The Adoration of the Shepherds, seventeenth century. Worked by the Court embroiderer, Edmund Harrison. The garments mainly in gold thread laid down in pairs horizontally and couched with coloured silks (*or nué*)
Victoria and Albert Museum, London

Coronation of Charles II in Westminster Abbey. With the exception of the white set, they are still worn on special occasions. The distinctively designed decoration is completely different from the figurative subjects of the Pre-Reformation embroidery. Here, the silver and gold bullion, plate and passing threads, spangles, etc, are used to good effect for rich fillings such as basket work and for padded shapes (**182**). In the Anglican Church the cope came to be worn only on occasions of high ceremony.

In Europe altar frontals were in use: the fourteenth century example now in the museum at St Gallen, Switzerland, is interesting (**21**) as is also the frontal of German origin in the Cluny Museum, Paris, which is an example of the use of embroidered diaper pattern fillings (**22**).

Very richly embroidered vestments have been in continuous use in those countries which are predominantly Roman Catholic. From the seventeenth century onwards the influence of the Baroque was to be seen expressed in the large fringed hoods and very wide orphreys of the copes, and the high shaped mitres. The vestments were usually of rich silks or satins with elaborately ornate gold-work and floral

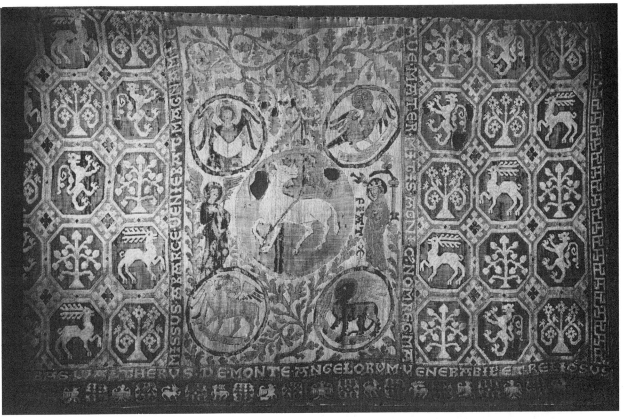

21 Altar frontal. Swiss, fourteenth century. Coarse linen embroidered in red, green and some yellow, also undyed silk outline stitch
Kunst Gwerbe Museum, St Gallen, Switzerland

22 *Below* Altar frontal from the Rhineland, first half fourteenth century, on a background of cream silk, mainly blue and green silk embroidery and narrow silver gilt plate couched
Cluny Museum, Paris

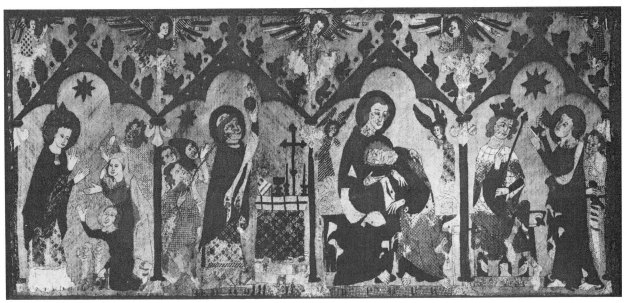

symbolism embroidered in coloured silks. Later the chasubles were shorter and cut away at the sides to give greater freedom of movement, and were stiffened. This style was replaced by the lighter and more fanciful Rococo decoration (25). This example is from Spain; characteristic of Spanish appliqué is the frontal (24).

In England, from 1830 there began a movement towards reviving the wearing of vestments. The revitalising influence which the Pre-Raphaelites exerted upon design and the approach to all hand crafts extended to the church arts, in particular stained glass; there are highly individual embroideries, where the stitchery and the use of colour – also fabric – introduces an entirely fresh outlook on religious embroidery (26A) and (26B). Some interesting examples were worked by amateurs. Later, to Dr Percy Dearmer's influence is owed the revival of the Gothic-shape chasuble. Although an improvement, the shape, compared with the true medieval vestment, is 'skimpy', having a short shoulder seam. The narrower straight stole was re-introduced, and the

23a Chasuble, Germany (Lower Saxony), fifteenth century. Front: Three Instruments of the Passion. Back: The Crucifixion Scene

23b Dark blue, woollen fabric with appliqué of leather, wool and linen. Embroidered in split stitch and tent stitch
Metropolitan Museum of Art, New York. The Cloisters Collection

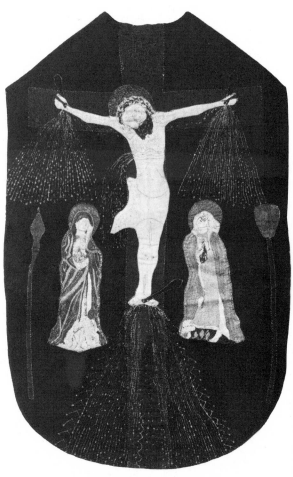

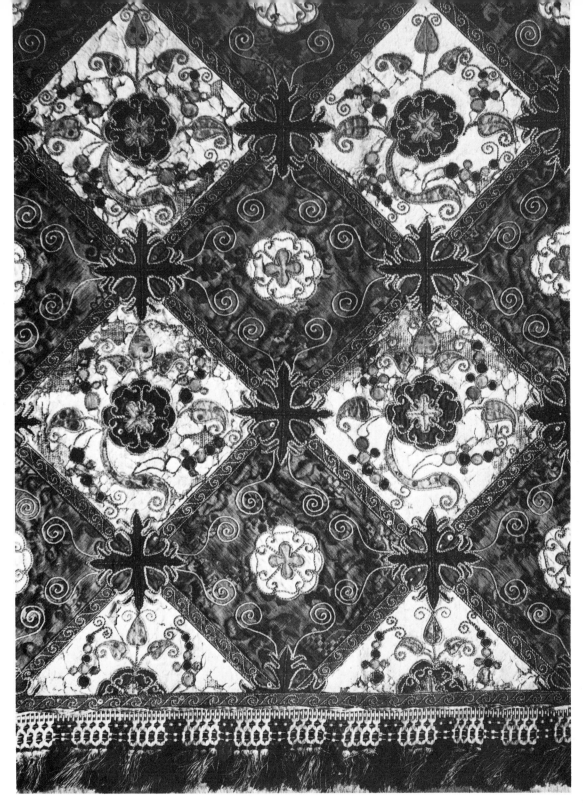

24 Altar frontal, sixteenth century. Spanish velvet and silk appliqué outlined with cords
Whitworth Art Gallery, University of Manchester

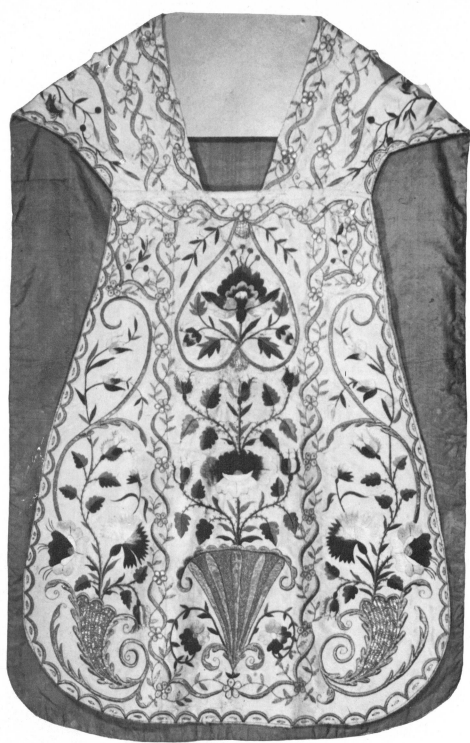

25 Chasuble fiddle–back shape. Chasuble front, Spanish,
eighteenth century. Silk embroidery in pinks and green also
gold on cream silk
Embroiderers' Guild Collection

26

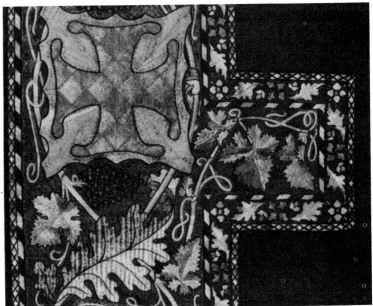

26a Altar frontal 147 cm × 33 cm (4 ft 10 in. × 1 ft 1 in.) designed by Philip Webb for the Deaconesses' House, Clapham Common, London which was opened in 1891. Embroidered by May Morris in floss silks using long and short and laid work, exploiting the changes of direction to obtain variations of colour. The areas of gold are couched. The background is of linen and worked in long and short stitch with light red; bluish green, oyster colour and soft purple predominate
Victoria and Albert Museum, London

26b *Above* Detail

27 *Below* Earliest kneeler project 1929. Designs adapted and the work directed by Louisa F Pesel. Various colour combinations. Wool on hemp canvas, long legged cross stitch throughout
The Wolvesey Canvas Embroidery Guild, for the Bishop of Winchester's private chapel at Wolvesey

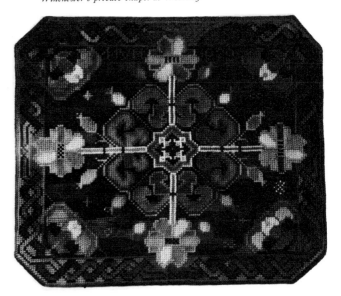

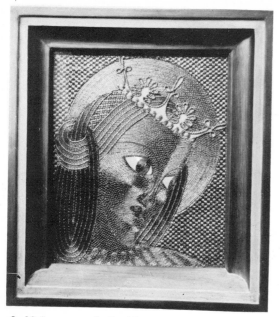

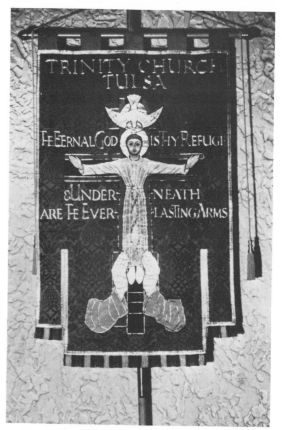

28a Madonna, 1932, by Beryl Dean. Japanese golds of various tones on a background of nuns' veiling

28b *Right* Banner designed by Eric Gill. Trinity Church, Tulsa, Oklahoma, USA

29 Altar frontal, designed and worked by Madeline Clifton. Silk embroidery on linen
Sandham Chapel, Burghclere, Hampshire, given to The National Trust

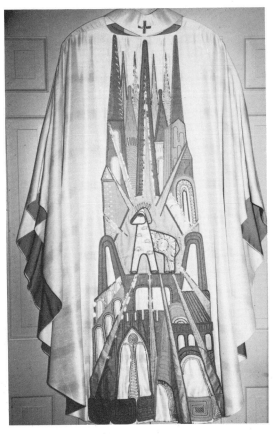

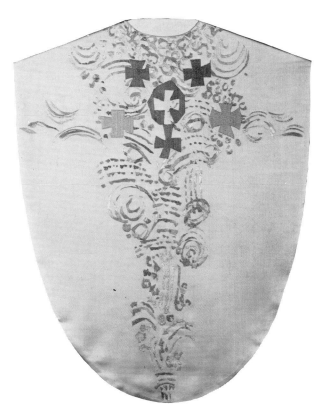

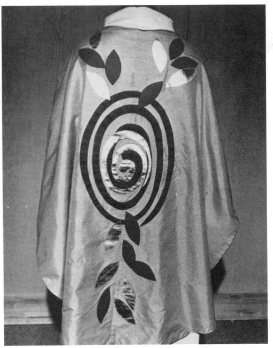

30 *Above left* Chasuble, West Germany, *c*1950, on ivory fabric, green, dirty pink, old gold and fawn appliqué, gold thread couched
Tulsa Cathedral, Oklahoma

31 *Above* Chasuble *c*1966 designed by Hans Krondahl, Licium, Stockholm. Made for the Swedish royal family

32 *Left* Chasuble designed by John Piper. Golden yellow silk, purple, green and white appliqué
Chichester Cathedral, Sussex. Photograph: D J Elson

mitre reverted to the early shape. The cope with a fitted shoulder and smaller hood or the cowl hood was re-introduced. It took time for these changes to be accepted.

To the Victorians is owed the destruction of much church embroidery.

During the first part of the twentieth century the design for embroidery was uninteresting; the same interpretation of a limited range of symbols, colours and outworn designs based on traditional sources resulted in deadness. This was characterised by anaemic flowers with yellowish green leaves contorted into attenuated curves, which were carried out in long and short stitch. Later the fabric of the background was shiny rayon damask or brocade, woven in designs of the sixteenth century; everything was outlined with braid or fringe. Art Nouveau, (of which this was the last lingering gasp) had had its own very good influence upon design for embroidery. But the degenerated commercialised form can still be seen.

Examples of the distinguished designs by Ninyan Comper are in Lincoln and Southwark Cathedrals. By 1929 Louisa Pesel had got together groups of people who worked kneelers (27) and there were other splendid exceptions to the general dullness, such as the altar frontal by Madeline Clifton produced in 1931 (29). This was the time when there was a great upsurge of enthusiasm for 'modern' embroidery, influenced by Swedish and German work reproduced in various publications. In Britain the work of Rebecca Crompton (and others) was bringing about a change of approach to secular embroidery.

German Ecclesiastical embroidery, even that made commercially, is well designed and interesting in its whole conception; the workmanship and the materials are generally of the best (30). This chasuble is but one example from the 1950 era. But down the centuries religious embroidery of the highest order has come from that part of Europe.

The characteristics of Swedish embroidery were common to church (31) and secular work. Later this freshness of approach had a great influence in Britain through the Needlework Development Scheme. At this time machine embroidery was developing in an adventurous way and experimental design and stitchery was replacing the traditional.

But embroidery for the church was totally unaffected by these forward looking trends in the secular field. It was not until 1953 when the Author, realising the great need for some sort of precept and stimulation of interest in an up-to-date approach to ecclesiastical embroidery, set about with singleness of purpose to produce and exhibit examples, to organise specialised instruction, to lecture upon the possibilities available for introducing more imaginative designs in this neglected field with new applications of old techniques. This led to the publication of her first book on the subject.

The re-vitalisation of church embroidery was promoted largely by Hammersmith, followed by other colleges and schools of art. Interest in this field is still growing and with it a desire for more information. For continued progress design must reflect the creative inspiration of the time.

CHAPTER II
Symbolism, a visual language

In design for the church at the present time symbolism seems to be less important than it was in the past when the spiritual ideas represented were generally known and recognised and the meaning understood. Today some of the imagery seems irrelevant, and certain aspects are outmoded; the unreal natural history of the bestiaries is interesting and decorative, but has little significance now. However, the stimulus of a fresh insight into the inspirational value of symbolism would be restored with 'a reaffirmation of the eloquence of Christian symbolism and of the vital role which symbols play in enabling religious experience'.

The Rev Cynthia Bourgeault, a deacon in the Episcopal Diocese of Pennsylvania writing most perceptibly in *Liturgy* says 'Renewal requires the opening up of our symbols, especially the fundamental ones of bread and wine, water, oil, and the laying on of hands, until we can experience all of them as authentic and appreciate their symbolic value! The importance of these passages for the artist cannot be over-emphasised. They are the basic starting point, for all art is fundamentally symbolic. To rediscover that our symbols are rich, that they speak to us in a language all their own, that they are to be entered into fully rather than passed through as quickly as possible, is the beginning of artistic awareness.'

Most of this visual language still communicates ideas and feelings between like-minded people, not only because these images have developed from the earliest times but we respond to the visual impact, through abstract design, consisting of shapes, rhythmic lines, and above all, colour; great concepts are communicated visually; the power of present day stained glass is but one illustration.

Symbols, being the rich imagery of the mind become vitally alive when translated in terms of design, and some inspire creative interpretation more than others. Not only because the Cross is the universally recognised symbol of Christianity but its form – a vertical line intersected by a horizontal is, in itself a strong basic construction as pattern, and a

huge range of types and of unlimited variations. The circle is, by its very nature, continuous rhythmical movement and suggests immortality, which can be interpreted in any idiom.

Lettering is intrinsically beautiful and is important symbolically as an element in all religious design; single letters, words or groups of words can be combined to create meaningful patterns if treated decoratively. Many symbols and mottoes are composed of letters which are pleasing to the eye, even when the meaning is not known.

Some designers for the church prefer not to use symbols or signs, depending for their impact upon the decorative quality of their work; and this may compensate for the lack of a deeper meaning. When symbols are included the artist strives to revitalise them with a new interpretation, they are chosen primarily for their visual qualities and potentialities as design, also their applicability in relation to usage. Alternatively, from time to time a form of private language or symbolic meaning is devised and substituted, which may become too obscure, so that some explanation is needed for a proper understanding, and if this is not forthcoming much of the intention is lost.

The following is but an arbitrary selection of Christian symbols taken from traditional sources, which, together with the brief notes is intended as an introduction to this interesting subject.

33 Symbols
Continues to page 37

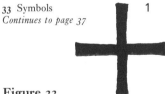

Figure 33

1 The Greek cross has an early origin, light (fire) striking from heaven is represented by a vertical line, water by a wavy horizontal, therefore the vertical striking the horizontal results in the cross, symbolising creation. The Greek cross is used more in the church of the East.

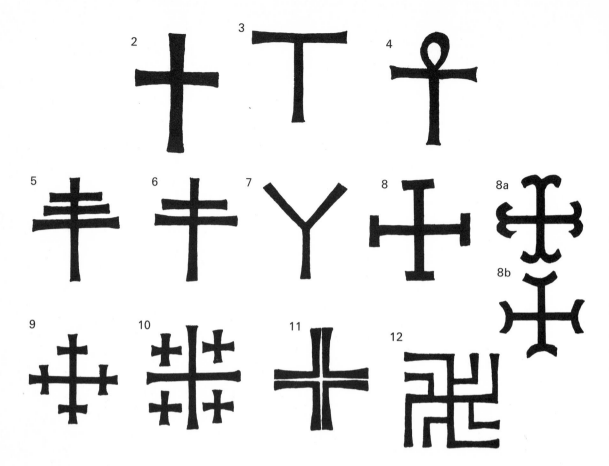

2 The Latin cross: the transverse branch is generally two thirds of the way up the vertical shaft. There are variations: on one, the cross is erected upon three steps. The Latin cross is used in the church in the West.

3 The Tau cross or St Anthony's cross is known also as the Egyptian cross.

4 The Ankh, the Egyptian symbol of life, the ansated or looped Tau cross.

5 The Papal cross, the Latin cross with three horizontal arms.

6 The Patriarchal cross, of which there are many examples in Byzantine art.

7 The Y cross is an early form and is also known as the fork cross, it symbolises the expectant soul, man gazing aloft with outstretched arms.

8 Cross potent, one of the many crosses used by the Crusaders.

8(a) Another form of the Cross potent.

8(b) A third variant of the Cross potent, also a Crusaders' cross.

9 Cross crosslet, or Holy cross.

10 The Crusaders' or Jerusalem cross. There are also many more highly decorative crosses used by the Crusaders.

11 The voided cross symbolises Christ as the Corner-stone of the Church.

12 An elaborated form of the swastika or fylfot which has a pre-Christian use and was an early symbol.

13 Roman Sacred cross.

14 The monogram formed from the Greek initials of Jesus Christ, and I and X are interwoven; in Greek the letter I is the same as J in English.

15 The double cross, an early Christian symbol, consists of the Greek X and the cross.

16 The ancient pagan Sun wheel, which was interpreted by the Christians as the monogram I Jesus X Christ within a circle.

17 The double cross within two circles, the outer as the finite and the inner as the sign of Eternity.

18 A very early symbol for running water. Zigzag lines have the same meaning.

19 The five-point star stands for the descent into matter, and denotes man as the Son of God. It is the symbol of the divine Trinity operating in the world of dual existence. There are other early meanings. When the star is depicted in connection with the stable at Bethleham it should be the five-pointed star.

20 The triangle, in Christianity the sign of the triple personality of God. Also, when pointing upwards it signifies the female element, and when downwards the male, which is by nature celestial, and strives after truth, whereas the female is always earthly in its conception.

21 The circle, being without beginning or end, is the sign of God or of Eternity.

22 The Double Triangle, seal of Solomon, in Christian symbolism denotes the perfect God and perfect man. The lower base of the triangle signifies spirit, the two sides soul and body, the apex pointing upwards. The intersecting triangle with apex downwards represents the Deity descending into matter.

23 The Alpha and Omega, after the words 'I am the Alpha and the Omega'. Here the form of the Omega has been altered.

24 These signs are widely used in the Christian Church, here two crosses are added to the sign of the Alpha and Omega. There are other variations.

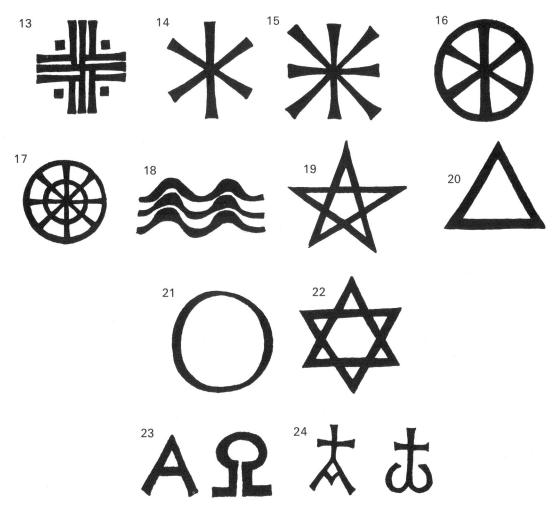

25 26 27

25 The Dextera Dei, for many centuries the Hand of God emerging from the clouds was the sign used for God the Father, First person of the Trinity. From a Limoges enamel casket. Metropolitan Museum, New York.

26 The Monogram of Jesus, an alternative to the more usual IHC which are the first three Greek letters of the word Jesus. This is but one of the many symbols for the Son of God.

27 The Dove descending symbolises God the Holy Spirit. Seven doves represent the seven spirits of God. Carved in stone, from S. Apollinare in Classe.

28 Flames of the Spirit are an alternative symbol for the third person of the Trinity.

29 Sign of the Trinity, Three persons in one God. There are many three-fold signs which represent the Trinity, all having three equal but distinct parts.

30 The Crowned 'M' one of the emblems of the Blessed Virgin Mary, (MR, for Maria Regina is another). Flush-work from St Mary, Dedham, Norfolk.

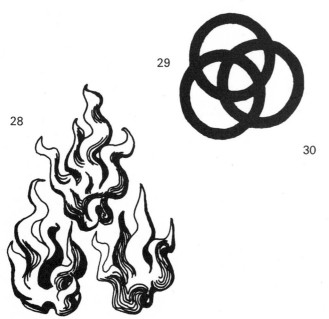

28 29

30

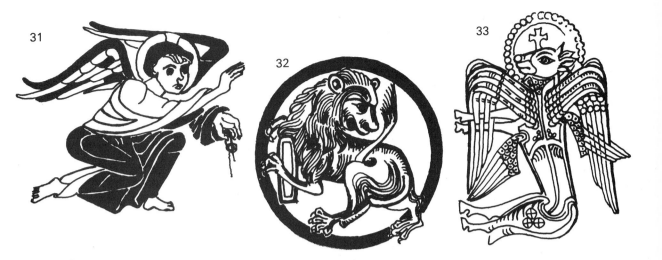

31 St Matthew, symbolised as a winged man. From a Limoges enamel reliquary casket. Metropolitan Museum, New York.

32 St Mark is signified as the winged lion. Each of the four Evangelists is generally shown as holding a book or scroll. From a German Missal, thirteenth century.

33 St Luke is represented as the sacrificial animal, the ox or calf, winged. From the Book of Kells.

34 The fourth Living Creature is the Eagle, for the Divinity of St John. From a reliquary casket of Limoges enamel. Metropolitan Museum, New York.

35 Another symbol of St John is the cup from which the poison departed in the form of a snake. A detail from a painting by Piero di Cosimo The chalice alone is a symbol of the Christian faith.

36 The twelve apostles were shown in the form of sheep in several early representations, such as this detail of a carving from Chartres Cathedral.

37 A form of disguised cross, but also used on floor decoration, as it was forbidden for a cross to be trodden underfoot. From an early fourth century mosaic.

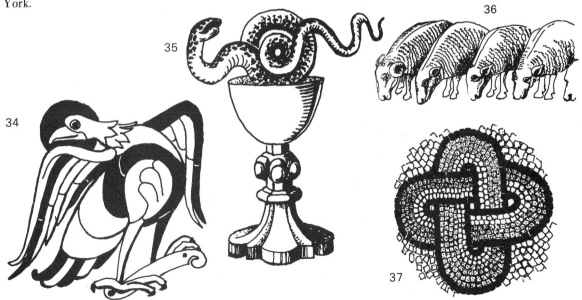

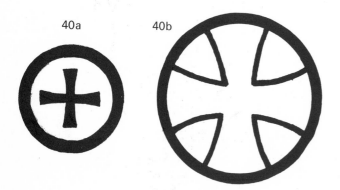

38a

38b

39

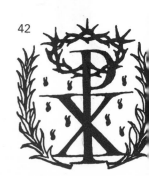

40a

40b

41

42

43

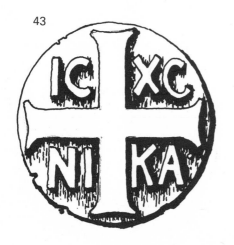

38 (a) The looped Tau cross, 38 (b) further disguised as an Anchor – which is an emblem of hope.

39 To the central Latin cross have been added two Clavis crosses, two Greek, and several fylfot crosses. Detail from a stone Transenna, Ravenna.

40(a) The Clavis cross is combined with the circle of eternity. It is to be found plentifully in Byzantine art. From embroidery.

40(b) An alternative form is also given.

41 A Christian cross derived from the Egyptian symbol of life, the ansated or looped Tau cross. The Chi Rho is combined with two Ankh crosses. The Ankh was used to represent the cross by the early Christians of Egypt. The Alpha and Omega are shown on either side at the top. Carved upon an early Christian gravestone.

42 The Chi Rho, the flames of the spirit, the crown of thorns and palm branches of victory and martyrdom.

43 The inscription means 'Jesus Christ, the conqueror'.

44 The Eucharist. The monogram of Christ is above the vine, which symbolises the relationship between God and His people. And with the peacocks of immortality, the whole composition symbolises the Source of Life. Low relief carving from S. Apollinare, Ravenna.

45 A vase containing a lily is associated with the Annunciation. The lily, the emblem of the virgin, is the flower of purity. A detail from a fifteenth-century tomb. Wells Cathedral.

46 The passion flower, the ten petals represent the apostles. Of the twelve one betrayed and one denied his Lord. Design for embroidery.

47 An ecclesiastical coat of arms, embroidered on fine canvas, from San José, California.

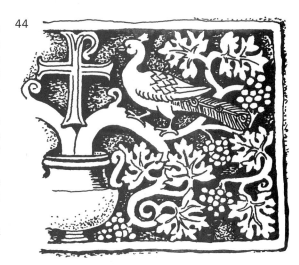

44

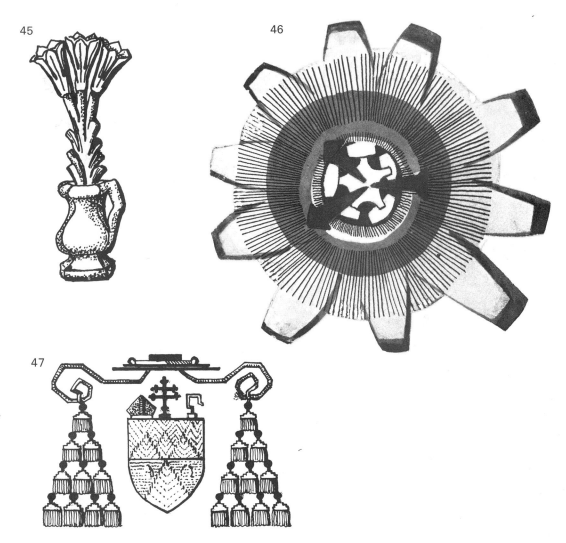

45

46

47

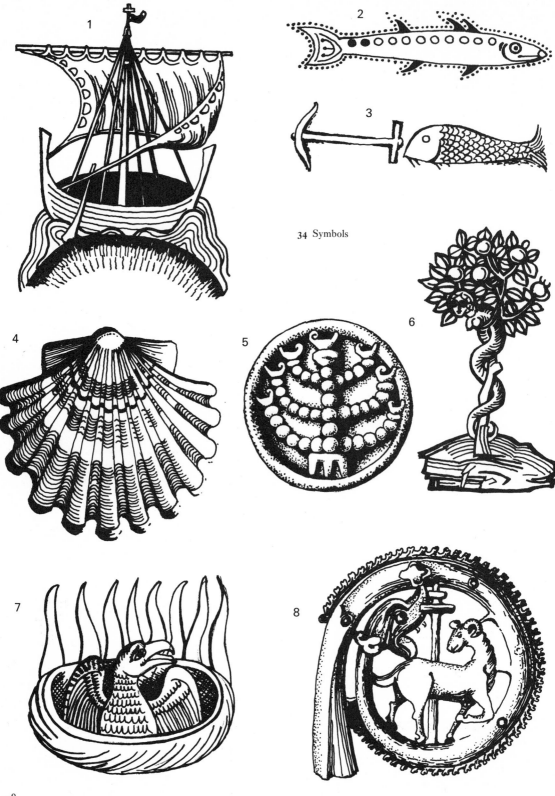

34 Symbols

Figure 34

1 The ship is an early symbol for the church. The yardarm and mast formed a cross above the ship which stood for the Church of Christ floating upon the seas of life. From a twelfth-century English Bestiary.

2 The Fish, symbol of Christ and the faithful soul swimming through the waters to salvation. Taken from the Book of Kells.

3 The Anchor, a disguised form of Cross, an emblem of hope, and the fish, another symbol employed by the Christians. From the Catacombs of St Sebastian.

4 The shell, an emblem of pilgrimage and long associated with St James the Great. From Leon Cathedral, Spain.

5 The Jewish seven-branched candlestick. Seven is known as the number of perfection and symbol of the Old Testament. Stone carving, Rome.

6 The Tree of Life, the golden fruit, and the tempter. The Temptation, the Serpent, from a Latin herbal printed in 1491. The origins of the Tree of Life were in the East long before the Christian era. The fountain of life has much the same meaning.

7 The Phoenix. This mythical Arabian bird was adopted as a Christian symbol of the Resurrection. Reproduced from a twelfth-century Bestiary.

8 A representation of the Agnus Dei with the circle of eternity. Thirteenth-century staff head, a serpent in the form of the circle of eternity.

These symbols have been selected for a variety of reasons, some because the deeper meaning remains applicable today, others inspire imaginative ideas for design, some are purely decorative, or may be curiosities. More examples can be observed throughout the illustrations to this book, for example those of the Passion or the pomegranate, which represents the hope of immortality and of resurrection. And there are the countless variants upon the Cross form.

Of the emblems associated with the Saints the most common are listed below. They are interesting as a means of indentification. For others, refer to books on the subject, given in the bibliography.

Attributes

St Andrew The X cross.
St Bartholomew the Apostle A large knife of peculiar shape.
St Catherine of Alexandria A barbed wheel, wears crown, bears the palm and carries sword.
St Cecilia An organ. She is the patron saint of music.

St Christopher wades through water with Infant Christ on his shoulders. Palm-tree staff.
St Francis of Assisi wears the dark brown habit of his order, bears stigmata, with wolf and lamb.
St George clad in armour, holds shield and sword. Transfixes dragon with lance.
St Gregory – Gregory the Great wears tiara, bears crosier with double cross. Dove (dictated writings).
St James the Great, Apostle has a pilgrim's staff, scallop shell and bears scroll.
St John the Baptist The lamb, sometimes a reed cross or dish with own head.
St John the Apostle, Evangelist The eagle, book, or cauldron of oil or cup with snake.
St Luke the Evangelist The winged ox, gospel book.
St Margaret Trampling dragon under foot. Crown, palm.
St Mark, the Evangelist A winged lion, pen, book of his Gospel.
St Mary the Virgin A lily, the flower of purity, crowned 'M'.
St Matthew, the Apostle and Evangelist A winged man, purse and money. Book and pen or axe.
St Paul the Apostle The sword, book or scroll of epistles.
St Peter the Apostle Keys, sometimes fish or cock.
St Philip the Apostle Latin cross on top of staff, or Tau cross.
St Stephen wears dalmatic, holds palm, stones.
St Thomas, Apostle Builder's rule and square.
St Ursula Crowned princess with arrow, staff with white banner and red cross. Surrounded by many attendants.
St Veronica Veronica's napkin bears imprint of the face of Christ wearing crown of thorns.

When angels and prophets are shown they are usually testifying to the majesty of God. Angels generally appear in mortal form wearing white robes, they have wings and sometimes hold a sword. There is usually a nimbus of glory around their heads. Then there are Archangels, two winged, in armour, and holding a sword. The Seraphims are six-winged, with feathered bodies and swinging censers. Cherubims are also six-winged, with feathered bodies marked with eyes, hands uplifted in adoration (see the Syon Cope). The Prophets are usually identified by an emblem and a scroll with inscription.

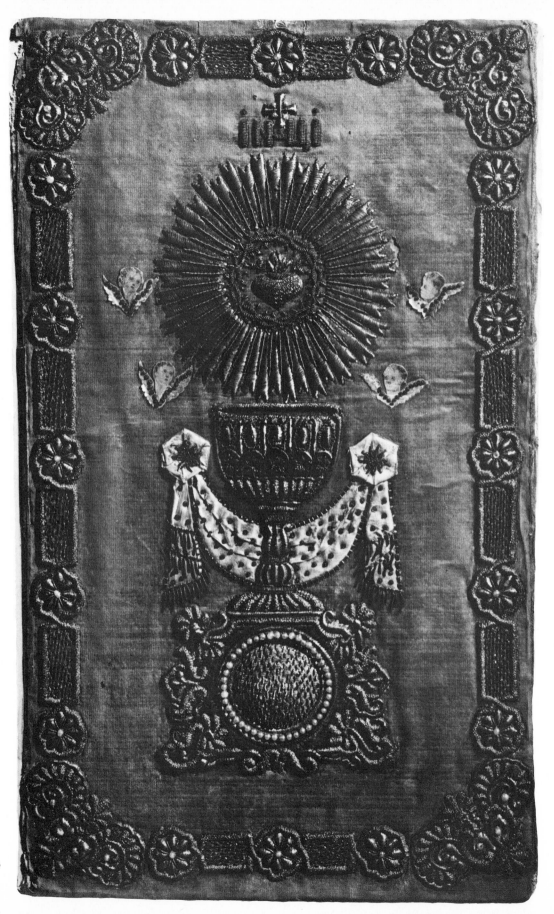

40

Colour in design and its symbolism

Colour is vitally important to the interior of a church, its effect adds much visual pleasure, furthering and intensifying the spoken word. The design and colour can assist, with the sound of music, in creating a response and bringing about a closer communication between the religious representatives and the congregation; everybody reacts to the wonder of colour in some degree. Young people are quick to feel the deadness of the out-of-date, so perhaps it is good that vestments should be thought of as expendable; the aim in the past has been to make things which will last. To be alive, the choice of colour should relate to present thinking, and, to some extent, fashion trends in interior decoration. This leads to difficulties, because there are traditionally minded people who believe that certain conventional and particular greens, blues and reds are, because familiar, more holy! But, generally, a much greater latitude of choice is acceptable today, extending to variants of the liturgical colours, for example, lime to bottle greens and all the intermediate tones.

When planning a scheme for any part of a church building it is essential that the proposed newly introduced colours should harmonise with those at present existing, but too much actual matching can be very boring. Always remember that the relative tonal values contribute more to the finished effect than do the actual colours. There are dark, medium and light tones of each colour; so, the most striking effect can be created by using extremes of contrast, perhaps dark blue and pale yellow. Whereas, if an even, all-over impression is desired, then this can be achieved by putting together several areas of similar size and of the same tone, for example, purple, olive green, brown and navy blue, this might be interesting at close range, but they would all merge together at a distance. Should the actual area of each be varied and a little light colour, say warm orange, be introduced, then the whole thing comes alive; add some scarlet (medium tone) and it is vibrant.

Dramatic effects can be planned which extend the idea on which a design may be based; this could be illustrated by arranging that all the lighter tones of the colours are placed towards the top, the medium in the middle and at the base the dark areas. Then, by superimposing lines radiating upwards and outwards an impression suggesting the Ascension will be created.

An essential practical consideration is in the choice not only of colour but of the texture of fabrics, which should always be viewed in their ultimate position within the church, and selected as a result of seeing them in day and artificial light. The changes are surprising and cannot be anticipated. The designer must insist upon adequate and imaginative lighting being provided. The lighting should be seriously discussed and agreed between all concerned.

It is advisable that the designer should ascertain the feelings of the priest concerning the adherence to liturgical and symbolic colours. The inexperienced do not always appreciate the importance attached to the significance of ritual, which has been developing from pagan times. Red, blue, purple, white and gold (the richest being kept for festivals) green and occasionally pink have been used from the earliest beginnings of the religious arts. The greatest heat of metal is white heat. It also conveys purity and innocence. Yellow signifies sovereignity, it represents gold and stands for the sun.

Red, the colour of blood is emblematic of life, lightning, fire from heaven, also the masculine principle. Blue represents the feminine principle and is emblematic of the soul and of the heavens. Green represents the earth, the birth colour. And purple is the royal colour originally associated with queens, and crimson red for kings.

Black symbolises the evil principle, night and hell, also sleep and rest. Rose pink symbolises Divine love. Emblematic of war and destruction is dark red, which is used also for martyrs.

Liturgical colours

'The practice of defining the Church's seasons and feasts and saints' days by the use of special colours only became systematised at a comparatively late date in the Middle Ages (the Lichfield Cathedral Use of c.1240 is the oldest now known). Before that, even the great cathedrals were content to use their best and newest sets of vestments for festivals, and the older and shabbier things for lesser feasts and ferial days. Even after the cathedrals had developed a distinctive Use, it is doubtful if any but the greatest and richest parish churches followed their lead. Abroad, Spain and France probably had the most elaborate colour sequences of all and these were generally followed by the diocesan clergy until the modern Roman sequence displaced them.'

35 Gold work on pink velvet, eighteenth century, various metal threads, including the use of plate

At the time of the Reformation here, and therefore at the period to which the Ornaments Rubric in The Prayer Book refers, the most general rules, though only very loosely applied, were probably unbleached linen for the first four weeks of Lent, and a deep red for the last two weeks. White from Whitsun to Easter, and for the Sundays following. Red was used for apostles, martyrs and evangelists, white for the Madonna and for virgins; blue for Advent and Septuagesima; a mixture of blue, green or even yellow for confessors. There was no universal ferial colour in England – generally a second best of any colour would be used for Sundays outside the main sequence, or possibly a green, or a mixture.

The most widely adopted use in the Church of England today (although there is no officially prescribed use, except in the diocese of Turo) is:

White, and/ or gold for All Saints' Days, baptisms, confirmations (or red), weddings, dedication of churches, Christmas, feast of the Epiphany, Easter, Ascension, Trinity Sunday, Feasts of Our Lady, Feasts of Virgins (if not martyrs).

Red for feasts of the Martyrs, Whitsuntide or Pentecost, Feasts of the Apostles (if martyrs), Holy Innocents.

Blue or violet used in the Church of England for Advent, Lent, first four weeks (or Lenten white), Rogation Days, Vigils, Ember Days (if desired).

Passiontide red used in the Church of England for remaining Sundays in Lent and for Good Friday (but altars are left bare).

Green for usage in the Church of England, Epiphanytide, Season of Trinity to Advent, Feasts of the Confessors (with blue).

Black for funerals, All Souls' Day (or blue or violet).

Rose pink can be used after Trinity and as a general ferial colour.

Yellow for the Feast of Confessors.

Lenten array, 'off white'. Used throughout Lent, or for the first four Sundays only. Design on frontals stencilled or appliquéd in red or blue, sometimes black.

Refer to Chapter VI for the colour sequence used in the Roman Catholic church.

Passiontide red is a deep, sombre colour, generally trimmed with black orphrays or embroidery, whilst for Whitsun and feasts of martyrs, etc, it is the noble bright red with characteristically exultant design. Other colours can be for ferial use, ie those days of the week which are neither fasts nor festivals.

Poorer parish churches simplify this use, and adopt a sequence of three frontals only, a best 'white', a ferial of mixed colour, and a Lenten frontal, either unbleached linen or a blue or violet if preferred.

Design

It seems that there is a real breakthrough, a whole new beginning for the church arts, stimulated by pastoral experience implementing post Vatican II reforms; one result being the publication of *Environment and Art in Catholic Worship* which is profoundly influencing all ecumenical thought on the subject. For, not only does it 'explicitly invite artists back into the church – but it also sets out to create a climate in which the arts can truly flourish, to the enrichment of the entire worshipping body'.

To design and create religious embroidery is something much deeper than mere decorating, yet this has not always been appreciated; there has been 'an abysmal lack of standards for judging artistic quality – a militant lack of understanding about what the artist really has to contribute to the church, it includes the full force of his creative being: vision, skill, discipline and a passionate commitment to quality'.

There is a long tradition leading to the changes of the present time. There is, too, the challenge. So much thinking is conventional and some old-fashioned: in consequence there is scope for a fresh and more vital approach, uncluttered by the outworn clichés. Generally it is not difficult to get up-to-date embroidery design accepted for newly built churches, but there are times when it is necessary for the designer to offer reasoned arguments in order to convince those concerned that a good design is one which is right and fitting for its purpose, in addition to being original and interesting – even arresting – and that a well conceived modern design can, and does take its place satisfactorily in any architectural style. But the fact cannot be overemphasised that this reasoning is the result of real knowledge and thoughtful consideration. Just as there are churchmen who wish to stick to the familiar, so there are artists who produce pure decoration, which lacks any understanding of, or feeling for, the faith it should enhance. Whereas an entirely new and exciting fresh concept, if sincere, can often be introduced as the result of an informed and carefully prepared explanation.

A really inspired and thoroughly competent design is, generally, the creation of one who has been

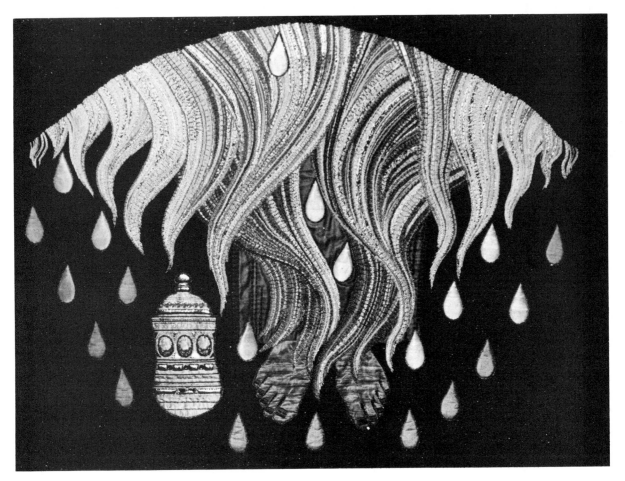

trained for the job and who understands the discipline of his or her profession; altar frontals, banners and copes, in particular, are too important in the total scheme for the untrained amateur to tackle. With these exceptions, there is great scope for those with imaginative ability to develop their spark of inventiveness into an interesting idea which is to be carried out in embroidery, avoiding hackneyed often repeated subjects and striving to approach the problem in a new way. So that some control can be exerted, it is usual for the church to obtain a faculty before accepting the larger additions to its furnishings. There really is, at present, an informed and enthusiastic interest in ecclesiastical embroidery. These heartening developments and opportunities are leading to an adventurous modern art in the church.

There are certain practical points to be considered before commencing a design.

Think about the architectural characteristics of the church, then the immediate interior surround-

36 Altar throw over, designed and embroidered by Constance Howard, 1964–65. Ground of woven black wool interwoven with brilliant green lurex. The hair is couched in a variety of gold cords, gold thread and gold and cream threads. The robe is of pinkish scarlet silk appliqué, and the feet appliquéd in pinkish fawn silk. The tear-drops are of pale pinkish silk, and the pot of pale pink silk, gold thread and 'glass' jewels. Approximate size of embroidery 1.52 m × 1.21 m (5 ft × 4 ft) *Mary Magdalene Chapel, Lincoln Cathedral*

ings against which the vestment or frontal, etc, will be seen; together with the colour of the walls, the direction and nature of the light and lighting: the colour and patterning of carpeting, runners and kneelers, and the prevalent colour and type of decoration. Find out what the relevant vestments, etc, are like. This may be daunting, but the very limitations may stimulate the imagination! It is important to view the situation from various parts of the building, envisaging the size and scale of design which would make an impact from a distance. The idea for the design may emerge at this stage, perhaps

43

one large unit or a few somewhat smaller ones, arranged either symmetrically or as balanced ornament. An all over large or a smaller diaper pattern might seem right. A decorative feature peculiar to the particular church might suggest the design to be created, the 'seeing-eye' of the artist may discover, and be inspired by some exciting detail in the church. But sometimes there are problems which cannot be ignored, features so dominating that they have to be taken into account when designing, however uninspiring.

Almost unrestricted is the range of subject matter upon which a design can be based, although today the designer still has a preference for expressing his or her intensity of feeling in terms of abstract design. The arrangement of shapes can be emphasised by the use of colour to create a wonderfully dramatic effect, large enough in scale to take its place splendidly in a cathedral, yet on a smaller scale, and in less intense colours suiting the village church too. A practical suggestion towards making the necessary decisions would be to cut out the shapes in coloured papers, grouping them and pinning them to the background, and looking at the whole thing 'in situ' making alterations where necessary. Given sufficient confidence the actual fabrics can be used. A 'mock-up' of the frontal for Kings College Cambridge was made and tried out before the final version was worked.

By pinning or sticking threads and cords on to a background a design can be created in the same way, but the emphasis would be upon the linear effect, by this means movement and rhythm are formed through the repetition of the lines making a flowing motion; this can be translated into hand and/or machine embroidery in terms of cords, braids, wools, threads, etc, upon a ground of varied colours. With opaque, transparent and translucent fabrics combined with lines of braid, a rich imagery can be created in abstract conceptions which convey in some way a spiritual quality.

Abstract design is at the present time preferred as an alternative to creating in terms of representational forms. The human form has, in a variety of idioms never failed to inspire. Its purpose in Opus Anglicanum was to convey stories from the scriptures in simply designed figures and gestures through embroidery, whereas at the end of the nineteenth and beginning of the twentieth centuries human figures were used as pictorial illustrations, even stole-ends were decorated with complicated compositions. The splendid exceptions were the highly decorative interpretations of the Pre-Raphaelites and of Art Nouveau. At the present time the emphasis is upon a formalised and very individual image. Churches often require banners depicting saints, and as there are colourful stories, symbols and emblems associated with them, this can be an interesting commission, always provided that an imaginative and not a realistic interpretation is acceptable.

With the re-ordering of liturgical space, there are new requirements – long banners to bring colour to an empty corner; the need to introduce interest where the centre for liturgical action is; the ministry of the Sacrament; or to put decoration behind the pulpit; the ministry of the word. For all this, what could be better than embroidery, fresh, vigorous and meaningful? The panel behind the pulpit from the Cathedral, Derby is an example (273).

As a basis for design, symbolism is still attractive despite the fact that much of its power and meaning has been lost through mass production. Take the mindless repetition of the Cross, which should signify the utmost sanctity, yet is embroidered on kneelers to be stood upon, or made with two strips of braid sewn onto stoles by the thousand. Conversely, fresh impetus has been added with the publication of books with reproductions showing symbols in their context from contemporary sources. Also the impact made by the great windows at Coventry Cathedral has had a far-reaching influence, as did Le Corbusier's chapel of pilgrimage at Ronchamp.

CHAPTER III
Liturgical vestments

In the quest for egalitarianism, there has in recent years been a tendency – even in the 'vested' traditions – to dispense with sacred garments. Another form of egalitarianism is that those officiating shall be similarly vested. The Celebrant or President's chasuble may, however, be more distinctive.

Traditional vestments will probably be made and worn for many more years, before being superseded. There are changes consequent upon con-celebration of the Eucharist because of the many participants. The Vatican Council and National Synod have advocated that the basic vestment (chasuble or cassock-alb) should remain the same, white or stone coloured linen or similar fabric, with a detachable orphrey or wide stole, of a colour changing with the season. There may be a central chasuble of a matching colour. The Bishop will wear a chasuble and mitre. Most Anglicans will wear chasubles.

The designing of the chasuble needs to be re-examined, not only because the presiding president (priest) now faces the congregation, although there is never a time when the back is not seen, but because the chasuble is the frame for the elements of bread and wine, and as such has to be considerably fuller and longer. This last feature is important due to the fact that many altars are in the form of a table, and are without a frontal, so that the whole length of the garment worn by the priest is seen.

The design of a vestment must be appropriate, and should be a work of art having value and dignity in its own right; it must also serve its ritual action. Although vestments have been simplified, they are important, to quote from *Environment and Art in Catholic Worship*: 'The wearing of ritual vestments by those charged with leadership in a ritual action is an appropriate symbol of their service as well as a helpful aesthetic component of the rite. That service is a function which demands attention from the assembly, and which operates in the focal area of the assembly's liturgical action. The colour and form of the vestments and their difference from everyday clothing invite an appropriate attention,

and are part of the ritual experience essential to the festive character of a liturgical celebration'.

In these times of change it is instructive to reflect upon the origin, significance and purpose of those vestments still used in the Protestant and Roman Catholic church.

As late as the sixth century classical Roman costume was worn, but it fell more and more into disuse, until various councils and synods insisted upon a distinction between the dress of the cleric when engaged in the liturgy, and at other times. And so, to quote C E Pocknee, 'The vesture of the Christian ministers of today, whether we think of the Anglican, Roman Catholic or Eastern Orthodox rites, is therefore nothing else than a stylized form of the holiday attire of the old imperial days of Rome. The use of such dress over the course of the centuries and in all parts of Christendom gives a sense of stability and continuity which are essential in a religion concerned with eternal verities.'

There have, from time to time, and particularly at present, been certain differences and changes in use and design.

The vestments, together with the altar frontal, dossal and usually the burse, veil and pulpit fall conform to the Liturgical colour of the season, and the design of the embroidered decoration is planned as a whole, with skilful variations, and avoiding monotonous repetition. Symbolism generally relates to the season being celebrated.

When intending to make a set of vestments consider first the design (Chapter II), where the creation of the decoration has been discussed. That the individual article is but one part of the whole scheme cannot be overstressed. It is this visual impact which, combined with the spoken word and the music brings about the total experience.

The chasuble

Throughout the whole of Christendom it is the chasuble and alb which are the proper vesture for the celebration of the Holy Communion, the former

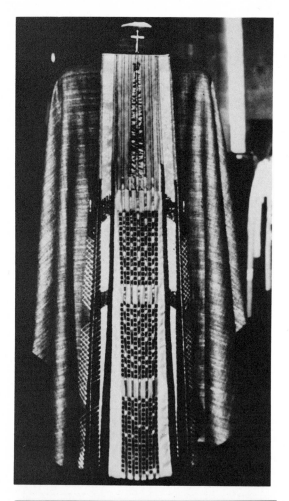

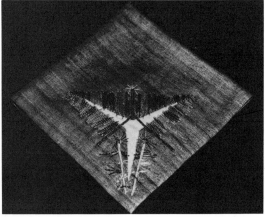

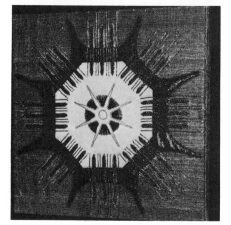

37a–d Set of low mass vestments embroidered and made by
Pamela Waterworth 1978. Soft green indian silk with tones of
green applied, embroidered with gold and dull silver. The
design is based upon architectural features of the cathedral
Blackburn Cathedral, Lancashire

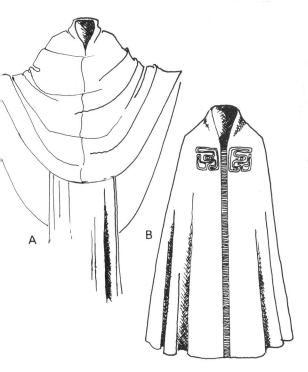

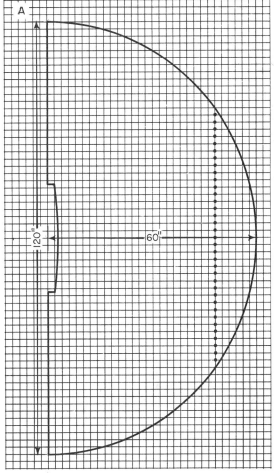

38A,B *Above* The Paenula, conical or bell-shaped chasuble

39A *Right* Scale 1 square = 5 cm (120 in. = 3.6 m, 60 in. = 1.52 m). The dotted line represents the join for 48 in. or 122 cm fabric. Amount required approximately 4 m
For instructions see page 52

40 *Below* The development of the chasuble

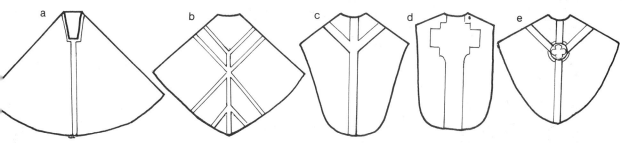

representing the seamless robe placed upon Christ after the scourging. During the centuries it has undergone a series of modifications. The early form is the shaped Paenula, a semi circle (38A, B) with the two straight edges joined down the centre front, leaving a gap at the neck, which may be cut away as at (40a). For this elegantly draped, but somewhat voluminous garment the fabric must neither be too heavy nor too light, if it is the latter it will not fall in

good folds. This, the Paenula, conical or bell-shaped chasuble can be seen represented in early carvings and a diagram of the pattern is given (39A). Other examples of the twelfth and thirteenth centuries and later, show the hem line coming to a point at the centre front and back as at (40b), which is the Thomas a Becket chasuble at Sens Cathedral. The shape was changed for convenience (40c), with the introduction, in the thirteenth century, of the

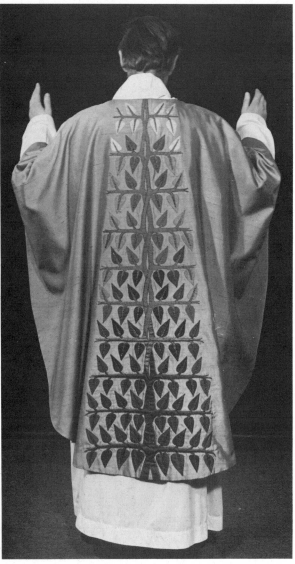

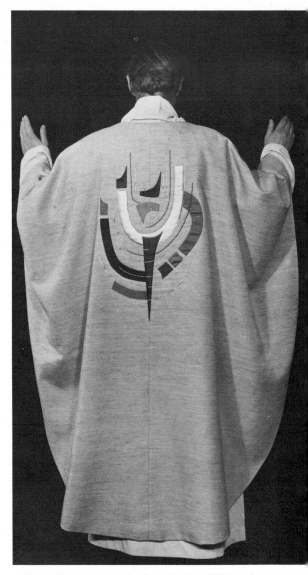

41 Green chasuble, Tree of Life, 1969, designed and worked by Sister Kathleen SSM. Blind appliqué of wild and Thai silks in tones of green
St Saviour's Priory, Shoreditch, London

42 Festal chasuble worked by Sister Kathleen SSM, and designed by Angela Lacy March. Appliqué in blue, green, red, yellow gold on off white
St Chad's, Shoreditch, London

Elevation of the Host: when the celebrant, at the Mass, was required to hold up the Host with both hands above his head.

In the Baroque period even more material was cut away to alter the shape (**40**d); furthermore this was stiffened, so that the embroidered cross on the back (the pillar in front) could be better seen. This is also known as the Roman shape of the chasuble.

Towards the end of the nineteenth century at the time of the Gothic revival there was a return to the early form, but this revived Gothic shape is shorter, and the seams follow the shoulder line, altogether a somewhat skimpy vestment (**40**e). This has developed into the present day chasuble which is both longer, fuller and has the length extended at the shoulder line; the front will probably remain a few centimetres/inches shorter for convenience. This long chasuble which hangs in graceful folds is recommended.

Having decided upon the shape of the chasuble,

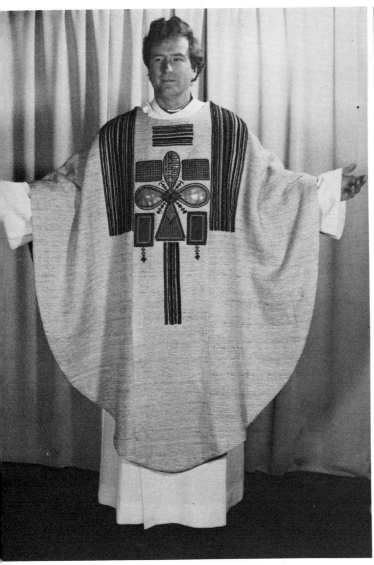

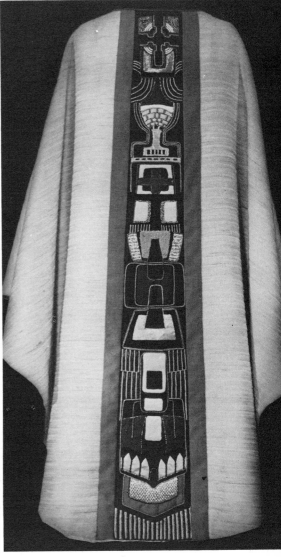

43 Chasuble, designed and worked by Pamela Newton. Embroidered in wool and cotton with velvet ribbon and braids. Brown, coral red and gold, on off-white Indian silk
St John's, Dormansland, Sussex

44 Chasuble. Part of a low mass set worked by Nancy Tatham, 1978. Off-white fabric, with old gold and brown embroidered in various types of gold
Parish Church, Hove, Sussex

some suggestions for the decoration are illustrated (**45**). There are many other possibilities.

Ideas for design are sparked off in a variety of ways. If symbols are to form the basis, then the interpretation should be fresh, alive and original, whether it is to be carried out in hand or machine embroidery, or alternatively with hand woven or other braids. The preferences of the wearer must be ascertained and taken into account, also his height and stature. Remembering that it is a garment to be

worn, and seen from a considerable distance, the decoration should be suitable for its liturgical purpose; with the Westward facing celebration the front of the chasuble is of equal importance with the back. The term orphrey might here be explained, as it is still applicable. It is a strip or band (usually vertical) of decoration, which is applied to or let into the background fabric. When designing for a chasuble the direction of the folds, ie whether vertical or horizontal, must be observed, as this has an in-

49

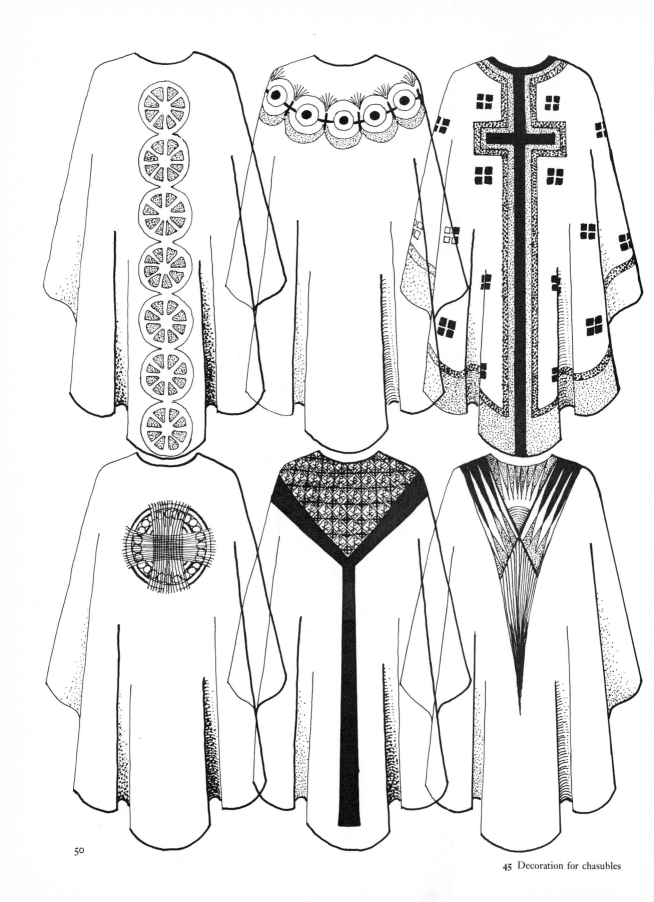

45 Decoration for chasubles

fluence. These points can be observed from the illustrations.

As a result of the change to the wearing of the cassock-alb, it has become necessary not only to alter the neckline of the chasuble, but to devise some interest in keeping with the embroidery, to take the place of the amice and its apparel.

Fabric for vestments

The materials chosen for vestments must be of the correct weight to hang in good folds, neither too thin and light nor too thick and heavy for comfort. Remembering that a chasuble is a garment which will receive hard wear, the material should be one which is not stiff, can be cleaned, will wear well and is crease resistant. In Germany and Holland fabrics are specially woven for the purpose, and in Scandinavia beautiful hand-woven materials are planned so that stripes in the warp are crossed by a group of weft stripes in just the right places, in relation to the garment in wear. Until weavers in Britain are interested enough to collaborate to produce experimental materials in this field, we shall have to continue to hunt for suitable furnishing and dress textiles.

It is the textural surface quality allied to colour which attracts and determines the eventual choice. It is impossible to name any but the obvious fabrics, or to recommend more than a few as they are constantly changing.

The exceptions to much of what has been said are the silks, professionally hand-woven for ecclesiastical use, by one or two weavers, which are wider than usual. (Being apt to drop a little, the vestment should be left hanging before completion.) It is still possible to find Thai silk, though the heaviest quality is too stiff, except possibly for copes. The colours are beautiful, but this is costly. Then there are Indian raw silks, and the thinner silks which are really too light. Wild silks are rather thin, but it is possible to compensate with a mull muslin interlining. This can also be used when a coloured lining shows through on the front.

Fine, light wool dress-weight tweed or fine wool crêpe georgette hangs in excellent folds, and also some man-made mixtures can be used to good effect. The matt surface contrasts well when, and if, a shiny fabric is applied as decoration. Good quality Jersey will sometimes be suitable.

A fabric with a Jacquard woven pattern makes interesting material for vestments, as parts of the repeating pattern could be picked out in stitchery or with velvet, suede or kid applied.

Vestments can be made with Dupion satisfactorily, but some furnishing fabrics with a pronounced slub will not hang well, owing to the fact that the weft thread is much thicker than the warp.

Screen printed, resist, batik or tie and dye are methods of printing which, with skill, can be employed to good effect, and combine well with embroidery.

When moss or similar crêpes are available, they drape beautifully, and are excellent for the conical chasuble, and for the whole Eucharistic set of vestments.

Whether a contrasting or matching colour is used, the lining material has to be selected with care; there are several extra wide synthetic linings, the colours are good, also the texture and they seem to be perfectly satisfactory in wear.

Shantung, Jap silk, and the very light paper taffetas are good too. Avoid stiff poult or taffeta, and materials with a shiny surface, as they slip when worn. The conventional Polonaise, a twill weave, may be preferred.

Vestments intended for tropical climates can be made of linen; when planning remember that they have to be washed, and so are not lined.

Drafting patterns for chasubles

The following chasuble patterns have been drawn out to scale, some at 1 square to 4 cm, others at 1 square to 5 cm. Should it be necessary to change the centre front and back measurements, it is quite easy to add to the length by re-drawing the line. Many priests prefer a much longer chasuble. When taking the measurements it is the centre front and centre back lengths and the length down the arm for the shoulder seam, which are important; these are usually made as long as possible. The front of the chasuble remains about 10 cm (4 in.) shorter than the back, as it constricts the movement less.

When an amice is worn, the neck of the chasuble measures about 69 cm (27 in.). But when worn with the cassock-alb it should be made smaller, thus necessitating fastenings, if small zips are let into the shoulder seam or seams there is no difficulty. Alternatively the front shoulder seam might be made to fasten over the back seam with strips of velcro sewn on the turnings. Or the neck might be finished with a narrow stand-up band with an opening on one shoulder, alternatively cut down about 7.5 cm (3 in.) at the centre front, decorated and faced to neaten (51g). Otherwise a collar makes a good finish.

Most of the chasuble styles have a seam at the shoulders, for several reasons other than as a means

of fastening; for example, the framing-up for embroidering is simplified, it cuts into less material, and it is easier to make up.

It is always an advantage to try out the pattern in some odd piece of material, marking the position for the decoration. Then fit it to check the length, and the proportion and position of the decoration in relation to the wearer, who will probably have his own ideas on the subject!

When corrections have to be made as a result of the fitting either re-draw and cut the pattern or extend it by sticking on additions. Accuracy is important as the pattern is used for the lining.

Graphs of chasuble patterns

39A The conical chasuble is based upon a semi circle with a 152 cm (60 in.) radius, the two straight edges are placed to the selvedge and joined to form the centre front seam. The graph (page 47) shows the position of the join for a 122 cm (48 in.) fabric, approximately 4 m (4½ yd) would be required.

46B This shows possible modifications, the small dots represent the shoulder line.

47C The Roman or Latin chasuble. Alternatively the back shoulder can be extended without a seam, and joined across the front, as shown by the dotted lines.

48D Modern chasuble.

46B Modifications of the conical chasuble Scale: 1 square=5 cm – radius 152 cm

49E The Gothic Revival chasuble, a shape which seems somewhat skimpy now. It can be cut from 122 cm (48 in.) material without central seams, this is shown in the layout.

50F The set, chasuble, stole, burse, veil and if required, maniple, takes about 3.20 m (3½ yd) according to length of chasuble and width of material.

51G This is the shape of the chasuble most generally worn, the length can be varied, as can the length of the shoulder line seam. It is usually necessary to have centre back and centre front seams. With a line of small dots is shown the smaller neckline, with 7.5 cm (3 in.) openings on both shoulders, (or one longer opening), which is necessary when worn with the cassock-alb; a decorative central neck opening is shown at (**51G**).

The lay-put (**52H**), is planned for fabric 1.22 m, (48 in.) wide, the amount required would be about 5 m (5½ yd).

Estimating the amount of material required

The most economical method is to cut out all the pattern pieces in newspaper; on the floor mark out as long a strip as possible, which represents the width of the proposed fabric. On this strip arrange the pattern pieces to fit in with each other, remembering to *allow for turnings and hems*, and making sure that the grain of the material will run

47C Chasuble, Roman shape Scale: 1 square=5 cm. Back length 128 cm

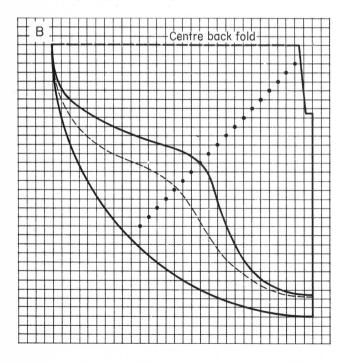

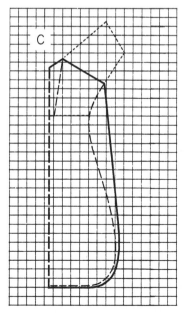

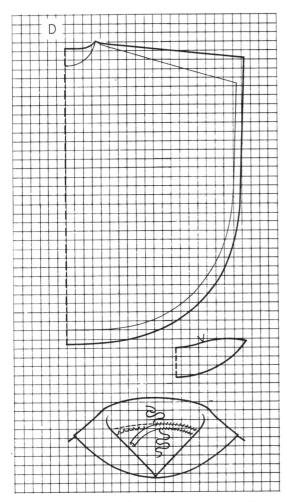

49

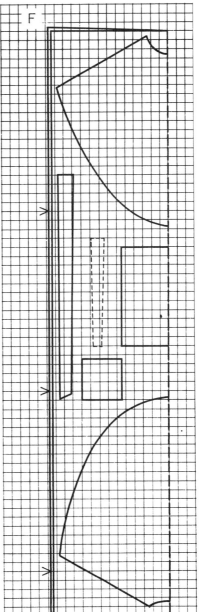

48D *Above* Chasuble, Modern Scale: 1 square = 4 cm. Back length 114 cm

Thick line = back Fine line = front

But the back or the front can be cut to either the back or the front line of the pattern.

Add 2.5 cm turnings, also hem width.

Put the centre back of the collar to a fold, cut double.

For 1.60 m wide fabric put CB and CF to fold. For narrower fabrics a join. Therefore turnings are necessary. Stitch shoulder seams and hem.

Cut and attach interlining for collar, with right sides together stitch outside edge. Press and turn out.

With underside of collar to right side of neckline, match up shoulder seam to nick in collar pattern.

Stitch around neckline. Nick turnings.

For an unlined chasuble neaten the join by hemming on a narrow cross cut facing, as illustrated.

For a lined chasuble, this is turned in at the stitching line, nicked and hemmed.

49E *Above right* Chasuble, Gothic Revival shape Scale: 1 square = 5 cm. Back length 120 cm

50F *Right* Layout showing placing for the set, material required about 320 cm according to length of chasuble and width of material

50

53

51G The chasuble generally worn now, the length can be decreased Scale: 1 square = 5 cm

52H *Opposite* Layout for 122 cm (48 in.) fabric

down the length of each piece (this is not always necessary for stoles). Or the whole process might be worked out to scale, on graph paper.

If the material is patterned, the seams must be planned so that the design matches up when joined. Inevitably, more fabric is required. This applies also where there is a nap or pile, or the shading varies.

To arrive at the amount of material required, measure along the strip (which represents the material) and allow a little more for safety. Then plan out how much lining will be needed, as this may not be the same width.

As most ecclesiastical embroidery is mounted on a backing, the cutting out can be completed and the edges overcast by hand or machine to avoid fraying; but if the embroidery is to be worked directly on to the material, it may be advisable to mark out the outline, postponing the cutting out until the embroidery has been completed. But this means that the material is cut to waste, and more is required.

Placing the pattern on the material

The specimen lay-outs given may serve as a guide, but they are only suggestions; and it is essential that the width of material is checked, also the actual shape and measurements of the vestments be cut out. A longer than average stole can alter a whole arrangement. (Maniples are no longer required).

Place the pattern pieces on the material, tack or baste in the fitting lines; using tailor tacks where the material is double. Put in balance marks.

Making-up processes

The embroidered decoration having been completed and stretched or pressed, if necessary, the vestment can be cut out, allowing 2 cm ($\frac{3}{4}$ in.) for turnings and about 3 cm ($1\frac{1}{2}$ in.) for the hems. The centre should have been marked upon all pattern pieces, these are now laid out flatly, face down. (For making-up a large table and weights are essential).

Cut out the lining, marking in the centres.

Complete seams.

Then turn up the hems, matching straight grain to straight grain, keeping the pins at right angles to the edge, tack close to the edge, (53.1)

To press a hem, cut a curved strip of dry cloth, insert it between the hem and the garment (this is moved along as the pressing proceeds). Over this is placed a very slightly damp cloth (if the material is suitable), then, keeping the iron pointing inwards, press. This shrinks away the surplus fullness (53.1).

Catch stitch (53.2) or lightly herring-bone (53.3) the hem (on some materials it is sufficient to press only). (A strip of heat fusable gauze, cut to shape may save time when putting up a hem).

Putting the chasuble together

In these diagrams, L = lining
R = right side of chasuble
W = wrong side of chasuble fabric.

When making up a chasuble it is necessary to start

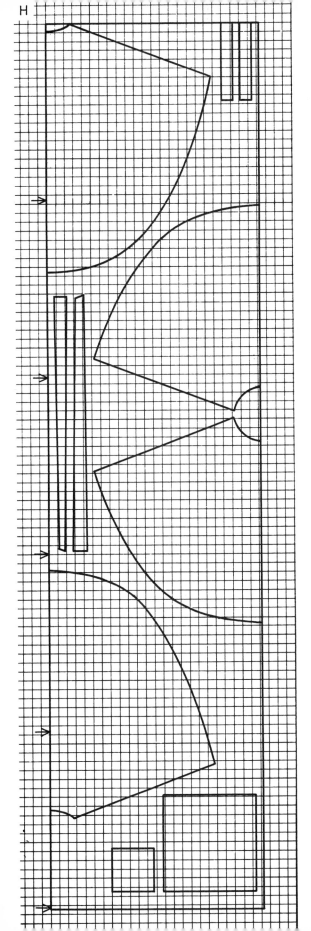

and finish stitching the hems of the front and of the back about 8 cm ($3\frac{1}{4}$ in.) away from the shoulder lines. This is shown at **54**b.

Because it makes for easier handling, the linings are attached to the front and back separately, before they are joined together. Spread each out flatly, place the lining pieces over the wrong sides of the back and front of the vestment, pin together, keeping the pins horizontal, zigzag tack vertically, tack 8 cm (3 in). in from the edges on one half as at **54**a.

Next, fold back one half of the lining down the centre (**54**b). Lightly lock the two together with tiny invisible tie-tack stitches about 4 cm ($1\frac{1}{2}$ in.) apart, these must not be drawn up too tightly (**53**.4). Start and finish about 8 cm (3 in.) from the edges. Generally, to stitch down the centres is sufficient, if more is needed, follow the instructions for a cope.

Replace the loose half of the lining, complete the tacking (**54**c). Turn in the lining around the hemline, and slip-stitch, (**53**.5) (or hem). For this the needle is taken through the edge of the lining, then it is slipped through the fold of the hem. This stitching starts and terminates a short distance from the shoulder line (**54**d). The whole process is repeated on the second side.

Pin back the lining at the shoulders, then, putting the front and back of the chasuble together, right sides facing, open out the unstitched portions of the hems, pin, tack and stitch the seams (**54**e) press open, and unpin and release the linings. Refold and stitch up the hems of the chasuble.

Smooth the back lining over the shoulder seams and attach to the turnings with running stitches (**54**f). Bring the front lining up to the seam line, fold the turning under, arrange the hem line, hem the edge leaving a loose thread at the neckline, f, (for completing the stitching later.)

For a fitted neckline, turn under the shoulder turnings and slip a small fine zip underneath, stitch the edges through to the tape of the zip on the reverse side, bring the lining up to the metal part, and hem it to the zip. Repeat for the other shoulder.

For a traditional neckline (if necessary enlarge neck to measure 68 cm—27 in.), cut piping cord to this length, but make the cross grain strip longer, cover the cord, sew it round the neck opening starting at the shoulder (**54**g) allowing the covering to extend 2 cm ($\frac{1}{2}$ in.) beyond the ends of the cord. At the join arrange the end to lie over the beginning; in this way the cords do not overlap. Nick the edges, (**54**h).

Turn the piping over, and on to the reverse side of the chasuble, (**54**i) press, nick round the neck of the

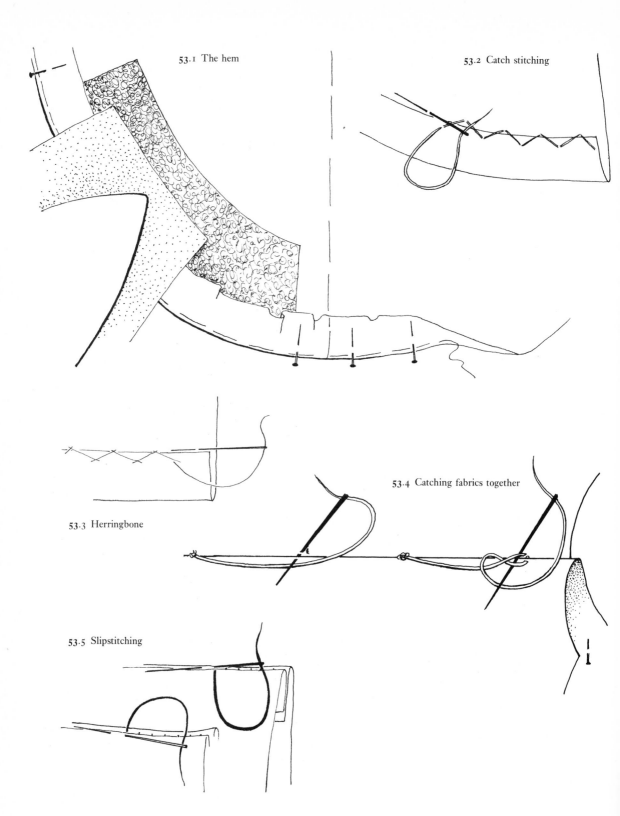

53.1 The hem

53.2 Catch stitching

53.3 Herringbone

53.4 Catching fabrics together

53.5 Slipstitching

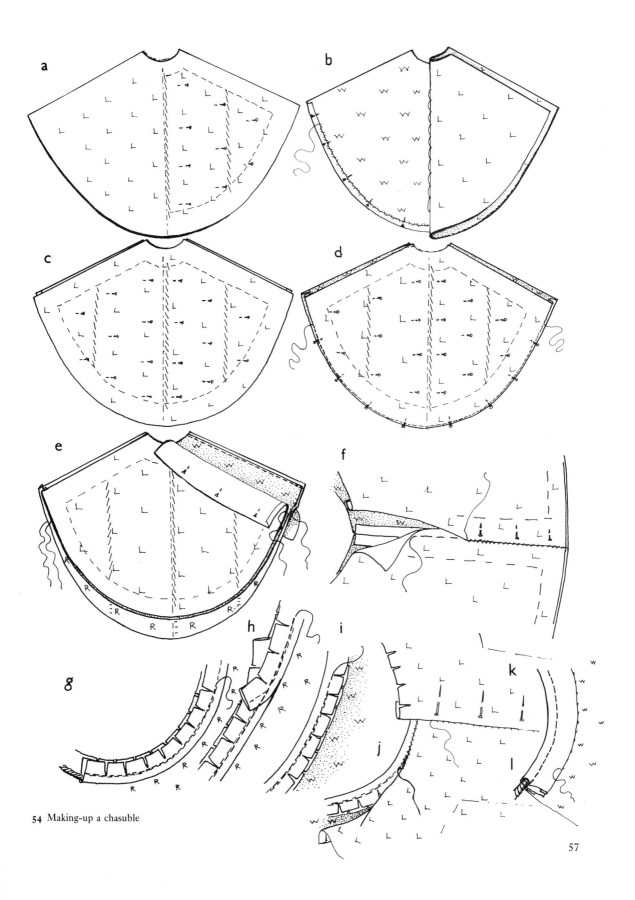

a

b

c

d

e

f

g

h

i

j

k

l

54 Making-up a chasuble

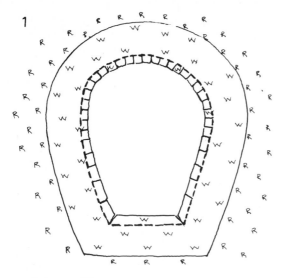

55 Facing a neckline

lining, then, starting at the shoulder seam, turn under the edge of the lining, and hem it to the back of the piping (54j).

This is the simple method; professionally the casing of the piping would be joined on the cross to the correct measurement. The cord, also cut to size, would be joined together, then inserted, and sewn in place.

For an unlined chasuble, arrange for one edge of the piping to be wider, turn in a small lay, and hem invisibly (54l).

Alternately the neckline can be neatened with a facing. Cut the facing to the shape of the neck (it may need shoulder seams). With the right sides together, place it upon the garment, stitch round the neck, nick at intervals and into the corners (55.1), turn through to the wrong side, catch the edges invisibly to the garment. Taking the lining, nick around the neck, turn down a lay, hemming it to the facing (55.2). If it is an unlined chasuble, the facing is cut narrower. The first part of the process is the same, when turned on to the wrong side of the garment, the edges of the facing are folded in and invisibly stitched to the fabric.

The hem of an unlined chasuble is usually about 1.5 cm wide. But a narrow cross-cut facing, with both edges turned under, makes a neater finish.

A quick way of making a lined chasuble is achieved by first completing the shoulder seams of the chasuble and the lining, then finishing the neckline with a facing. Next, put the right sides of the two pieces together, matching the centres, tack, and machine

stitch round the hem line; pare down the edges. Turn the whole thing to the right side through the neck opening. Match up the centres and the shoulder seams, catching the latter together with invisible stitches. Press around the outside edge. Hem the lining to the neckline facing.

The stole

The stole is one of the Eucharistic vestments and is a sign of the priest's authority.

Design

The conventional three crosses so frequently used are not obligatory, although the one cross at the centre back of the neck is usual, and in the Roman rite this cross is required. Any decoration suitable for the season can form the basis of the design, but it should belong to the set of which it is a part. When considering other vestments, emphasis has been laid upon the advisability of keeping the design large in scale; but the embroidered detail on a stole can be appreciated at close range. A repeating pattern can extend along the entire length of the long narrow stole, or, if it is about 8 cm – 9 cm (3 in. – $3\frac{1}{2}$ in.) the ends could be variously embellished. Now that fringes are no longer thoughtlessly added, the time has come for re-introducing decorative fringes where applicable.

The baptismal stole may be white or cream on one side and purple on the other. A deacon's stole is generally straight, and has an inconspicuous fastening.

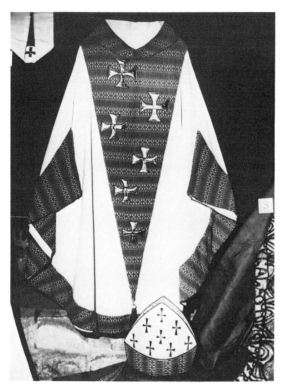

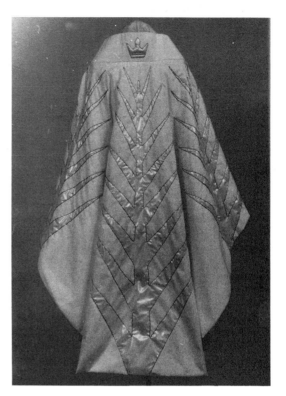

56 Chasuble and mitre designed and made by a young Philippino in 1973. The principal fabric is made from banana plants and is cream colour. The orphreys are woven in red wool; all are Philippine materials. The crosses are applied in gold kid. The eucharistic set of vestments was presented to Lord Ramsey when Archbishop of Canterbury
In Manila at the church of St Mary and St John of the Episcopal Church of the Philippines

57 Chasuble and stole designed and made by Elizabeth Kennedy. Ground fabric pure cotton gabardine, the palms and crown (symbols for all saints) are applied in disco-jersey and outlined with synthetic gold thread
All Saints' Anglican Church, Kooyong, Victoria, Australia

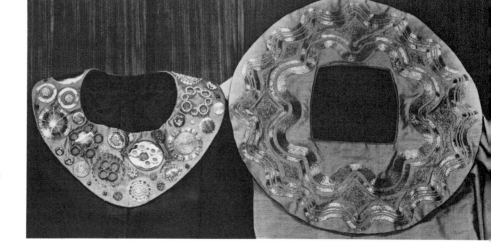

58 Yokes for two chasubles. Designed and made by the Rev Leonard Childs. *Left*: olive green chasuble with a light blue yoke, embroidered in various kinds of gold. *Right*: couched Jap gold on golden yellow silk
Festal vestments for Derbyshire Royal Infirmary

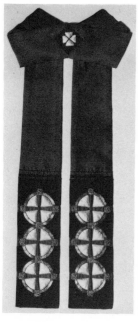
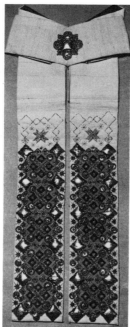
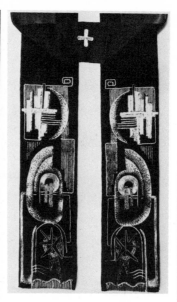
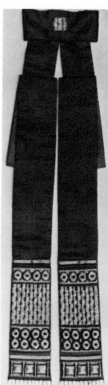

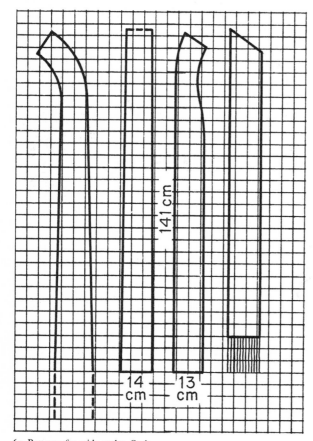

60 Patterns for wide stoles Scale: 1 square = 5 cm

59a *Above, left to right* Stole designed and embroidered by Joyce Williams, 1979. Tones of violet stitched with couched Jap gold

59b Stole designed and worked by Joyce Williams, 1977. Raised gold, coral pink organza applied to ivory dupion

59c Stole designed and worked by Katarin Privett, 1968. Purple Thai silk with Jap gold couched

59d Stole design (based on Autun stone carvings) embroidered by Joyce Williams, 1968. Jap gold couched over padding, purple Thai silk background
The Church of Saints Peter and Paul, Chingford, Essex

The maniple is no longer used, but should one be required its total length is $122 \, \text{cm} \times 6 \, \text{cm}$ ($48 \, \text{in.} \times 2\frac{1}{2} \, \text{in.}$) wide and the making-up the same as for the stole.

The wide stole

When the celebrant or president of the Eucharist started to enlist the assistance of the people, they tended to take and wear any stole that was the colour of the day, which, not having been intended to be worn outside, was unsuitable. This resulted in the emergence of the new wide stole to be worn over the cassock-alb, and advocated by the Church Commission.

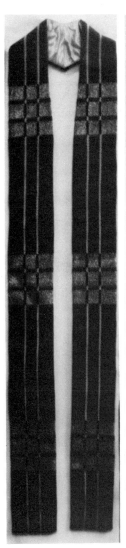

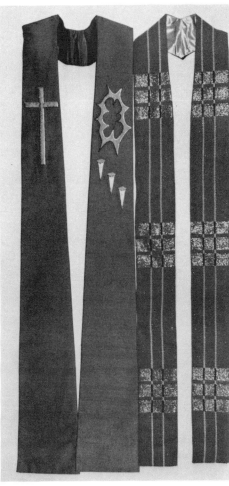

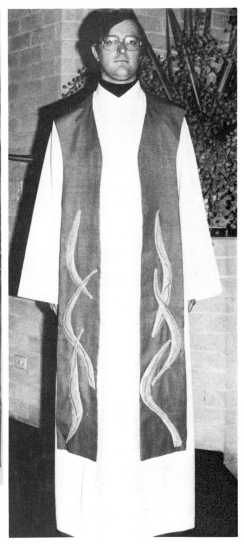

It was decided that the old Byzantine stoles, worn by the Orthodox Church of the East (**200**), and seen in the Mosaics of Ravenna, were a much better shape. They vary in width from about 11 cm–20 cm (4½ in.–8 in.) and can fall to within 15 cm (6 in.) of the ground.

Broad stoles are frequently reversible and afford the embroiderer unlimited scope (**61**A,B,C) and the Derby stoles are fine examples, (**Plate II**). Almost any material can be used, or they can be made of the handsome wide, woven braids. These stoles are carried out in the liturgical colours.

There are several ways of dealing with the neck, the simplest being the mitred join. The French have a way of sewing a piece of cord across the back of the

61 Wide stoles.

Left **A** Designed and embroidered by Sister Kathleen, SSM.

Centre **B** Stoles made with woven braid

All-Hallows by the Tower

Right **C** Stole, designed and made by Nigel Wright, wild silk with flame motifs applied in silver, yellow, green, heliotrope and pink.

Cassock-alb made of polyester viscose fabric

Victoria, Australia

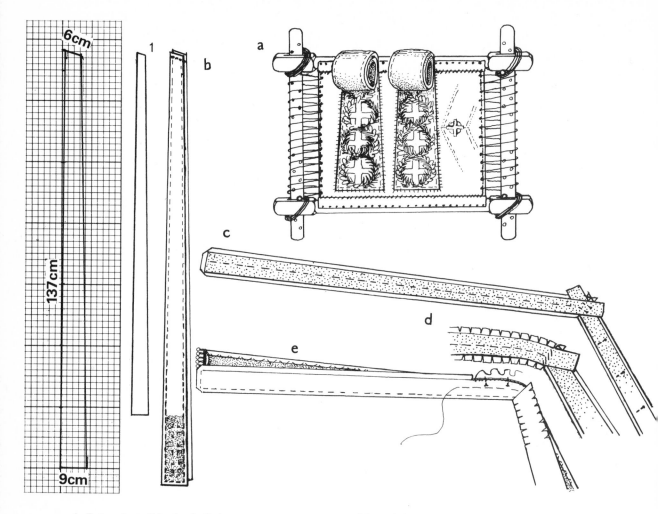

62 Pattern for traditional stole Scale: 1 square=2 cm.
Embroidering and making up a stole

neck, which prevents the stole from slipping. Or it can be shaped, and joined at an angle. But when the shaping is carried out by making two or three tucks around the neck, the material has to be soft but firm, and there is no stiff interlining. This stole is cut as a straight strip. The patterns are given in diagram **61**. The length can be adapted for the height of the wearer.

The making-up is similar to that suggested for the traditional stole (**62**), except for the last style. Here a fairly firm material is used, and if an interlining is necessary it should be cut away at the neck before stitching the tucks.

If a fringe is needed, the heading is sewn to the reverse side of the stole, and the edge of the lining is placed over it and hemmed down.

Materials

The fabrics listed as being suitable for all vestments, with, additionally, gros-grain ribbed or corded silks, and the thicker Thai silks, can be used for stoles but bulky materials cause clumsy corners. Dowlais (a course linen) is used for interlining, also other firm and fairly heavy interlinings.

Measurements

The traditional Eucharistic stole is generally longer than the pastoral or preaching stole, as this shows below the chasuble. Preferably the length from the centre is 137 cm (54 in.) or 122 cm (48 in.) and 7.5 cm–9 cm (3 in.–3½ in.) wide at the bottom, narrowing to 5 cm–6 cm (2 in.–2½ in.) at the neck.

The long narrow stole is a uniform width of about 7 cm (2¾ in.) and about 137 cm (54 in.) to the neck (it too can be shaped at the neck). The new wide stole can measure a total of 244 cm (136 in.).

Method

For making up a stole.

1 Draw out the pattern, spread it on the material with the grain running down (if suitable it can be placed across the grain). Tack round the pattern outline.

To prepare the embroidery, frame-up the backing (fine linen, holland, or unbleached calico), roll up the remainder of the two stole lengths (**62a**), then transfer the design (**242**). Complete the embroidery.

2 Stitch and press open the centre back seam; it slightly slants to give shaping (**62b**). Having left a space on the framed-up backing, open out the centre back seam and place this on the backing, pin and tack, then embroider the small central cross over the join (**62a**). (It is possible to stitch the cross in the hand.) This process has to be adapted for machine embroidery.

Remove the embroidery from the frame, and cut away the backing to the pattern line as shown in the diagram (**62b**). Or, instead, it may be preferable to cut it away close to the embroidery.

3 Cut two pieces of interlining just a fraction inside the pattern line except at the centre back, where each end is extended by about 6 cm ($2\frac{1}{2}$ in.).

4 Smooth the stole out flatly on the table, face down.

5 Taking the pieces of interlining, place these over the stole, smoothing towards the centre from the bottom of each, allowing the ends to overlap at the centre back, pin and zigzag stitch the join in the interlining (**62c**). Tack, cut away surplus overlap.

6 Re-shape by cutting the neckline of the interlining into a curve. Snip the concave and clip the convex turnings of the stole fabric (**62d**).

7 Fold the turnings of the stole over on to the interlining, catch stitch or herringbone (**53.2 and 3**), working upwards from each end (**62e**), so that, should any adjustment become necessary, the stitching at the overlapping join can be unpicked and the alteration made.
Press the turnings on the wrong side.

8 Cut out the two lining pieces, allowing turnings. Stitch the centre seam at exactly the same angle as the one on the stole. Press this open.

9 Match up the centre back seams, place the lining in position, and, working outwards from the centre-back pin and tack down the middle; this keeps the lining in place.

10 Starting from the centre back, fold in the turning, a section at a time (a fraction inside the edge). Snip the inner curve and clip for the outer curve at the neck (**62f**), slip stitch (**53.5**) or invisibly hem.

The fold of a contrasting lining coincides exactly with the edge, and the heading of a fringe covered by the lining. Adhesives suitable for use on fabrics can replace the catch stitching.

The amice

This is a neck cloth worn under the alb, and is a rectangle of linen, tied with tapes. An apparel, which may be embroidered, can be sewn on as decoration.

Design

It is usual for a small cross to be worked in the centre, about 4 cm ($1\frac{1}{2}$ in.) in from the top edge, alternatively a band of embroidery, which incorporates the cross can be worked with washable threads, when worn this should be turned down over the chasuble.

When the apparel is made separately, the colour and design of the embroidery matches the rest of the vestments. It measures 51 cm–56 cm × 8 cm (20 in.–22 in. × 3 in.), and is interlined and lined, then tacked to the amice on all four sides, so that it can be removed when necessary.

Material

Linen for the amice. The material of the liturgical set for the apparel.

Measurements

92 cm × 61 cm (36 in. × 24 in.) plus (**63**) turnings for hems.

The tapes should be 1.90 m (6 ft 3 in.) long.

63 Amice Scale: 1 square=2.5 cm

Method

Make a narrow hem around the rectangle. Any white-work method (Chapter VI) can be used for embroidering the cross or border. The tapes are sewn at the upper corners or slightly below.

With the introduction of the cassock-alb the wearing of an amice is unnecessary. It is now sometimes replaced by a smaller version of a cowl hood.

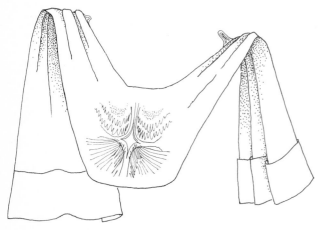

64 Humeral veil

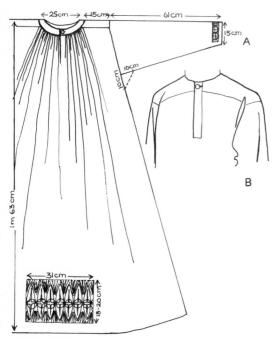

65A Alb with apparels 65B Alb set into yoke

Humeral veil

This is a scarf-like veil worn by the deacon at High Mass, and by the priest at Benediction.

Design

The decoration is usually at the centre back and at the ends.

Material

Soft, light fabrics should be used because the veil has to drape well. It can be unlined, but when there is a lining it is light but not slippery.

Measurements

Generally 276 cm × 61 cm (108 in. × 24 in.) wide.

Method

If unlined, the edges are neatened with narrow hems along the sides, which are wider at the ends. When the veil is lined quite often the lining is folded back at the ends to form two flat pockets, across the width, or there may be two triangular pockets across the corners. It is necessary to have some form of fastening (64).

The alb

The traditional alb is made from white linen, but now, more often nylon, polyester 60% and 40% cotton or moygashel. There is also a light but opaque viscose linen. Other non-iron fabrics can be used.

The alb (65A) shows the gathered material set into a round neck facing which is cut double, as are the shoulder yokes. A continuous wrap opening with button and buttonhole form the fastening. The length is adapted to the wearer.

Embroidered apparels are made-up and lined, then stitched to the sleeves at the wrist, and at the hem, back and front (65A). Traditionally the sleeve apparels are 20 cm–23 cm long × 7.6 cm (8 in.–$8\frac{7}{8}$ in. × 3 in.) and the skirt apparels 20 cm × 25 cm–31 cm (8 in. × 10 in.–12 in.).

The alb with a yoke, cut double is shown at (65B).

Many albs have wide embroidered decoration around the bottom and at the wrists, this is sometimes worked in coloured or neutral threads. There is a fine example at Liverpool Roman Catholic Cathedral. Any of the white-work methods are suitable, except that a material of coarse weave is generally used for drawn thread or pulled work.

66 *Right* White cassock alb designed by the Rev Leonard Childs, tailored by Lilian Bedding
Cathedral Workshop, Derby

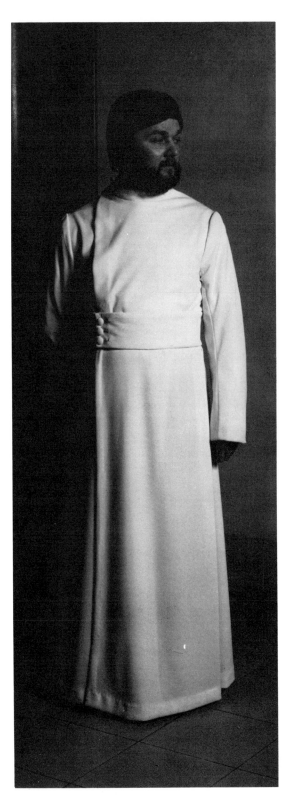

The cassock alb

The cassock-alb (**66, 60**C) is an outcome of the discussions held by the Liturgical Commission in 1978 and is the now accepted shape. It is worn with the chasuble or with a stole. The girdle is unnecessary. A belt, about 14 cm ($5\frac{1}{2}$ in.) wide and fastening with matching buttons can be worn with the cassock-alb as shown. The collar or a cowl replaces the amice.

For the pleats to hang well much depends upon the choice of material, it must have sufficient weight, yet it should launder easily. Recommended is the 'Linen Look' polyester viscose obtainable from John Lewis, also the John Lewis polyester 60% and 40% cotton.

The scale for the graph of the pattern for the cassock-alb is 1 square to 5 cm (2 in.) and, in this instance, an *allowance* of 1.5 cm ($\frac{5}{8}$ in.) *on all seams* of the pattern pieces 1, 2, 3, 4 (**67**) has been *included*.

To save the time spent on neatening the edges, the front and back facings 1 and 2 can be placed upon the material with the selvedge grain running across (the selvedge can then be used for the edge).

Place the centre back to a fold; and cut the front double.

The collar, 3: place the centre back of the pattern to a fold on the cross (bias) of the material, cut two.

Facings for the pocket openings, 4, cut four. Here too the selvedge can be used instead of a hem.

The sleeve, 5: *turnings of 2.5 cm (1 in.) have been allowed* for french seams. And a hem with lay of 15 cm ($5\frac{7}{8}$ in.) is included.

Place the centre back (**67**b) (dotted line) to the

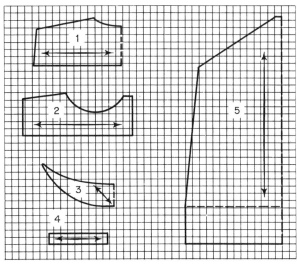

67 The pattern for the cassock alb. 1–5 Scale: 1 square=2.5 cm

67 .6 and 7 Scale: 1 square = 5 cm

fold, with the grain of the material. *Turnings for french seams* 2.5 cm (1 in.) *have been included* on both the back and both fronts, also a hem with its lay of 15 cm (5⅞ in.). The position of the pleats and pocket openings should be marked and should correspond on the back and both fronts. The pattern for the front (**67**.7) is cut double, the straight edge of the front folds can be placed to the selvedge, so avoiding a hem. (This could be cut wider.)

Mark through the position for the buttons and buttonholes, X on the graph, and the position for the *Velcro*, the lower x.

Method

With the back and the fronts laid out flatly, fold, pin and tack in the pleats, which should fold outwards towards the sides. Stitch down both edges for about 15 cm (5⅞ in.) at the shoulders.

Pin and tack, then press as each stage is completed.

Join the shoulders with an open seam.

Match the centre top of the sleeve to the shoulder seam, then fit the sleeve top into the arm-hole (**68**.1) very slightly easing the sleeve. For this a french seam is used, so the wrong sides of the two pieces are put together (**68**.5) (with the right sides outside);

make the first row of stitching, trim the edges, fold it over, press, and make the second row of stitching on the wrong side of the garment.

Put each pocket facing with the turning of the cut edge to the side seam line of the garment, and stitch (**68**.2) along on the seam line. Turn over on to the wrong side of the garment, fold back the pocket pieces and catch stitch. (**68**.3). Neaten and then strengthen the ends either by working a little bar (**68**.4) or machine stitching across.

Next, join the sides, with french seams starting at the sleeve hem and through to the top of the pocket opening, then from the bottom of the pocket opening to the hem.

Stitch down a 5 mm (³⁄₁₆ in.) lay around the cut edge of the hem and the sleeves.

Turn up the hems, matching the straight grain and seams. Herring-bone or catch stitch the sleeves and hand stitch or machine stitch the bottom hem. (These are wide enough to allow for adjustment to the wearer's height.) (**68**.6a).

Join the shoulder seams of the facing.

To make the collar, put the two collar pieces together, stitch round the outer curve, press, and turn out.

Place the centre back of the collar to the centre back of the garment, pin and tack it to the neckline.

Take the facing, and with right sides together put the centre back over the centre back of the collar and garment. Stitch along the fitting line. Pare down the surplus turning and nick at intervals (**69**.6) then turn the facing over, on to the inside of the garment. Catch the shoulder seams together by hand (**69**.7).

Next, turn over the fold which forms the facing down both sides. (This lies over the yoke facing. It can be cut a little wider than the 5 cm—2 in. allowed in the pattern.) Turn in the top edges and slip stitch together, and machine stitch down, keeping the stitching at the same distance from the edge (**69**.7)

Sew two washable 2.5 cm (1 in.) covered buttons in position on the left front (**69**.8).

Next make two buttonholes 3 mm (⅛ in.) larger than the button, either by hand or by machine, on the right-hand front (**69**.9).

Sew pieces of *Velcro* to the upper side of the left front and underside of the right front, in the positions marked by the lower crosses on the pattern.

Transparent plastic press studs can be sewn to keep the sleeve-ends together, so that the shirt or other coloured sleeve is not seen.

Roughly three times the total length + sleeve length will give the amount of material required.

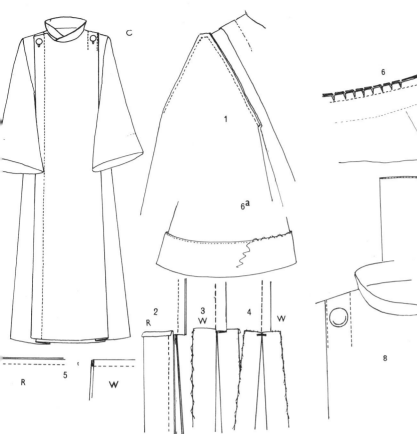

68 Making the cassock alb

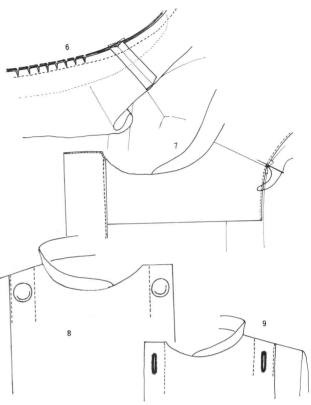

69 Finishings for the cassock alb

Dalmatic and tunicle

These vestments are generally being replaced by the cassock alb worn with the wide stole. Where it is still the practice a dalmatic and tunicle are worn by the deacon or gospeller and sub-deacon or epistoler respectively. The dalmatic and tunicle are a part of the whole set of High Mass or Eucharistic vestments. The shape derives from the Coptic tunic, the two vertical bands, the clavi, can be seen on many of the early mosaics, etc, and they persist today. The dalmatic has wider sleeves than the tunicle (because a bishop wears both, one over the other, for this purpose they are made of very thin material). The stiffened, befringed, rather short garments, with the open underarm and side seams, which were laced together at the armpit are seldom used now.

Design

The characteristic clavi can either be bands of colour or decoration or indicated by inverted pleats, or dispensed with altogether. Traditionally the dal-matic usually has two apparels, one at the chest and the other at about knee level, both back and front: the tunicle has but one at chest level, again, the decoration forms a part of the scheme for the whole set. But many modern vestments are without ornamentation, relying upon the additional fullness and length to form deep folds.

Materials

These should be the same as those used for the complete set.

Measurements

Centre back length 122 cm–140 cm (48 in.–50 in.) or longer, with a shoulder seam length of 59 cm–66 cm (23 in.–26 in.).

Graph 70A shows a dalmatic with a shoulder seam, the length can be increased. It is usually necessary for there to be seams down the clavi line. Cut, allowing turnings and hems.

To calculate the amount of material required, take

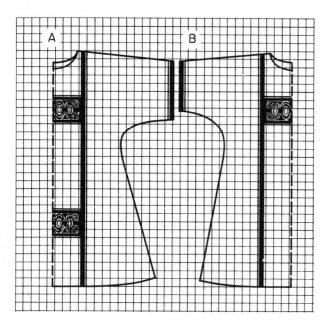
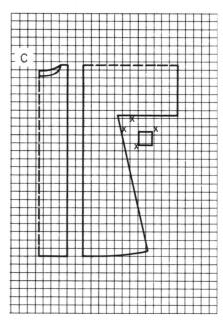

70 Patterns of dalmatics and tunicle. Scale: 1 square = 5 cm

about three times the length + turnings and hems (more if longer) of 122 cm–137 cm (48 in.–54 in.) wide material, or of 90 cm (36 in.) wide material about 5 m (6¼ yd) would be required, this includes hems and turnings.

Graph 70B is similar.

Graph 70C is similar except that the sleeve for a tunicle is narrower. It can be made longer.

This is unsuitable for a material with an up and down direction in the design.

Method

The making-up of both the dalmatic and tunicle is much the same as for the chasuble except that the clavi seams and ornamentation are completed first, and it is important to nick the turnings of the underarm curves. The whole length of the side seams is generally stitched, but about 24 cm (9½ in.) at the bottom can be left open.

Graph 70C First stitch the little seams at the neck of the front and back panels, next make the two long seams joining these to the side sections. Then stitch the underarm and sleeve seams, leaving the position for the gusset open. The points of the gussets are matched-up, and these too are stitched in place.

It is probably quicker to make up the lining separately. Then pin, tack and hem it into position, but as it may drop in wear, it is advisable to catch it as invisibly as possible through to the back of the clavi seams.

Alternatively the whole vestment can be cut in one piece, when the width of the fabric permits. To do this the pattern pieces must first be put together, but when this is done a wider, boat-shaped neck is cut, and small triangular gussets are inserted to give a better fit at the shoulder and neckline as at 71.4. This style is unsuitable when there is an up or down direction in the design of the material.

The basic patterns for the dalmatic and tunicle can be adapted in various ways. 71.1 is the traditional shape, laced with cords and tassels at the neck and joined together for only a few centimetres/inches at the underarm.

71.2 is a Dalmatic with a wider sleeve, and an opening at the hem line of the side seam, or with a plain faced neck opening as at 71.3

71.5. Here inverted pleats suggest the clavi, these insets can either be let into the seam down the clavi line or the material on one side of these lines can be extended and joined to the centre panel; then the pleat is formed in the usual way after the lining is in place.

These alternatives will add to the amount of fabric required.

Dr Jan Weijer, a professor at the University of Alberta in Edmonton, Canada, created the dalmatica (72) for the Feast of Saints Peter and Paul. It is both original in form and particularly interesting for the erudite use of symbolism in the design.

In iconography certain objects have been con-

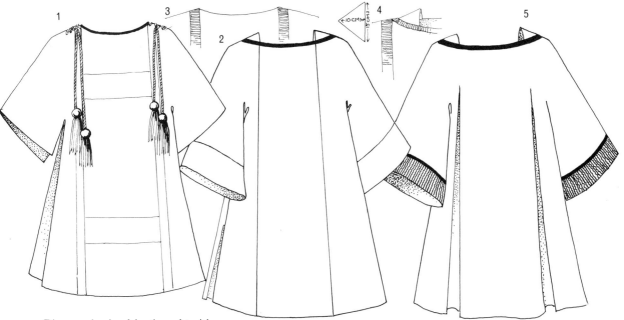

71 Diagrams showing dalmatics and tunicles

nected with individual saints. For example, for St Peter it is the inverted cross signifying his crucifixtion in an upside down position; the rooster who crowed thrice and the fish—a secret code word of the early Christians. Peter was also a fisherman and he was selected to become the first leader of the young Christian Church. According to the scriptures he was given the keys to Heaven and Hell. The symbolic colours of St Peter are blue and yellow and are still found as background colours in the Papal flag. The blue signifies Penitence and the yellow stands for the Betrayal. They are always used in combination, with the overtone of light and darkness, Heaven and Hell.

This dalmatica tries to return to its original design in which the message of the Feast becomes totally visual: St Peter, the Fisherman, catching the souls for eternal salvation. The eagerness to follow is depicted in the intensity of the colours in which the fish are executed. The border of the dalmatica carries the last phrase of the Lord's Prayer from the *Codex Argenticum*, a fourth-century Gothic Bible used to bring religion to the Barbarian Goths. In order to write down the tongue of his people, Bishop Ulfilas had to develop an alphabet combining Greek and Roman letters and Scandinavian runes. The text reads: '*Theina ist Thiundangardi jah Mahts jah Wulthus in Aiwins, Amen . . .*' (Thine is the Kingdom, the Power, the Glory, for Ever, Amen). Also *Tu es Petri* is executed in lettering taken from the

Anglo-Frankish Gospel Book of the ninth century.

The emblems of St Peter are combined with the keys to Heaven and Hell and are displayed on the left arm of the dalmatica together with the Greek letters Alpha and Omega. The shoal of fish and the ropes of the net culminate in the emblem for Christ: P and X.

St Peter's martyrdom is given in the colour of the collar: red with fish in blue and yellow. The lining of the garment is blue and yellow.

The materials used for the dalmatica are white denim and artificial suede.

The scapula

A scapula (**73, 74**) or a tunicle is worn by the crucifer; although it follows the design and colour of the vestments it is not a Liturgical vestment.

The pattern can be adapted from one for a tunicle, its length determined by the height of the weaver.

The general making-up process applies. The outer edge is folded over an interlining and the neck finished as for a chasuble. After cutting the lining would be hemmed in position.

The cope

Copes will always remain as a decorative feature of the Roman Catholic Church, although they are worn less than in the Anglican, where the cope will be retained for use at certain times, such as at weddings,

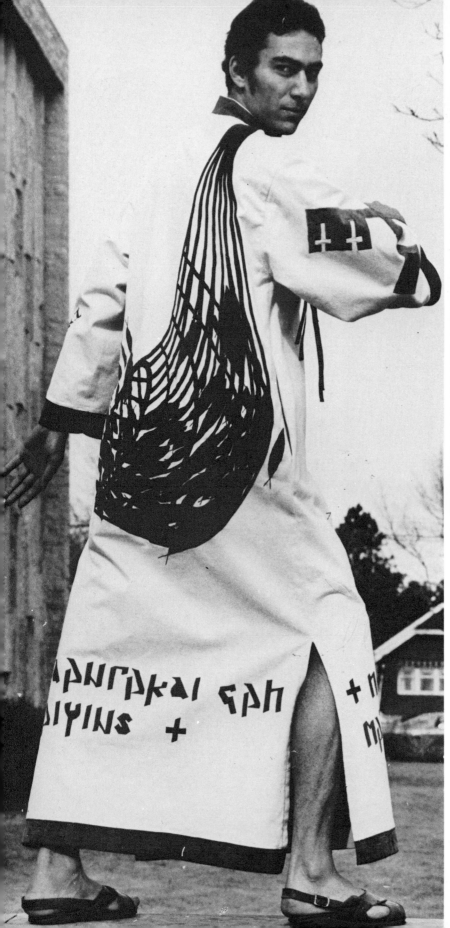

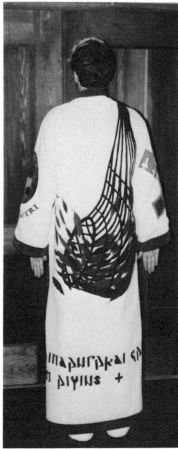

72a *Left* Dalmatica designed and made by Dr Jan Weijer, Canada, for the Feast of St Peter (and Paul). Executed by machine (Bernina), appliqué with artificial suede on white denim
72b *Above* Back view

73 Scapular (or tabard). Designed and made by Julie Mawhinney, Manchester Polytechnic 1978, in red satin with machine pintucking in green thread and with applied green velvet ribbons. It is bound in green satin. The shoulder section and the tie-cords are constructed on a knitting machine in red, green and gold metallic thread

baptisms, processions and festival services, but seldom for public worship on Sundays, unless it be for collegiate worship in a cathedral. Strictly the cope and mitre are not Eucharistic Vestments.

In the Canons of the Church of England there is special reference to the cope B8:

2 At the Holy Communion the celebrant, as also the gospeller and the epistoler, if any, shall wear with the cassock either a surplice with scarf or stole, or a surplice or alb with stole and cope, or an alb with the customary vestments.

3 On any appropriate occasion a cope may be worn at the discretion of the minister –'

As befits its dignity, the cope is the principal vestment worn for ceremonial occasions. It derived from the open fronted paenula of Roman times. Representations appear in early mosaics and even in

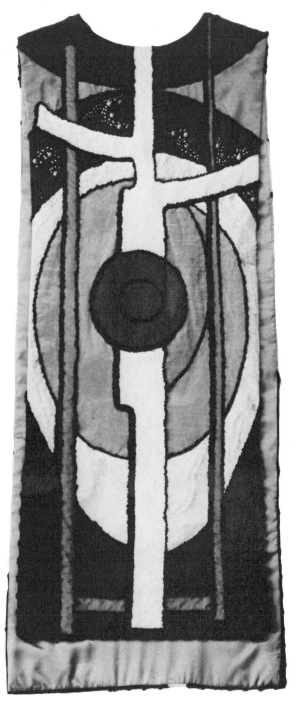

74 Scapular for the cross bearer. Designed by the Rev Leonard Childs, 1977, made by Grace Graham, Eileen Mills. Design based on the cross as an instrument of torture. On the front it is flanked by candles, with a deliberate target effect. The cross is an aim in Christian life, as well as a source of life, hence the egg shapes in the design
Cathedral Workshop, Derby

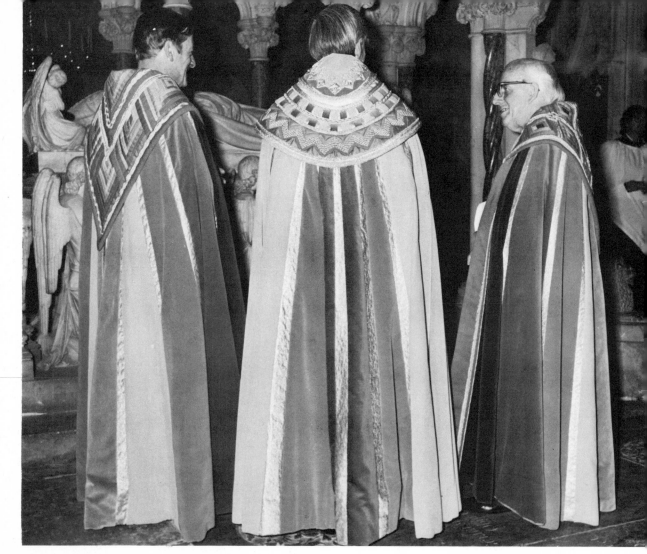

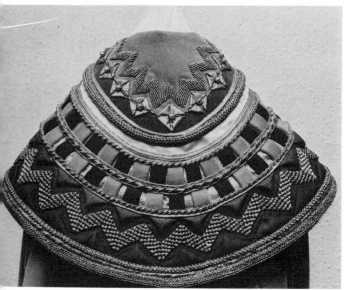

75a *Above* Set of five festival copes made in celebration of the nine-hundredth anniversary of Winchester Cathedral; designed by Nancy Kimmins and Moyra McNeill. The panels of velvet shade from crimson through scarlet and orange to gold and are separated with channels of gold lurex

75b *Left* Hood of the Dean's cope. Lighter weight materials in an extended range of the velvet colours were used for the hood: handmade and military cords and braids are of lurex gold

embroidery itself, and it can be seen that the form has not greatly changed; in some of these examples the jewelled morse is excessively large. From the extant copes (some of which are illustrated) the interest and variety in the design of the embroidery can be seen. The medieval copes were semi circular, with 13 cm (5 in.) wide orphreys and small triangular hoods. Gradually these measurements increased until the excesses of the Baroque were reached, when the large flat rounded hoods (attached to the lower edge of the 20 cm (8 in.) orphreys) reached half-way down the back of the cope. The embroidered morse

was very wide too. Towards the end of the nine-teenth century, when the cope was worn, it had a narrower orphrey and the smaller hood was intro-duced (mainly in Britain). And the cope with fitted shoulders returned, together with the narrower, shaped orphrey, which greatly improves the hang of the cope and so the size of the morse or clasp can be reduced. Usually there is also a reversion to the early form of cowl hood, which is often pointed.

The flat, semi-circular cope is less often used now.

A popular variation upon the conventional shape is the cope composed of several sections, which when joined together form more than a semi-circle, even as much as three quarters of a circle. This shape requires individual fitting at the shoulders. There is generally a hood with this cope

Information for cutting and making it are given (**86, 87, 89**).

Design

Much has already been said about planning design, this certainly applies when a cope is contemplated. It is the hang of the vestment which determines the distribution of the pattern. When worn the centre back panel is flat, and will be seen to advantage, whereas at the sides there are rich, deep folds, and the centre fronts hang straight down. The cope is usually seen from a distance, and in procession; and frequently several copes of similar design are worn at the same time this offers tremendous scope for the designer to plan on a large scale, towards an almost dramatic effect, suited to the architectural character of the building.

When the cope is made from a material where the woven design is complete in itself, then the em-broidery is generally confined to the hood and orphreys or perhaps to a bordering down the fronts. There are so many possible ways of introducing interest into this vestment, but it is essential to make sure that it is not too heavy to be comfortable.

Generally the cope forms a part of the Eucharistic set. There are other occasions on which the cope is worn, and this allows for latitude in colour and decoration.

Materials

The selection must be towards those fabrics which will hang in deep folds, be fairly firm, yet not too heavy in wear. The 152 cm (60 in.) wide hand-woven silks are ideal; Dupion and Thai silk, fine wool crêpe or jersey, and also many Sekers fabrics. Other fabrics of similar weight are also suitable. It is important to select materials which will not crease as the wearers have to sit in their vestments, for this reason certain fabrics should be avoided.

When a light fabric is used it may be advisable to compensate for any lack of weight by adding an interlining of mull muslin. The right lining is important, whether it is a fairly stiff rayon taffeta, or a light polyester will depend upon the nature of the main material from which the cope is made. There are good colours in the acetate linings and these are 90 cm or 122 cm (36 in. or 48 in.) wide. Silk linings vary from 84, 86, 90–100 cm (33, 34, 36–40 in.) wide. (83F) will help with estimating the quantity re-quired. When the fabric and the lining are the same width, the seams coincide, and this greatly facilitates the making-up process, as the turnings can be caught together.

Measurements

The pattern for most copes is based upon the semi-circle. The average radius is 152 cm + 10 cm (60 in. + 4 in.). That is, the centre back length measurement + 10 cm (4 in.), bearing in mind that cope (**76A**) rises up above the nape of the neck. The centre for the semi-circle is marked upon the diagrams.

If a hood is required its neck line is straight or one of the other hoods can be adapted for cope **76A**.

Orphreys are generally not more than 10 cm (4 in.) wide, but they are unnecessary; if dispensed with the cope will keep its shape better if an interlining is inserted and/or a covered piping is put down each side of the front. Hoods too are a matter of choice.

With all copes, if possible, the length and position of the morse should be determined on the wearer; the morse is generally attached on the wearer's left-hand side.

76 Pattern of cope A Scale 1 square = 5 cm. Note centre

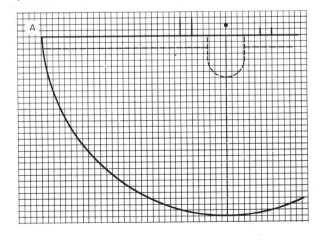

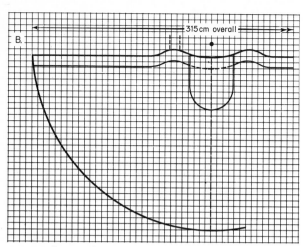

77 Pattern of cope B with shaped neckline Scale: 1
square = 5 cm

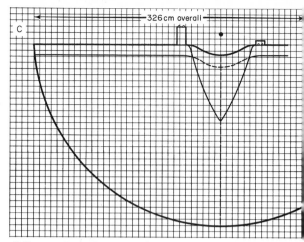

78 Pattern of cope C with slight shaping Scale: 1
square = 5 cm

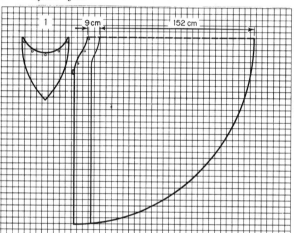

79 Pattern of cope and hood, shaped at the neck Scale: 1
square = 5 cm

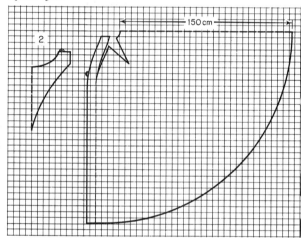

80 Pattern of cope with hood, shaped at the shoulders Scale:
1 square = 5 cm

77B. The diameter of the semi-circle upon which this fitted cope is based is 315 cm (144 in.), so the radius is 157 cm (62 in.), making the actual back length of the cope 148 cm (58 in.).

Should it be decided that there is to be no orphrey, it is an advantage to insert an interlining along the edge about 12 cm (4¾ in.) wide, and possibly a piping.

For this cope, the cowl hood is preferable but whatever its shape it should be one with a curved neck line.

The same processes apply to the cope (**78**C) which also has a curved neckline.

Another pattern (**79**) is for a cope which is slightly longer at the back, and is shaped at the neckline. The hood is intended to be attached to the cope with

press studs or Velcro. The fastening is positioned rather higher than usual.

80.2 Here the orphrey is cut in one with the cope. In the following example it will be seen that the shoulders are shaped by means of darts which fit into the orphrey. Over this the hood is fixed: when cutting extra wide trimmings should be allowed for possible adjustment.

The scale of the diagrams is 5 cm (2 in.) to 1 square.

A fitted cope

To make the pattern or 'toile' for a cope with fitted shoulders. Cut the semi-circle in paper, mull muslin or sheeting, marking the centre back (CB) line. Put

this in position on the wearer, leaving the fronts about 7 cm (3 in.) apart. Tether the pattern down the CB.

Make darts on both shoulders so that it fits snugly, about 14 cm (5½ in.) long, then pin the darts (there will be a considerable amount of surplus fabric).

Mark in the new neckline, continuing down into the front edge. Cut away surplus. Mark the position for the morse.

Check and mark the length of the cope.

To make the pattern for an orphrey to fit, having a CB join, take a sufficiently long strip (about 23 cm – 8⅞ in. wide) of paper or fabric, pin it to the edge, up the front of one side of the cope, then fold it over the shoulder (it will now be off the straight grain of the fabric), smooth it towards the CB, so that it lies flatly, mark in the line for the CB join.

Next mark in the line for the edge. This will be straight up as far as the morse, then it will curve round for the neck and towards the CB.

Measure out from this line for the desired width, marking the position with pins, then correcting with chalk or a tacked line. Cut away to these lines.

When cutting the fabric, allow turnings.

The 'toile' will also serve as the pattern for the interlining, and lining.

Generally this cope is improved by the addition of a hood, the neckline of which may need adjustment to make it fit the neckline of the cope.

The layout

When planning the layout of the pattern pieces upon the material, the position of the seams determines the placing. Whether there is a CB seam or a plain panel at the centre back, it is inevitable that seams run across the fronts of the cope, therefore it is preferable for these joins to be towards the bottom. **Graph 81D** shows a possible lay-out for 122 cm (48 in.) wide fabric. The mitre, burse and veil could also be cut from a total of about 4.5 m (5 yd).

The cope hangs better if the grain runs down the back. **Graph 82E** shows it running parallel with the orphrey edge, necessitating a join at the bottom. Dotted lines show that about 3.5 m of wide fabric are required.

Graph 83F gives the alternative by arranging for the CB of the pattern to be placed to the fold of 152 cm (60 in.) fabric; or if the centre is placed to the selvedge, a front join may not be required. This graph shows the positions of the joins for fabric of several different widths, and helps with estimating the amount of fabric required. But it must be remembered that if the material is patterned or has a

81 Graph showing layout for cope; width of fabric = 1.20 m Scale: 1 square = 5 cm

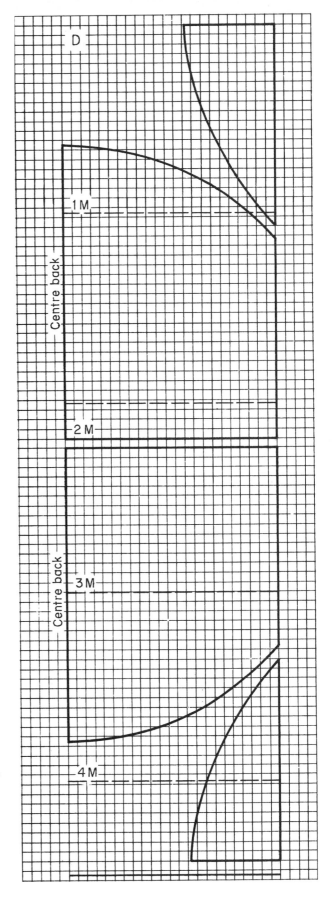

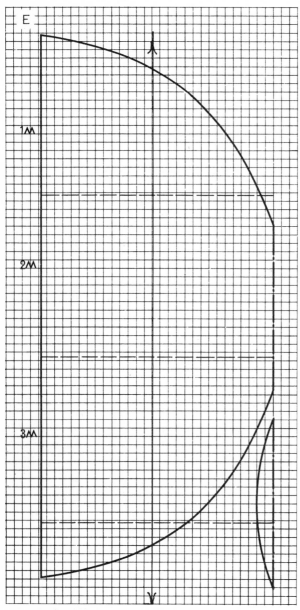

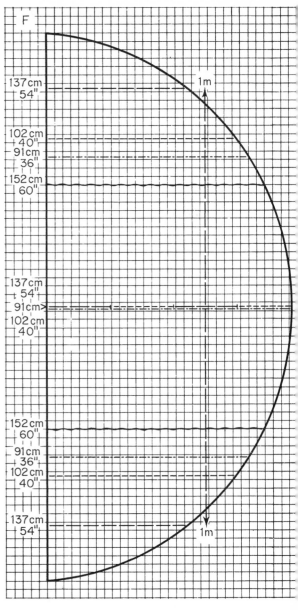

82 Graph showing layout for 1.50 m fabric. Amount required = 3.50 m Scale: 1 square = 5 cm

83 Diagram showing how to calculate the length of fabric required, according to the width Scale: 1 square = 5 cm

nap, extra is required. When cutting out, turnings and hems should be allowed. A lining of similar width is an advantage.

Complete and make up the hood and orphrey.

Refer to the general instructions for making-up a chasuble which apply, with some exceptions, to making a cope.

1 Having finished the seams of the cope and the lining, cut and invisibly attach by stitching or ironing on *Vilene*, hair cloth or tailor's canvas interlining along the straight side, about 12 cm–15 cm ($4\frac{3}{4}$ in.–$5\frac{7}{8}$ in.) wide. Alternatively attach the orphrey or piping.

2 On a large table, smooth out flatly the cope, face down. Turn up the edges and hems, and lightly catch stitch invisibly. Heat-fusible gauze could be used during the process of making-up, as a means of saving time.

3 Make the morse, and attach the hooks. Sew the eyes firmly to a strip of material about 4 cm (1½ in.) wide, both are interlined with tailor's canvas (double) or buckram. This can be seen in **diagram 88**. Stitch the morse very strongly to the cope, using button thread. Then sew on the hood.

4 On a large table, smooth out the cope, put the centre back seam of the lining over the CB of the cope, keep one half of the lining in place with weights, fold back (over it) the other half, so making it possible to catch the turning of the lining to the turning of the centre back seam of the cope, starting and finishing about 8 cm (3⅛ in.) from the edge (**53, 54**).

5 Move some of the weights, pin, and fold over the loose half of the lining about 33 cm (13 in.) further on, and lightly lock the two together with tiny invisible tie-tack stitches about 4 cm (1½ in.) apart. These must not be drawn up too tightly (**53, 54**).

6 Move these weights on again, and pin, keeping the pins horizontally, then work another row of tie-tacks, about 33 cm (13 in.) further on, and another if necessary.

Put a tack round this half, about 7 cm (3 in.) in from the edge, to attach the lining to the cope.

7 Now, remove the weights from the second side, smooth the lining, keep in place with weights, pin. Keeping the pins horizontally as before, fold back at about 33 cm (13 in.) further on, lock stitch. Repeat as before. Tack round the edge.

8 Turn in the edges of the lining and hem or slip-stitch.

Hoods

For flat hoods (86) shapes 1, 2 and 4, the embroidery would be completed, then the material cut out, allowing turnings. Firm interlining cut to the pattern line would be placed (centre lines corresponding) upon the wrong side of the hood. Except for the neck edge, the turnings would be catch-stitched to the interlining, and the lining hemmed in place.

The cowl hood may be embroidered on the inside, outside or both. If the former, the inside of the hood has to be joined up first.

When cutting out allow extra wide turnings along the neckline, for possible adjustment.

84 Cope designed and made by the Rev Leonard Childs, 1976. The cloth of gold moire is nineteenth century, the borders and hem panels are light brown and blue green, as is the yoke/hood
Worcester Cathedral

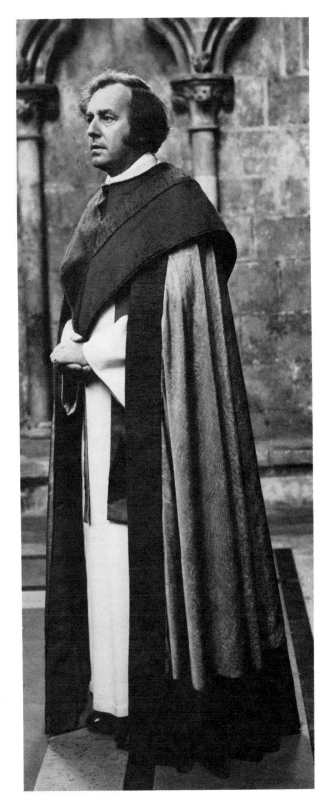

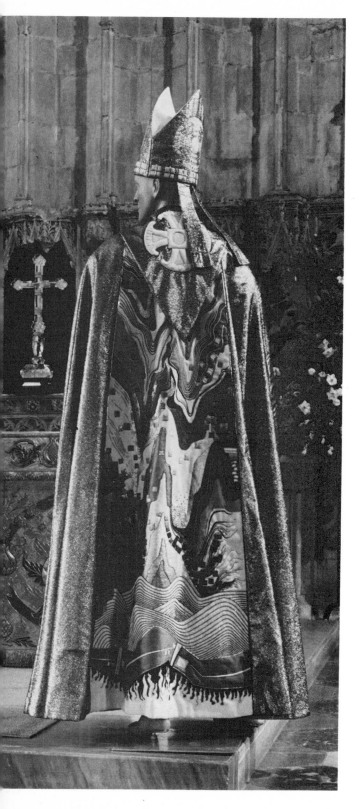

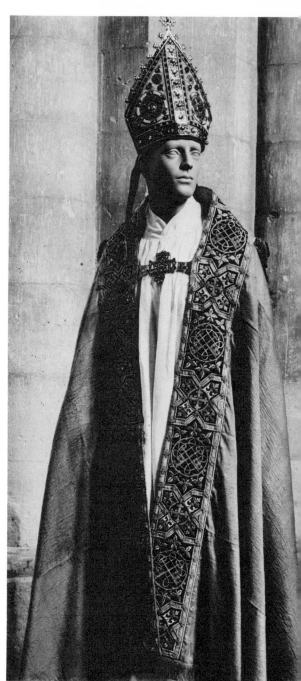

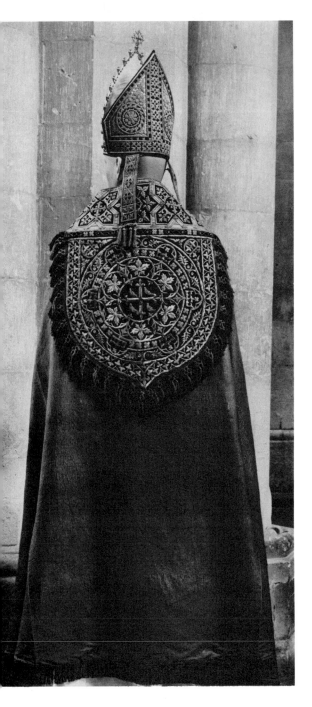

85a The canterbury cope, for the Archbishop. Designed and executed by Beryl Dean, assisted by E Elvin and P Waterworth. The elements are symbolised by fire, water by sea, rivers etc and air by thermal currents. Mountains, motorways and houses symbolise man's habitation, with the cross of Canterbury over all.

85b *Cope* Cloth of gold, plain weave, with appliqué on velvet and cloth of silver, raised and padded with pearls and metal ornaments, gilt and red silk fringe

85c *Mitre* Cloth of silver and silk cut velvet with panels of silver enamelled copper plaques and semi-precious stones, embroidered with metal bullion inlaid work. Designed by Augustus W N Pugin, 1812–1852 for Cardinal Nicholas Patrick Wiseman. Metalwork by John Hardman & Co, Needlework probably by Lonsdale & Tyler. Lent by Westminster Cathedral.
Photographs: Sandra Hildreth Brown, Penna Press Ltd

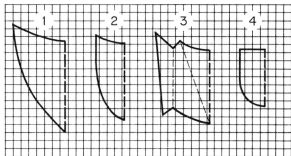

86 Patterns for cope hoods Scale: 1 square = 5 cm

To make up the cowl hood (86.3), put the pattern upon two thicknesses of material, matching up the centres and mark them, snip (87A). Fold each piece, right sides facing, stitch along the base line (87B), of each, press these seams open. Then, with the right sides together, fit one piece inside the other, and stitch round the outside (87C).

Turn through to the right side (through the open top edge); press the seam flatly.

Arrange the folds, making pleats at either side; stitch along the top or neck edge, (87D).

Do not cut down the extra wide turnings or snip the neckline until after it has been fitted to the edge of the cope, as this gives the chance for adjustment, if necessary.

Method of attaching the hood

With centre to centre, snip the neck edge of the hood, stitch to the cope turning. Having made the morse and attached the hooks, and the eyes having been strongly sewn in place, these are sewn to the cope with strong thread. Turn over the turning and herring-bone or catch stitch. The method of putting in the lining has been described, and is illustrated in

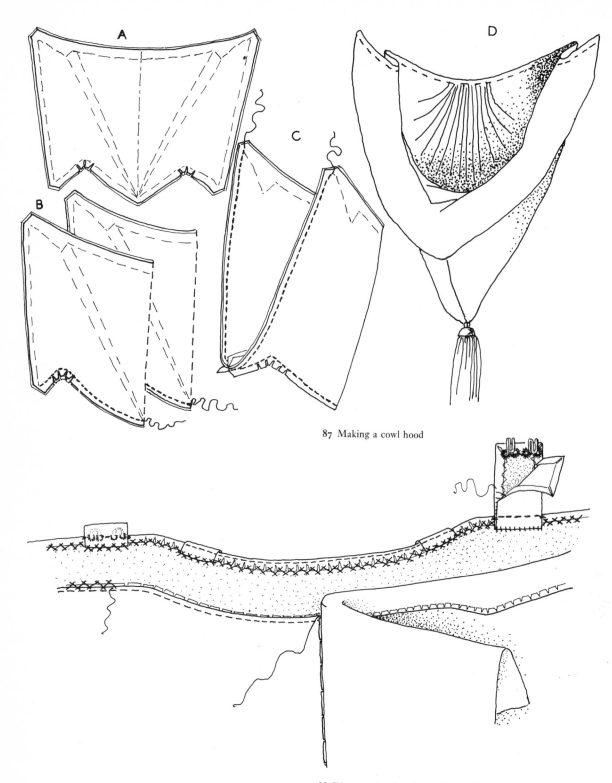

87 Making a cowl hood

88 Diagram showing the making of the orphrey, attaching the hood and sewing in the lining of the cope

the diagram (88). As can be seen the edge of the lining is turned down and would be hemmed or slip stitched to the edge of the cope.

Orphreys

The embroidery is worked on a very long frame. Either, the orphrey can be made up as for a stole and applied to the material of the cope, so obviating the need for interlining, and attached with slip stitching, using a very strong thread; or, the interlining can be attached to the back of the orphrey, either by tacking or ironing on *Vilene*. Putting the right sides together, join the cut edge of the cope to the turning of the orphrey, (this can be machine stitched) press upwards and lightly catch to the interlining. Attach the morse and hood, catch stitch or herring-bone the turning. This method is shown in the diagram (88). It will be understood that with this method, the cope can be cut minus the width of the orphrey, which can be an advantage.

Another way is to apply the strip of orphrey fabric to the cope along one edge, then attach the interlining (if required) bringing the cut edge of the cope and interlining together; fold the turning of the orphrey over, catch it down.

It is generally advisable to stitch or stick strips of interlining along the front edges of the cope. Where there is no orphrey, a piping gives a good firm finish.

A cope constructed from radiating sections

When joined together the total circumference totals more than the usual semi-circle.

It is advisable to try out this method by first cutting it in any old fabric, tacking the seams together, and fitting it on the wearer. When the corrections have been made, it can be used as a pattern. Between 6 and 7 m of 122 cm fabric (6½ and 7½ yd of 48 in. fabric) and lining will be required.

Figure 89

1 Divide the length of material into three.

2 Mark out and cut very accurately one complete and two half triangles, on each third.

3 Take two pairs of the half triangles, with right sides of the fabric together, put the selvedges one on top of the other, seam to the apex and press open.

4 With one complete triangle at the centre back, put a joined triangle on each side, stitch the seams. It is important to finish the machine stitching of all the seams about 10 cm (4 in.) short of the centre.

5 To both of these, join the other two complete triangles.

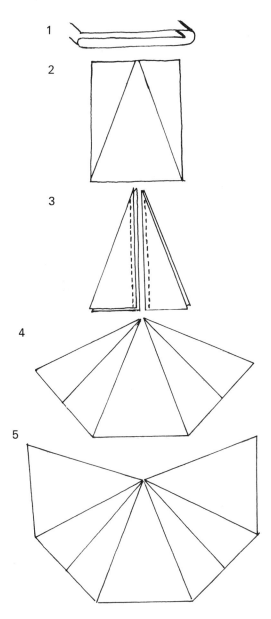

89 *1–5* Diagrams showing the cutting and making of a cope constructed in sections

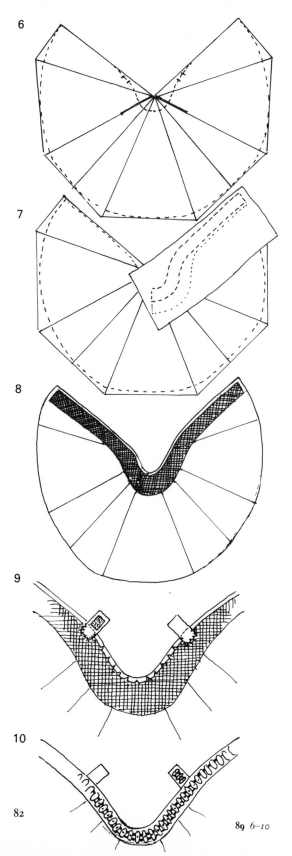

6 Putting the cut edges together, join on the two half triangles, checking that the selvedges run along the centre fronts. Press open all the seams.

Fit the cope upon the wearer or on a stand, fixing it at the centre back. Adjust the shoulders at the seams marked on the sketch 6. Pin. Mark out the neckline, so that it runs into the line of the centre front selvedges. It will be found necessary to cut away some of the surplus material. Mark in the hem line. Mark the position for the morse.

Next, stitch and press open the shoulder alterations. Spread the whole cope out flatly, right side upwards.

7 Put transparent paper over the area, up to the centre back. Make the pattern for the interlining, which will be about 13 cm (5 in.) wide, a little wider towards the neck. Draw in the line for an orphrey if this is required. Cut this out, add turnings when cutting the fabrics.

8a

8 Turn the cope face down. Place the interlining about 2 cm (1½ in.) inside the edge of the fabric, attach at intervals to the seams. Fold over the turning and catch-stitch to the interlining. The hem can be cut and invisibly stitched. Make the morse either as previously explained or as shown in **figure 89.8a** using *Velcro*. Cut two pieces of buckram, allowing an extra 2 cm (1½ in.) on the ends for stitching to the cope. Cover the underside of one with lining material, turn over the edges on three sides, cut a square of *Velcro* and firmly stitch this through. Cover the front with soft padding material

and over this fold the embroidery, turning in the edges on three sides and stitching invisibly to the edge of the lining.

For the second side, cover the upper side with the cope material, and to it stitch another square of *Velcro*, then neaten with the lining material, stitching round the edges.

9 Sew the morse pieces strongly in place.

10 The orphrey can be prepared, and sewn on to the cope by hand, with slip stitching.

11 Make-up the lining to exactly the same shape. Catch the seams of the lining to those of the cope at intervals. Arrange it flatly, turn in the turnings all round, and slip stitch or hem.

This cope is improved by the addition of a hood. For this, make a pattern which fits the neckline, otherwise follow the directions given for the other hoods.

The mitre

The mitre varied in form as it developed. Originally made of linen, it was roughly triangular in shape, but gradually it increased in height until the excesses of the sixteenth to eighteenth centuries were reached, when the sides curved slightly outwards; since then it has been modified. The mitre is a part of the episcopal insignia and the prominent ensign of a bishop.

Design

Imaginative alternatives have replaced the traditional central orphrey and headband. The infulae or lappets are still attached on either side of the centre back.

Material

The fabric generally links up with the cope, but need not conform to the liturgical colours. From cloth of gold to canvas work, many materials and techniques are suitable, except those which are too thick.

Measurements

An average head measurement is 58.5 cm–61 cm (23 in.–24 in.) and the height is generally not more than about 31 cm (12 in.).

Method 1

92A The advantage of this type of mitre lies in the ease with which the fitting can be altered. To do this the stitching which joins the sides is unpicked. To decrease the size, pare down the stiffening, re-stitch the sides inside the original line. Re-stitch as much of the headband as has had to be unpicked, cutting

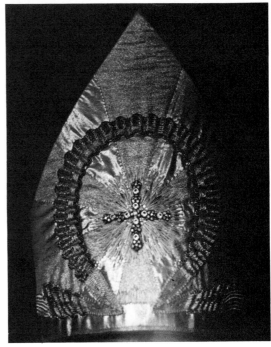

90 The Omega Mitre, designed and embroidered by Anna Crossley, (San Francisco) couched in gold and silver and Jap gold threads on gold and silver tissue. The couching is in rainbow coloured Filo Floss. The rays give a sunburst effect radiating from a cross of rhinestones
The property of C Kilmer Myers, USA

91 *Below* Mitre, designed and worked by Beryl Dean. Tones of gold couched on cloth of gold
The Bishop of Lewes

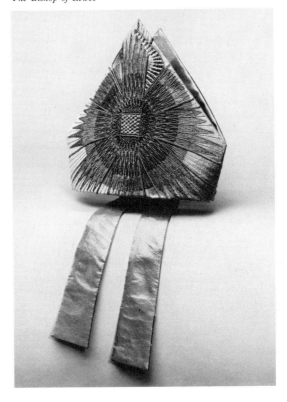

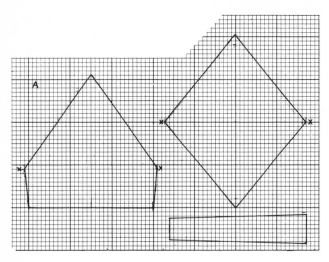

off a little at the join. To enlarge: the turnings at the sides are released, and re-sewn outside the original line.

In this method, the embroidery upon the front and back pieces of the mitre is completed, then each is separately made up, joined together and the gusset and lappets are added, and afterwards the headband. The colours can be arranged according to choice.

Make the pattern 92A.

1 Mark out the shape of the pattern on the embroidered material leaving turnings on all sides (93B) including lappets and gusset.

2 Cut out the stiffening, without turnings. This can be buckram, sparterie or a stiff canvas. It is advisable to cover the cut edges with cross-cut muslin or other thin material (it can be tacked or stuck in place) or, preferably cover the outside of both pieces, which prevents the roughness wearing through to the fabric.

92 Pattern of mitre Scale: 1 square = 1 cm. *Note*: the lines from the base to points X and X should slope at the angle shown

93 Diagrams showing the making of a mitre

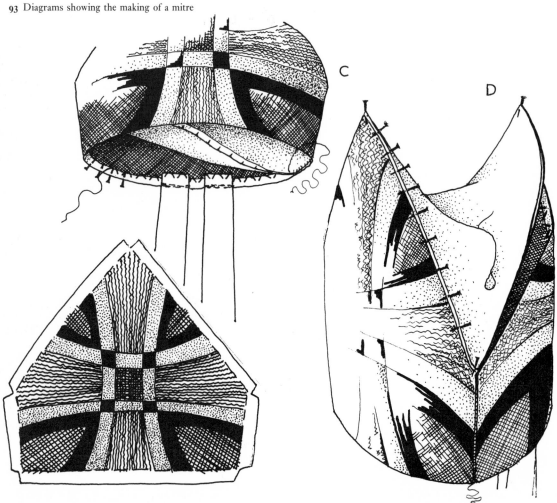

3 Place the embroidered pieces *loosely* over the stiffening, fold the turnings over, snipping away where necessary, catch stitch (or it can be lightly stuck) to the stiffening.

4 Make the lappets, using an interlining. These can be made up like a stole, or, if the material is thin it can be folded over, instead of sewing on a separate lining. Attach the lappets about 1 or 2 cm ($\frac{1}{2}$ in. or $\frac{3}{4}$ in.) either side of the centre back.

5 Cut out the lining for the mitre pieces and fold in the turnings, hem to the mitre all round the edges (93C).

6 Put the front and back together, right sides out and, as invisibly as possible sew the sides together strongly (93D).

7 Cut out the gusset, this need not be lined. Mark the fitting line, bend over the turning and tack. Then pin the points to the corresponding mitre points (93D), and the corners to the side seams; fit the whole gusset in place, pin; it may be necessary to adjust the gusset to fit. (The cut edge of the gusset may be neatened before commencing if preferred, but the turning hardly shows when finished.)

8 Invisibly sew the gusset in place. Conventionally a cord was always sewn over these joins. But a bunch of threads couched down all round will neaten any irregularities.

9 Buy (or make from thin leather or skiver) a headband, punch little holes along the top edge and thread with very narrow braid. Sew this headband along the bottom edge of the mitre, tie the braid in a bow at the join: it can be pulled up more tightly if the mitre is too large.

Method 2
This is a simple shape, the points are at an angle of 45 degrees, which results in a shorter mitre.

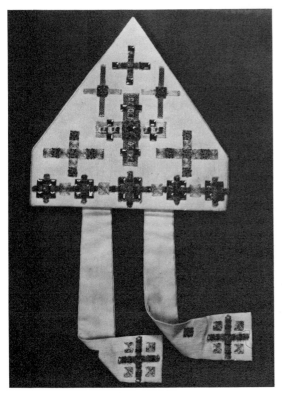

94 Mitre, designed and made by the Rev John Healy. Couched Jap gold kid and old gold jewels on an ivory silk fabric background

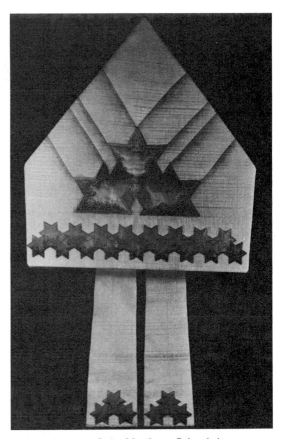

95 Mitre by Lynne Stoke, Manchester Polytechnic, 1979. Cream silk, slightly quilted with gold machine lines. Hand painted-silk is applied

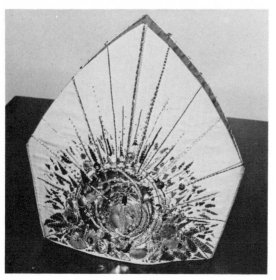

96 Mitre, designed and made by Morna Sturrock. Gold and silver kid, metal threads, silks and jewels worked on gold coloured pure silk
For the Archbishop of Melbourne, Australia

97 Making the pattern for mitre method 2 Scale: 1 square = 1 cm

As the seams run down the centre front and back, a design which will cover them is appropriate, but any stitchery which actually crosses the seam has to be completed after it has been stitched, and this determines the design.

1 Cut a rectangle of fabric 46 cm × 29 cm (18 in. × 11½ in.) or half the wearer's head measurement + about 1 cm (½ in.). Allow at least 2 cm (¾ in.) turnings when cutting (97.1). Mark the dotted lines with tacking, fold in half across, right sides together. Stitch and press open the centre back and front seams. Turn out to the right side and complete the embroidery over the seams (98)

2 Next, start bending the front over towards the centre back, fold for the sides 8 cm (3⅛ in.) up, marked with an arrow (99).

3 Then press in folds from the arrows to the points marked with crosses (99). These lines can be defined with couched threads or with cords.

4 Cut the stiffening (sparterie, buckram or canvas)

without turnings (97.2). If the join is to overlap, allow extra for turnings. Cover the stiffening with thin material, taking it over the cut edges, to prevent wear on the outer fabric.

5 Cut out the lining so that the seam will come at the side. Bend the turnings over the edges of the stiffening, catch stitch (or stick). But do not stitch the headline.

6 Put the lined stiffening inside the mitre, pushing the points right up and catching them in place with a stitch. Then fold the turnings of the mitre over the stiffening around the headline (93c) and catch stitch, make and attach the lappets. Throughout this part of the process the lining has been pinned back, out of the way. Now bring it down and pin along the headline and slip stitch or hem. This is the same process as shown at 93c.

Make and attach the headband as for method I.

Make a fold across the soft top, from one arrow to the other in **diagram 99** so that, when finished, the mitre can be folded flatly.

98 Joining the embroidered fabric

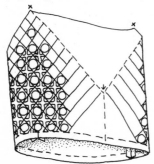

99 Bending into shape

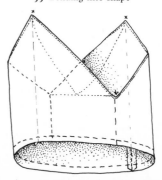

CHAPTER IV
Vergers' gowns

With the re-ordering of the eastern end of churches and with the modern trend towards changes in the nature of the vestments worn, many of the traditional sources of colour are disappearing. One way of compensating for this loss is to introduce colour and interesting styling into vergers' gowns. An outstanding modern example is illustrated in the photograph (100). This gown has, additionally, distinctive embroidered motifs (101).

By contrast the verger's gown from All Hallows-by-the-Tower, London, is of a decorative historical

100 *Below* The verger of the cathedral wearing his gown, made in 1969. Designed and made by Rev Leonard Childs. Grey silk-rayon dupion. The design uses both sides of the fabric, the light grey being the reverse of the material
Derby Cathedral

101 *Right* Badge from the verger's gown. Purple Sekers fabric with embroidery in silver and gold kid. The design is the seal of the Provost and Chapter of the Cathedral. Designed and embroidered by Maureen Voisey, then leader of the Workshop, 1970

102 *Below right* The verger of All Hallows-by-the-Tower, London, wearing his gown of blue cloth and silver braiding with embroidered coat of arms of the church

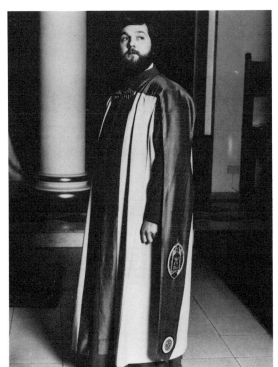

style (as formally worn by Parish Clerks) and is carried out in blue cloth. It is personalised and identified with the church by the embroidered arms (**102**).

Vergers' cassocks can also be made more interesting as can be seen in photograph **103**. The pattern for the cassock–alb may be adapted for this purpose.

It seems an anachronism that vergers, who are not normally academics, should traditionally be clothed in semi-academic stuff-gowns which are unnecessarily dull.

Colour may also be introduced into the attire of church stewards, as has been done at Chichester Cathedral.

103 Verger's cassock in grey Trevira (washable) designed by Rev Leonard Childs, tailored by Lilian Bedding *Cathedral Workshop, Derby*

CHAPTER V
Soft furnishings for the church

The Altar

The most important symbol in the Roman Catholic and Anglican church is the Altar, the Lord's Table. In the past, the only time when the altar ceased to be veiled was at the close of Holy Week which evinced the sanctity surrounding the altar. The frontal was not necessarily in the form of a textile, though references from the fifth century and the representation in the Ravenna mosaics shows a silk cloth embroidered with symbols, thrown over a cube-shaped altar. Later, in the west the altar was lengthened, and the pall was adapted to become the frontal, and the priest celebrated the mass from behind. After a time it was the custom for him to stand in front of the altar which was placed against the east wall in the sanctuary with the laity becoming spectators. After the break with Rome in 1532 frontals were still used, although many were destroyed or hidden; others were later vandalised during the Commonwealth.

After stone altars had been replaced by wooden tables, the frontal was still used. The Laudian (or throw-over) frontal derives from the great Carolean divine who is known to have furnished the altar in his private chapel with frontals and hangings.

In the seventeenth century, in addition to the pall frontal, a shaped type was introduced which fitted over the table and was sewn at the angles. A frontal embroidered in canvas-work for the church in Axbridge, Somerset, where it is still (181), is of interest as an example of the fitted type, and because it depicts a complete contemporary altar, vested with the throw-over frontal.

During the middle of the nineteenth century variants of this type appeared. The reformers began to introduce the kind of altar frontal which was stretched tightly over a frame. To some this is considered an offence upon aesthetic or liturgical grounds. So, for varied reasons many altars were left bare.

It is permissible, but unsatisfactory for the frontal to be replaced by the frontlet only, which should not be more than 15 cm (6 in.) in depth, anyway. In Germany an abbreviated substitute is used resembling a pulpit fall.

The present-day Liturgical movement emphasises the connection between Liturgy and daily life, consequently the free-standing altar is more often preferred. Because both sides are visible it should have two frontals and a fair linen reaching to the floor. Alternatively the pall or 'throw-over' frontal is used. The corners can be rounded.

A square altar presents certain problems. These were overcome at Wigmore, Gillingham, Kent, by Pat Russell who created four frontals, the two opposite sides each being attached to a square of linen which covered the top of the table, and allowing for rearrangement according to season.

The pleated frontal is considered incorrect.

With churches changing to the free-standing altar, one purpose of which is to see the whole figure of the president or priest, it becomes essential to do away with the frontal altogether. The transition will be gradual, if only because few older altars are fine enough in themselves to be seen without a frontal, whilst others are of unsuitable proportions.

For free-standing altars the importance of the fair linen cloth increases, and as in the USA the ends generally hang to the floor.

Design

The experienced designer will realise that because of the importance of the altar, the character of the entire building and of the interior decorations must be considered when planning the frontal, so that it may become a part of the whole scheme. The scale of the design depends upon the surroundings, and the choice of colours too. These must be decided in position, as day or artificial light can change a colour. The altar is the focal point, therefore the design should make an impact when seen from a distance. See Chapter II also.

Whether the design is based upon religious symbolism or is abstract will depend upon the ambient. Whatever the inspiration, the concept of sanctity and faith need to be conveyed in a revitalised

104 Altar frontal and cope. Designed by the Rev Peter Delaney and worked by Sister Kathleen, SSM.

The design of the frontal is based upon an abstraction of rock and moss forms, interrupted by the gold energy of the new life. The tomb diffuses darkness and death, indicated by dark greens and purples, cut through by black cracks and crevices, tying the whole design together. Light radiates in the shape of a cross emerging in the centre at the tomb entrance, which is marred by drops of the blood of Christ. At the bottom the sunlight is reflected in strips of water on the floor of the cave. The design of the cope shows the glory of the Resurrection shinning through the Passion of the three crosses
Church of the Resurrection, Upton Priory, Macclesfield

105 Frontal for the high altar. Designed by Pat Russell. Machine quilted in shades of yellow, gold and vermilion and bright gold. Also chevron striped cope in gold, red and dark green. Set of three co-ordinated copes in shades of red and orange
Norwich Cathedral. Photograph: Jarrold Colour Publications

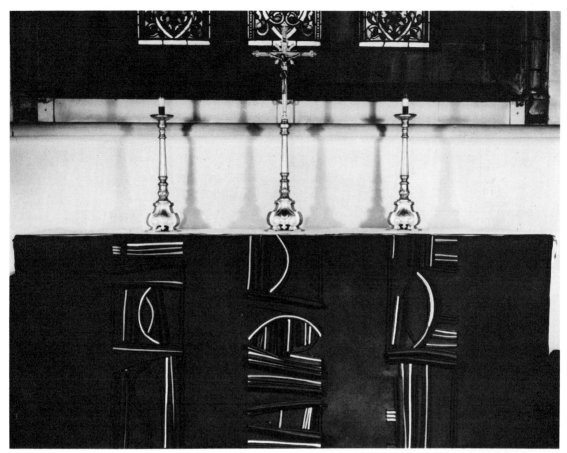

106A *Above* Trinity altar frontal designed and worked by Diana Springall, 1973. Felt relief. **106B** *Right* Detail *Farningham Church, Kent*

approach to design. This seems to be the very antithesis of the conventional, traditional altar frontal of brocade or damask, which is composed of panels divided by contrasting orphreys, all edged with braid, with which there is usually a superfrontal, having twice the number of divisions, and which is fringed.

The frontal generally follows the colour appropriate to the season with something neutral for ferial (neither a fast nor festival) use.

Lenten array

It is the practice to cover the altar, etc, with veils of coarse unbleached ash-coloured holland, or linen, or hand-woven material. The frontal is often ornamented with a design stencilled in black, red, red and black or blue. Traditionally the instruments of the Passion form the subject, but many designers prefer to try to capture the 'feeling' of the season in terms of more abstract shapes.

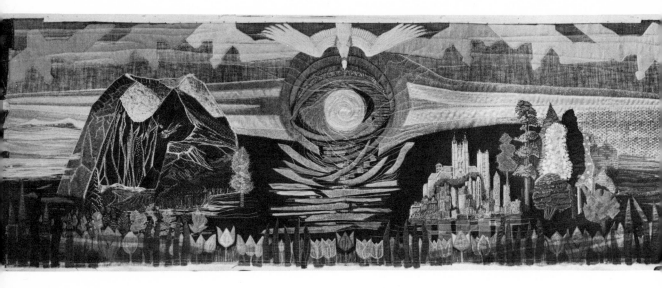

107 Altar frontal, The Way of Life, designed and embroidered by Joan Gardner, 1972. Appliqué overlaid with stitchery. Below the outspread wings of the dove of peace is the central vortex of silver and gold threads representing light and love drawing in every aspect of the frontal. On one side is pictured a Colorado Mountain, the rocky places of life, and on the other Manhattan silhouetted against Canterbury Cathedral symbolizing the Anglican Communion throughout the world. Close by are Colorado trees
St Luke's Episcopal Church, Fort Collins, Colorado

Measurements

Most altars are 99 cm (3 ft 3 in.) high and a fairly average length is 2.28 m–2.33 m (7 ft 6 in.–8 ft) or more. The width varies greatly, from 61 cm (24 in.) upwards.

To estimate the amount of material required for a frontal, the position of the seams must first be decided; the fabric generally runs parallel with the length. But when it is patterned, then more is needed and the reverse direction of the joins applies. If there is no embroidery avoid a centre seam.

With many of the wider materials, the grain can run horizontally, without seams. But this will depend upon the way the material hangs.

Material

Brocades and damasks are not often chosen as a background for modern embroidery.

Obviously a throw-over frontal cannot be made from heavy thick material. The handwoven 150 cm (60 in.) silk fabric created for ecclesiastical purposes is specially good.

Furnishing fabrics, if not too thick or heavy, also many dress materials and suitings are excellent for most frontals.

When the frontal is to be mounted on a stretcher, there is unlimited scope for experiment.

Sateen is practical for lining, and sail cloth, duck or canvas for the interlining, Substitutes are not so firm or heavy. The importance of shrinking the interlining and backing for the embroidery cannot be overemphasised, as many churches are very damp.

The design and its working is generally large in scale for any type of frontal. The framing up, embroidering and finishing processes are described in the appropriate sections.

To make up the altar frontal

Mark and match up all centres.

Mark out the outside shape of the embroidered rectangle (if slight shaping is preferred, each side can be extended by 5 cm (2 in.) at the bottom). Cut away the surplus backing from the embroidery. Then cut allowing about 2 cm–3 cm (1 in.–1¼ in.) turnings all round.

Mark out and cut the interlining, without turnings. If this fabric (sail cloth) runs horizontally it will probably need a strip joined on at the bottom. (If necessary make these sides also slant outwards by 5 cm (2 in.) at the base.)

Spread out the embroidery, face downwards, then put the interlining in place, matching up the centre marks. Keep this in position with weights. Fold the turnings of the frontal over on to the interlining, pin, keeping the pins at right angles to the edge, and mitre the corners, catch-stitch to the back of the interlining.

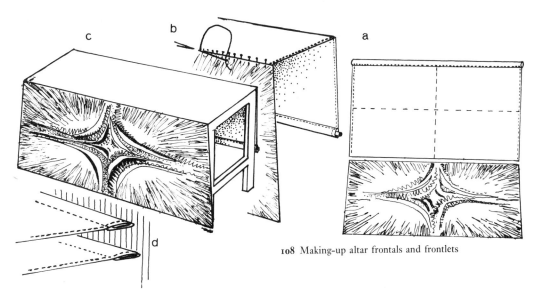

108 Making-up altar frontals and frontlets

It is advisable to stitch the front of the embroidery to the interlining. Using a long or curved needle, with fine thread (or invisible), from the front take tiny stitches following the outline and long stitches on the wrong side, at intervals. There is difficulty in reaching, and it is hard work to push the needle through, but the life of the frontal is prolonged.

At this stage the frontal is lined. Fold in the turnings all round, put the lining in place, and slip-stitch or hem around three sides. For Method I the linen will later be inserted between the front and the lining of the frontal, then stitched (108b). Or the top of the frontal may be completed and later hemmed to the linen.

Method 1

For the suspension of the frontal procure linen (as only linen may be used to cover the mensa) measure the depth of the altar and add about 54 cm (22 in.). Cut two (or more lengths for a wider altar), stitch the join(s), press open. Stitch narrow hems along the sides, making sure that the finished width equals that of the frontal. On the other cut end make a hem 5 cm (2 in.) wide finished, leave the ends open (108a).

Take the front cut edge of the linen, insert it between the embroidered front and the lining, and pin (108b), slip-stitch or hem using strong thread. If necessary the lining can be stitched to the linen on the wrong side, for neatness.

Alternatively, fold in the cut edge of the linen, and put this edge to the top edge of the lining of the frontal, and stitch. Then, matching up the centres, place the top of the embroidered frontal to the edge of the linen, stitch them together, invisibly.

Yet another way is to cut the linen (or holland) long enough to form the lining to the frontal also. The made-up frontal would then be stitched to the linen, on all four sides. If there is a super-frontal it can be attached as a permanent part of the frontal. (The linen part would be made as before on three sides.)

Finally, a heavy rod is put through the hem, after the frontal is in place. This end which hangs down at the back of the altar can be seen in the diagrams (108b and c).

Should there be a super-frontal, it is made up in the same way and if it is not to be attached to the top of the frontal, it is mounted on linen separately. This is necessary when one frontlet is used with several frontals.

When the altar is flush with the reredos or wall, cut linen to size of altar+hems, with about 8 cm (3 in.) added for the wide hem at the back, the ends of the hem remained open, and the rod which is pushed through the hem must be flat as it lies on the altar top (108d). The frontal and frontlet can be mounted in the same way.

Method 2

The altar is sometimes fitted with hooks under the front edge. The frontal is made-up and lined as already described. It is suspended by a metal rod, as illustrated (109e) and the frontlet is mounted as already described.

Diagram 109f shows the appearance from the reverse side. To do this, take a strip of linen or holland measuring the width of the frontal and about 8 cm ($3\frac{1}{8}$ in.) deep. And, according to the position of

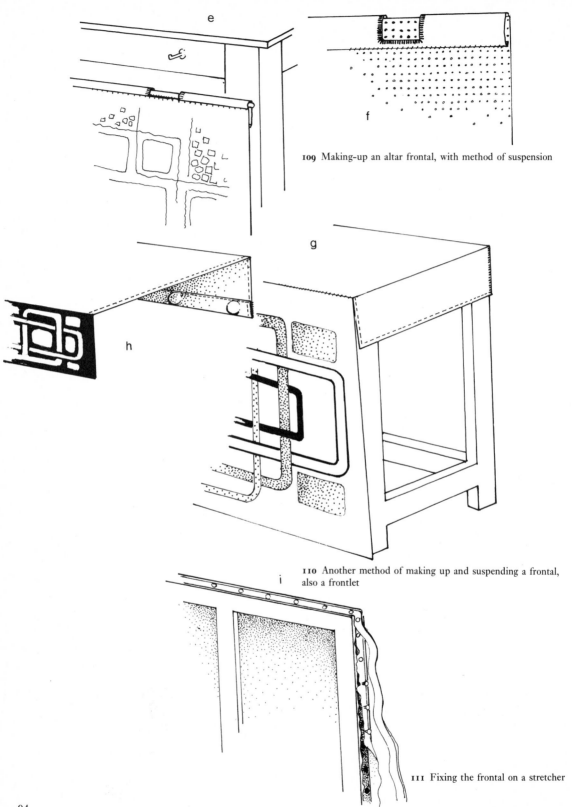

e

f

109 Making-up an altar frontal, with method of suspension

g

h

110 Another method of making up and suspending a frontal, also a frontlet

i

111 Fixing the frontal on a stretcher

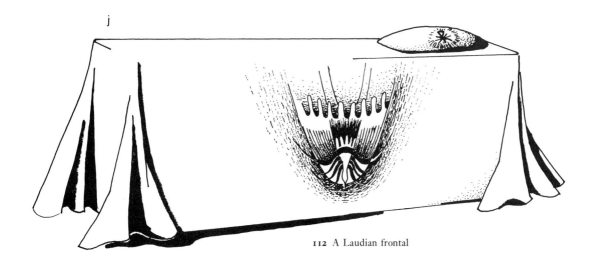

j

112 A Laudian frontal

the altar hooks, cut away the same number of squares from the linen, with the position corresponding to the hooks. Neaten the edges with buttonhole or blanket stitching. Pin, then tack and stitch the top edge to the top of the frontal. Turn in the bottom edge of the strip and sew it to the lining of the frontal.

When there is to be no frontlet, the hooks on the altar may have to be raised, and the false strip must be set a little below the top of the frontal so that the rod and hooks are hidden. The differences affect the measurements and must be taken into account.

Method 3

Another way of suspending a frontal and/or frontlet is to make a linen cover for the top of the altar, allowing for the two short sides and the back to overhang about 18 cm ($7\frac{1}{8}$ in.). Arrange the corners to fit, pin, cut away the surplus material, overcast the two corners at the back. Turn up the hem and stitch. The frontal having been made-up is pinned to the front edge of the linen cover, and stitched (110g). A slight variation upon other methods of suspending either a super-frontal or frontal is shown in 110h. This has lead weights inserted into the hem; the ends of the hem must be stitched up.

Method 4

Although not favoured by churchmen, the following method of mounting a frontal is the most satisfactory to the embroiderer, because puckering is prevented, an advantage when materials react differently to the dampness of many churches.

For this method a stretcher or frame of wood is made to the exact measurements of the front of the altar. This will either slip under the top or is fixed in front of the altar, kept in place by a hook and eye at both sides. The stretcher has first to be covered with pre-shrunk unbleached calico which is attached with tacks, over this is stretched the embroidery, the centres being matched up; first the top and bottom, then the sides are folded over and lightly tacked to the frame. Until the whole has been adjusted do not hammer home the tacks or nails. Cut away surplus turnings round the edges and neaten with tape which is also tacked down (111).

Method 5

When the altar is free-standing and is visible on both sides, there can be frontals back and front or a Laudian, or throw-over frontal, which is dignified, and is a reversion to the older form of pall. It is a rectangle and measures the length by the width of the altar plus its height and a hem all round (112j).

The making-up process is described and is the same as for the funeral pall. The corners may be rounded.

In order that the corners sit properly, some workers recommend that a strip of buckram 12 cm–15 cm ($4\frac{3}{4}$ in.–$5\frac{7}{8}$ in.) wide should be tacked all round the hem edge on the wrong side. This necessitates cutting the fabric to allow for a hem of this width which should be turned up over the buckram, when the frontal is on the altar, and lightly caught to the fabric. The frontal is then lined.

Method 6

The gathered or pleated frontal with frontlet is not advocated. The frontlet would be made and suspended as already described not more than 13 cm

113 The gathered frontal and method of fixing

114 *Below* Methods of suspending curtains and riddles

(5 in.) deep and can be of a contrasting colour. Allow for a hem up to 10 cm (4 in.) wide and wide enough for gathering or pleats, which are sewn across the top. A flat backing of a suitable lining material is then made up to the size of the altar and the pleated or gathered fabric is first pinned then sewn strongly to the top of this lining or backing. The whole can then be attached to the lining of the super-frontal, if it is not to be separate (113k). Two other possible ways for suspending this frontal from a rod are given in 113l.

Method 7

An altar according to the English tradition is vested with a frontal, with or without a frontlet. It is the dossal and riddles which are characteristic. The dossal which may be flat and embroidered or without decoration and falling in folds, hangs behind the altar, and the riddles hang in good folds, reaching to the floor on either side of the altar from rods supported by riddle-posts which terminate in sconces with tapers or carved angels. (An English altar may be seen at Thaxted Church, Essex, and many

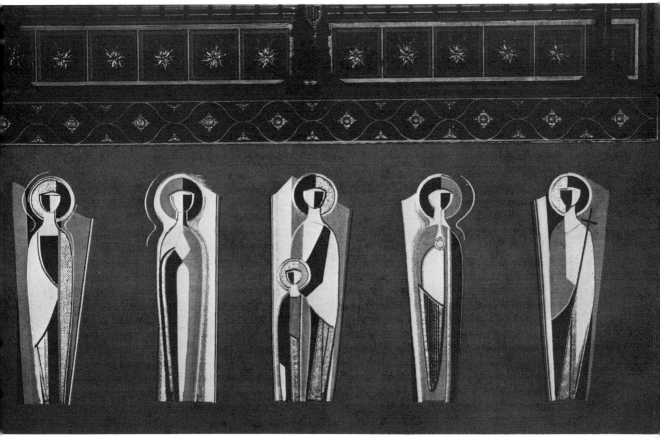

other churches.) Otherwise rods or brackets are fastened to the reredos or the wall.

The curtains must be made sufficiently full and of material which hangs well, preferably they are lined and are made in the same way as a funeral pall (**130, 136**), but there is a choice of finishing for the top edge. (If unlined a run and fell seam is inconspicuous: this is necessary as both sides show.) Weight the hems, and overcast the ends. The fullness at the top may be gathered or pleated and the turnings folded over, and neatened with cross-cut binding, as flatly as possible, or it can be left plain. The diagrams show several ways of hanging the riddles and dossal from the rods (**114**).

In individual instances the use of *Velcro* might eliminate more complicated fixing for frontals and frontlets.

The burse and veil

The corporal (or corporals) are kept in the burse, also the linen chalice veil and purificators. When the veil covers the chalice the burse lies flatly upon

115 Altar frontal designed and worked by Sylvia Green. Red with gold, white and dark red
St Michael's Church, Highgate, London

them, otherwise it stands, hinge uppermost, upon the altar. But the burse and veil are not now required, although still used in some churches.

Design

There are no limitations either in design or technique. But it is necessary to find out whether it is the practice of the church concerned to stand the burse with the hinge on the top or the side, and to plan the design in accordance.

The burse and veil and usually form a part of the Eucharistic set, though they need not conform to the Liturgical colour. The chalice veil must be kept light as it hangs over the chalice. Often the decoration is confined to the front.

Materials

If suitable in weight, then the main fabric of the set of vestments is used. If too thick the corners of the burse become clumsy.

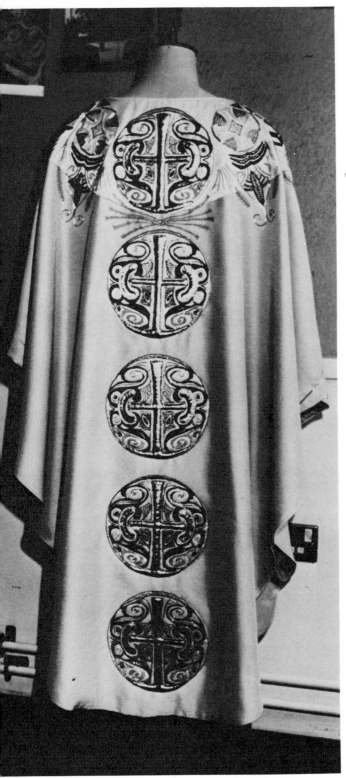

116a *Left* Paschal vestments, designed and worked by Katarin Privett. Off-white embroidered in brown, fawn and gold. Gold kid applied
St Mary's Church, Bridport, Dorset

116b *Above* Burse and veil, designed and worked by Katarin Privett, 1976. Part of a set of vestments in off-white, with padded gold kid, and embroidered with tones of brown, fawn and gold threads

A thin soft lining is essential for the chalice veil. Linen is used for lining the burse. On the Continent a thin silk lining often replaces the white linen.

Measurements

In the Church of England the burse boards are usually 23 cm (9 in.) square. Two squares about 28 cm (11 in.) (according to the method) of fabric are cut and two of linen or lining.

For the chalice veil, one square 51 cm–61 cm (20 in.–24 in.), or larger + turnings, and the same amount of lining are cut.

Method

Two squares of card measuring the required size of the burse and two thinner squares are cut, or purchased already cut.

Mark the centres of each, both ways.

For all methods, cover the two thinner cards with white linen (or silk, which may be coloured). These are laced with strong thread as shown in **diagram 117**A, B.

Method 1

1 Mark out the front and back square boards upon the fabric. Cut, allowing turnings of about 2.5 cm (1 in.), except for the top edge of the back piece, this should have a turning of about 5 cm (2 in.).

The backing of the embroidery should be retained, otherwise the rough edges of the card at the corners are apt to wear through.

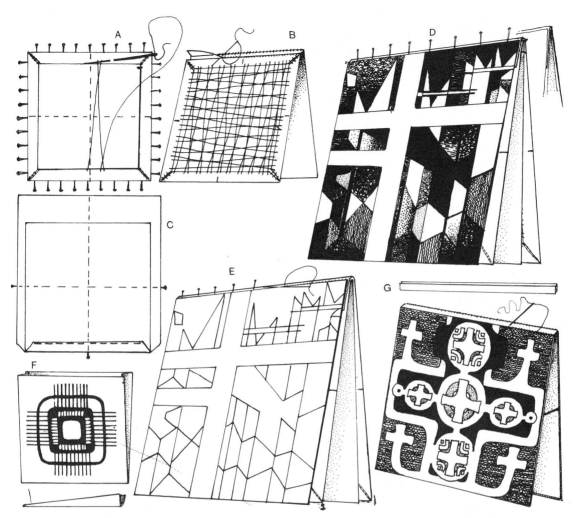

117 Diagrams showing methods of making-up burses

2 With the embroidery face down, put the board in position matching up the centres, then bend over the turnings of the fabric, cut across the corners (not too close), and pin all round, top and bottom first, then the sides. Lace across with strong thread, downwards first, then across, this can be seen in 117, A, B. It is quicker to stick, but then it is not possible to get the embroidery really taut. Copydex is quite good for this purpose.

3 For the back of the burse, set the board in position for the lacing, but stitch or stick the bottom turning to the board, replace the material with the wider top turning left loose. The other two turnings can now be laced across (or stuck) (117C).

4 The two lining squares having been covered (the linen may first be washed), one way to make a hinge is by overcasting two edges together. But a more satisfactory hinge is made by folding both sides and the ends of a narrow strip of linen. These edges are overcast to the front and back lining squares (117B).

5 Next, with the lining squares closed together, place the embroidered square over the front lining, pin in position, then, matching up the halves and quarters, pin the back in place, the wide turning at the top, holding the four squares together with the left hand, and with the right hand tuck the wide turning down behind the front square, and pin (117D).

6 Invisibly slip-stitch along, thus forming a hinge (117E). A surgical needle makes this easier. The burse should close flatly. If it does not, release the back flap a little before stitching.

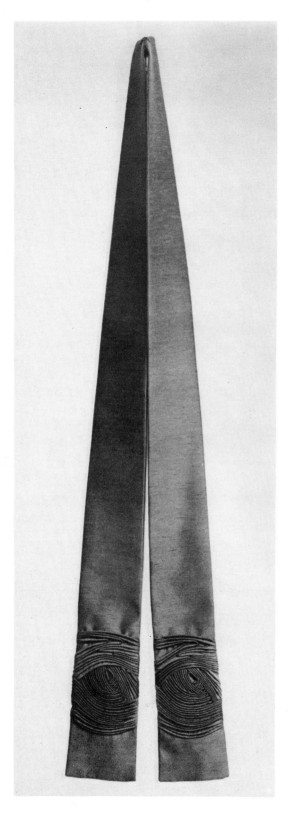

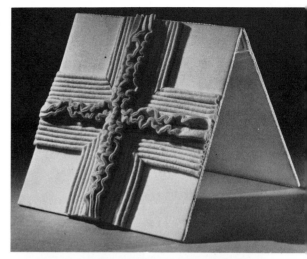

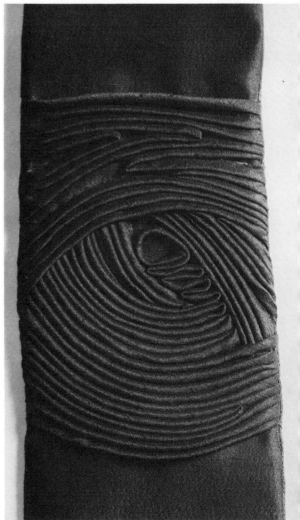

7 Pin, then overcast or slip-stitch together, all round the lining pieces to the outside of the burse. If it needs neatening threads can be couched or a fine cord sewn around. About half way along both sides a bar should be worked 4 cm or 5 cm (1½ in. or 2 in.) long.

It is seldom that gussets are required. They are triangular, and measure half the length of the side, and 4 cm or 5 cm (1½ in. or 2 in.) at the other end. They are made separately, and sewn in.

Occasionally the gussets are cut as triangles having two sides the length of the burse and the third about 6 cm (2½ in.). These are lined and made up and folded down the centre. They are attached to the sides of the burse, **diagram 117** F.

Method 2

Complete both the front and the back of the burse as described for the front in Method 1.

Cut in the fabric a narrow strip measuring the length of one side of the burse + turnings and the width slightly less than 1 cm + turnings. Repeat in the lining linen. Stitch the two together to form a hinge.

Put the long sides of the hinge to the top of the front and to the top of the back of the burse, and overcast invisibly (**117**G). Neaten if necessary and work the bars to connect the two sides.

Method 3

The process is the same as for Method 2 except for the hinge. Instead of the strip of material, little bars are worked across at intervals of about 4.5 cm (1¾ in.) joining the front and back together and forming a hinge. This is very simple, but it neither looks as good nor is as functional as the other methods.

Another alternative: Machine stitch around three sides of both the front and the back, joining the lining and outer fabric, turn through, insert the squares of card, turn in the edges of the open side, and slip-stitch the edges together. Make the hinge according to the method chosen.

The chalice or silk veil

The burse and veil match. Should the positioning of the embroidery prevent the veil from falling softly then it defeats its own purpose. If the embroidery is kept light, it need not be confined to the centre front, as is the convention.

Measurements

51 cm–61 cm (20 in.–24 in.) or more, square + turnings depending upon the height of the chalice (**119**H).

Material

The same as for the burse, usually, but not necessarily the same fabric and colour as the Liturgical vestments. A thin, soft lining, such as jap silk or shantung is recommended.

119H The chalice veil folded back showing the pall and paten upon the chalice.
119I The lining of the veil

120a Red spray-dyed velvet burse, one of a set of four, all using some variation of the triangle/star grid symbol, designed and made by Sarah Monk, Manchester Polytechnic. Though white velvet forms the background fabric in all cases, colour is given to each of the burses by means of spray-dye, chiffon silk appliqué and machine stitching. The symbol and piping also add to the colour in each case

120b Red cotton satin burse with inset decoration. The burse is one of a set of four, each with a cut-out triangular section housing symbols appropriate to the liturgical colour. The decoration is machine embroidered in fine silks with 'jump-stitches'. Gold fabric shapes are applied by hand and edged with couched purl

120c Machine stitching up to 1 cm ($\frac{1}{2}$ in.) wide is used with fine double-needle pintucking, french knots and leather piping, to form the design of this cream silk and leather burse. A piping of extremely fine gold kid surrounds it. All four burses make use of a cut-out shape to isolate the decoration or to strengthen the impact of the symbol. Fabric is turned over card in all cases

120d Velvet burse, designed and made by Helen Armstrong, Manchester Polytechnic. A gilded metal shape has been cut by hand, etched with marks similar to the hand-stitches in the background, and polished. The design is inset within a circle which also constitutes a symbolic image

Method

Cut away the backing close to the embroidery. Cut out the fabric and lining, allowing turnings, mark the centres of each side. Fold down the turnings of both. If pressing is not enough, then lightly catch the turnings down (1191).

If it seems that the lining will separate from the fabric of the veil, fold back the lining along the centre, and lock the two together, invisibly (53) and slip-stitch or hem around the edges.

The burse and veil are not universally required. Fewer churches are using them, as the chalice is put on the altar before the service in many places of worship.

121 Diagrams showing veils for the tabernacle, ciborium and monstrance

Veils for the tabernacle, ciborium, monstrance and aumbry

Some of the ritual objects used in the services of the church are covered with veils, the form of which must depend upon their shape.

The design of any embroidery needs to be kept fairly simple and light. An interesting variant to machine-made fringe could be contrived for the hems (if decoration is considered necessary). When there is a central opening the embroidery can embellish the corners and continue up both sides. The sanctity of the tabernacle calls for something special, but not heavy or stiff.

For the circular veils an embroidered border is suitable, but those composed of joined sections can be planned as an all-over design. They are generally made in the colour for the season.

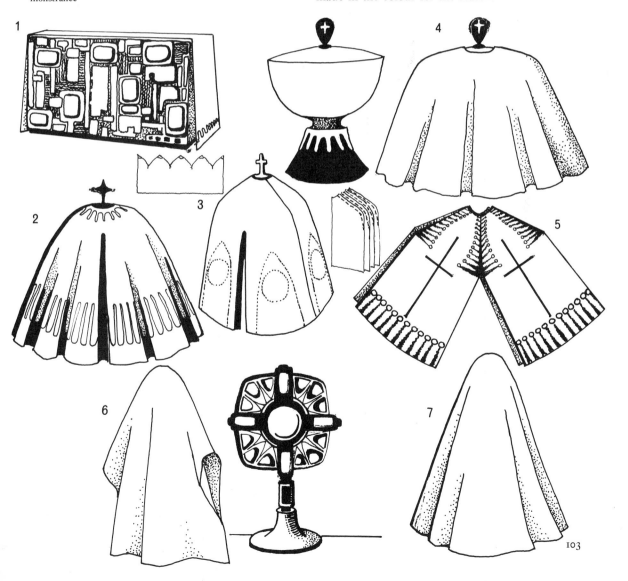

Material

All veils must be made from soft, light fabrics, which will fall in folds. Jap silk makes a good lining.

Measurements

The height and circumference of the object must determine the measurements.

Method

A simple cloth covers a rectangular tabernacle (121.1). But for most other forms (121.2) together with the ciborium (121.4) and monstrance (121.7) the circular veil is most satisfactory. It can have a centre front opening, but must have a sufficiently large hole in the middle, if there is a knob or cross.

The radius of the circle is determined by the height of the object plus the width of a narrow hem (when required cut away the hole in the centre, allowing turnings which are nicked, turned over and neatened with a cross-cut facing). Invisibly stitch the hem. But if there is to be a decorative braid or fringe, it can be turned on to the right side, when the cut edge will be covered by the braid. Otherwise a narrow cross-cut facing makes a neat finish.

For a lined veil cut the circle in both fabric and lining, spread out flatly, with right sides together. Stitch all round the edge when there is a centre hole; otherwise leave a gap in the stitching, as the veil can be turned through the hole or gap, and slip-stitched afterwards. When it has been possible to pull the whole thing through the centre hole, and it has been pressed, the turnings of the centre are nicked and folded in, then slip-stitched together. The ciborium veil is usually white.

Another method for constructing a tabernacle or ciborium veil is shown at 121.3. The first stage is a strip of fabric measuring the depth of the object by its circumference plus a little extra. Divide it into eight divisions, shape the darts in relation to the curve of the top of the tabernacle or ciborium, and cut leaving turnings. Stitch up the darts, repeat for the lining, press the turnings flatly, put the right sides of each together and stitch all round the outside edge and turn out, then neaten the centre hole.

Alternatively, quite another ciborium cover is shown at 121.5. Here four sections of interlining are cut, and covered with the embroidered fabric sections then each is lined, and the tops are joined together.

The monstrance veil (121.6) is made from a length of soft white silk which measures twice the height of the monstrance and wide enough to fall at the sides. A narrow hem neatens the edges.

An aumbry veil is made as a small curtain, embroidered and lined, and kept very light and flexible. Little curtain rings are sewn along the top edge. Or, the veil may take the form of a rectangle, the embroidery is mounted over an interlining, and is lined. It is generally suspended from rings or hooks, so that it covers the aumbry.

Pulpit falls

Because of its position in the church a pulpit fall can well be a focal point, an important feature, bringing colour and interest to a pulpit which may otherwise be visually featureless. Therefore the design should be one of real character, and at the same time harmonising with the interior decoration. It is usually the colour for the season.

The design may well be striking, and the fall can be longer than is usual thus making a shape of better proportion.

Almost any material can be used except one which is very thick, and any lining—sateen is specially good.

The measurements must depend upon the width of the stand, and the length of the hanging rectangle is in proportion to this, except when there are specific reasons for deciding upon quite another shape. The actual stand must be measured before starting.

Method

Having completed the embroidery, mark out the rectangle; when cutting leave a wider turning at the top. Cut the rectangle of interlining, such as dowlas, sail cloth or deck chair canvas (when obtainable) or heavy *Vilene*: it must hang well. Put this over the back of the embroidery, turn over the edges and catch-stitch, on three sides but not along the top edge. Sew in the lining on three sides, in the usual making-up method, as for a banner.

Cut two rectangles which measure the width of the desk on the pulpit and its depth. Firm card or strawboard or thin hardboard can be used.

Cover both with the lining material by either of the methods used for a burse. Sticking down the edges is adequate. Then attach a piece of elastic across the underside piece (122A and B).

Putting the two boards together, wrong sides facing, overcast the two sides and the top.

Next, slip the top turning of the fall between the two boards, as shown at 122, B.

Slip-stitch invisibly along on the edge (122C); a curved surgical needle may help.

To save time, after the rectangle of each fall has

122 Diagrams to show the making of a pulpit fall

been completed, pieces of *Velcro* can be attached at the top, underneath. Similarly placed pieces of *Velcro* would be attached to the edge of the board. In this way the one board is used for several falls.

Falls for the ambo or lectern

As a result of the Vatican Council steering guide, and the recommendations of the Liturgical Reform Commission, it was decided that the ministry of the word should take place as near to the people as possible: from a lectern or ambo, which is a standing desk for reading and preaching. The ambo represents the dignity and uniqueness of the Word of God and of reflection upon that word. As the Liturgical centre for action, well designed decor-

ation embroidered on a fall of good proportions would reflect and enhance its importance. Should there be a secondary lectern, that too could have a fall, for both the main colours would be those for the festival or season.

The practical process would be the same as for a pulpit fall.

Banners and hangings

In new churches, also in the more ancient, with the re-ordering of Liturgical space, banners and hangings have become increasingly important as a means of bringing colour and interest to those spaces which may now be unsuitable for the Liturgy. This is a return to the medieval practice of bringing out the long banners and pennants at festival times. Quoting from the Bishops' committee on the Liturgy (1978) it was written '. . . invite temporary decoration for particular celebrations, feasts and seasons. Banners and hangings of various sorts are both popular and appropriate, as long as the nature of these forms is respected. They are creations of forms, colours, and textures, rather than signboards to which words must be attached. Their purpose is to appeal to the senses and thereby create an atmosphere and a mood, rather than to impress a slogan upon the minds of observers or deliver a verbal message.'

This practice has long been followed in the beautiful old church at Thaxted, Essex, England. And at Southwark Cathedral the recent set of hangings used during Christmas and Easter, are hung from the columns, and being well lit, transform the ambient. Carried out as a corporate project designed and directed by the Rev Peter Delaney, these banners are of felt appliqué upon felt (296, 297). Originally shown at the *Civitas Dei* 1958 Exhibition in Brussels the strikingly vibrant set of banners created by Norman Laliberté are now in the Rockefeller Chapel, New York. The fabric used was a fairly finely woven raw silk with a matt surface, the technique being appliqué. Another of his banners is in the remodelled St James's Church, Jamesburg, New Jersey (126). Another instance is the Trinity Church, New York, where the whole of the sanctuary was re-done by Robert Rambusch, who has made good use of the best Victorian in his scheme.

These and many other examples illustrate, as the Rev Horace T Allen, Jr said 'The growing interest in the use of banners. In addition vesting the Church building or "sanctuary" has developed rather naturally. . . . culture has become more and more re-

123 *Left* Pulpit fall made by Florence Hind. Darker layers of brown organza form a cross on the background. The graining and knots of the wood are embroidered in gold check purl, couched Jap gold with brown french knots
St John's Church, Harrow
124 *Below* 23rd Psalm, pulpit fall, designed and created by Hannah Frew Paterson. The background is composed of bands of colour representing images contained in the lines of the well-known psalm – the pastures green, the quiet waters and death's dark vale. The patchworked circular shape symbolises the varied membership of the Church linked together, the colours ranging from gold through orange to reds and muted purples. The Trinity is represented by the three gold leather bands which lead up from the centre to the slight canopy at the top edge of the fall, representing the 'House of the Lord' *The Gorbals Parish Church, Glasgow*

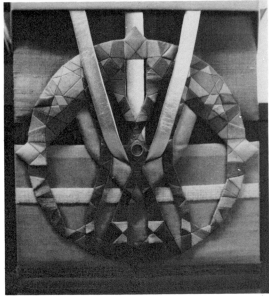

occupied with what it sees, as it begins to learn visually as well as aurally.'

Banners of all kinds give great scope to the designer as they should be vigorous and also attractive, taking their place as a part of the decor; this applies in particular to the choir banner which stands in the Church between festivals and when used in procession is only seen for a short time so that the impact must quickly be established. Therefore fussy detail should be eliminated along with any lettering which is illegible because too small. The scale of the whole must necessarily be large; and if well chosen to harmonise with the surroundings the colours can be brilliant, where this could be an advantage. The well drawn and competently created decorative and original representation of the patron saint is still a good subject and suitable because it will only be seen in an upright position. There is also scope for good lettering, and as both the front and

back are seen, there is sufficient space for an effective lay-out on the back. Unless an intentionally naïve approach is desired, the designing of a figure subject is really for one trained to do the job.

Many banners, undoubtedly excellent in their day, seem old-fashioned now, because the treatment and choice of subject is hackneyed or sentimental. The too frequent addition of contrasting orphreys detracts from the main interest, as do the fussy shapes and the fringe and tassels so often decorating the bottom of commercially made banners. This is today replaced by a good clean line or shape, which might be finished with a really interesting hand-made fringe.

Having re-thought the banner, the pole must also be designed with the same degree of imagination, remembering that for travelling, one which takes apart is an advantage. It is possible for a wood-worker to contrive a fixture which obviates the necessity for cords and tassels.

If too small the banner is unimpressive, it needs to be as large as practicable, bearing in mind that it has to be carried in procession, and sometimes this happens out-of-doors, when the wind can cause trouble. If too long, the person carrying it cannot see ahead.

Measurements

That the decorative features should be kept large is an advantage. Closely related to scale is proportion: If the banner is to be a rectangle, it might well be based upon the Golden Section (**129**) which can be produced by assuming that a short side measures 1 unit (be it in feet, inches, metres or whatever) then it would have a long side of 1.618 units. It is easier to express the golden section as an angle. The diagonal of the rectangle will always be at 58.5°.

Very approximately an average length might be 115 cm (45 in.)

Materials

Avoid thick heavy fabrics. But conversely if the materials are too thin it may be necessary to use *Vilene*, preferably not the iron-on variety for very light textiles, as it may come through to the surface.

For the background of a conventional banner, Masonic silks, gros grain, Thai silk, etc, are suitable, but design-wise damasks and brocades having a woven pattern conflict with the character of the embroidery.

A fairly heavy interlining should be used, pre-shrunk sail-cloth, cotton duck or pelmet weight *Vilene* are suitable.

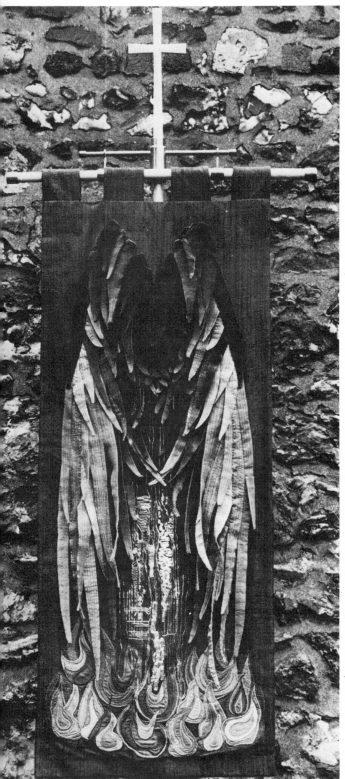

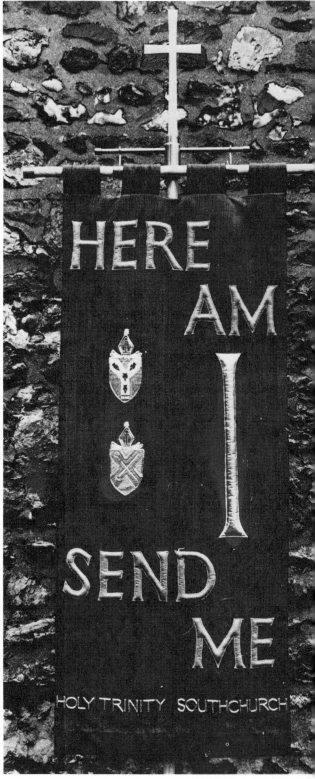

HERE AM I SEND ME

HOLY TRINITY SOUTHCHURCH

125a *Far left* Celebration banner 152 cm × 64 cm
(60 in. × 25 in.), designed and executed by Kate Whitfeld,
1974. Deep red Thai silk background. Design based on the
wings of angels in the Thorby window, each feather lined
with rich materials, stitched only at the top and hang loosely.
The centre depicts a piece of burning wood
*Holy Trinity Church, Southchurch, Essex. Photographed by
Edward Whitfeld by kind permission of Canon and Mrs
Norwood*

125b *Left* Reverse side of celebration banner, designed and
worked by Kate Whitfeld, 1974

126 *Right* Banner depicting 'Man in his World', by Norman
Laliberté, 1966. It was intended to bring into the interior of
the church a visual statement of joy – about 4.26 m (14 ft)
high
*St James's Church, Jamesburg, New Jersey, USA
Reproduced by courtesy of The House of Dan, Jamesburg*

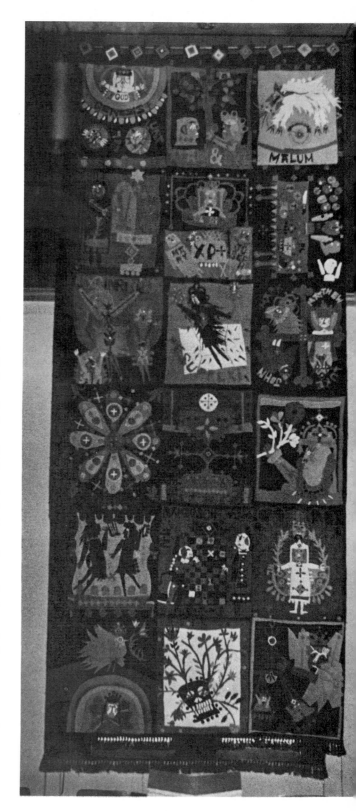

Method

The information given concerning making-up applies to banners.

Most embroidery techniques are suitable provided that the method will not prevent the banner hanging well. Machine embroidery is especially effective.

For a conventional banner, should it be necessary to have orphreys, these would be attached whilst the work is still on the frame, for preference.

As it may be necessary to roll up the banner from time to time, the embroidery should always be rolled on the outside.

It is essential to stretch any embroidery thoroughly if at all puckered, and to paste back any ends. Decide whether or not it is an advantage to cut away surplus backing.

Summarised are the following points relating in particular to the making-up of a banner.

1 Cut out the interlining, lining, and embroidery as usual, keeping the grain of the fabric running down (**130.1**).

2 Place in position, fold over the turning on to the back of the interlining and catch stitch, or it might be stuck.

3 Cut across the turning at the corners and fold over. Then stitch the corners (**130.4**)

4 The loops from which the banner is suspended are called 'sleeves'. Cut the required number of strips of material, twice the finished width, plus turnings, and add turnings to the length. Insert a thin interlining, fold in the side turnings and slip stitch (**130.5**) or machine stitch and turn out. Press

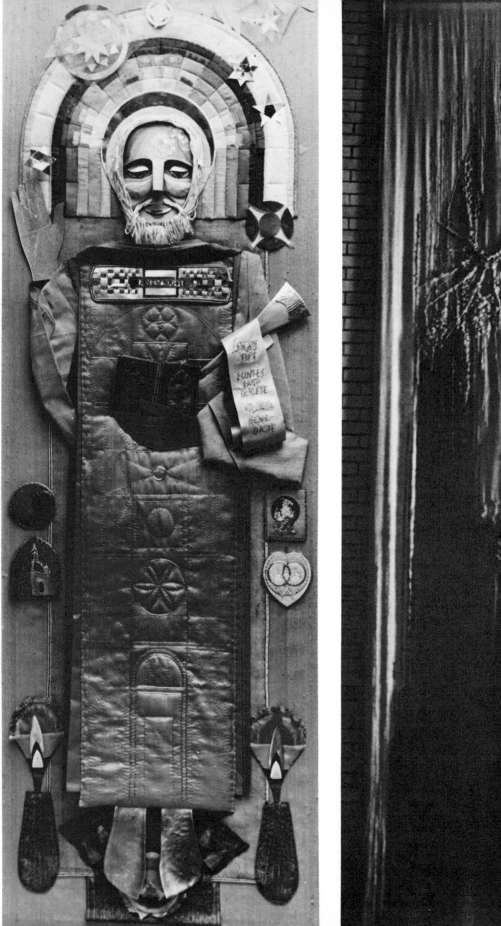

127 *Far left* St John's Vision, Book of Revelation, enclosed in a gold box frame. The figure, 165 cm × 57 cm × 6 cm (65 in. × 22½ in. × 2½ in.), was designed and created by Kathleen Whyte, 1978. Head in bas relief against a bright spectrum of coloured patchwork. The garment is quilted in a design symbolic of the church, and the breast-plate of woven gold incorporates a white stone and the woven words 'A New Name'. There are various other symbols, some relating to the minister in whose memory the work has been donated. It is made of Indian and Thai silks and is predominantly gold and orange/red in colour with additions of red, blue and purple, also soft browns and greys
Netherlee Church, Glasgow

128 *Left* Hanging 6.09 m × 1.52 m (20 ft × 5 ft), designed and hand-embroidered by Ruth Stonely. Ground fabric of tussore silk with velvet, silks and rayon applied. Worked with silk, wool and other threads
Brisbane, Queensland, Australia

1·618

58·5°

129 Diagram, the Golden Section

130 Diagrams showing the making of a banner

and pin into position, leaving a gap in the centre for the fitment on the pole. Stitch firmly to the interlining of the banner, (**130**.6).

5 With a tiny invisible stitch on the front and a long one on the back, catch the embroidery to the interlining at intervals, working from the front.

6 Place the lining in position, and if necessary lock it to the interlining, (**130**.7).

7 Slip stitch or hem the lining to the banner around the outside.

Rugs and carpets

Altar rugs and altar or sanctuary carpeting, although not actually embroidered, can be needle made. Too little thought is given to the choice of design and colour, yet they form such an important part of the whole decorative scheme. So often the valuable oriental or other rug, beautiful in its own right, but designed for domestic use is entirely out of keeping with ecclesiastical architecture, the patterning being small in scale and the colour too broken up.

There is so much scope for individually planned and designed woven and needle made floor covering that it seems a pity that this aspect of the craft should have been neglected when much which is exciting

131 Detail from one of a pair of large entrance door curtains, designed and made by Pamela Newton. Machine appliqué, tones of blue and yellow
St Nicolas's Church, Chiswick

132 *Right* Hanging, The Seasons, in symbols and spirit, designed and executed by Joan Gardener. The ancient symbols for the seasons are carried out in various threads and fabrics on a background of greenish brown wool bouclé

could be produced; there are several books which set out instructions, some are listed in the bibliography.

In its day the carpet woven for Guildford Cathedral created an impact; and the varied greens and the texture used in the carpeting for the chapel at St Andrew's, Holborn, are just right with the stained glass.

There are good modern tapestry woven and woven altar kneelers by Peter Collingwood in Thaxted Church, Essex; by Roger Waters at St Paul's Church, Jarrow; Margaret Bristow at St Mary's Church, Sudbury-on-Thames and David Hill, St Philip and St James, Hodge Hill, Birmingham. These and other examples were shown in a Crafts Advisory Committee sponsored exhibition in 1977.

Funeral or casket palls – Easter banners or hangings

A conventional pall may be of any suitable colour and fabric, with or without decoration and fringe.

The size is based upon the measurements of the coffin or casket, an average is 182 cm × 48 cm (6 ft × 19 in.) with a depth on all sides of 38 cm (15 in.). The shape illustrated would be made to this size (135A). When a fringe is added to the edge, then its depth is subtracted from the total measurement of the width and length.

A pall for ceremonial occasions is generally a rectangle of about 364 cm × 273 cm (4 yd × 3 yd). As it is intended to drape the corners can be square or rounded.

Conventionally the decoration is generally heral-

133 The branches of this Tree of Life symbol, designed by
Sarah Pickard, Manchester Polytechnic, 1976, take the form
of an aerial view of landscape and also give the feeling of a
stained glass window. Hand woven fabrics were used and
various rugging techniques which give the panel great surface
interest. Green velvet was turned over plywood to form the
shaped border

134 *Tree of Life*, by Lucy Owen, Manchester Polytechnic,
1979, is in machine appliqué using a variety of different
fabrics and colours on a pale green background. Letter forms
make up the foliage of the tree and the fallen leaves create the
legend amongst the grasses at the base of the panel. Green
fabric was also used for the shaped frame

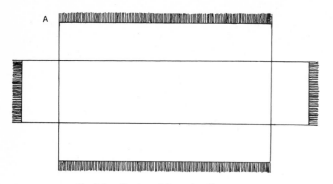

135 Traditionally-shaped funeral pall

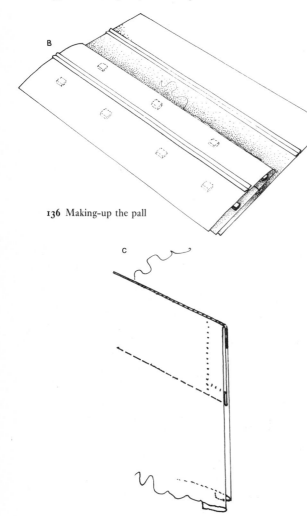

136 Making-up the pall

137 The casing to form the top hem

dic in character. Rochester Cathedral, England, possesses a magnificent funeral pall (138). Alternatively a wide gold cross is suitable, its size fits the shape of the top of the coffin or casket, or the arms may be extended over the sides in both directions. The decoration is generally carried out in appliqué or with applied braids. But there is scope for variation, the design could well be much more imaginative. This is more acceptable in the States than in Britain, where there is a precedent for very splendid palls in the medieval palls of the Livery companies of the City (17).

When making a pall the sheer size causes the weight to be considerable, and very difficult for the amateur to handle, and this should be remembered when selecting the fabric. For the lining sateen is recommended.

Method

Plan the position of the seams, which generally run parallel with the length. The making-up can be much more straightforward when the seams of the pall and its lining coincide, but this probably means cutting the material to waste.

Spread out the embroidered and seamed fabric, face down, having marked the centres on all sides. Place one half of the lining up to the centre (wrong sides together), keep it in place with weights at intervals all over the one half. Fold back the other half of the lining and lock this, stitching invisibly to the centre of the pall (136). Then move the weights forward, so that one seam is over the other, these can be caught together with an ordinary tack. When the sides are only about 38 cm deep further locking is unnecessary. But for a larger pall another row is required. Repeat the process on the other half of the pall.

Turn in the hems. When pinning, keep the pins at right angles to the edge; when there is to be a fringe, its heading is sewn to the fabric at its own depth from the edge or the heading is attached on the edge to the back of the turning of the hem. The lining is then brought up to the edge and hemmed or slip-stitched.

138 *Opposite* Cathedral funeral pall, presented in memory of Dean Lane (who died in 1913) and given by Lord Northbourne. This magnificent pall is of very dark blue brocade, with cloth of gold and black velvet applied. The diocesan Arms and the Lane Arms are carried out in appliqué with dusky pink crêpe de chine, cloth of silver and of gold predominating
Rochester Cathedral, Kent

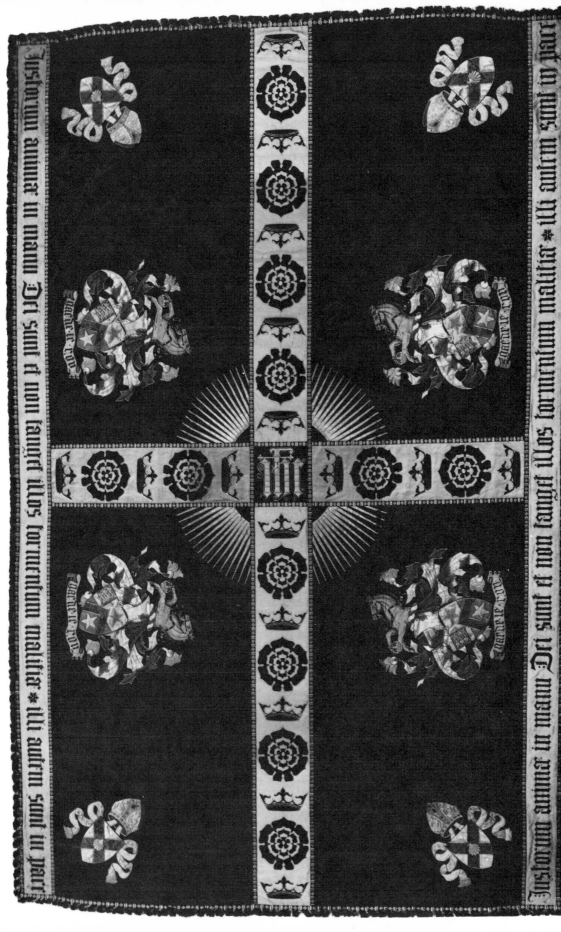

The funeral or casket pall used also as an Easter hanging

To hang the pall as a banner during Easter has not yet become a widely spread custom in the churches of the United States, but it is an idea which occurred to Rev Charles O Moore of Northbrook, Illinois, whilst celebrating the Eucharist during Lent, and it may well be extended.

To undertake the creation of this most exciting, and interesting project is a challenge, mainly because, at first, the two uses of the pall, in terms of design, would seem irreconcilable. Yet by taking Resurrection as the basic theme, then the commemoration and the celebration can indeed be united within the symbols for re-creation.

There are limitations, but they need not lessen the dramatic impact of the large-scale design. When considered as a hanging the feeling of growth may determine that there is a top and bottom to the design. That it will fall in slight folds is a possibility.

The colours and scale of the design must be right for the surroundings and 'read' when seen from a distance. Some sort of border down the long sides may define the shape, but a fringe is unsuitable.

The central panel of this design when not hanging up is seen lying flatly upon the casket, and those parts of the pattern which extend beyond the central rectangle should form satisfactory decoration when viewed from the sides. At the corners the pall will fall in deep folds. Average measurements are 335 cm × 198 cm (132 in. × 78 in. (**139**).

Material

If too heavy, problems would arise when hanging up. The fabric chosen should not mark as a result of the sprinkling with water during the funeral service.

Method

The practical considerations and method are the same as for the large rectangular pall, except that at the top of the lining some means of suspension must be provided. The most simple way is to make a wide hem, with open ends; the turnings at the ends should be stitched back, otherwise when the rod is slotted through it will get caught on the turnings. **Diagram 137**C shows the hem and these stitches on the lining, and on the other side the fabric of the pall, which is turned in all round, and slip-stitched to the edge of the lining.

Alms bags

Design

Alms bags are fun to make as there is freedom in the choice of colours and scope for creative design. As they have to be renewed fairly often it is practical to obtain an effect with a minimum of small scale embroidery. Although fine canvas work is specially suitable, as it is attractive and durable. Many different shapes can be devised both for the flat form of collecting bag and for those which are attached to mounts.

Material

It is essential that the fabric should be strong, but not too thick, otherwise the result will be clumsy. A material which will not soil quickly is an advantage. Some materials with a woven pattern composed of repeating units can be embellished with a little embroidery to good effect. All sorts of methods can be employed to decorate the bags.

Method 1

The flat alms bags are still used at certain services. The following basic instructions for making-up can also be adapted for other shapes, (**140**).

1 Make a pattern for the back, and for the pocket piece which is cut a little wider across the pocket mouth.

2 Put the pattern pieces upon the previously embroidered material, seeing that the selvedge grain is running down. Mark out two pieces for the back and one for the pocket piece. Mark in the centre lines and the positions for attaching the pocket piece.

Cut, allowing turnings, cut across any corners and clip at intervals along convex curves, snip for concave curves. Repeat for the pocket piece.

3 Cut one piece of lining, allowing turnings for the pocket piece, using polonaise, a lazed cotton sateen or chamois leather. For the latter cut without turnings, as it is hemmed in place. The back piece can be lined half way up with chamois.

4 Cut out to the pattern line of the back and front in interlining, dowlais, holland, or firm *Vilene*.

139 *Opposite* Casket pall, used also as an Eastertide hanging 3.35 m × 2 m (11 ft × 6 ft 6 in.), designed and embroidered by Beryl Dean, 1977. The colour of the background fabric is old gold and the appliqué in which the Tree of Life is carried out is of silk organza, in tones of burnt orange, greys, brown and greens, all outlined with gold braids. The dove is silver and the centre mauve and jade green
The Parish Church of St Luke, Evanston, Illinois, USA

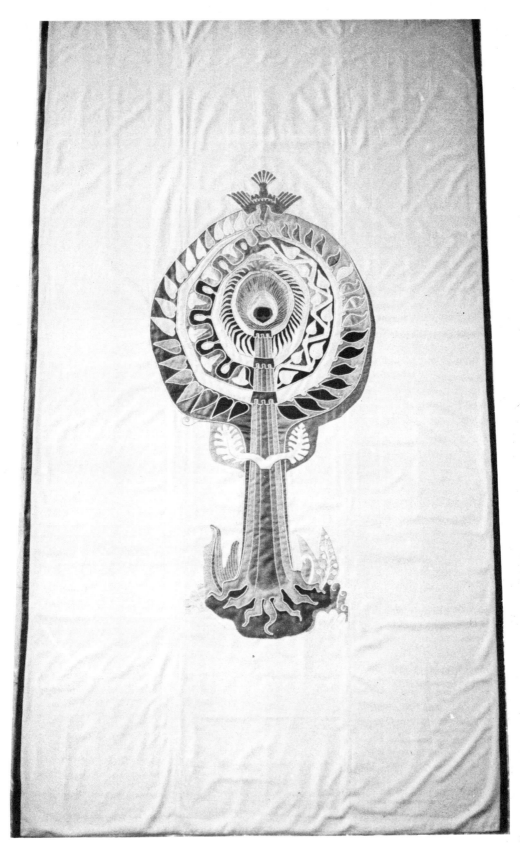

5 Pin and tack the interlinings in position (**140**a).

6 Fold over the turnings and lightly catch-stitch, an adhesive can be used. Press the edges on the wrong side (**140**b).

7 Taking the lining pieces fold down the turnings, slightly inside the pattern line, and tack. Pin into position and tack.

8 Slip-stitch or hem around the edges; press (**140**c).

9 Putting centre to centre, and matching up the position of each side of the pocket mouth, pin, and tack the pocket piece in place. (This will not lie flatly, as it may been made a little larger.) Securing the ends of the pocket mouth very strongly, slip-stitch all round (**140**d), or, alternatively overcast, but this will necessitate a cord to neaten. Always sew into a cord (not over it); start by tucking the end in between the top of the pocket mouth and the back, stitch, then take the cord across the top of the pocket mouth (if this is preferred), then round the edge; or simply round the edge, poking the end down inside the pocket and stitching it invisibly.

Method 2

For collecting bags with metal fittings first cover part of the metal with material as this prevents wear on the outer fabric.

1 Cut out the lining pieces in chamois leather, letting the top come up to the edge of the metal. Then putting these two pieces together stitch around the sides and base.

2 Cut out the front and back embroidered pieces for the bag, allowing turnings. (The backing can remain.) Stitch around, snip off the corners, press, and turn out.

3 Cut two rectangles from the interlining and two from the other fabric; each measuring slightly less

140 Making-up alms bags of various types

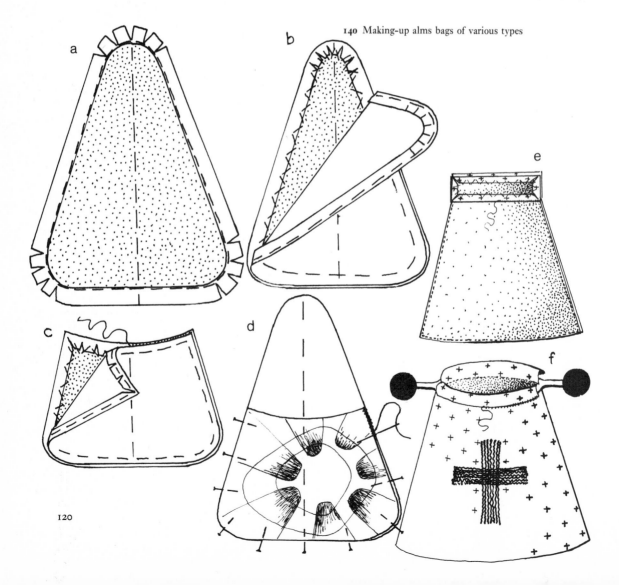

than half the circumference of the oval at the top and about 4 cm wide. Allow turnings on the outer fabric. Fold these over on to the interlining and catch-stitch.

4 Overcast these two pieces on the wrong side, to the top of the chamois bag (140e).

5 Slip this bag inside the embroidered outer covering, and invisibly catch the two together around the top.

6 Fold the rectangular pieces over the metal fitting, and neatly but strongly hem them down (140f). If necessary couch a line of thread to cover the stitches.

There are several alternative methods.

Method 3

With the increasing number of churches adopting 'Planned Giving' the question of suitable alms bags arises, because the envelopes are bulky when they contain coins. When planning to make a set, it is necessary to find out the number of bags required, and the approximate number of envelopes which will be put into each, in addition to some loose cash. There is scope for inventive ideas by collaborating with a woodworker or metalworker to produce original mounts. To be practical, the way of attaching the bag has to be thought out.

As already suggested, the bag can be carried out in fine canvas work, using silk, stranded cotton or fine wool or even pliant metal threads. To facilitate the making-up the stitchery should be taken up to the pattern line, but not beyond, so that the seams are made in the canvas only (to include the embroidery would be bulky). Other embroidery techniques which can be used include patchwork and inlay, provided that there is a strong lining to take the strain, or appliqué using thin leathers.

The alms bags photographed (141) are worked in

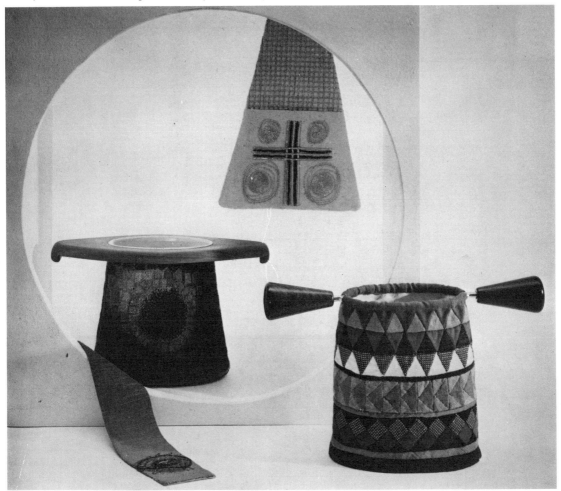

141 Alms bags, patchwork and canvas work by Beryl Dean

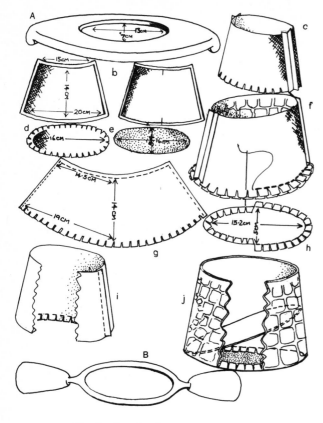

142 The alms bags fitted to mounts

3 Use thin leather or fabric, cut an oval to fit, using thin strawboard or plastic (142e).

4 With the right side of the base uppermost, place the bag over, matching up the markings for the centre and seam (142f), and with button-thread stab-stitch together. Turn out onto the right side, insert the stiff oval base, pushing it underneath the turnings, then apply paste to the upper side around the edge of the stiffening and on to the underside of the turnings, and press the turnings downwards, over the stiff base. (It is tricky to get the hand inside to do this!)

5 Use chamois or skiver for the lining. Join the two pattern pieces together (to avoid one join). Cut out in one piece, and a cut edge can make a lay for one side of the join unnecessary. Add turnings on three sides, and slightly reduce the size as usual when cutting linings (142g).

6 Cut out a slightly smaller oval in thin card, and then the same shape with turnings cut in chamois or skiver which are folded over and stuck down (142h).

7 With the right side of the leather and of the join inside, bend up the base turning (142i).

8 Insert this lining within the bag, smooth out flatly, put adhesive round the turnings at the bottom, and put in the stiff base, right side up, press down in place (142j).

9 Next bring the top of the lining and the turning of the embroidery together and stick with paste, trim off any fraying. The method of attachment to the mount has been described.

The measurements given in the diagram must be taken as approximate owing to variations caused by the materials and tension of stitching etc.

Method 4

The metal mount B has handles attached to a brass frame made by a metalworker, the metal used for the oval has a diameter of about half a centimetre, but the diameter of the ends is slightly more and they taper. They are brazed to the oval, which measures about 12 cm ($4\frac{3}{4}$ in.) × slightly less than 7 cm ($2\frac{3}{4}$ in.). The handles were designed to be convenient for passing from one person to another; they are a job for the wood turner, and in this example were made from rosewood (Indian).

This bag was made in patchwork, the top of the material was extended by about 3 cm ($1\frac{1}{4}$ in.) with an opening at both sides. This extension was turned over on to the lining and invisibly stitched to it. The method described and illustrated at 142f could be used.

tent stitch and patchwork and show the mounts A and B for which the following instructions are given.

For mount A the bag was attached with staples using a wood stapler and an adhesive. A trial bag was made up in calico, in which any necessary corrections were made to the pattern. The embroidery was then undertaken, and made up, and lined. When this had been attached to the mount there remained the problem of rendering invisible the stapling. This was solved by fixing a plastic edging (such as used for the edges of tables) round the inside of the opening, using white glue and making the join accurate and neat.

For embroidering the example shown at 142A the methods described in the section on canvas work were followed.

1 Having worked up to the pattern line, cut out allowing turnings. Stitch and press open the side seams, snip the turnings at the bottom (142b and c).

2 Cut out the oval for the base, leaving turnings and snip (142d).

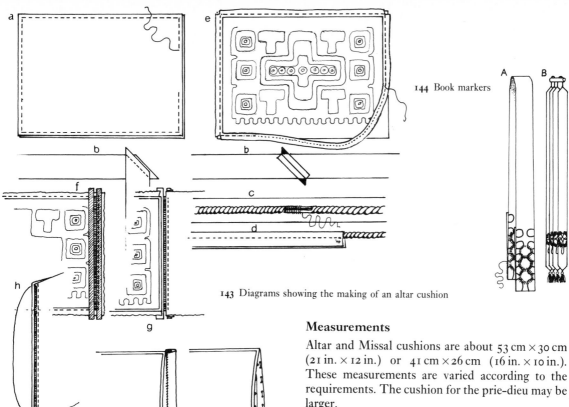

144 Book markers

143 Diagrams showing the making of an altar cushion

The altar cushion

With the re-ordering of the liturgy cushions are not placed on the altar. But, when they are used, instead of book-rests or Missal stands and put on the altar and pulpit, they are made in the following way.

Design

Any embroidery should be flat, and metal threads avoided as they might scratch the binding of the Bible or Missal. If the cushion is carried out in canvas work it must link up with the design and colour of the altar frontals, this also applies to all cushions.

Material

When the cover is used for all seasons the colour has to be chosen with care, a furnishing fabric should be soft, velvet, thick silk or fine wool can be used, but a slippery silk must be avoided. Traditionally a cord is still sewn round the edge, with tassels at the corners. Alternatively, the cushion may be made with a narrow (2.5 cm–1 in. wide) gusset all round.

Measurements

Altar and Missal cushions are about 53 cm × 30 cm (21 in. × 12 in.) or 41 cm × 26 cm (16 in. × 10 in.). These measurements are varied according to the requirements. The cushion for the prie-dieu may be larger.

As the cushion needs to sag slightly when lifted by the server to prevent the book sliding off, it is better not to insert a board to stiffen it, although this is done sometimes.

Method

From pillow ticking cut two rectangles slightly larger than the finished size plus turnings (on one side may be a fold). Machine stitch or overcast all round leaving about 13 cm (15 in.) open in the centre of one side (**143a**). Turn through to the right side.

The filling may be closely packed feathers, a mixture of feathers and kapok, kapok alone, or foam rubber cut up into very small fragments, or horse-hair and feathers. Foam latex is not recommended. If kapok is used it must be thoroughly well teased out.

Handfuls of the filling are inserted through the opening, these are pressed well into the corners. It needs to be fairly firm but not too full. Next sew up the opening. The seams can be soaped to prevent feathers poking through. The cushion for the pulpit is usually a little flatter. To make the cover, cut out two rectangles plus turnings.

If there is to be a piping, cut a strip on the true cross of the material about 4 cm (1½ in.) wide. The length equals the total measurement of the four sides plus a little extra for the join. Seam the join and press open (**143b**).

Take the length of piping cord; this can either be

123

cut to the exact length, with the two ends brought together with stitches or it can be spliced; for this, an extra 2 cm ($\frac{3}{4}$ in.) is allowed; then wind a thread round the join (143c). Next, fold the strip of material over the cord and stitch (143d), using the piping foot.

Pin the continuous length round the outside edges of one rectangle, tack, snip at the corners, stitch (143e).

If the cover is to be permanent, with or without piping, put the two right sides of the two rectangles together; stitch round, leaving an opening. Press the seam open and turn through. Push the filled interior through the opening, pressing it well into the corners. Pin and slip-stitch the opening.

For detachable covers the neatest opening is made with a fine dress zip fastener along one short side. To do this, put the right side of the zip and the right side of the front rectangle together, place it so that the right-hand tape comes over the stitching line, then stitch (143f). If there is a piping this stitching will come over the previous stitches securing the piping.) Fold the zip back, and invisibly catch the turning of the piping and the tape to the wrong side of the fabric, which can be neatened with bias binding.

Next take the rectangle of material for the back of the cushion; fold and tack back the turning along one short side. Place this over the zip to hide it (143g). (In the diagram the zip is not entirely covered.) Stitch, keeping clear of the zip, and with the zip slightly open, fold the back rectangle over the front, and so with the right sides together, stitch around the remaining three sides, over the line of the piping stitching. Open the remainder of the zip, and turn the whole of the cushion cover through (143h).

Method 2

Put the two rectangles together, right sides facing. Stitch round three sides.

Fold back the turning on one short side of the front, neaten it by invisibly hemming a facing or bias binding on the reverse side.

Cut a strip, the length of the short side, and twice the finished width, plus turnings, for a facing.

With the right side of this facing to the right side of the back of the cushion, stitch along the short side. Turn the outer edge over to form a lay, and fold it over to the first row of stitches, then hem (143i).

Tuck in the ends, stitch and fold in this facing.

Sew hooks to the front, not allowing the stitches to penetrate, and sew eyes to the facing on the back of the cushion cover (143j). Alternatively strips of *Velcro* could be sewn to both sides.

Book and missal markers

For the decoration the design should be confined to that part of the marker which hangs below the Book.

Material

If ribbon is used, it must be soft, as a hard material or ribbon will damage the pages.

Measurements

Take the total of the length of the volume, the projection at the top and the overhang at the bottom, plus the amount necessary to neaten the back of the embroidery, when ribbon is used.

Double either the length or width, plus turnings, for a marker made of material.

Method

1 Cut twice the usual length plus enough at each end to fold over and hem down for neatening the back of the embroidery (144A). Trace the design on the right side, placing it a few inches up from the end, and on the reverse side, repeat for the other end. The embroidery, whether hand or machine can, of course, be done free hand. This type of marker is folded over at the top. A single marker is usually preferred.

2 When material is used the marker is made up in the same way as for a stole, but without the interlining.

3 Four markers can be attached to a headpiece (144B). Fringes and tassels, if not out of scale, give weight to the bottom.

Bible and missal covers

There is unlimited scope for designing book covers enriched with imaginative embroidery. Bookbinders have an advantage, as they are able to inlay and combine embroidery with leather.

Removable, slip-on covers

1 Be sure to do all the fixing and measuring with the book closed. Make a pattern which measures the height of the book, fold the paper round the book and fold the ends round the front and back covers, cut away the surplus paper and mark in the folds and the width of the spine.

2 Select a fairly thin fabric, the result will be clumsy otherwise.

3 Mark out the pattern and the position of the folds upon the material and cut, allowing turnings and a narrow lay at the ends.

4 If it is to be worked in a frame use a thin backing, sew the fabric in place and trace on the design. The backing may be cut away at the end. Complete the embroidery and remove from the frame.

5 Invisibly stitch the single lay at the ends (**145**).

Fold over the turnings at the top and the bottom, snip away unnecessary turnings.

6 Cut a rectangle of thin lining, put this over the reverse side of the cover, press and hem in place.

7 Fold the cover around the book when closed, match up the markings, fold in the end pieces, pin and stitch with the book closed (**145**A).

An improved fit can be obtained when a little flap of fabric is left extending above and below the spine (finally this is tucked into the spine). Either strengthen the area with a small piece of iron-on *Vilene* (**145**B), or smear a very little adhesive to prevent fraying. Then work a buttonhole stitch round the edge, taking care to take the stitching round the base of the little snips (**145**C).

A cover will fit better when it is made to be permanent. For this follow the instructions, except that the front and the back folds are made three quarters of the width of the book covers. A lining is unnecessary.

Proceed as before, overcast the top of the folds, put the cover on to the book, tuck in the little flaps, then pin the bottom edges together and stitch whilst on the book (**145**D).

Kneelers

It is through joining a scheme for making kneelers that most people are introduced to embroidering for the church, and this so often leads to more adventurous undertakings. In the first instance it may be that only the stitchery is completed before being handed over for professional making-up. By following the instructions, the worker can carry out the process of producing a kneeler herself.

For canvas work to be referred to as tapestry is a misnomer. True tapestry is woven on a loom; imitations of the wall hangings were carried out in tent stitch (tent meant a frame) because the originals were very expensive. Actually, for this type of embroidery to be called needlepoint is no more correct, as this is a type of lace making.

Design

It is of the utmost importance to have really good, strong designs for kneelers, be they expressed in abstract forms or geometrical patterns, enhanced by

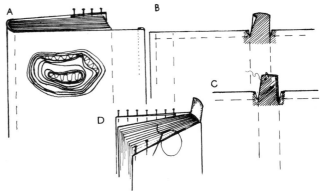

145 Making a book cover

well planned colour, and made more interesting by variety within unity. In several cathedrals and churches there are excellent schemes, but there are also too many which artistically amount to a waste of labour and materials. Because of the poor design plan, the weakness adds up to nothing more than neat monotony, whereas the total impact of a well designed and considered group of kneelers can add life, vitality, interest to the body of a church.

On the whole, large scale designs are more effective than over elaboration and small detail. Pictorial representations treated realistically are better avoided; so too should certain symbols such as the cross, as a hassock is essentially something on which to stand.

Canvas work can be used in many different ways, where durability is an advantage.

Materials

A single canvas is easier to see, except for tent and cross-stitch where a double is better. The buff is stronger than white canvas, but sometimes hemp may be preferred for stitching done by hand. Obtainable in several widths, it is made with a varying number of threads to the inch, the choice depends upon the scale of the design. Crewel wool (two or three stands), tapestry wool (a single strand) and French, Medici or Florentine wool (three strands) is used for the embroidery, which is worked with tapestry needles.

For much finer work stranded cotton or silk can be used.

Measurements

The average kneeler is about 23 cm × 31 cm × 7 cm (9 in. × 12 in. × 3 in.), or it may be larger and deeper. Sanctuary hassocks are generally consider-

146a One of a set of 12 kneelers, designed by Diana Springall. Scarlet cowhide inset with a circular panel of canvas work, carried out in Wilton carpet thrums. Each design is different but related. The embroidery is predominantly blue and buff, the whole thus tying in with the scarlet and blue roundels of the stained glass window above. Each motif is repeated once to form the altar cushion
St Anne's Chapel, Lincoln Cathedral

146b Detail showing stitchery

ably deeper, and somewhat larger. The width and length of the communion rail kneelers must depend upon the individual requirements of each church.

Method

When cutting the rectangle of canvas, allow for the depth of the sides, plus turnings; at each corner a square measuring the depth of the sides is left unworked; this forms the shaping when it is later seamed up.

If it is to be worked in the hand, then bind the edges to avoid fraying.

For framing-up canvas (and other materials when there is no backing), webbing is strongly sewn down both sides. The stringing for the bracing-up is threaded through this. When worked in a frame, the shape is kept permanently, without distortion.

Transferring

A design which can be worked out to the counted thread will probably be easier to follow if drawn out on graph paper and coloured. It is usually advisable to work outwards from the centre.

For the type of design which has greater freedom of line, ink in or paint the outlines of the drawing or tracing. Put this under the canvas; if it has been framed-up, build up underneath the design (with books), so that the design is in contact with the canvas, then paint in the outline. Take care if using a felt tipped pen (or use an alternative) as the ink may run, when the work is finally dampened.

Technique

Simple groundings or counted thread all-over diaper patterns are sometimes more effective than sophisticated designs beyond the capabilities of the worker. Examples can be discovered upon samplers, especially Victorian woolwork examples. It is not difficult to make diagrams using graph paper. A few patterns are given in **diagram 148**.2, composed of tent stitches, with a long darker stitch dividing the colours. For **148**.3 it is essential to work with a sufficiently thick thread or bunch of threads. **147**.4 shows the principle upon which Bargello patterns are constructed, but traditional examples should be followed. **148**.5 shows how a large design can be carried out entirely in one stitch.

The most satisfactory way to start stitching the canvas embroidery is by making a knot in the thread, take the working thread through to the back about 2 cm ($\frac{3}{4}$ in.) from the point where the needle will bring it up to make the first stitch; it will get worked in as it becomes covered, then the knot can be cut off. To introduce a new thread, bring the old one up a short distance away, the end will lie on the surface (it will get worked in, then it can be cut off). The new thread is brought in as for the start as shown in **diagram 148**.1. And the thread is ended in the same way. The diagram shows tent stitch (petit point) being stitched diagonally. It is better to work the pattern first, then to fill in the background.

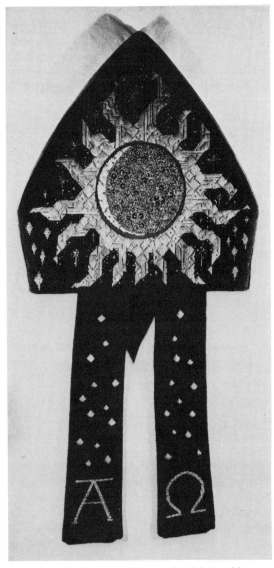

147 Mitre, worked by Priscilla Leonard and designed by Sylvia Green, in a variety of canvas stitches with wool, stranded cotton and metal threads

147a Detail of back

Stitches and groundings

For textural contrast a variety of stitches can be introduced, a selection is given in diagrammatic form. For uniformity the stitches must be worked in the same sequence throughout. The needle is shown entering the material, and small crosses indicate the point at which it will emerge, because it is assumed that the canvas has been framed-up.

149A The large crosses are worked over 4 threads, in between are small upright crosses.

149B *Parisian* stitch, upright stitches are worked over 4 and 2 threads of canvas alternately.

149C *Gobelin*, this is the most satisfactory way to work the stitch.

149D This grounding is composed of slanting satin stitches alternating with back stitches.

149E *Upright gobelin* can be worked with the addition of one or two trammed stitches underneath as shown in the diagram, as the canvas is seldom completely covered without. The stitches are worked over 4 threads, but can be 3 or even 2 threads wide.

149F *Hungarian*: Care should be taken to see that the canvas is covered.

149G and **H** *Mosaic* stitch.

149I *Diagonal* stitches are worked over 1, 2, then 3 threads before decreasing again to one. This is taken diagonally across the canvas.

149J *Plaited gobelin*: The stitches slant across 2 upright and 4 vertical canvas threads, in the next row the slant is reversed.

149K *Velvet* or *Astrakhan* stitch produces a cut pile texture, and consists of loops each secured by a cross stitch; these loops are cut afterwards to form the pile. Commence with a cross stitch, bringing the needle out at the bottom left-hand corner, make a loop

148 Diagrams of canvas work groundings and patterns

149 *Opposite* Diagram of canvas stitches

(these can be formed round a narrow strip of plastic or whalebone) and insert the needle above and across two threads of the canvas in each direction, then bring it out again at the bottom left-hand corner. Take a stitch diagonally across re-entering the material at the top right-hand corner, and emerging at the bottom right-hand corner. Next, complete the cross-stitch as shown in the diagram.

149L Over a diagonally laid thread, tent stitches are worked.

149M *Cross-stitch* is worked diagonally over two threads of the canvas, the top stitches must all start in the same direction.

149N *Mosaic* and *tent* stitches alternately.

149O *Straight cross*, worked over 2 canvas threads in each direction, the stitches are upright and across. The thread should not be too thick.

149P *Upright gobelin*, stitched over 2, 4 or 6 horizontal canvas threads. If this stitch does not completely cover the canvas, either add to the thickness of the wool or work over trammed threads.

149Q *Encroaching gobelin*: the stitches slant across 1 vertical and 4 or 5 horizontal threads. The stitches of each row encroach between those of the previous row.

149R Work *long-armed* (or long-legged) cross by

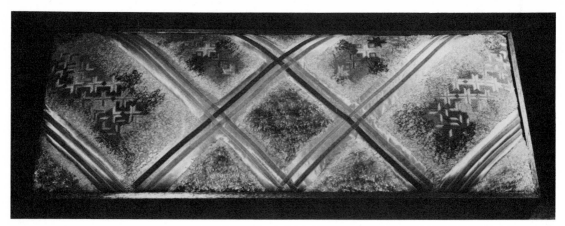

150 Wedding kneeler, designed and worked by Jayne Raines,
Manchester Polytechnic, 1979. The kneeler has rosewood
sides and a padded top of canvas which is worked with some
traditional hand canvas work stitches. The Cornely machine
was used for moss stitching and machine tufting. The kneeler
has an appliqué strapwork of padded satin and velvet ribbons

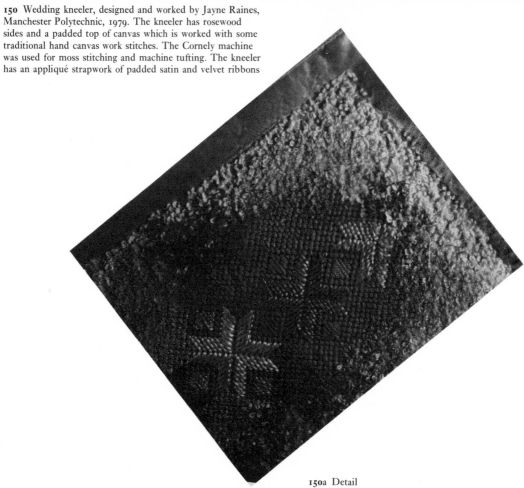

150a Detail

151 Stretching embroidery

taking the stitches diagonally across either 2 and 4 and down 2 threads or 4, 8 and 4 threads.

149S *Upright gobelin* covers better when worked over a self-coloured trammed thread.

149T *Diagonal satin* stitches worked in lines over two vertical and three horizontal threads of the canvas.

149U and U When several rows of these *Turkey knots* are worked, and the loops cut, a delightful texture results. For clarity only one working thread is shown, more would be used in practice.

149V *Tent* stitch worked in diagonal rows is stronger and more even; this shows the beginning and joining of the thread.

149W *Florentine* is one of the most characteristic of the canvas stitches and is worked over an even number of threads.

149X *Rice* stitch. Make a cross over 4 threads both ways, then cross each corner with a short stitch.

149Y *Smyrna* or *double cross*: a diagonal is crossed by a straight cross.

Stretching

When the piece of canvas work is finished, it should be kept in the frame, but unrolled and straightened up if necessary, then tightened. Turn it over with the reverse side upwards, then thoroughly dampen it with a sponge and water, allow it to dry for about twenty-four hours. It can then be removed from the frame.

If, however, it has been worked in the hand, or it has become misshapen, it is necessary to pin or nail the work out flatly on a wooden surface, which has been covered with a clean cloth. Place the embroidery face upwards, with one straight selvedge side to the edge of the board, stretch it, and pin it out with drawing pins (thumb tacks) or nails to the second edge, at right angles to the first. Do the same with the third and fourth sides; these will require more pulling to regain an accurate shape. **Figure 151** illustrates this process.

Thoroughly dampen with a sponge and water,

152 The shape of the kneeler

153 Making-up a kneeler

154 Making a communion rail kneeler

being sure to dab rather than rub; the latter would cause the wool to fluff up. Allow to dry for about twenty-four hours.

The threads should first be tested to see if the colour is likely to run.

This process can be used for an embroidery worked on fabric which will not be harmed by the dampening. For linen the embroidery is put face downwards. For light materials it is sometimes sufficient to pin it out over damp clean blotting paper.

To make-up kneelers

After stretching, cut out allowing a fairly wide turning all round (152). Stitch the corner seams, press open and turn out.

To make-up a kneeler with separate sides, which may be of another material: first join up the corner seams, then, if there is to be a piping, stitch this around the top piece of the kneeler. Match up the corners of the sides with those of the top right sides facing, and stitch.

Filling for kneelers or hassocks

1 Rubber latex This needs to be thicker than the depth of the kneeler so that it can be compressed; it can be cut with a very sharp knife or scissors. Cover with calico and always add several layers of thick carpet felt. The disadvantage is that after being in use for some time, the covering is apt to slip off the edges, even when the corners are stitched through.

2 For *plastic foam* the process is similar, but the foam must be compressed to half its bulk. Alternate layers of thinner plastic foam and thick carpet felt are another possibility.

3 Several thicknesses (cut to shape) of carpet felt stitched through, can be used, but this is rather heavy.

For any of the above methods, the interior is slipped inside the cover, and if necessary some wadding is stuffed into the corners. The turnings of the canvas can be stitched down to the rubber or felt on the wrong side, or it may be laced across (153).

Next, cut a rectangle of black upholsterers' linen

(sometimes called bucket-cloth) and press down the turnings, match up the corners and centres of the top with the sides, hem this lining all round to neaten the bottom. Just before completing this, fold a short length of material or webbing, push it through a ring (for hanging) and attach this to the canvas, then finish hemming the lining.

4 When plastic foam cuttings, rubberised hair, or horse-hair is used, the black linen lining for the base is pinned and hemmed to the three sides of the cover of the kneeler (for horse hair, first pin in a thick layer of wadding). Then pack in as much stuffing as possible so that it is really very firm, press well into the corners, then pin, closing the fourth side by hemming in to the lining.

With experience it will be found that short cuts can be taken, provided that the durability is not impaired.

To make-up a communion rail kneeler, stuffed with horse-hair

1 Cut out the top, bottom and sides of the case in hessian, allowing extra for turnings and about 3 cm ($1\frac{1}{4}$ in.) extra for every 31 cm (12 in.) of length, and add on to the width in proportion.

2 Join this together with outside stitching on the right side, by machine, leave one end open.

3 Stretch out this case, to secure it firmly, knock in a nail through each corner of the base (**154**), and at intervals along the sides.

4 Tease out the horse-hair, and push it into the interior, using a regulator or knitting needle to get right into the corners.

5 Using fine string threaded into an upholstery needle, stab-stitch along the edges; this helps to keep the shape (**154**).

6 With a very long upholsterer's needle and string, stitch right through, from top to bottom and back, pulling it tightly and tying the ends. This is repeated at intervals, keeping one row fairly close to the edge. This would not be done until the stuffing had been completed and the open end sewn up, and nails removed. The ties prevent lumps forming in the horse-hair.

7 Fill up these indentations with wadding, and put a thick layer of wadding all over the top to ensure its smoothness. A rectangle of thin foam latex cut to shape would have the same result.

8 When the outer covering has been put over the whole kneeler, the upholsterer likes to make the job more rigid by tying through again with string and buttons or tassels, but the designer and embroiderer of the communion rail kneeler prefers to sacrifice this in the interest of an unbroken surface.

The black upholsterer's linen lining is then hemmed in place.

Kneeling pads

These are made up on the same principle as other kneelers, but omitting the gusset. For these a ring for hanging is essential. The cover can be of leather, durable fabric or plastic, or it can be made in canvas work.

The Pelican in her piety, a fabulous bird from the Bestiaries of the Middle Ages symbolising Man's redemption from the Fall through the blood of the Redeemer. This representation was taken from an *Opus Anglicanum* embroidered orphrey now in Lyons, France

CHAPTER VI
Altar linen

The fair linen cloth

The Christian altar is associated with the idea of sacrifice. It is a table around which people gather to eat the consecrated bread and drink the consecrated wine at the Eucharist.

Positioned at the east end of the sanctuary, altars, from the fifth century, were of stone, but after the Reformation and again recently, altars nearer to the proportion and design of domestic tables have been used.

The Canon Law of the Church of England states: '. . . it shall be covered in the time of Divine Service with a covering of silk or other decent stuff, and with a fair white linen cloth at the time of the celebration . . .'. It is implied by the rubrics in the Prayer Book and required in Canon Law that a frontal or suitable covering shall be provided.

This cloth must be made of linen, fine or coarse, because it symbolises purity. Five small embroidered crosses are also obligatory – one in the centre and at each corner of the mensa, when in position (155).

Usually these crosses are not worked on the altar cloth in the Roman Catholic Church: but there is often a narrow flat border along the long sides in addition to the embroidery at the ends.

Design

It is possible to adventure far beyond the limitations of traditional white-work when planning the decoration for the ends of the fair linen and to think in terms of large-scale shapes which make a bold and imaginative statement, or one of intricate detail where this is suitable; but provided always that this latitude will not interfere with the serving of the Eucharist, and practically, that it will withstand washing. For example, handsome hand-made fringes may well return to favour, but in a washing machine, might be damaged; or, wool would shrink, white silk discolour, and loops or tassels become spoiled. Other than these limitations, there is scope for design of importance and character.

Measurements

The free-standing altar is often wider and not so long as the high altar. The fair linen is made to the measurement of the width of the altar, plus hems, when finished. This varies, as does the length, which is calculated by measuring the height of the table from the floor, plus the width of the hem twice, and adding the length of the altar.

It is usual for the cloth to reach to the floor at both ends.

Materials

Fine or coarser linen, Stranded cotton, DMC Coton Floche à Broder, blue or red label, in various sizes, (20 is fine), linen thread, linen lace threads, and various cotton threads can be used for the embroidery.

Method

Having completed the embroidery, prepare the hems for whichever method is selected for their finishing. The folding and making of a mitred corner is shown in **diagram 156**. At **156d** the mitre is slip-stitched together. For hem-stitching, the threads are not withdrawn right out to the edge, and the hems are folded up to these threads. If a plain finish is preferred, the hem **156e** (without a lay) is folded over and neatened with linen tape or bias binding, and sewn by hand or machine, but invisibly caught to the cloth. At **156f**, another way of neatening is shown – here a shaped facing is cut in a finer material if the linen is very thick. It can be an imaginative alternative to hem-stitching which is too often used for the hems of altar linen. For its preparation the threads are withdrawn. When a wide band is to be worked, the ends are either darned back or buttonhole stitched. Worked on the wrong side, from left to right, the commencement is shown at **157g**. The knot is cut off afterwards. The join is done in the same way. For handkerchief hem-stitching two threads are withdrawn and two threads picked up for each stitch.

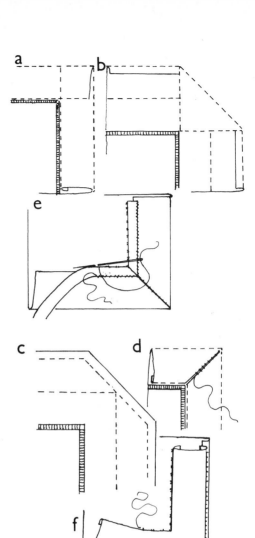

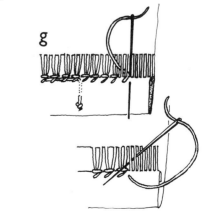

155 The placement of the embroidery upon a fair linen cloth

156 Diagrams showing a mitred corner and ways of finishing hems

157 Diagram of handkerchief hemstitching

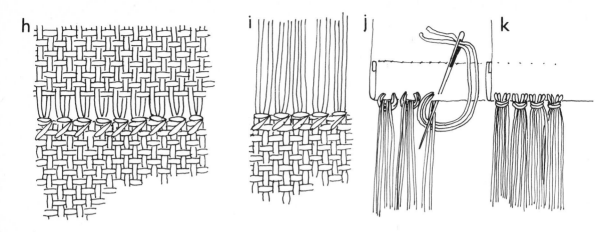

158 Working a hemstitched fringe and needle made fringe

159 Diagram showing the making of a pall

To make a fringe, withdraw three or four threads, and hem-stitch **158**h, at the width of the fringe in from the edge, then, when completed, the remainder of the threads can be pulled out (**158**i). It may be necessary to supplement the threads at the corner. More can be added as shown at **158**j. The stitching is done on the wrong side of the work. This makes an attractive hand-made fringe, as shown at **158**k.

Pinstitching **171** and pulled-stitches make good decorative hems.

A wide hem is preferable for the ends of the fair linen cloth.

Credence cloth

This matches the fair linen. The width, when finished, is that of the credence table and the ends hang down generously.

The pall

When dressing the chalice, the folded purificator is first placed across the chalice; over this the paten (in the diagram this just shows on one side) with the priest's wafer upon it. This is covered by the pall, which is a stiffened square (**159**a). Sometimes a second corporal is used instead. It is folded in three both ways and forms a pall, embroidered with a cross in the centre, and is folded with this uppermost.

The pall is used in the Roman Catholic Church, but not always in the Church of England.

Design

The pall is planned as a part of the set of altar linen. The decoration is generally derived from a cross or the sacred monogram or Passion symbol and is placed centrally. It should be readable, whichever way it faces. Usually worked in white, red or blue can also be used.

Measurements

Usually 15 cm (6 in.), but it can be 10 cm – 17 cm (4 in – 6½ in.) square, depending upon the size of the paten.

Material

Fine white linen; also a square of cardboard, perspex or plastic, for stiffening, which may be covered. Alternatively, folds of stiffened (with starch) linen can be used.

Method 1

This is on the principle of an envelope.

1 Tack out the shape, complete and press the embroidery.

2 Cut, allowing turnings and a lay at one end, and shape the other end slightly inwards, allowing a narrow turning and a little lay to form the flap. Snip as shown in the diagram (**159**b).

3 Remove threads, turn down hems, work the hem-stitching.

4 Cut across the corners of the flap, fold down turnings, arrange the mitres, tack the hem and press.

5 Fold back the side turnings, and with the right sides facing, fold at the base, overcast the sides (**159**c). Turn out, and insert the stiffening, tucking in the flap.

Method 2

Prepare as for Method 1, but without the flap, allowing for a hem with lay at both ends. (If there is to be hem-stitching, withdraw the necessary threads.)

1 Overcast the sides together on the reverse side.

2 Turn down the hem around the opening and hem (**159**d), or hem-stitch. Turn out.

The completed pall is shown at **159**e with the stiffening (which is cut slightly smaller) protruding.

Method 3

A single embroidered square with its edges neatened as preferred, has little buttonholed bars worked across each corner on the back. The covered stiffened square is slipped in, under the bars.

Method 4

1 Take two squares of linen (one embroidered), cut, allowing turnings round each.

2 Fold the turnings back on both sides. Putting the wrong sides together, insert the stiffening between, and overcast around all four sides. When the pall needs washing, one side is unpicked, the stiffening removed. It has to be re-stitched after being washed.

The corporal

The chalice stands on the corporal upon the altar. When not in use it is folded in three both ways and kept in the burse or corporal case. In the Church of England two corporals are occasionally used instead of one, with a pall instead of a chalice veil. It is the most sacred item of church linen, as the consecration of the Elements takes place upon the corporal.

160 Set of linen

Design

The design is planned as a part of the set (**160**). Traditionally but not necessarily, a cross is worked in the centre of one side. The decoration can form a border, or a motif on each side, but practicality must be respected. Some stitches are unsuitable, such as drawn thread work, because particles of the Host might adhere. Highly padded or raised work should not be used, as an uneven surface might cause the chalice to spill its contents. As the corporal has to be folded flatly plan the embroidery with this in mind (**161**a).

Measurements

A square, from 46 cm – 61 cm (18 in. – 24 in.), but usually 48 cm or 51 cm (19 in. or 20 in.) in the Church of England and about 53 cm (21 in.) in the Church of Rome.

Material

White linen of any weight except that which is very heavy.

A second corporal has a central cross and possibly corner crosses or borders, arranged for folding.

A fine cambric or linen lawn corporal, embroidered in white or colour can replace the chalice veil, and is from 51 cm – 61 cm (20 in. – 24 in.) square. Lace was used on altar linen, but is unsuitable.

Method

Complete the stitchery, then, allowing for the width of the hem, plus a narrow lay, cut a square, to the thread of the material.

If it is to be invisibly hemmed down with mitred corners, follow the method already explained.

Any treatment can be used for the neatening of the hem, provided it will wash well.

The lavabo towel

Used for drying the priest's fingers before the Consecration.

Design

There may be a small motif or a cross at the end or ends. The treatment of the hems would usually match the set (**160**b).

Measurements

Generally 61 cm × 25 cm – 38 cm (24 in × 10 in. – 15 in.). Made of linen or diaper.

In the Roman Catholic Church it is about 23 cm × 46 cm (9 in. × 18 in.), or 38 cm or 41 cm × 51 cm (15 in. or 16 in. × 20 in.), and made of linen or diaper. It is folded in three lengthwise.

Method

Make a narrow hem down the long sides, and a wide hem, hem-stitched or fringed, at the ends.

The purificator

The purificator is used for drying the Holy Vessels during the celebration. Purificators are folded in three lengthwise (**160**c).

Design

A small cross or motif in the centre or at one corner.

Measurements

About 23 cm × 31 cm or 31 cm or 36 cm (9 in. × 12 in. or 12 in. or 14 in.) square. In the Roman Catholic church the purificator is usually 23 cm × 46 cm or 33 cm × 51 cm (9 in. × 18 in. or 13 in. × 20 in.).

Material

Linen or bird's-eye diaper. Generally stitched in white, sometimes colour.

Method

Cut, allowing for hems. These are usually narrow along the longer sides and wider or fringed along the short sides.

Communion cloth

Used in the Roman Catholic Church and intended for catching falling fragments of the Sacred Host, therefore the embroidery is restrained. Also called the Houseling Cloth, it is seldom used now. The length depends upon the altar rails, and it matches the fair linen.

161 Corporal designed and made by Honor Redman. White
linen, with blue machine embroidery and hand pinstitching
Derby Cathedral

Altar and credence table dust covers

These are generally made with coloured linen, and are a little larger than the fair linen and the cloth for the credence table. The edges are hemmed.

Or there is a narrow runner, and a wider one covering the remaining width of the altar.

The amice

This is worn as a linen neck-cloth.

Design

A centre front cross, or incorporated in a border. Otherwise one large cross. A detachable apparel embroidered in colour or gold can form part of a set of Eucharistic vestments.

Measurement

A rectangle 61 cm or 64 cm × 90 cm (24 in. or 25 in. × 36 in.), with two tapes about 150 cm (60 in.) long.

In the Roman Catholic Church it is generally 53 cm × 80 cm (21 in. × 32 in.) with tapes 140 cm (54 in.) long.

The apparel is about 56 cm × 7.5 cm or 10 cm (22 in. × 3 in. or 4 in.) wide.

Method

Having completed the embroidery, and hems, attach the tapes below the front edge on either side.

For the apparel, cut the inter-lining to size, cut the embroidered fabric with turnings all round. Then, matching up the centres, place the inter-lining on the back of the embroidery and fold the turnings over, catch them to the inter-lining or stick. Line the apparel. It is attached with large stitches which are unpicked when the amice is laundered.

With the introduction of the cassock-alb, the amice is not now worn.

Altar linen – the embroidery

Designing for altar linen has changed: firstly, by the re-positioning of the altar, and, secondly, the use of machine embroidery.

The concept of the design can be more inventive and the scale altogether larger, because the fair linen becomes an important decorative feature, as it is visible to all when used on a free-standing altar: without a frontal, there is a need for interesting decoration upon the fair linen cloth. Not only is it possible for the interpretation of a large-scale design to be imaginative, but the impact can be enhanced by carrying it out in coloured threads (washable), which has for long been the practice in Europe (163).

The limiting factor in the embroidery of church linen is that it has to withstand frequent laundering. The traditional methods fulfil this requirement, yet are too small in detail unless grouped to use as a filling for larger areas. How well the mediaeval embroideress understood this! The fourteenth-century German frontal (2) is one example, and the Lenten cloth (3) is another. It was the Victorians' insistence upon very closely woven linen which restricted the scale, and led to the predominance of satin stitch. Coarser, textured linens and thicker threads result in the emphasis required for self-coloured stitchery.

The development of embroidery worked on domestic and other machines has extended the scope decoration (164) and it is entirely suitable for church linen provided that it launders satisfactorily. Specialised machines add to the possibilities.

The combination of hand and machine embroidery techniques is interesting. For example a cloth of fine linen was kept taut in a frame and the stitching was carried out on a zig-zag machine with DMC Retors d'Alsace no 50, to give an open texture. Whip stitch was chosen to interpret the drawing. The star stitch on the Elna Supermatic was worked in a small area. The hand stitches included Roumanian (170g).

The very essence of white or self-coloured embroidery is to produce contrast by juxtaposing raised surfaces with cut-away holes, and textures with semi-transparent areas of stitchery. A raised shape will form a shadow: this can be achieved in various ways and with stitches such as padded satin stitch (169r), trailing (170f), raised stem or chain band (169h).

Shadow was produced by entirely different means on the decoration for the chasuble (165), which is part of an off-white set, designed with the intention that the play of light should enhance the effect with movement when worn. To make the decorative orphreys three 23 cm (9 in.) strips of fabric were used. Three rows of pintucking were worked by machine either side of the centre line, using pintuck foot 028 and a double needle (machine used was a Bernina 830E). The gimp for the tucking was Retors à Broder, and some DMC. The stitching was in Sylko (165A).

The fabric for the piping was prepared first on the right side of the fabric with feather glue to prevent fraying. The reverse of the fabric was used as the right side, for the rouleau strips made round no. 3

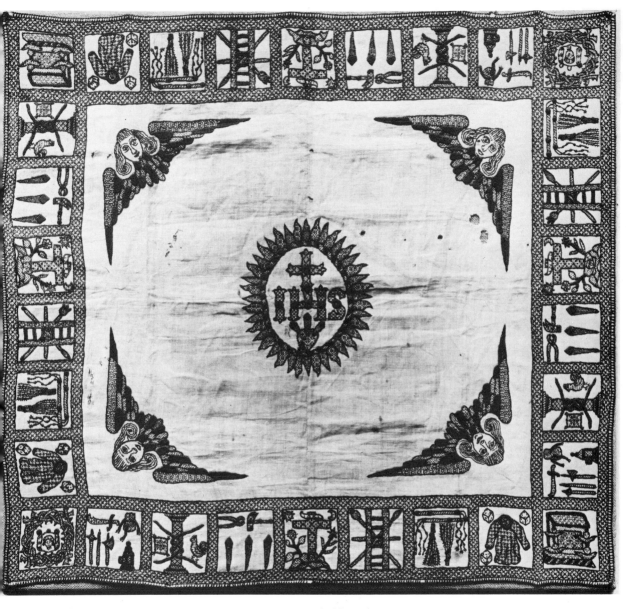

162 Chalice veil with border of symbols of the Passion and central motif of cross, I H S and heart with nails. The embroidered fillings are composed of fine counted thread patterns
Victoria and Albert Museum, London

piping cord which was left in the tube. The edges were trimmed to 3 mm ($\frac{1}{8}$ in.) and two strips were placed either side of the tucking with their raw edges touching. A ladder was worked across the narrow gap between the cords in coton à Broder, DMC. Two rows of raised chain-band were then worked on this ladder using Twilley's 'Crisette' Super Cotton no. 3 in self-colour.

The 23 cm (9 in.) wide lengths of embroidery were then stretched and mounted on vilene. Small crosses were worked up the centre of the pin tucking at 9 cm ($3\frac{1}{2}$ in.) intervals.

An orphrey was slip-stitched down the centre front and back of the chasuble and the third and fourth pieces were cut and fitted into the centre back orphrey to form the traditional cross.

The chasuble was mounted on sanforised calico (to add weight to the fabric) and lined with curtain

163 Altar linen, one set from Cologne worked with muted green stranded cotton. Another, also from Germany is all white, and the pall is worked in black and grey, and is from Spain

164 *Opposite* Altar cloth for St Katherine's Chapel, designed and made by Honor Redman, 1978. Machine embroidery on cotton twill, beige-pinks and gold on white
The Cathedral Workshop, Derby

lining in order to prevent the garment slipping whilst in use. The neckline was piped and faced.

A strong decorative effect can be achieved by cutting away shapes, as these areas then show in strong contrast: Richelieu, Broderie Anglaise and drawn thread work carried out by hand or machine will give this result, whether used exclusively or combined with other stitch treatments. The characteristic of Richelieu lies in the cutting away of the background, therefore these shapes need to be good in themselves, and not too large: where needed, decorative bars, with or without picots, are worked across for extra strength (166). One method of working the bars is shown at 166a. Put a running stitch round the outline, work small buttonhole stitches from left to right, with the heading towards the edge to be cut. When reaching the position for a bar, take a stitch into the other side and return on the surface, as 166a. Repeat, but either whip or buttonhole-stitch back, as at 168b over the three threads, finishing in a position to continue the buttonhole stitching on the edge. When complete, cut away the areas of the background as at 166c.

An embroidery technique whereby the pattern is composed of eyelet holes which are cut away, is known as Broderie Anglaise. This is very adaptable and well suited as a filling for large shapes; and, because it launders easily, can be included with other stitches or used to carry out a motif entirely, as at (167). The eyelet holes should be as large as practicable in order to show to advantage, and the material must be closely woven – the method of

working can be followed from the diagram 167a. Outline the shape with small running stitches 167b pierce with a stiletto for a small eyelet, or, as at 167c, cut down and across from the centre for a larger one. Turn back a section at a time, and, using the same working thread, closely oversew through the double material. Fasten off at the back or carry the thread to the next hole. Cut away the turnings on the wrong side.

Before starting a drawn thread filling work small running stitches around the shape with outline and over this do buttonhole or whipping. To have the material fairly loosely framed up whilst drawing out the threads and taut for the stitching, is an advantage. The lace fillings become more transparent when a greater number of threads are withdrawn: the whipped foundation and patterning are worked with a twisted thread, a fine lace or linen thread being preferable, or cotton. For the basic foundation any given number of threads are withdrawn each way, generally two or four, and leaving in two or four threads. These are whipped in both directions (168a), and form the foundation for several lace fillings, or they can be solidly overcast, lightly whipped or left without whipping.

This variation of *chequer filling* is usually worked on the right side of the fabric with 4 threads withdrawn and 4 whipped, both ways, using a fine thread. It is worked in four stages diagonally across the mesh, in both directions, starting at 168b, and returning, as at 168c. Next, work a row of the whipping stitches across the first rows as at 168d, and return, crossing these as at 168e. It is usually worked on the right side of the fabric.

Using the same foundation, the density can be varied by changing the spacing and number of threads withdrawn, as can the size of the little woven 'whirls' (174, 168f). For another variation shown in the diagram, a lace knot is made on the wrong side to keep the threads bunched together (168g). At 168h wave filling is worked from the right side, from right to left. The needle is taken under 4 threads and down over 4 horizontal threads, then 2 vertical threads from the original group and 2 new ones are picked up. This is repeated and can be followed from the diagram. It will be seen that this is a pulled stitch.

Semi-transparency can be produced with the pulled stitch fillings. For this a fairly loosely woven linen is necessary, with a fine strong thread and a tapestry or canvas needle.

168i *Squared ground* stitch is typical of this group. It is worked on the reverse side. Start at the point marked with an arrow, then take the thread diagon-

ally across 4 threads in both directions. Next, put the needle under 4 threads from right to left: pull through and return back over 4 and downwards under 4, and back to the commencement. The next row is also worked from left to right. The appearance on the right side is also shown.

168j *Algerian eye* stitch, with 4 threads of the linen in each direction. Take a whipped stitch from the corner into the centre, then, leaving two threads, make another stitch from the outside into the centre, and come out in the next corner, etc.

168k *Eye* stitch. The process is similar. Work the 16 stitches from the outside into the central hole over 4 threads, with 2 between the stitches. Then 4 back stitches on each side form the square. They can be worked so that they touch on all sides, or spaced at random.

Some of these stitches have been used most satisfactorily for the embroidery on the stole (173). 168l *Barred buttonhole* wheel is composed of 16 stitches. The first 4 are worked into the same hole, then one thread is missed, and the next 4 are worked

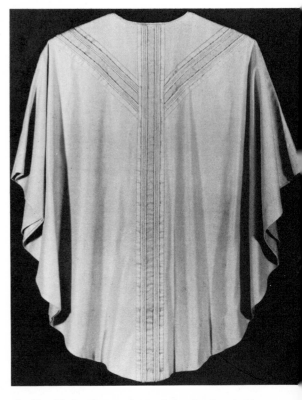

165 Chasuble (back), part of a set, designed and worked by Pat Wright. Hand and machine embroidery
St Mary's Gillingham, Dorset
165a *Opposite* Detail

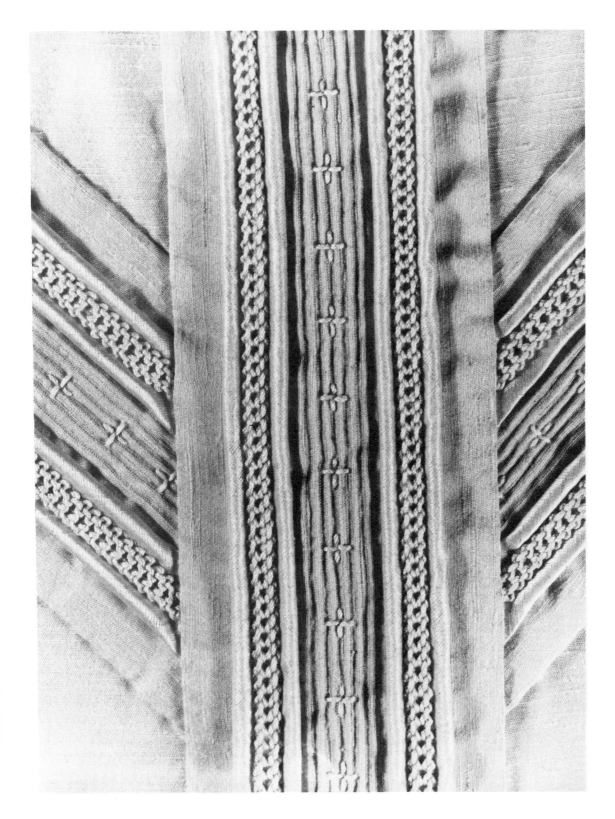

166 Richelieu, the background is cut away

into the hole, miss another thread and work a further 4, etc. If preferred, 2 threads in each direction can remain. Stem stitch can encircle the first row of whipping stitches.

168m *Drawn square* is yet a further development. It fills a square of 12 threads of the fabric in each direction. Start by overcasting the outer 3 threads all round the square. It will be seen from the diagram that the first 4 of these stitches pass into the same perforation at the corner on their inner side; but on their outer side, each stitch has a thread of ground fabric between it and the next. The following 6 overcast stitches are taken so that on both sides they have a thread of ground fabric between each one, and the next. The remaining stitches are worked like the first ones. The overcasting of the circle in the centre is treated in much the same way.

168n These slightly raised squares are worked from the wrong side of the fabric using *double back* stitch, and pulling the thread fairly tightly. They are stitched in both directions. For an all-over filling, threads between the squares can be withdrawn to give a more open effect. Or the squares can be worked individually at random. An even number of stitches must be worked on each side of the square, generally over two threads of fabric. This stitch is attractive when worked on transparent material, as the squares are opaque.

Solid fillings

169o To this group the many *all-over satin*-stitched counted thread diaper patterns belong: it is possible to break up the regular spacing if necessary. DMC (Red label), cotton floche or any thread which is not tightly twisted should be used for the best effect (**169o**).

169p Massed *French* and *bullion knots* give a complete contrast to more open stitches. The working can be followed from the diagram.

169q *Seeding* produces an alternative. For this a small back stitch is worked, then another over it.

169r Sometimes *raised satin*-stitch gives just the emphasis which is needed. The best result is obtained by working tiny running stitches or split stitch around the outline, and filling in with herringbone or chain stitches for padding, but when worked in a frame there are three stages – first a few laid stitches in the centre, followed by some which cross them at right angles, with final padding stitches crossing these, and being taken up to the outline. It is important that these stitches should remain on the surface, with tiny stitches only on the reverse side. The satin stitches are worked over this, either diagonally or at right angles.

169s *Morris darning*. Here two stitches are worked over 4 threads of the fabric, with a space between the

146

167 Broderie Anglaise,
composed of eyelet holes

168 Drawn thread and pulled work fillings

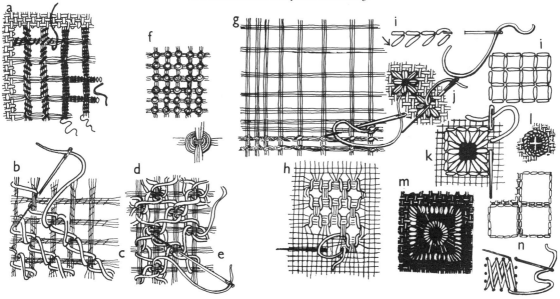

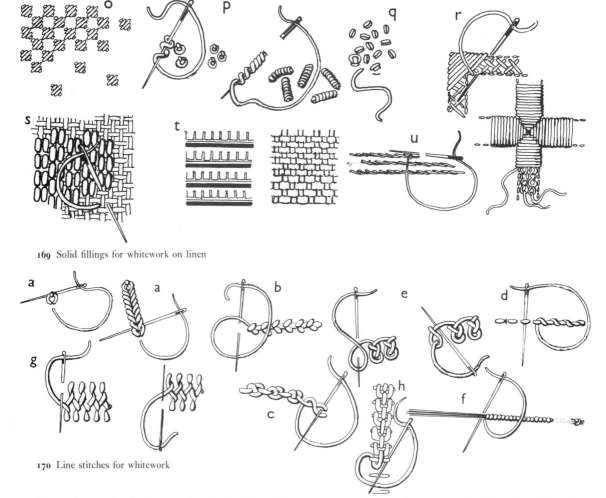

169 Solid fillings for whitewerk on linen

170 Line stitches for whitework

first and second stitches equal to their width. The alternating stitches are bricked with these, as shown in the diagram.

169t The many variants of *buttonhole fillings* and *surface buttonhole* are also useful.

169u Rows of *stem* stitch repeated give a pleasing texture.

Outline stitches

The following is but a small selection of the most useful stitches. By using thick untwisted cotton, fine sewing or stranded cotton, the appearance of these stitches can completely change.

170a *Heavy chain* gives a usefully broad flat line which is very adaptable. Start with a little running stitch, bring the needle out as for another stitch and go back through the first, come out ahead again, and for a second time return through the first running stitch. Now bring the needle up ahead and always

return through the second stitch back, as shown in the diagram.

170b *Coral* stitch is worked from right to left. Having put the needle into the material, bring it out at right angles to the line. Then, with the thread twisted round, and with the thumb of the left hand kept over the stitch, pull the needle through. The intervals between the stitches and their width can be varied.

170c *Double knot* stitch. Work from left to right, make a small slanting stitch, the needle and working thread slip under the short stitch just formed, and now lie on the material. Then for a second time the thread slips under the same stitch, working this time after the manner of buttonholing. The thread must be pulled taut at each stage.

170d *Whipped running* stitch. First work a row of running or back stitches, which are then whipped.

170e *Rosette chain* is more effective when worked

b a

d c

171 Diagram of pin stitching

with a thick thread. Bring the thread up on the right-hand end of the line, pass it across to the left and hold it with the thumb. Put the needle into the fabric and bring it up through the loop formed by the thread and pull it through; this is shown in the first part of the diagram, and in the second the needle is seen passing under the thread to the right. This process is repeated.

170f *Trailing* is essentially a white-work stitch, and it has to be worked in a frame. For the three padding threads, knot the end and bring them up at the commencement of the line. With the finer working thread, make tiny satin stitches over the padding threads to cover them entirely.

170g *Cretan* stitch is useful because both its width and spacing can be varied. It is worked from left to right. When the stitches are worked close together it becomes *Roumanian* stitch.

170h *Raised chain band* is another decorative stitch. The transverse stitches which form the foundation are worked first. To start, bring the needle up at the top, above the first transverse thread, then the thread is passed once round the bar of the centre and comes up again above it, on the left. Next a looped stitch is made as in the diagram. This is repeated.

An embroidery technique which can be used for the decoration of altar linen is appliqué, whether carried out by hand or machine (**172, 175**). It is considerably stronger if it is worked as blind appliqué (ie with narrow turnings on the outside edges). The areas to be applied must not be large, and the grain of the material must correspond to the background linen. Slip-stitching or hemming are

used for attaching the pieces; but the strongest and therefore the most practical way is to work pin-stitching. For this a very fine thread and a needle, size 7 or 8, is used. It is stitched on the right side for appliqué, and is commenced on the right-hand side towards the left, as shown at (**171**).

To introduce contrast, an opaque and more closely woven linen can be applied to a background with a more open weave. An example (**175**) shows the effect of applying fine fair linen to a hand-woven linen. This was specially woven in order that the inclusion of drawn and pulled work would be possible.

Washing altar linen

Where the amount or intricacy of the embroidery makes special care and hand-washing essential, dip the work up and down (dunking) in hot water and soap flakes, or a detergent which is not too strong. Do not rub or squeeze. Rinse quickly and put the work face down on a well-padded surface which has over it two layers of clean dry cloth. Cover the reverse side of the work with another cloth, and dry it off with a hot iron.

Altar linen is usually ironed when wet, on the wrong side, over several layers of thick blanket and a clean cloth.

When embroidery has been worked in a frame, cover the back with a damp cloth and press (whilst still in the frame) with a hot iron.

Using several layers of blanket or felt and a clean cloth, embroidery which is not puckered can be put face down and pressed, using a damp cloth.

Work which is clean but puckered can be pinned out, with the grain of the material straight down and across. First cover the drawing board (or wooden surface) with layers of blanket and a clean cloth. Put the work face down, and stretch it out, pinning the edges with drawing pins (thumb tacks) as for stretching. Thoroughly dampen the whole and leave to dry for twenty-four hours.

Surplice, cotta
(**176, 178**)

Any type of washable embroidered decoration which is suitable can be adopted.

Material

If drawn thread borders are to be worked – linen, moygashel or any of the man-made fabrics resembling linen in appearance.

The cotta has to a great extent been replaced by this

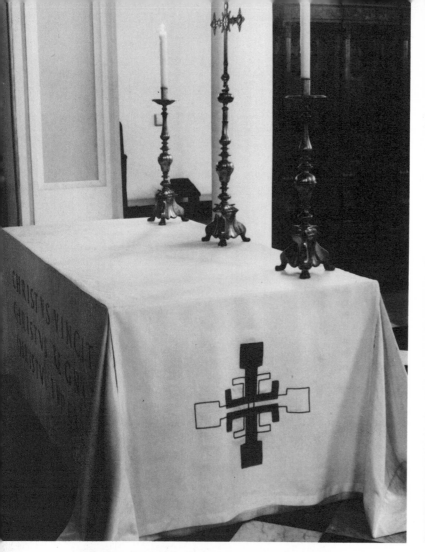

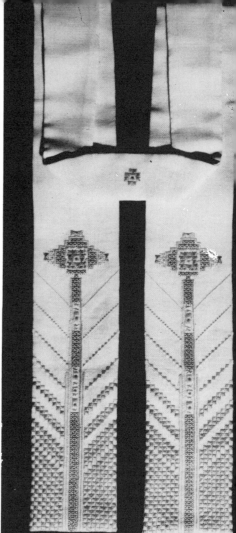

172 *Above left* Altar cloth for the high altar. Design and embroidery by Liz Wilson and Audrey Bennet. Line appliqué and embroidery shades of red and maroon with bright gold linen appliqué
Derby Cathedral

173 *Above* Festal stole, designed and worked by Mary Hamilton Fairley. The counted thread patterns are worked in satin, rice, four-sided and eyelet stitches

174 *Left* Detail from a fair linen designed and embroidered by Hilda Bailey. Worked on coarse linen with thick threads

surplice in the Roman Catholic Church. In the case of the cotta, the shape is the same as the surplice but it is shorter. It is cut longer when intended to be worn as a surplice.

Method

Cut 2 front and 2 back yoke pieces. The width of the yoke depends upon the chest and back width measurement of the wearer.

175 One end of a fair linen altar cloth, designed and worked by Beryl Dean, 1965. Hand woven linen embroidered in various white work techniques and appliqué

Decide upon the length, longer for the surplice, or about 92 cm (36 in.) for a cotta. Add the width of the hem. Shape for the armhole (178a).

Cut 2 lengths which are the full width of 122–132 cm material (178a).

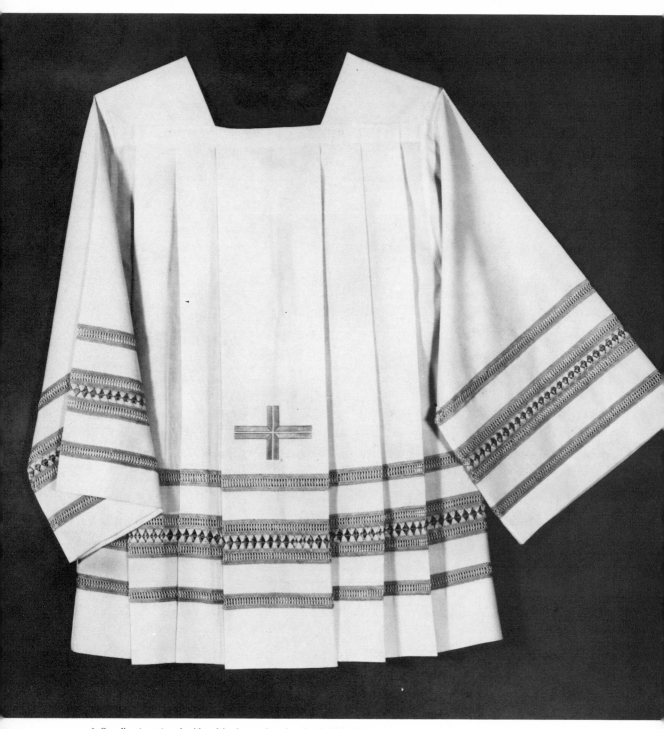

176 Surplice (cotta) embroidered in drawn threadwork stitched with grey

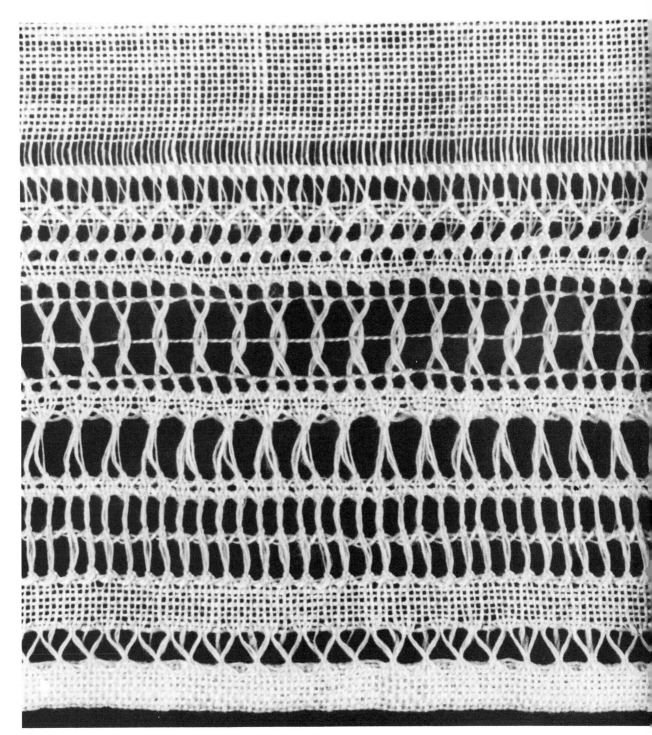

177 Drawn thread work sample by Lynne Stoke, 1979, Manchester Polytechnic

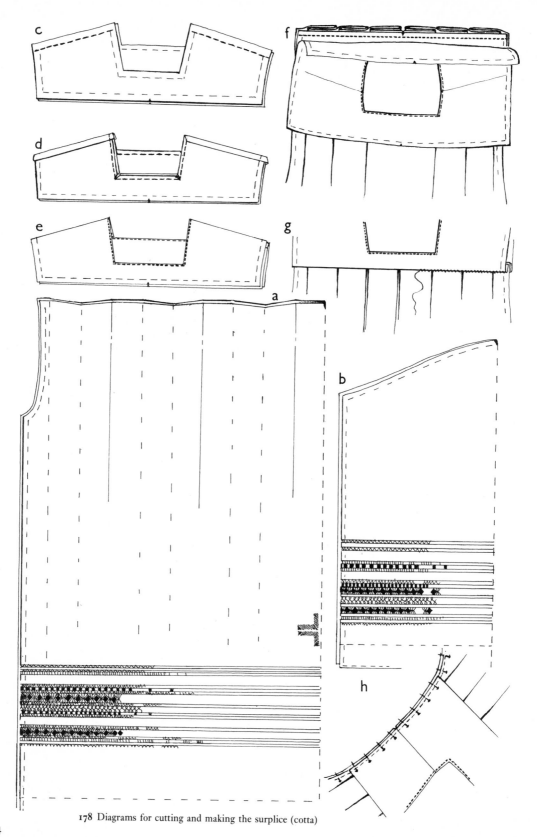

178 Diagrams for cutting and making the surplice (cotta)

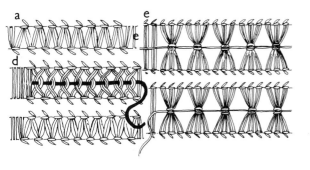

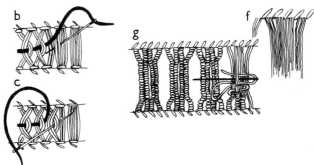

179 Diagrams for working drawn thread borders

For 2 sleeves, divide the width of the fabric in half, and cut and fold in half again. The width of the hem is added to the length required. Curve the top as shown in the diagram 178, 179 (b).

Join the front and back of each yoke at the shoulders (178c).

Put together the right sides of both yokes, snip into the corners and stitch round the neck (178d).

Turn out, stitch round the neck on the right side (178e).

Mark the centres of the front and back skirt pieces, and make three pleats on each side facing outwards from the centre (178a). Tack and press.

It is more convenient to work the drawn thread borders (177) at this stage, although the joining can be made more accurately if the embroidery is worked after the side seams have been completed.

Place the right side of the yoke to the right side of the skirt piece, tack and stitch (178f). Repeat for the back.

Fold the lining of the yoke over onto the reverse side of the skirt and hem (178g). Repeat for the back.

The measurement of the curved sleeve top should equal that of the slightly shaped armhole.

With the right sides together, for an open seam, or reverse sides together for a french seam (68.5), match up the centre of the sleeve with the shoulder seam of the yoke, pin in place, very slightly ease the sleeve and fit it into the armhole. Stitch (178h).

Next, match up the drawn thread borders and the armhole seams, join together the side seams in a continuous line from the sleeve-end to the bottom hem.

Turn up the hem at the bottom and on the sleeves. Work the final row of hem stitching. If french seams have been worked, the seam at the hems needs manipulating.

Open-work borders

The effect of these open-work borders can be heightened by working with a grey thread and by incorporating other stitches.

For chevron hemstitching (179a) 4 threads are grouped, and for the second row, 2 threads from each group are stitched.

This open-work border is worked by withdrawing the required number of threads, and hem stitching groups of an even number of threads; the same on both sides. From left to right, with a fairly thick working thread, divide the vertical clusters equally. Then insert the needle from right to left under half the threads of the second cluster (179b). Then, by another movement, bring the eye of the needle back from right to left, picking up half the threads in the first group, (179c). The working thread is then passed under and in front of the threads from the first cluster. This is shown at 179d.

For the open-work border (179e), draw out 12 threads twice, leaving 4 threads in between. Hem-stitch in groups of 2 threads, secure the working thread on the right-hand side, and make 3 back stitches round every 3 clusters. At the third stitch, slip the needle under the first 2 to fix the thread. This is known as faggot stitch.

There are many variations of darned insertions. They are worked on the same principle as the insertion shown at 179g. For this example, withdraw 20 threads. Then overcast both edges with stitches taken over 3 vertical and 3 horizontal threads, (179f). For the open-work, twist the thread six times quite tightly round the first cluster of 3 threads; then take it up to the edge. Pass on to the second and third groups and cover them with 6 darning stitches, succeeded by 12 stitches on the first and second clusters, until there is only enough space left uncovered for the 6 overcasting stitches. The second part is worked to match in the opposite direction.

CHAPTER VII
Churches of the East and West using vestments

Protestantism

The Church of England

The following are some of the events in the history of the Church of England which serve to explain – albeit in an oversimplified form – the development of the background to the Church's vesture.

Until the middle of the sixteenth century (when Protestantism, the movement against the supremacy of Rome, began) this history forms a part of the Church of Rome. The earliest roots are mainly Celtic and isolated areas of Britain were evangelized by Saints Columba, Cuthbert, Augustine (at Canterbury) and others, the relationship with Rome remained close, though somewhat intermittent – mainly from the thirteenth century there is recorded evidence testifying to the excellence of the embroidery which came to be identified as *Opus Anglicanum*; there are references to Popes stipulating from Rome the desire to acquire gold-embroidered vestments of English workmanship.

The Mass was the heart of mediaeval religion, for which eucharistic vestments were worn. The priest, when celebrating would wear a chasuble, and had his back to the congregation, as the altar was placed against the wall at the extreme east end, and the congregation could not see what was happening. This was the time when the great Gothic cathedrals were built and the spirit of the age found expression in art – the subject matter of the decoration embroidered upon the vesture was mainly narrative, as was that of the frescoes which the peasants and others could see in splendid colours on the walls of their churches, showing scenes from the scriptures.

Towards the end of the fourteenth century feelings of unrest stirred, there was the great Schism, and at almost the same time Wycliffe attacked the papacy itself having witnessed the bishops' neglect of their ecclesiastical duties. Papal indulgencies and relics were hawked about, mainly by friars, and in addition the Black Death not only weakened the state of the Church in England but was a contributory cause of the decline in the standard of ecclesiastical embroidery at that time.

Relations fluctuated between Henry VIII, the Church and the Pope, its head and supreme judge. With the spreading influence of the Reformation the monasteries gradually declined, following centuries of splendid work and great leadership in many fields.

In the sixteenth century the Reformation shattered the unity of the Western Church. The reaction in several parts of Europe was to break free from the domination of Rome, influenced by Luther. But in England the effect was different. Henry VIII took to himself both temporal and spiritual power; this supremacy which the royal leadership implied was an innovation in Christendom, as the functions of the Pope were accumulated upon the monarch. Apart from his personal reasons the king desired to acquire the monastic wealth, but it was their lowered standards which he gave as his reasons for the dissolution of the monasteries. Thus it was that the Church of England was established. Although in the first English Prayer Book of 1549 it was appointed that vestments should be worn, by the end of the reign of Elizabeth I only the cope for cathedral wear, and the surplice were in use. The church treasures and vestments were despoiled or converted for secular use—this is evident from the inventories of Bess of Hardwick and other sources.

In England the party known as Puritans rebelled against the prescribed church order. They would not admit any authority in religion not based upon the Scriptures and rejected the use of vesture associated with Rome – whilst adherents of Rome vainly tried to obtain sanction to attend services. Those who secretly attended mass were imprisoned. It is to these families who hid away vestments and to nuns such as those who treasured the Syon cope (Victoria and Albert Museum) that we owe many of the examples of church embroidery which exist today, of which a later example is 182.

The traditional wearing of Eucharistic vesture has continued throughout Italy, most of France, Spain, Flanders and other countries.

The Renaissance church architecture in England

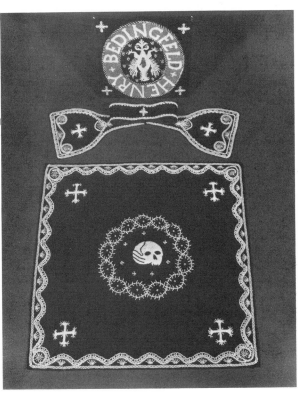

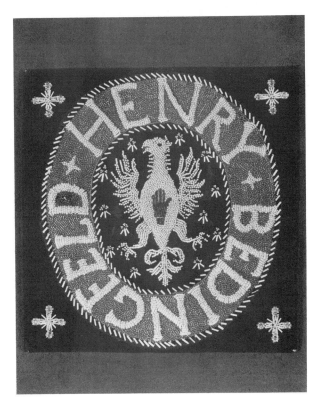

180 Burse, veil and stole belonging to the Bedingfeld family. Embroidered mainly with white and grey beads, the head in red beads stitched onto black velvet
Oxburgh Hall, Norfolk

180a Burse

allowed for a greater participation in the worship due to the basically rectangular plan: typical of its classicism was the increased amount of daylight. In general the protestants were to attach more importance to the pulpit than to the altar, which at this time took the form of a table.

Although the Puritans were offended, Archbishop Laud introduced more ceremonial; his name is associated with the throw-over frontal for the communion table, and also a type of draped pulpit hanging, an example of which remains at Staunton Harold chapel. The design which was most typical consisted of a sacred monogram, surrounded by a sunburst of rays generally embroidered in metal threads upon dark crimson velvet. The Axbridge frontal (181) is not only interesting in itself but is valuable in depicting a contemporary communion table. Although at this time copes were not generally worn, two of five which have survived are kept in the treasury at Durham Cathedral. Much ecclesiastical art and many embroidered vestments were destroyed by Cromwell. Consequently, at the Rest-

oration four sets of copes (182) had to be made for the coronation of Charles II, most are still used for special occasions at Westminster Abbey. One outcome of the Civil War was a move towards greater religious toleration as the influence of the Puritans declined. After the reign of Anne the Free Churches flourished, although the activity later declined except for the interest shown in the preaching of John Wesley and the formation of the Methodists.

From 1830 onwards the great revival of religious feeling and many reforms were brought about by the Oxford Movement resulting in the encouragement of the high church ritualists who increased the use of eucharistic vesture, and by 1860 the Anglo-Catholics had elicited a religious emotional fervour not witnessed since Wesley.

During this period altar frontals and dossal hangings were embroidered by amateur ladies for their local churches; they have an individuality and are interesting.

Dr Percy Dearner, in the *Parson's Handbook* of 1899 defended a moderated mediaeval ritual as 'The

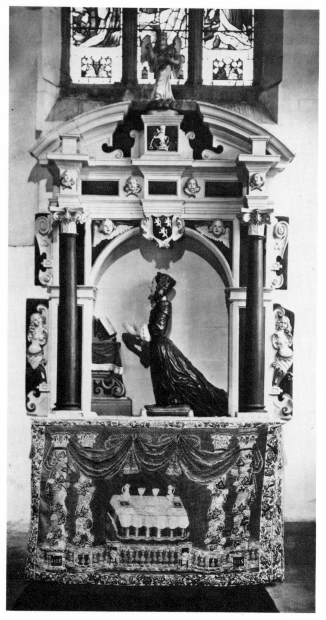

181 Altar frontal at Axbridge Church, Somerset. Begun in 1720, it is worked in cross-stitch and shows an altar of the time

English Use', and this links up with the Gothic revival in architecture with which the names of Pugin and Lutyens are synonymous, and in the decorative arts generally. This influence continued in an outworn form until the second quarter of the twentieth century; then the new liturgical movement in church architecture and the Arts on the Continent brought about a revival of interest in creating a lively approach to design for church embroidery.

One aspect of the present liturgical renewal is the relation of the altar to the congregation, and the space to contain them; this problem has been worked out in many new ways. In most places of Christian worship the free-standing altar and the re-arrangement of the furnishings has led to changes in the shape and decoration of vestments and the introduction of banners and pennants to give colour – these are of particular interest. The present ecumenical renewal emphasises lay participation and involvement which is the challenge underlying the importance of communicating through all forms of artistic expression.

Presbyterianism, the Church of Scotland

Christianity existed in Scotland by the fifth century. There are two known missionaries, Ninian, who settled in the south west at the end of the fourth century and Columba, who settled in Iona in 563. Until the Reformation, Scotland was a Catholic country like the rest of Europe.

The Reformation was established in 1560, having been triggered off by the preaching of John Knox, who had returned from Geneva. It was Andrew Melville who carried it forward into Presbyterianism fourteen years later. Both men were adherents of the Calvin doctrine.

The primary requirements of the reformers were that 'The Word' should be preached and the Sacraments administered. In the last hundred years there have been many developments in worship, the most important being a renewed emphasis on Holy Communion.

'For services', writes Margaret Forbes, 'Ministers of the Church of Scotland wear a black cassock with a girdle or cincture sash and a white linen clerical band'. Over this is worn the 'Geneva' robe with degree hood and a preaching scarf. Both robe and scarf, originally outdoor garments, are usually black though nowadays sometimes dark blue. The scarf is long, almost the same length as the robe, often embroidered and has serrated ends (183a). Some ministers wear a preaching stole instead of a scarf (183b). No other vestments are used.

There are no regulations governing the use of embroidery in the church, nevertheless embroidered items are few, being confined to pulpit falls (184, 185), lectern falls and bible markers. Some churches have sets in the liturgical colours, white, red, purple and green or blue.

The colour of cloths or scarves for the com-

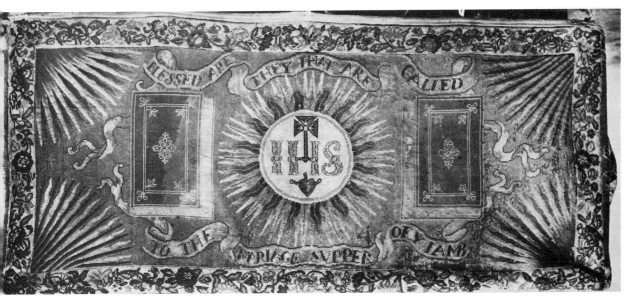

181a The top of the Axbridge altar frontal

182 *Below* One of a set of copes made at the time of the Restoration, for Westminster Abbey. Embroidery in silver on a purplish black velvet

183a, b Diagram showing the scarf and the preaching stole

159

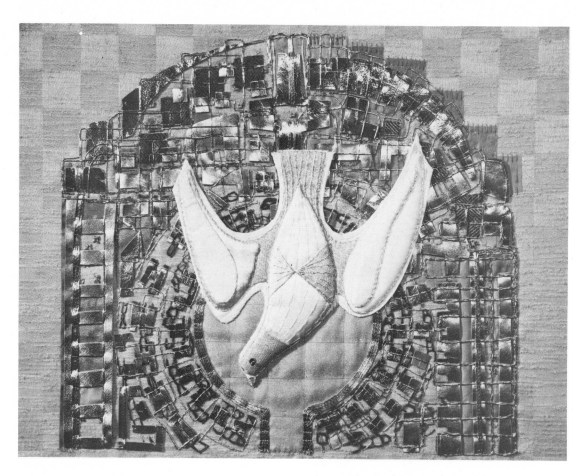

184 Dove pulpit fall, designed and worked by Kathleen Whyte, 1971. The 'Holy Spirit breaks through the bounds of church building'. The background is pink/orange checked fabric like a Pictish wheelhouse as part of symbolic building in gold and copper kid with Jap gold
Gourock Old Parish Church

munion table depends on the setting and varies from church to church. The scarf, left on the table all the time, lies along the centre and hangs down each end. The cloth may be fitted or of the draped Laudian frontal shape (187, 301).

Hangings for specific locations (124, 127) are used, such as at the back of the pulpit or in the vestibule. Kneelers, chair seats and cushions are occasionally to be seen. There are no frontals, burses, fair linen, etc, nor any Mother's Union banners.'

Much of the new commissioned embroidery in Scottish churches has been created by Kathleen Whyte (184, 186 and 187), and Hannah Frew Paterson (185, 124) and their students at Glasgow School of Art. As Kathleen Whyte has said: 'In Scotland the Reformation swept all visual art from the churches. A break in tradition, however, need not be a bad thing. Today the designer goes for inspiration directly to the Bible, taking account of the particular church and the needs of the people and has no occasion to follow any outmoded tradi-

tion'. This work has had an immense influence upon church embroidery, it is to be hoped that it spreads in the United States, where Presbyterianism is strong.

The Protestant Churches

Led by Luther in the sixteenth century, the protesters formed themselves into bodies which became (apart from the Anglican Church) Methodists, Baptists, Congregationalists, Presbyterians and Lutherans*. Within these Protestant Churches there is a degree of freedom in regard to the wearing of sacred garments: vesture tended to be confined to

* Vestments, including copes were laid aside because of their fear of popery.

185 'The Heart' pulpit fall 51 cm × 66 cm (20 in. × 26 in.)
designed by Hannah Frew Paterson. The design is worked on
a pale lilac silk background and is based on the human heart,
while the surrounding area symbolises the lungs or the 'breath
of Life' radiating outwards from the Cross. The outer shapes
are made of varied shades of green, purple and gold silk,
while the central shapes are different kinds of gold fabrics
used three-dimensionally, surmounted by a gold leather-
covered Cross of triangular section
Mansfield Parish Church, Kilwinning, Ayrshire

186 Commemorative pulpit fall 'Arms of Gourock'
51 cm × 36 cm (20 in. × 14 in.), designed and embroidered by
Kathleen Whyte, 1976. Presented by the Town Council on
the occasion of the change in local government. The arms, by
repetition and increasing tone, are receding. The silver boat
represents the church. Strong heraldic colours on brick red
silk background *Gourock Old Parish Church*

the black gown of academic or judicial attire. Only
certain groups of Lutherans have any fixed customs
which vary according to national origins; but it is
they who generally wear the cassock-surplice as do
Episcopalians. Although Calvin refused to rule in
this matter, the black gown, the academic insignia, is
generally worn by Calvinists.

Vestments are not used by the denominations of
the Baptists and Congregationalists as their view of
ordination is strictly functional; and the Society of
Friends has no ordained officers.

The Methodist Church grew out of the Church of
England in the early eighteenth century, and was
founded by John and Charles Wesley. Special
emphasis is laid upon participation in the sacrament
of The Lord's Supper, with the altar seen as The
Lord's Table. Practices vary concerning the wearing
of the preaching gown, which continues to be that of
the Anglican clergy of Wesley's time; sometimes it is
the cassock with bands, but most often the gown is of
the Geneva pattern, and is black and heavily
gathered, having very wide sleeves.

The southern part of Germany and also the
Rhineland are mostly Catholic; in the north
Lutherans predominate, therefore gowns with tabs
at the neck are worn, and pulpit falls with matching
bookmarks for the lectern are used. These are either
woven or embroidered, the design being modern;
the whole constitutes a work of interest, the same
applies to the 'runner' which is placed across the

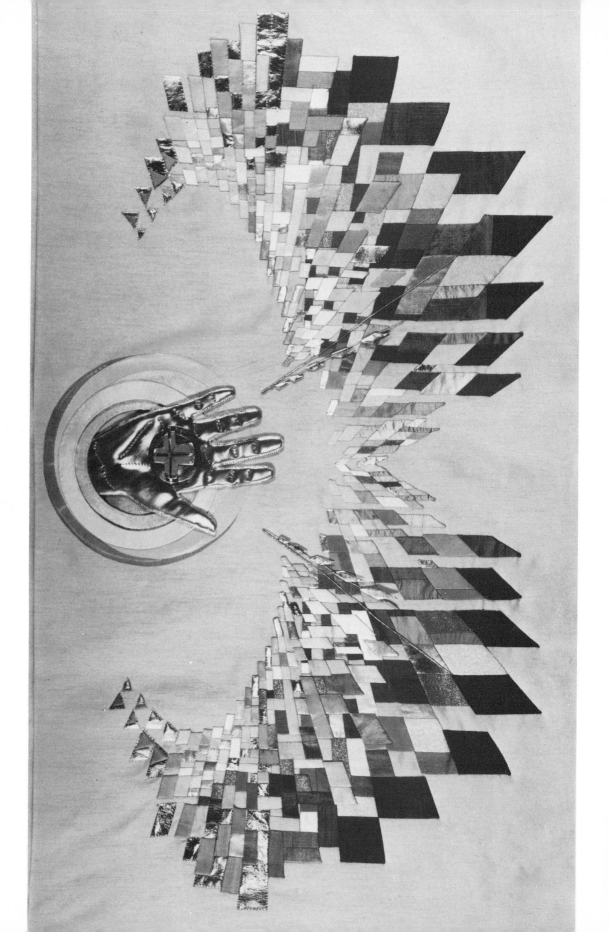

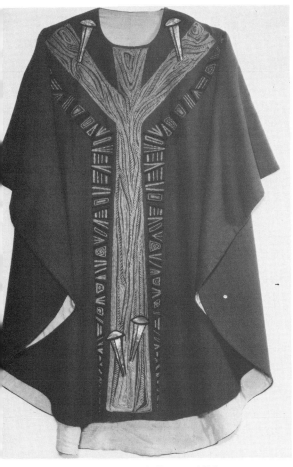

188 Chasuble by John Baptist Duster of Cologne
Presented to St Matthew's Church, Wigmore, Kent by the Parish of St Nicolai, Dortmund

189 'Angel', designed by Eva-Maria Boenke, of Munich, and embroidered by her with synthetic threads and worsted or woollen yarn on linen

altar, to hang down in front and, made in the liturgical colours, it replaces the conventional frontal. The technical information given elsewhere applies, but it should be noted that the altar in a protestant church is usually narrower.

This is a time of change, and of new creative thought concerning vesture. It has been written 'a result of this cross-denominational development has been the emergence of the alb and stole as a suitable alternative to the full priestly array of Catholicism on the one hand, or to the black gown of Protestantism and the cassock-surplice of the Episcopalianism and

187 *Opposite* The Mayfield Cloth 90 cm × 152 cm (36 in. × 60 in.), designed and worked by Kathleen Whyte, 1972. Converging on the Hand of God, it symbolised the feeling of people coming together. The background is pale golden putty with purple, copper, scarlet and salmon pink applied, also gold.
Mayfield, Edinburgh

Lutheranism on the other. The alb is also appearing in Calvinist Presbyterianism'.

Not only in Germany (**188, 189**) but also in France, the Scandinavian countries, Holland and Belgium the artistic standard of ecclesiastical embroidery is of a very high order. The designs are imaginative and forward-looking and interesting not only for the decorative qualities but also for the creative use of fabric. Hand-woven materials of varied textures are produced for this specific purpose, and because of this co-operation they are planned to integrate with the form of the vestment and its ornamentation. This excellence carries right through much of the commercially produced work in various media, intended for religious use. It is splendid that really good examples of modern embroidery are being created for the church of today. Perhaps it is not surprising that the vestments, etc, being made in

163

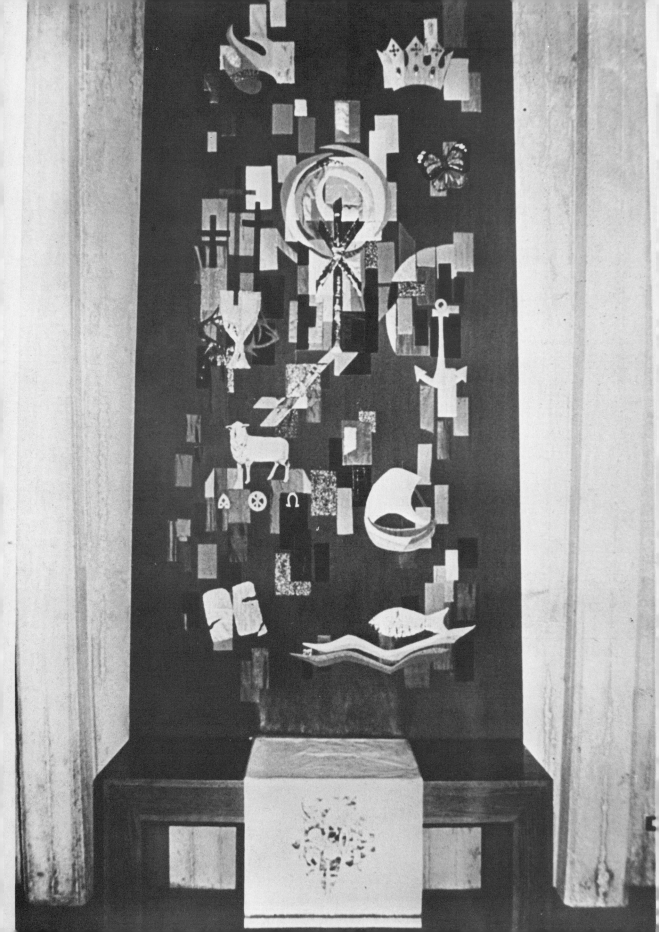

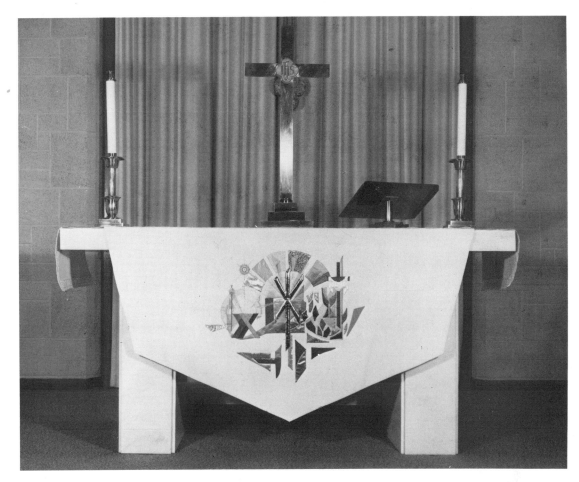

191 Altar antependium designed by Marion P Ireland for Grosse Point. *United Methodist Church, Grosse Point Farms, Michigan, U.S.A. Photographs: Terry Radloff*

many convents should also be outstanding both in design and execution.

In the United States, forward looking design for hand and machine embroidery is to be found, examples are the large hanging by Marion P Ireland for the United Methodist Church of Garden Grove, California, USA, (**194**), and the work of other artists such as Anna Crossley, but much is still traditional.

The American Episcopal Church

Following the Reformation, and by the reign of Elizabeth I, the Church of England was established. It had survived the hostility of Rome and the attacks

190 *Opposite* The Resurrection Hanging 365 cm × 167 cm (12 ft × 5 ft 6 in.), designed and embroidered by Marion P Ireland, 1976. The background of this hanging is dark green on which are applied tones of orange in the centre, out to purple and blue leading the eye from one to the other. Of all the symbolism the central theme predominates: it is the radiance of the tomb and the victorious Christ *United Methodist Church of Garden Grove, California, USA*

of the Puritans; this was the Anglicanism which, transplanted to Virginia in 1607 became the heritage of the Episcopal Church, together with the Prayer Book (which has again been revised by the American Church). As most of the clergy were English there had long been a desire for an American bishop, but it was not until 1784 that Samuel Seabury was consecrated by bishops of the Scottish Episcopal Church. He admired its Liturgy and was also influenced by the ancient Western forms, and those of the Eastern Church. In time the consecration of other bishops followed.

'The Church of England came to the North American colonies; it was established in the crown colonies of the South, tolerated in the middle Atlantic colonies and existed under persecution in the Puritan colonies of New England.' Upon independence in 1789, it became necessary for the

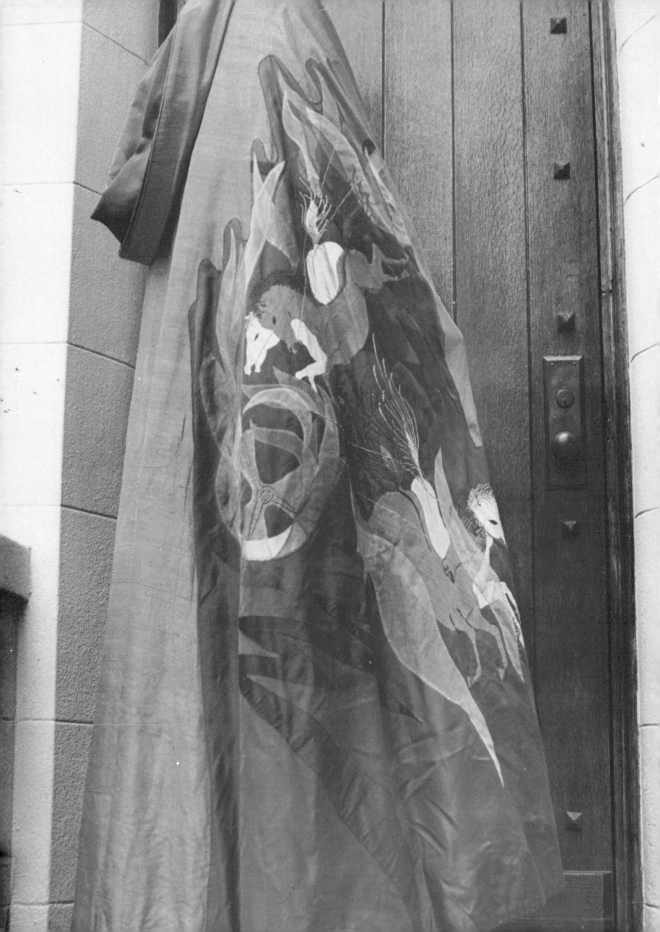

United States to set up an autonomous branch of the Anglican Communion, for this the title 'Protestant Episcopal' was chosen. There was a close similarity between the government provided for the nation and that provided for the Church. That the laity are included in the administration is characteristic of the democratic system.

Despite some contention and apathy the Church grew, strengthened by the new strife with England in 1812. As the evangelical movement waned it was followed by the ecclesiastical movement. Then, towards the second half of the nineteenth century the new churchmen emerged from the intellectual and social movements, some of these were high churchmen. Activity grew and expanded in many fields and many lands.

In the twentieth century Liturgical experiment has been characteristic of all churches. Perhaps the greatest ventures in Liturgical renewal have been made in the Roman Catholic Church since the Second Vatican Council, and as a result the Episcopal Church, in common with other Anglican churches has established a close ecumenical fellowship.

As the Episcopal Church derived originally from the Church of England it is not surprising that the wearing of vestments should follow somewhat the same course. In the early days even the surplice was seldom used, although later the cassock-surplice became the general wear; and it was not until the latter part of the nineteenth century that the tentative introduction of the wearing of vestments was made, though at first only the stole was introduced, developing out of the black scarf worn with the academic hood, over the surplice. Then, a little later and very exceptionally a chasuble was worn. It was not until about 1950 that the chasuble together with the stole really became an alternative to the surplice and stole. However, it was some ten years later that the wearing of the dalmatic and tunicle accompanied the celebrant's chasuble. The cope and mitre have increasingly been worn by the Anglican Communion. There are three kinds of bishops in the Episcopal Church, the 'diocesan' or 'ordinary', and his two assistants the 'bishop coadjutor' and the 'suffragan'. In general the wearing of liturgical vestments has become more usual, and those examples created by Anna Crossley of San

192 *Opposite* Cope 'Behold the mountain and the horses with flames and chariots of fire', designed and embroidered by Anna Crossley. Red silk with soft purple predominating, the appliqué covers both sides from shoulder to hem
San Francisco, California, USA

Francisco are considered to be outstanding (**192, 193** and plate IIIb). She is (1980) completing work for Washington National Cathedral. Information concerning the embroidering and making of vestments can be found in the sections devoted to the technical aspects of the subject.

The vesting of the church building has developed as American culture has become more and more preoccupied with the visual impact, and the importance of design and colour is understood as being equal to that of the spoken word and the reaction to music. There is a serious and growing interest in the planning of decoration in relation to church interiors, which is linked to the re-ordering of the sanctuary, which emphasises the importance of banners and hangings in present-day schemes, for example the large hanging by Lee Porzio. The development in soft-furnishings and vestments, together with the embroidered (hand and machine) decoration and woven fabrics and hangings has received the added stimulus and impetus activated by exhibitions of the Church Arts such as that held in St Louis, Missouri in 1967, and at the Convention in Seattle, Washington 1967, also that which was entitled 'Raiment for the Lord' in Chicago, 1975, etc.

The Roman Catholic Church

Founded on the apostles by Jesus Christ, the Son of God made man, the Church was formed among the Jews in the Greco-Roman world, later suffered persecution and following Constantine's conversion spread under imperial protection. The rise of many great saints – Augustine, Patrick, Benedict – together with various heresies took the Church through the Dark Ages. The reign of Charlemagne and the consequences of his domination of the Church, Rome's break with the East in the great schism of 1054, the founding of new Orders and the flowering of learning with such saints as Thomas Aquinas closed the Middle Ages. The Black Death, the period of the Avignon papacy and the Renaissance led up to the Reformation. The momentous council of Trent consolidated the Counter-Reformation and again there followed new Orders such as the Jesuits. The period of the absolute Monarchs ended with the French Revolution, and the Church now faced the modern world and its problems. The Second Vatican Council realistically awakened the Church of today which now moves forward with creative vigour under the guidance of a non-Italian Pope.

Liturgical vesture in the Roman Catholic Church

developed mainly by tradition until the thirteenth century, then rules began to be included in church law. The paragraphs relating to Liturgical law in the Roman tradition, and its adaption for the present, though few, are contained in the General Instruction of the Roman Missal issued in 1970.

The types of Liturgical vestments are defined as the alb (or the surplice except when a chasuble is worn), the chasuble, dalmatic (worn by deacons), the stole, worn under the chasuble: it hangs down in front when worn by presbyters and bishops, but is crossed over the shoulder and fastened on the right side when worn by deacons. The cope is worn by presbyters and bishops, in processions and other services, and by deacons and sometimes by cantors on solemn occasions.

Fundamental to the beauty and symbolism of the vestment is the material and the form of the garment, which are more important than its ornamentation. Sacredness, in turn, derives from the nature of the events for which it is worn. The fabric used for vestments need not be restricted to silk; many man-made materials, cotton and combinations of these with wool and other yarns are suitable if they are in keeping with the dignity of the event and the wearer.

Writing about the subject of vesture in the Roman Catholic tradition, the Rev John (Bruno) Healey gives the following information.

The chasuble

The chasuble originated from the 'paenula' which was an everyday outer garment worn by both sexes in the Greco-Roman world. It was conical in shape reaching close to the ground on all sides. With the introduction of an investiture ceremony as part of the ordination rite this garment gradually became restricted to priests for the celebration of the Mass.

The reverence for this garment led to its eventual ornamentation which in turn led to the alteration of its original shape. At first simple orphreys covered the seams but by the mediaeval period oblique side bands were joined on to form a Y shape. The embroidery upon these orphreys became more elaborate so that by about the fifteenth century there was a broad Latin cross.

Another factor contributed to the chasuble's changed shape, this was a result of the use of heavy silk brocades which from fourteenth century were woven in Italy. As the conical chasuble required great amounts of material to fall over the arms, part of this simply had to be cut away to reduce the weight. Over a period of time this cutting away was

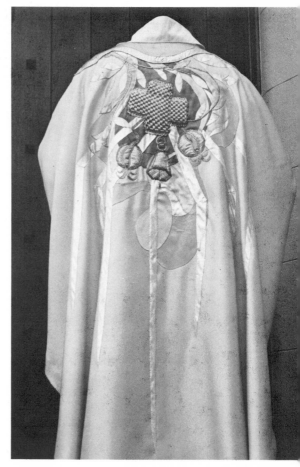

193 The Glory chasuble, designed and embroidered by Anna Crossley

to reduce it merely to a front and back panel, Post-Reformation models had their own variations in Italy, France and Spain (25, 25A).

In the nineteenth century there was a vain attempt to revive the so-called 'Gothic' chasuble. The cut was slightly fuller but much decoration and heavy fabric was still employed. This form of false restoration has been almost the norm right up to the middle of this century. Happily, many things have happened to alter this situation: the acceptance of the use of suitable non-silk (furnishing) fabrics, hand weaving and an authentic revival of the conical shape and the most healthy development of all, the great liturgical movement following from the Second Vatican Council in 1965.

These developments have of course been closely allied to the artistic movements of the various periods. For example, the excesses of the Baroque and Rococo caused lavish and flamboyant decor-

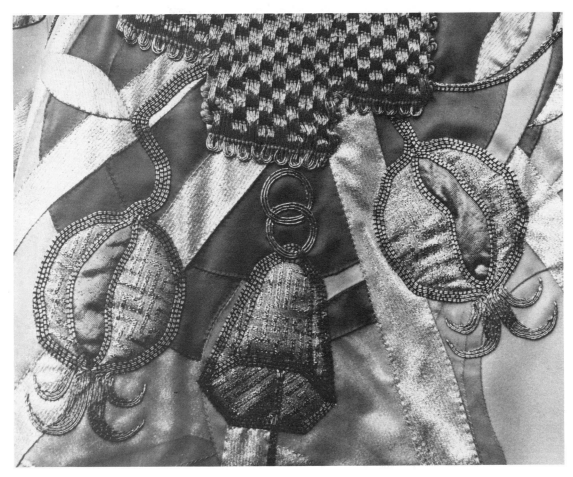

193a Detail of Glory chasuble

ation, and resulted in stiff and heavy copes and chasubles in gorgeous textiles being smothered in flowers and foliage. Mitres of towering height became the fashion.

Today clarity and simplicity have become the norm in vesture which complements the best contemporary church architecture. This can be seen in the embroidered decoration upon both the front and the back and in the ample and flowing chasubles now being worn (especially those seen in the televised Papal ceremonies) and also in the replacement of lace albs and surplices (cotta) with bands of drawn-thread work in grey thread upon white linen (**176**). This development is only to be highly commended as these simple garments are restored more nearly to their original forms, and present a manly appearance.

There is a return to the straight, long stole, which tends to become wider. This replaces the spade and other shaped ends. The white side of the reversible stole is used for communion for the sick and the purple for confession.

The cope as an enveloping garment is worn for Benediction and all ceremonies outside the Mass, for example Vespers or for liturgical processions such as those at Candlemass and Palm Sunday. There is a return to the cope with shaped shoulders and a cowl hood. Other variations are used with or without a hood, and are sometimes made from sections of fabric joined together which, combined, form more than a semi circle. The height of the mitre is reduced. Inverted pleats generally suggest the parallel lines of the clavi upon the Dalmatic, which remains the vestment of the deacon, and of the tunicle; these garments are longer, and being fuller fall in graceful folds. The humeral veil is still used in Benediction for holding the monstrance.

Buskins, gloves and the maniple are no longer

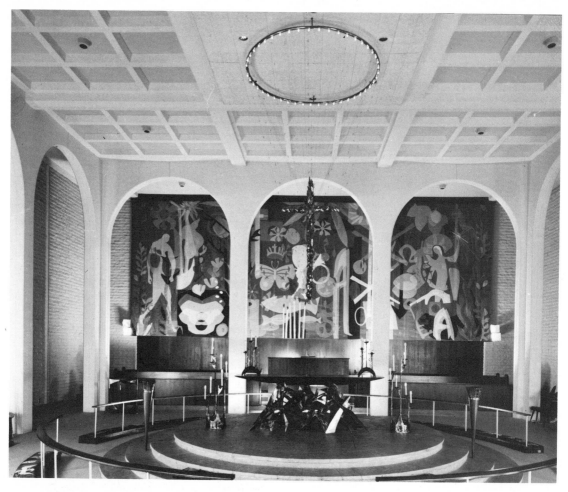

worn. Although not authorised for general use, the 'cassock alb', over which is worn the broad stole of the appropriate colour is allowed at concelebrated Masses for all the celebrating priests except the chief celebrant.

The altar in the Roman Catholic church symbolises the body of Christ, the altar of sacrifice and the table of The Last Supper. The designs for the frontals will emphasise these three ideas.

In old churches the high altar stood against the wall at the eastern end of the sanctuary, and frequently had an embroidered frontal. Now, with the liturgical re-ordering, it stands further forward, and is slightly lower; and, as the priest faces the people, the altar is not so long, Each altar must have three linen cloths; the top one must run lengthwise, dropping to floor level at both ends. The two wider cloths cover the whole top surface and symbolise the shroud of Christ.

The altar may have a frontal at the back and the

194 Panel in collage 5.48 m × 13.41 m (18 ft × 44 ft) which forms a screen for the organ. Designed and executed by Lee Porzio who thought of the collage as a song of praise. The colour scheme was influenced by the desert (earthy) and the theme (spiritual). The background is Sligo linen in a natural colour, all the fabrics are of an open weave, white nylons, silk organza, metallic laces and nets: but with reds, blue and black for the development of minor themes. The theme is joy – as exemplified by the passion – presented in recognizable symbols
The Episcopal Parish of St Barnabas-on-the-Desert, Scottsdale, Arizona. Photograph: Michèle Ditson

195 *Opposite* Nativity in Blue, wall hanging in appliqué, weaving and embroidery, 243 cm × 152 cm (8 ft × 5 ft), designed and worked by the Benedictine nuns of Cockfosters, London, for their chapel. When designing, Sister Regina, OBS, aimed at creating an impression of warmth and light in the midst of a dark world. The colours grade from navy blue through greens to yellow towards the centre where Jesus is dressed in white representing the Light of the World. The shepherds and the Magi catch a glimpse of this light. In the Church's Liturgy the Epiphany is linked with Christ's Baptism and this is symbolised by the waves

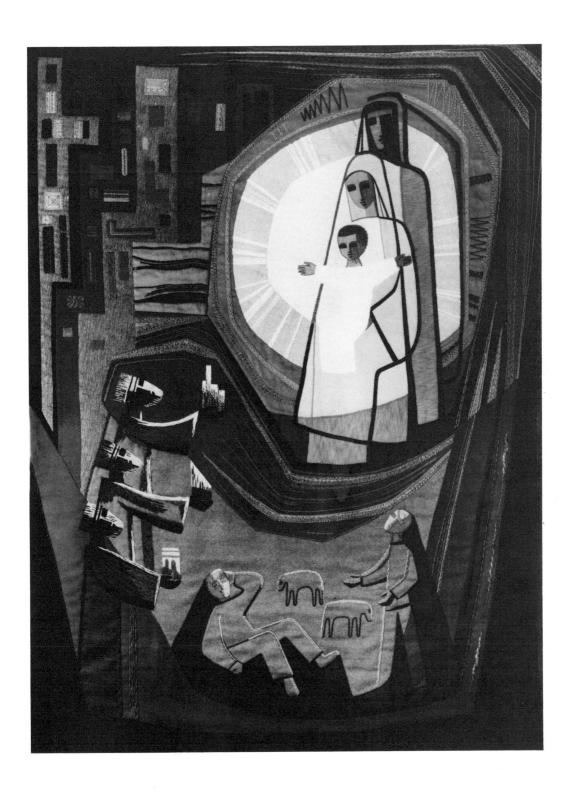

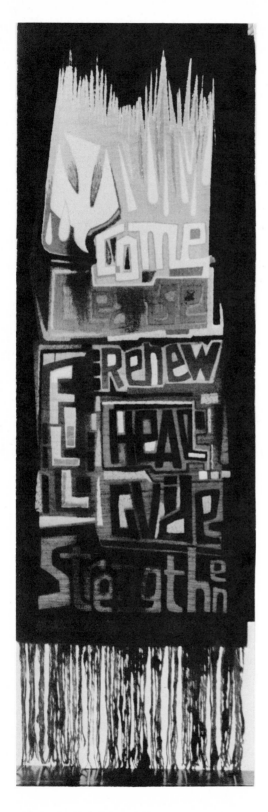

196 Pentecost wallhanging, 243 cm × 76 cm (8 ft × 2½ ft), designed and made by the Benedictine nuns of Cockfosters for their own chapel.

The design was conceived as a composition of glowing colours, expressing the life-giving, renewing, invigorating action of the Holy Spirit, who appeared at Pentecost in flames of fire. Therefore, the colours are those of fire: orange, yellows and white. Within this composition words appear, expressing prayer to the Holy Spirit. At the top the design reaches, so to say, up into infinity; the long fringes at the bottom repeat this movement in the opposite direction, thus suggesting an upward and downward movement, expressing God's coming down into the world and our reaching up to him

front, its use is optional, and it symbolises Christ's ceremonial dress of glory. Ideally a church would have green, red and white, also a reversible frontal which would be gold and violet for penitential occasions.

The Laudian or throw-over frontal is most suited to the free standing altar, and has replaced to a great extent the frontal with frontlet or super frontal.

Canon law requires that the tabernacle (in which the ciboria are kept) should be covered by a silk veil, which is usually shaped like a tent, but with an opening in the centre of the front. There are also veils for the ciborium and monstance which may be plain or embroidered.

The burse, generally 23 cm (9 in.) (sometimes 30.5 cm – 12 in.) square, and the chalice veil from 51 cm – 61 cm (20 in. – 24 in.) square, have almost disappeared from use, as now, in the Mass the gifts are brought to the altar at the Offertory by the faithful.

With the reordering which is taking place in many cathedrals, churches and chapels, the importance of colourful hangings has increased. The Benedictine Nuns of the Priory of Our Lady Queen of Peace, Vita et Pax, Cockfosters, London have created hangings of exceptional interest (**195, 196**). These are smaller examples.

The embroidered baldacchino is seldom used now, but falls, banners and palls are needed, and kneelers continue to proliferate. However, it seems to be a pity that one seldom sees the Stations of the Cross carried out in embroidery, yet the subject presents such possibilities for the sincere and imaginative embroiderer.

Practical information concerning the construction of vesture and the decoration and making of altar linen will be found in the appropriate sections of the book.

Liturgical colours

Liturgical colours in the Roman Catholic Faith: 'The liturgical colours – white, red, green, violet and

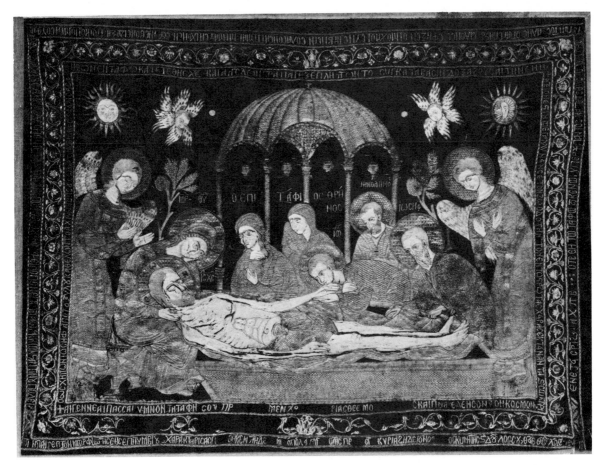

197 Epitaphios, Byzantine embroidery by Despoineta, 1682.
Gold and silver on dark blue silk
Benaki Museum, Athens

black – were by the twelfth century the subject of ecclesiastical legislation. This first known ruling was made by Pope Innocent III for the Crusaders' Church in Jerusalem and, with only minor alterations, is what is commonly observed today.

White is worn on feasts of Our Lord, Our Lady, confessors and virgins and throughout Paschal time. Red is used for Pentecost, Holy Cross, Apostles and Martyrs; and more recently on Good Friday and for the funeral of a Pope. Violet is used in Lent and Advent and has now replaced black for funerals. Green is used on Sundays and ferial days from after Pentecost until Advent, and from after Epiphany until Ash Wednesday. Rose is optional for the mid Sundays of Lent and Advent.'

The new rubrics say that the more precious vestments may be used on solemn days even though they are not the colour of the day.

Great effect is obtained by colour for it quickly appeals to the emotions and, properly used, it helps both priest and people to feel the mood and true spirit of each different feast or season.

Liturgical vesture of the Greek Orthodox Church

The following brief introduction is intended as a background to the extant examples of Byzantine embroidery in the museums of the world.

Up to the fall of Constantinople to the Turks in 1453 and to a lesser extent, afterwards, the ecclesiastical arts of Byzantium have exerted a lasting influence. During the second half of the fifth and sixth centuries, in particular, the Christian concept inspired artists to create in most media, but especially famous are the Ravenna Mosaics; from the close parallel between the lavish imperial court attire and religious vesture can be observed and traced the origin and development of the eucharistic vestments used today.

173

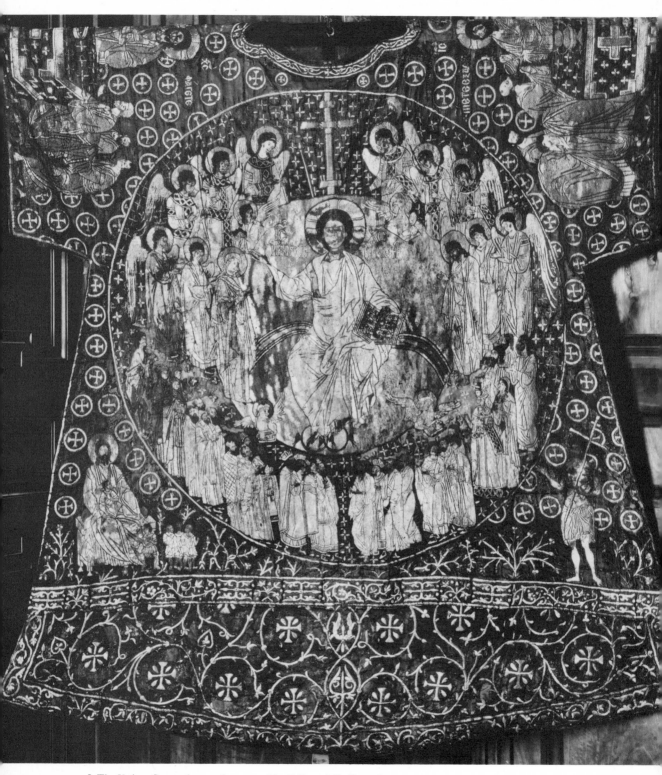

198 The Vatican Saccos, fourteenth century, 'the Calling of the Chosen'
Treasury of St Peter's, Rome

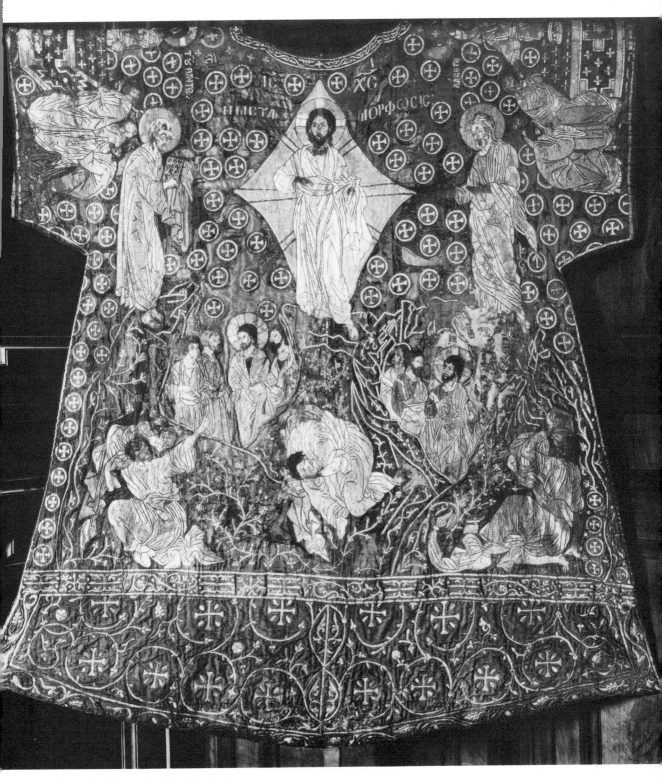

199 The Vatican Saccos 'The Transfiguration'
Treasury of St Peter's, Rome

The concern of the iconoclast controversy of the eighth and ninth centuries was whether the veneration or even the painting of a religious representation became idolatry; the far-reaching effect influenced artistic interpretation. The characteristics of Byzantine art were its vitality as opposed to the sincerity of the intellectuality; the repose which conflicted with the flowing movement; and the opposition between the two-dimensional stylistic forms and the classical physical beauty: all are exemplified in the narrative embroideries.

That the embroidery of the West shows little of this influence may be because the standards of design and workmanship were as high or higher, from the eleventh to the fourteenth centuries in Europe, more especially in Britain.

The interior of an Orthodox Eastern Church is arranged differently from those of the West, as, except for stone seats along the walls of the nave, seats are not provided. At the eastern end is the santuary, which is separated by a screen, the *iconostasis*, in which there are three openings. The centre double doors are known as the Royal Gates or Holy Doors, behind these is hung a gold embroidered curtain, the Amphithuron, which is usually red, white or purple. The screen is enriched with icons.

From a low dais the Bishop or priest holds up the Blessed Sacrament, and the Holy Table (the Throne) is placed behind the Royal Gates, where are also the bishop's chair and, on the left, the *prothesis*, the table upon which the elements are set out.

The holy table is a large cube (which can be seen represented in several embroideries). It may be covered with a white linen cloth (*katasarka*); over this there is generally a silk cover (*endykai*) which hangs down to the floor all round. The *antimension* is a consecrated cloth, used as a corporal, and is made of linen or silk, with relics sewn up in the centre or corners, with printed decorations. The *eileton*, a rectangle of linen or silk, was embroidered with a representation of the entombment.

Over the holy table there may be a decorative canopied dome, supported on four columns (this can be seen depicted on several old embroideries).

The various liturgical veils of linen or silk are often embroidered and jewelled, one is cut to the shape of a Greek cross, with the central section stiffened. The little *aëres* and great *aër* were veils used for covering the chalice and patten. The former which covered both together developed into the *epitaphios sindon*, a large veil, embroidered with the Body of Christ Crucified, it was carried in procession during Good Friday services (**197**). (The Victoria and Albert Museum, London, possesses an epitaphios.)

Some interesting examples of embroidered tomb covers exist, which portray an effigy of the dead person. Another veil made for a very different purpose is the *podea*, which is embroidered with a subject similar to that of the icon, the base of which is covered with this cloth.

Vestments

As happened in the West, so the ordinary dress of the third and fourth century Roman developed, although with differences, into the liturgical vestments of the Eastern Church: but the symbolic meaning was much more mystical, although there were no special colours, except that the richest were reserved for festivals.

The long tunic, the *sticharion*, was worn by all priests as an undergarment, and was like the alb – it could be made of cloth of gold, silk, velvet or linen, with embroidered bands from shoulder to hem at the front and the back (similar to the clavi on the dalmatic). There were also embroidered bands decorating the wrists of the narrow sleeves.

This decoration developed into the detachable richly embroidered cuffs worn by bishops, priests and deacons called *epimanikia*.

The *zone* is a girdle, which may or may not be embroidered and is worn by bishops and priests.

Worn by priests as a cloak is the *phelonion* (or paenula), it is like the western chasuble, but in its early form it was circular with a hole for the head, and was embroidered all over with crosses; latterly it was cut down the centre to form a cloak, which could be decorated with embroidery.

The *saccos* was originally worn by selected patriarchs, then later by all bishops, and was a tunic-like garment with wide sleeves. Crosses featured in the elaborate embroidery. The so-called Dalmatic of Charlemagne in the Treasury of St Peter's, Rome, is a saccos (**198, 199**). It is worked with silks and gold on blue silk.

There are two mitres. Today, only one (the crown) is worn, the other is very ancient and out of date.

The crown is high and rounded, and surmounted by a cross; it is stiffened, and the fabric is sewn with jewels.

Originally the stole was a cloth folded into a long narrow strip. As a mark of rank it was, from an early date, a part of priestly insigna. Later the bishop's and priest's stole was called the *epitrachilion*, and was

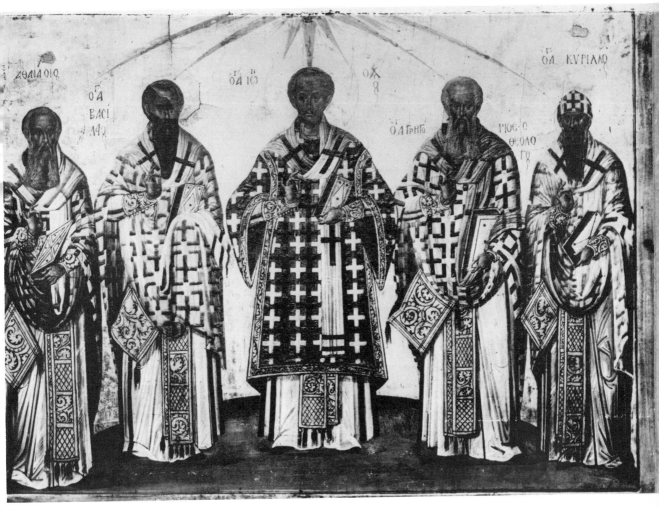

200 Greek Icon, sixteenth century. The Liturgical dress is
that of the sixteenth century
Pinacoteca Vaticana, Rome

long and wide, then it was made narrower and
shaped to fit around the wearer's neck, when there
was an opening with a fastening, otherwise the two
ends were joined together in the centre down the
entire length. Elaborate gold embroidery of a narrat-
ive character decorated both sides, which frequently
terminated with fringes.

The deacon's stole, called the *orarion*, was long,
straight and narrower and also embroidered, and was
worn over the left shoulder. As deacons were often
depicted as angels, their stole symbolised wings.

The *omophorion* which was like a stole, was the
distinguishing sign of a bishop, it was a long strip
laid across the shoulders with one end falling in front
and the other at the back, later made of silk it was
decorated with five large crosses, with bands of

decoration at the ends. It approximates to the
pallium.

Originally the *epigonation* was a hand cloth, then it
became a square fabric, richly embroidered and
stiffened. It is suspended from the girdle by a cord
attached to one corner and hangs at knee height
(**200**). It is used by bishops and elevated priests of all
Orthodox Churches: Greek, Russian, Rumanian,
Serbian, Bulgarian, Finnish, Albanian, Georgian,
Armenian, Polish, Church of America, and others.

The embroidery

Certain characteristics in the design of Byzantine
embroidery are of particular interest. When the
iconoclast controversy was resolved 'the mosaicists

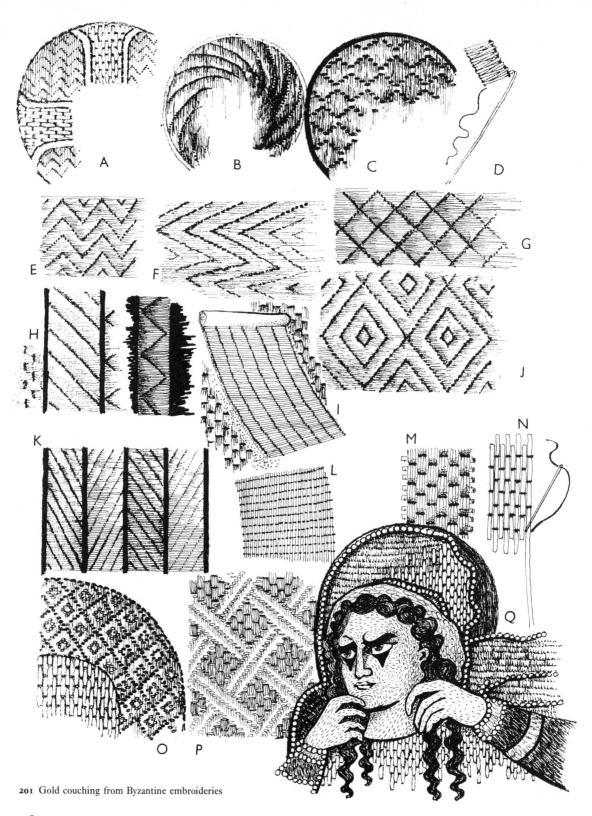

201 Gold couching from Byzantine embroideries

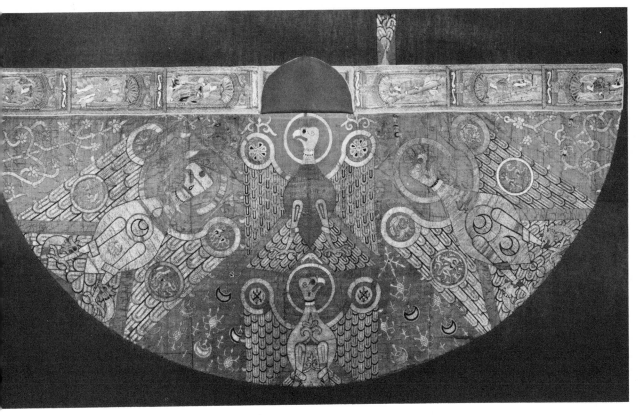

202 Known as 'the cope of Charlemagne', Byzantine, late twelfth century. Gold and silk embroidery on a dark red ground. *Metz Cathedral Treasury*

once again poured the mystical spirit of Christianity into pictorial decoration of the churches'. This applied to the later lesser form of artistic expression, embroidery and, to quote Pauline Johnstone again: 'The new style, which was born of the marriage of the twin arts of iconoclast days, tempered with a Hellenistic grace of drapery and freedom of movement the severe and awe-inspiring mysticism of the old tradition, and found in a stylised elegance of attitude a deep serenity which touches the sublime'.

It was supposed that by depicting the figure front view, communication with the beholder was achieved, and that this was heightened by the expression of the soul through the human face, especially by emphasising and enlarging the eyes. Whereas rhythmical movement was achieved by representing the narrative through figures turned to the three-quarter view, so forming groups as demanded by the composition. The subject matter and the designs were regulated by tradition. As a later introduction to avoid the possible distraction of attention away from the main subject the ornamentation was relegated to the borders; and lettering was frequently embroidered around the outside edges.

It seems fitting that gold embroidery was considered worthy of depicting the sacred subjects, and that this technique should have been exclusively employed. Endless variations of effect were obtained by slightly changing the direction and therefore the play of light upon the gold. Each nuance achieved was the result of careful planning. The nature of the thread was appreciated and had to be understood because the work was carried out entirely in variations of couching, see page 220. By spacing the stitches effects either subtle or with strong contrasts are achieved by the colour of the silk or linen sewing thread. It will be observed that the gold or silver threads never followed the contour of the shape which was being covered, but were taken across or downwards; at the edges they were turned and were carried backwards and forwards across the form. Both directions are combined at **201**A, which is the type of halo used to identify Christ. The next two show typical treatments for the halo. In the diagram variations of stitched pattering taken from other Byzantine examples are shown at **201**E, F, G, H, I, J, K, L, O and P.

Another characteristic method is shown at **201**D. Here the metal thread is passed backwards and forwards in a zigzag across the width of the line, and the couching stitch attaches it at each turn, this makes it a very suitable way to treat lettering and outlines, if not too narrow. A bunch of soft padding threads may be put down first, and the metal can then be taken over these. Or a thick thread or fine string can be sewn down in rows as a foundation, and the gold taken over these in various patterns as at **201**M. In contrast flat couching is shown at **201**N. It will be found interesting to compare this method with the underside couching so characteristic of *Opus Anglicanum*. As with other types of gold work this technique has to be carried out with the material stretched out taut on a frame; the background fabric was generally dark red or blue silk, though later a pale blue was introduced.

Silk thread was only used for embroidering the flesh, which was worked in rows of very fine split stitch following the contours of the features; this is indicated in the diagram **201**Q, which is a drawing of the head of St Mary Magdalene, from the *Neamt epitaphios* at the Museum of Art, Bucharest. It will be noticed that the spirals serve to heighten the modelling of the flesh. The importance of the expressive eyes has been referred to and is here illustrated. The curly hair and outline of seed pearls are also characteristic of Byzantine embroidery. In some later examples fine long and short stitch in a downward direction was used for working the flesh, and bullion and purl threads were introduced leading to a deterioration of technique and loss of vitality in the design due to extreme conservatism.

The Eastern Church includes the Christians of Egypt (Copts). The character of the decoration on their garments of the early centuries was totally different, as can be observed on the borders and roundels of the tunics which can be seen in many museums and are so typical of Coptic tapestry weaving. Now, some of the vestments show the Western influence both in shape and decoration.

Judaic ceremonial embroidery

From the earliest times embroidered decoration has formed an integral part of Jewish religious ritual, its importance is illustrated by the detailed instructions given to Moses for the creation of the Tabernacle. Typical is this quotation from Exodus 'Thou shalt embroider the coat of linen, and thou shalt make the girdle of needlework'. For almost three and half thousand years this tradition has survived due to the importance attached to the arts and the recognition of the visual impact. Few early ritual objects remain owing to loss during exile and dispersal; the extant embroidery goes back about three or four hundred years.

Prevailing trends are reflected in synagogue architecture, for example, Frank Lloyd Wright's design for the Beth Sholom Synagogue, Philadelphia, which symbolises a mountain of light, in its six-sided form. The approach to the decorative arts, such as embroidery, is in the contemporary idiom, and Jewish religious forms are represented despite the conflicting laws concerning 'graven images'. Although religious ceremonial objects have no characteristically Jewish decorative qualities, they nevertheless express Judaism as a way of life. The religious ritual appeals to the emotions, imagination and intellect, so the designer should, with sincerity and respect strive to convey sanctity and dignity through the work.

Great is the scope for imaginative stitchery upon ritual objects of the Jewish faith. The wealth of symbolism lends itself to adaptation.

Symbolism

Many symbols express such fundamental meanings that they recur in slightly different forms in most religions; the important exception being the cross. Basically, the symbol or sign is an image which is given a significance that inspires belief. It is with the balanced and interesting arrangement of these symbols that meaningful religious design is created. Without these images it would be impossible to attempt to convey, for example, such a concept as the mystical relation between God and man in synagogue art.

Torah In order that Judaism may be represented in the decorative arts, the Torah and other ritual objects are used as visual symbols.

The Crown, the symbol of the Torah, signifies the Crown of the Law. In some earlier examples three crowns were used. These are frequently combined with the Hebrew letters KOF and the TAV, which stand for Keter Torah – crown of the law. There are examples of many beautiful embroidered crowns.

Two Lions rampant, often used with the Crown.

A Lion is the symbol for one of the Twelve Tribes of Israel, the tribe of Judah, but is seldom now used.

The Ten Commandments are represented upon two tablets, five being embroidered on each; and these, together with the crown, the lion, and also the two

Columns (usually spiral) were carried out in embroidery on the central panel of many mantles and on the ark curtain (parochet).

The Two Columns, Yachin and Boaz, signify the pillars of Solomon's Temple in Jerusalem. The Baroque influence is seen in the spiral twist of the columns, but there are other styles.

The Menorah is the seven branched candlestick, and symbolises light, Judaism being the religion of light, the light of knowledge, truth, justice, eternity and God's radiance. Also other meanings.

The Star of David, the *Magen David*, the six-pointed Star existed long before its adoption as a Jewish symbol, which is fairly recent.

The Pomegranate and Bell are very early symbols of fertility and life (Exodus): 'Thou shalt make pomegranates of blue and of purple and of scarlet round about the hem thereof: and bells of gold between.'

The Tent of Meeting in the Wilderness, the *Tabernacle*, symbolise Judaism.

Solomon's Temple, or the sacred Temple objects, became symbols of the Jewish people.

The Tree of Life, = the ever living Torah, an ancient Hebrew symbol – with a distant Hindu source, and seen in European traditional art as the Tree of Jesse.

The Ner Tamid, the *Eternal Light*, is a very sacred symbol, which represents God's presence in the synagogue.

203 Gold work, mainly eighteenth century
Symbols from embroideries in the Jewish Museum, London

The Torah Ark can, in design, be represented on a Torah mantle.

Cherubims are seen as an adjunct to the Throne of God and they generally represent the protection of the Ark. These two-winged angels are seldom used now in design. Cherubims have been included in the art of many nations.

Angels represent Divine activity in the world of men.

The Seal of Solomon is the five-pointed Star.

The Human Figure. Its inclusion in decorative art has been a source of controversy, because it contravenes the second commandment.

Hands. A priest has been symbolised by two out-stretched hands, and the Levite by the pitcher.

Tongues of Fire are frequently used in design.

Flame of the Burning Bush is decorative and often included.

Animals, although their inclusion has, from time to time, led to controversy, form a part of many Judaic designs. The lion is the most important, also the gazelle.

Birds symbolise the soaring message.

The Dove, used as a symbol of Peace, and of the People of Israel. It is associated with the story of the Flood.

The Twelve Tribes of Israel symbolise Judaism. The breast plate of the High Priest contained twelve stones.

Palm tree and the Vine symbolise the Jews as a nation.

Altar fire – reminiscent of worship in the Temple in Jerusalem.

Sun and Moon are the signs for God's creation of the whole world.

Harp and Shofar: the latter, the ram's horn – calls to the Judgment Throne, and is associated with redemption.

Passover symbols – the lamb, matzos, bitter herbs, parsley, grapes.

Flowers and Fruits symbolise the plenty of nature, therefore Harvest Festivals.

Signs of the Zodiac are connected in Jewish art with the twelve tribes of Israel and are generally in the reverse direction.

Colours

Linen (white), blue, purple and scarlet represent the four elements of which the universe was created.

White symbolises life, purity. Used on High Holy days, and for vestments and coverings for the Torah and Ark, also in the Sanctuary for the holiest days. A white Torah mantle is used for the New Year.

Scarlet Life and Blood.

Purple Power, Royalty.

Gold is the symbol of Divine or celestial light and the Glory of God.

Silver Innocence and holiness.

These are but a selection from the wealth of visual signs.

Of paramount importance is the inherent beauty of the Hebrew script. Its decorative value has for long been recognised, so, being complete in itself, it is frequently used without further embellishment **204**c, d.

Judaic embroideries

Torah mantle

The love of God has been expressed in embroidered decoration from early times, yet extant Torah Mantles are not earlier than the eighteenth century. They reflect the current style of European decoration, and traditional Torah Mantles had several characteristics in common. On a background of silk brocade, the elaborate gold embroidery was worked upon a central panel of velvet, in the middle of which was depicted an embroidered Ark with miniature scroll and mantle, or some other symbol, also the Crown and foliation.

There is an upsurge of interest in, and a desire to create sacred ritual objects in the modern idiom. Dorothy E. Wolken is an exponent of these ideas; she writes 'The Torah or Pentateuch, consisting of the five books of Moses, is the most sacred object of the Jewish religion. In the Western world the Torah mantle or cover is richly decorated, and is made with a rigid top which measures the width of the scrolls, pierced with two holes large enough to allow it to slide over the two staves, on which the parchment scroll is wound.

Modern changes have been made in Torah mantles, the binder for the scrolls, prayer shawls and hats. The breast plate is not always used so that embroidered decoration can be worked over most of the front surface of the mantle, this is illustrated (**204**a, b). Replacing the traditional velvets and fringes are the many elegant and unusual weaves which are available today and which lend themselves to embellishment. For example, there are heavy

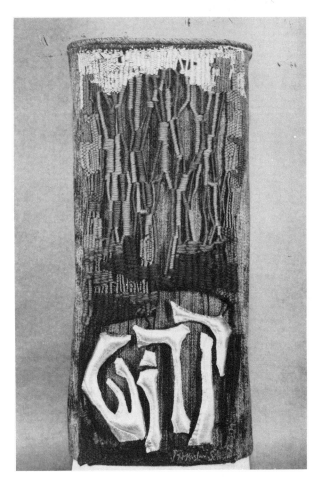

204a Torah mantle designed and embroidered by Dorothy E Wolken. Worked in various gold threads, etc
Temple Israel, Canton, Ohio

204b Torah mantle designed and embroidered by Joan Koslan Schwartz, 1972. Needleweaving and leather sculpture
76 cm × 36 cm (30 in. × 14 in.)
Chapel Cong Emanuel, San Francisco, California, USA

wool, cotton or linen furnishing fabrics (and some strong heavy silks). Each part of the design can be embroidered with a different type of bead, cord, braid, kid skins or metallic fabric. Since only one colour is sometimes used, different textures will reflect light differently and bring out all facets of the design clearly. It is essential that all materials used in executing a mantle be both attractive and durable, to withstand the continual handling during dressing and undressing of the heavy scrolls and staves. Many synagogue women's groups are now designing covers in canvas work or surface stitchery using wool threads in designs based on Biblical motifs, Hebrew letters and religious symbols.'

Technical information concerning types of embroidery suitable for mantles will be found elsewhere.

The general principles for making up apply to the mantle and the following particular details will be found to supplement the general instructions (206). An average size for a Torah mantle is 92 cm × 112 cm (36 in. × 44 in.), but they vary greatly.

Method 1

Take the embroidered rectangle of fabric for the mantle, turn over the edges on three sides. If there is to be an inter-lining, attach this. Cut out the lining and turn in the three edges, then after matching up the centres, tack and slip-stitch or hem around the three sides (206A). Stitch across the top.

From millboard (strong card which does not crack as easily as strawboard) or from thin hardboard, cut two ovals, the circumference of which should measure the width across the embroidered rectangle;

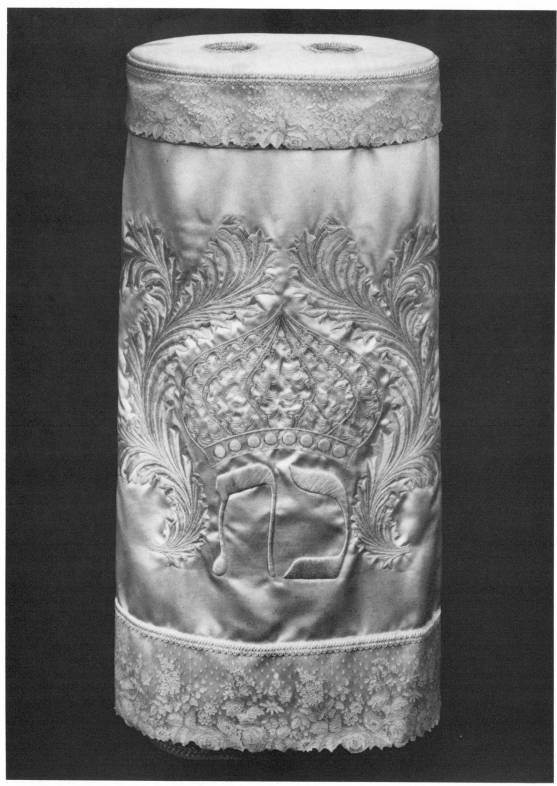

204c Mantle for the Days of Awe, designed by Rabbi Harold
Reinhart, embroidered by Beryl Dean, 1962. Satin and long
and short stitches self colour on off-white satin
Westminster Synagogue, London

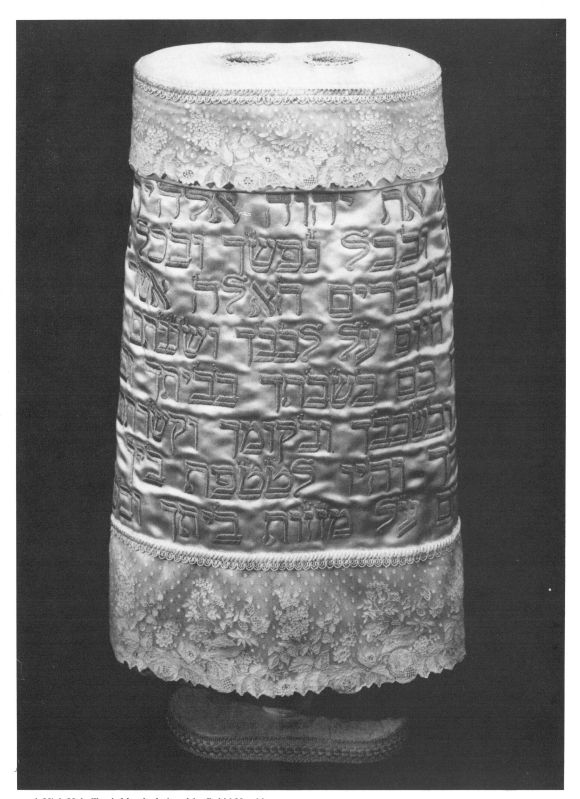

204d High Holy Torah Mantle designed by Rabbi Harold
Reinhart, embroidered by Beryl Dean, 1962 Satin stitch in
self-colour on off-white satin
Westminster Synagogue, London

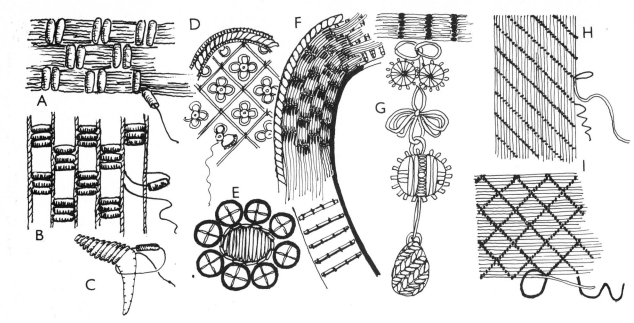

205 Gold work from an eithteenth century Dutch mantle
Jewish Museum, London
A Laid silk, sewn with lengths of check purl
B Fine cord, sewn with lengths of check purl
C Satin stitch with purl over padding for lettering
D Cord and pearl purl outline, spangles surrounded with loops of fine rough purl
E Satin and stem stitch in rough purl, with spangles
F Basket stitch in fine gold passing over cord
G Part of the fringe made with passing thread, spangles, etc
H and **I** Gold tambour laid, sewn with silk

then cut away the two holes, which should correspond with the position of the staves. If required, soft inter-lining can be stuck to the top oval.

Cut ovals from the lining and the outer fabrics, including an extra 1.5 cm ($\frac{3}{4}$ in.) for turnings, place one stiff oval over each as at **206**B (with the inter-lining under the outer fabric). Nick at intervals, then fold over the turnings (**206**c), stick, or sew these down.

Take the embroidered rectangle, top edge upwards, and wrap it around the outside edge of the oval which has been lined, starting at the centre back marked X. Match up the halves and quarters and pin (**206**D). Sew the turning to the oval, just within the edge. This is shown in the diagram (a curved needle helps). Cut away surplus fullness in the turning as at **206**E, so that it lies flatly. It can be carefully pressed with the tip of the iron.

Next, matching up the half and quarter marks, put the top oval in place, pin, then slip-stitch (**53**) or invisibly hem or overcast the two edges together

(**206**F). Repeat this stitching around the central circles. Should the edges require neatening a narrow cord can be used.

At the centre back the two edges of the mantle can be caught together for 10 or 13 cm (4 in. or 5 in.) from the top, the remainder is left open.

Method 2

Cover one oval with the outer fabric as at (B) and (C), then cut the lining, pin it in place on the under side, fold in the turning and hem or slip-stitch around the edge.

Either, neaten all four sides of the embroidered mantle, and bring the top edge to the edge of the top oval, and overcast and neaten.

Or, bring the fourth (cut) edges of the mantle and fold them over the top oval, sew, cut down the turnings; to neaten place a narrow braid, flatly, over the turnings, with the join at the centre back, and stitch. Repeat this neatening for the two circles.

The Torah binder or wimple

There are old interesting examples in many museums. Their purpose is sacred. 'The scrolls of the Torah are tied together with a binder' and, quoting Dorothy E. Wolken 'until about the eighteenth century this was made from the swaddling cloth used during a baby boy's circumcision; it was then torn into three strips which were joined together lengthwise and embroidered with the baby's name and other details concerning his early

life, decorative motifs, also scenes and events which might occur to assure a rich and happy life. Later it was used as a wrapper or binder at his Bar Mitzvah service.

'The binder shown (208) is modern and is more practical and less cumbersome. It is made of a firmly woven doeskin fabric and inter-lined with the heaviest weight seat-webbing which supplies maximum strength and wear and does not roll or twist. At each end of the binder is a 2 cm ($\frac{3}{4}$ in.) strip of *Velcro*, which, when pressed lightly together, cannot be pulled apart horizontally. It can be separated only by a slight upward or downward pull of the *Velcro*. It is measured to hold the scrolls together tightly so that the mantle will slide on and off the scrolls easily. The decoration on this binder consists of gold kid-skin Hebrew letters which spell the names of the books of Moses. The textures of the leather and the beads used for each name are different, to facilitate identification.'

Tallit or Prayer Shawl

Instructions for the making of the Tallit or Prayer Shawl were given in Exodus 'they put upon the fringe of each corner a cord of blue'. On many traditional examples there was embroidery in addition to the stripes. Many shawls are now woven with stripes and the fringe is made from the warp, and may be embroidered by hand or machine. There are some with fringe only at the corners, where longer threads are knotted as a ritual which is symbolic. Very approximate average measurements are 182 cm × 46 cm (72 in. × 18 in.) with a 20 cm (8 in.) fringe. When a light lining is necessary, the edges of the long sides are turned in and both are slip-stitched together, but the folded edge of the lining is hemmed to the back of the heading of the fringe.

'The prayer shawls to-day need no longer be large woollen squares or wide oblong stoles', Dor-

206 Diagrams illustrating the construction of a Torah mantle

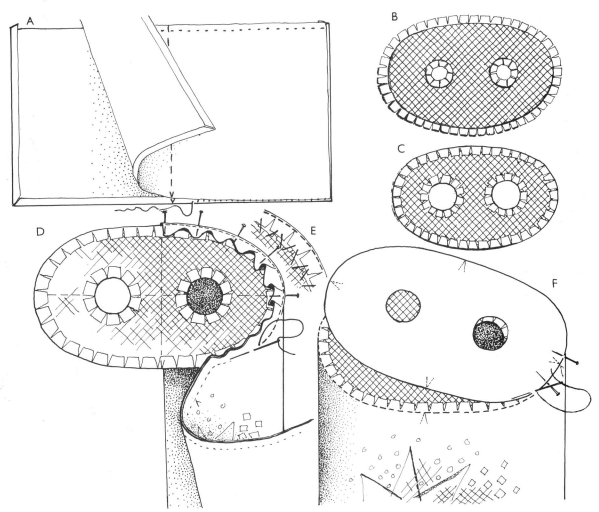

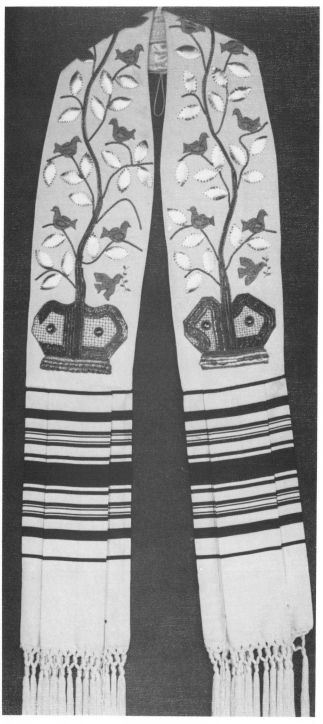

othy Wolken continues, 'Woven horizontal stripes, fringed ends and decorated neckbands were, for many centuries, their only decoration. To-day, the fringes can be confined to the four corners when they are worn by Orthodox or Conservative Jews, and may be embroidered according to the style desired by the wearer. The prayer shawl illustrated (207) is embroidered with gold leather leaves stitched to metallic gold cord representing the Tree of Life growing from the staves of the open Torah scroll, which is worked in gold and brown beads to indicate its use by a boy during his Bar Mitzvah service. The fabric is an off-white pure silk but it could have been made with pure wool, linen or cotton.'

'The prayer hat need not be insignificant; it can take the shape of the pillbox style and can be embroidered with significant designs and symbols such as the Hebrew letters which spell the Hebrew name of the wearer and the symbol which indicates its meaning. It is made of the same silk as the prayer shawl.'

The skull cap (kippah) embroidered by Estelle Levy (209) is made of grey woollen material with some black velvet applied. The grapes are worked in metal threads couched with coloured silks. Where gold kid is used it is padded, for the centre of the top it is outlined with gold cords and pearl purl, the radiating long black stitches are laid and couched. To make up the hat, the circular crown is cut out leaving turnings, and marked at the centre front and back, also halfway round the sides: its circumference is slightly less than the head measurement. Cut the side band to the head measurement, and on the cross of the fabric, with a wider turning at the bottom edge, divide into half and quarters, stitch the centre back seam. Then, putting the right sides of the top and the sides together, match up the centre fronts, back and sides, keeping the pins at right angles to the edge, very slightly easing the side band into the crown, pin at 2.5 cm (1 in.) intervals around the crown, stitch this seam. Make a small thick pad, hold it under the seam, and, with the tip of the iron press it open. If the material is suitable, a slightly damp cloth can be used, this will shrink away surplus easing. Press the bottom edge upwards. Make a lining, sew it in place, cut narrow petersham ribbon to the head measurement and hem in place as a headband.

Tallit bag

For carrying the Tallit a bag is generally used which measures about 25 cm × 30 cm (10 in. × 11¾ in.). It can be decorated with embroidery of appropriate design: many present day examples are hand woven.

207 Berkson Cantorial Tallit showing the atarah worked in gold. Designed and made by Dorothy E Wolken, Pittsburgh, Pennsylvania

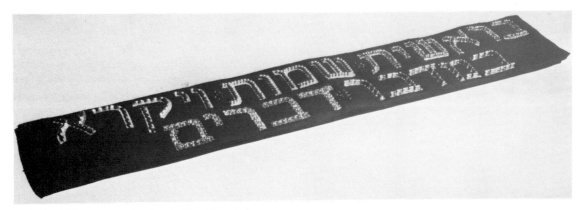

208 Torah binder designed and embroidered in gold by Dorothy Wolken, Pittsburgh, Pennsylvania

The top may have a flap, a zip, velcro or drawstrings and is usually lined (**210**).

Parochet or Ark curtain

In front of the holy Ark hangs the Ark curtain, the Parochet; it recalls the curtain which hung in the Tabernacle. It is exceptional for a synagogue to have no curtain – usually it hangs outside, but occasionally inside. As time went on the splendour of the embroidered ornamentation increased, and with this desire to create beauty, brocades and silks of many colours but mainly red and blue, were used, the decoration being carried out in gold embroidery. The design followed the trends of fashion in the decorative arts, and this still applies today, when there is a revival of interest in the creative approach to interior design, and the Ark curtain is considered as an integral part of the architecture. An embroidered Ark curtain, in the modern idiom, if only for its sheer size (which may be any measurement between 2.90 m – 7.62 m × about 4.2/m (9 ft – 23 ft × about 13 ft) constitutes a wonderful challenge to the designer who can visualise the effect of the use of lovely fabrics in a combination of appliqué and decorative stitchery (hand and/or machine). The colour scheme and the size must also be planned in relation to the interior of the synagogue. The technical methods which could be employed are described in the section devoted to technique. The making up of an Ark curtain would follow the instructions given for constructing a pall (**211**). This example is 6 ft × 6 ft.

Kapporet

In the Temple days, this valance over the top of the Ark curtain was 'the mercy-seat' and, with the two cherubims symbolised both the place where the holiness of God was revealed and where people's sins were removed. It was not until the seventeenth century that this top piece was added. It was elaborately embroidered often with a scalloped edge, with or without alternating tassels, the design was composed of inscriptions and symbols. This valance did not always match the Ark curtain. Frequently it is not included in modern schemes.

Desk cover

Because the scroll is laid upon the Reading Desk during the Service, to show due reverence and respect, an elaborately embroidered cloth covers the desk. The design takes various forms, as did the fabrics used – interesting examples from the past can be seen in many museums. An approximate size of the desk top might be about 74 cm × 115 cm (29 in. × 45 in.). The amount of overhang varies.

Tefillin bag

There are examples from the past which were embroidered in interesting ways; being small, 25 cm × 20 cm (10 in. × 8 in.), there is the same scope today. Rich fabrics are generally used for the Tefillin Bag, which is fastened with a flap, drawstring, *Velcro* or zip. As the bag is in use almost every day of the year during the recital of morning prayers, it should be made with durable materials.

Challah cover

'Judaism is one of the few religions which employs the use of ceremonial and ritual objects for specific holidays in the home and also the synagogue' writes Dorothy E. Wolken, 'Each Friday at sundown the beginning of the sabbath is observed by the blessing of the bread and wine. A sabbath bread cover, the Challah Cover, is designed with any attractive

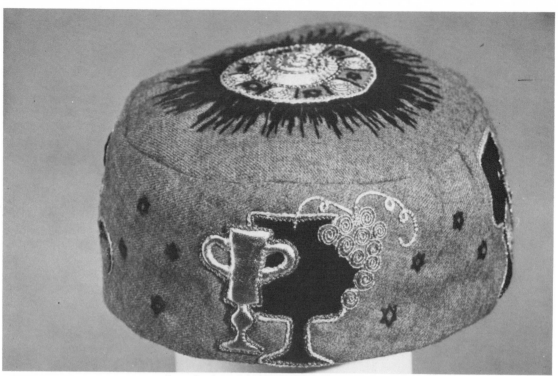

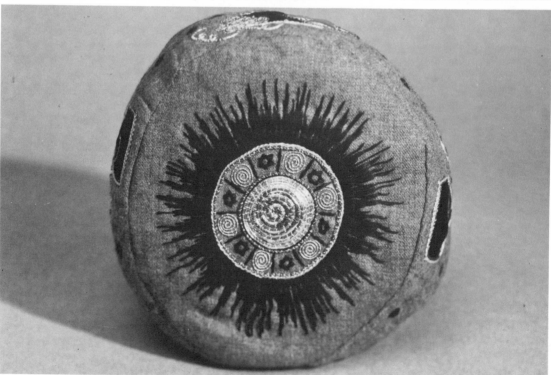

209a *Above* Skull cap. Gold, black velvet and gold thread sewn with coloured silk on grey wool by Estelle Levy, London

209b Detail. Crown of cap

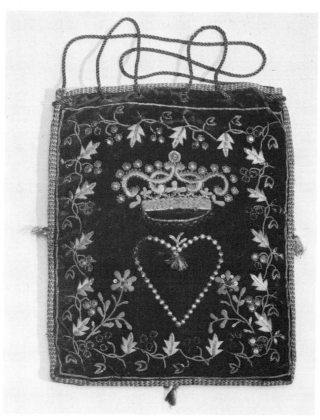

210 Tallit bag early nineteenth century. Gold embroidery on
green velvet belonging to Rabbi Abraham Levy, London

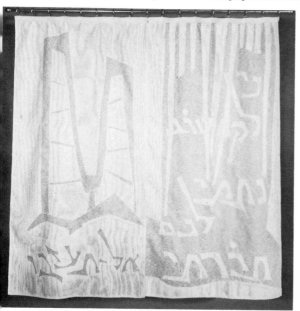

211 Ark curtain (Parochet) machine appliqué designed and
worked by Joan Koslan Schwartz, Vienna, Virginia, 1973

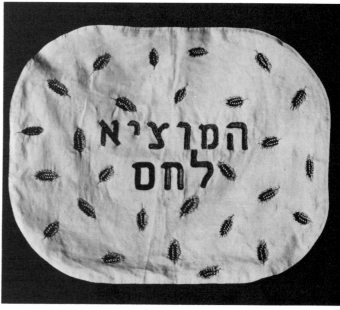

212 Sabbath bread cover designed and worked by Dorothy
Wolken, Pittsburg, Pennsylvania

213 Pulpit Bible slip cover (Tenach) machine appliqué and trapunto, 1973. Joan Koslan Schwartz, Vienna, Virginia

214 Passover pillows. Designed and worked by Joan Koslan Schwartz, Vienna, Virginia *Top* Canvas work – gold thread; 1967 *Below* Surface stitchery
Collection of Dr Benjamin L Schwartz

215 Diagram to show the making of a simple modern Matzot cover

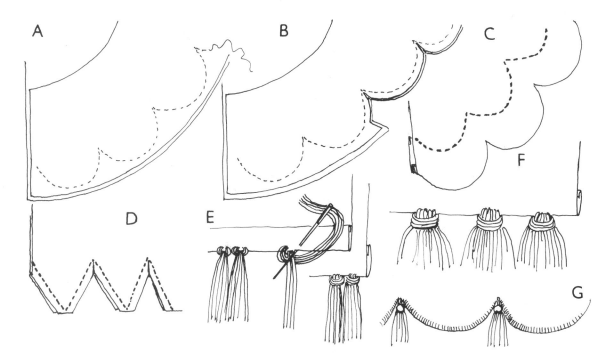

216 Diagrams for making decorative edgings, alternatives to machine-made fringes

embroidery.' It recalls the dew which covered the 'Manna' which the children of Israel received in the wilderness. A fine quality of white linen or cotton, decorated with cotton threads, is often used. In the example illustrated (212) the white linen is embroidered with symbolic shafts of wheat. It is worked with gold metallic beads, cords and braids and the design includes part of the blessing in Hebrew lettering. In common with the other cotton and linen covers, it can be washed and ironed with proper care. The Sabbath Bread cover can be made to almost any shape and measures about 31 cm – 41 cm × 36 cm – 61 cm (12 in. – 16 in. × 14 in. – 24 in.). Suitable stitch techniques will be found in that section and most of the white work or linen methods also apply (169, 170, 171).

Matzot cover

'During the Passover seder service, which is usually held at the family dinner table, a cover with three pockets, each containing a single sheet of matzah, is used as part of the symbolism of the service. The cover is made of fine silk, velvet or linen and embroidered with examples of the many types of food which are symbolic of the story of Passover.'

The Matzot cover can be made to any shape, square, circular or rectangular, and approximately 31 cm × 38 cm (12 in. × 15 in.) in size. The treatment of the edge may present a problem, and calls for creative ingenuity. Again stitch treatments worked with coloured threads, and any of the white work or linen techniques are suitable. Reference to the section dealing with embroidery techniques will be rewarding.

To make the simple, modern matzot cover, select any thin but firm material, cotton would be suitable. Take diameter measurements of 46 cm, 38 cm, 30.5 cm and 24 cm (18 in., 15 in., 12 in., 9.5 in.) adding 2 cm for turnings. Complete the embroidery upon one smallest circle, and press flatly.

Putting the right sides of each pair of circles together: stitch by hand or machine around the edges, leaving about 8 cm open: pare down the turnings and nick, as shown at 215A.

Next, bring the right side through the opening, manipulate the seam to form a good circle. Fold in the turnings of the opening and slip-stitch the edges together (215B).

There are many ways in which the outside edges can be decorated, simple machine or hand stitched borders can be worked (215C).

After pressing each, the four layers are placed one

217A, B Two hangings: Dan (serpent) Napthali (hind) from a series of twelve representing each of the Tribes from Israel, designed and made jointly by Judy Barry and Beryl Patten, 1978. Each hanging, 305 cm × 122 cm (10 ft × 4 ft), bears the name of the tribe it represents and a suitable inscription from Genesis relating to the image. Machine appliqué and bonding techniques were used with Cornely machine moss stitching. They were worked on a heat fusible backing before being cut and mounted onto the background fabric. The hangings range through the spectrum from red to purple round three sides of the synagogue

Yeshurun Hebrew Congregation, Gatley, Cheadle, Cheshire

over the other and each secured with invisible stitches to the layer underneath, but only at the top, bottom and sides in order that the matzah is accessible from all sides (**215**D).

It is important to think out imaginative ways of finishing edges as an interesting alternative to machine-made fringes. Some suggestions for doing faced edges are given at **216**A. The right side of the facing is put to the right side of the article, after machine stitching, cut down the turnings and snip into the points (**216**B). Turn through, cut down the width of the facing and either hem invisibly on the wrong side or stitch decoratively on the right side, thereby attaching the edge of the facing to the main fabric (**216**C). The method for doing points is the same, except for the cutting, which is shown at **216**D. A hand-made fringe makes a good washable finish (**216**E), or by using a greater number of threads in the needle, attractive tassels could be made (**216**F). Variations of scolloping can be enhanced with the addition of tassels (**216**G). Other edge treatments will be found in the section dealing with linen embroidery.

Book covers

An embroidered book cover can both personalise and enhance the value of any book, be it the Bible (**213**), Prayer Book or Haggadah. The cover should be designed so that neither the embroidery or the material will lead to a clumsy result. Instructions for making one type of cover are given (**145**). The measurements must depend upon the actual book.

Bible and book markers should be made of soft thin silk, and the embroidery kept light and flat to avoid damage to the page or binding. Large pulpit markers are about 41 cm – 61 cm long and 7 cm wide (16 in.–24 in. long and $2\frac{3}{4}$ in. wide) – suitable for most Bibles, and for Prayer books 20 cm–26 cm long × 5 cm wide (8 in.–$10\frac{1}{2}$ in. long × 2 in. wide). Examples of Passover Pillows are shown at (**213**) with instructions for making-up (**143**).

Wall hangings and panels

In the Synagogue there is scope for its enrichment with the creation of really imaginative hangings – on a large scale to read from a distance. The use of bold colours can strengthen the symbolic design subject. Typical of other commissions was that for twelve big panels to enrich the walls of an otherwise rather plain building. Judy Barry and Beryl Patten carried them out in machine embroidered appliqué. The stipulations relating to the briefing imposed a restraint upon the designers (**217**A, B). (If only those

218 Wedding Canopy (Chupa) marriage contract (Ketuba), 243 cm × 122 cm × 152 cm (8 ft × 4 ft × 5 ft) designed and worked by Joan Koslan Schwartz, 1976. Machine appliqué and stitchery
The Cong-Emanu-El, San Francisco, California

who commission could have complete confidence in artists.) The making-up would follow the process for a banner or funeral pall (**130**).

Wall hangings for the Jewish home also draw upon the wealth of traditional symbolism and ritual, together with calligraphy as an inspiration for design. For these panels, all embroidery methods can be employed if used with imagination, the aim being to obtain interesting, elusive or meaningful visual effects. Jerusalem as a subject for decorative interpretation can be carried out in many embroidery methods. These techniques can be found in that section which deals with the subject.

The Chuppah, or wedding canopy

The wedding canopy has a very early origin: the tent-like covering is fastened to four poles (**218**) and

219 *Jerusalem* a wall panel, designed and worked by Estelle Levy, Maida Vale, London. Embroidery is used for ceremonies in the home and to adorn the room.

is either made of plain material or enriched with embroidered symbols. There are some beautifully designed and executed modern examples of marriage canopies in America. Because the design needs to be on a large scale, appliqué can be used to advantage. Modern adhesives and machine embroidered appliqué could well be used to obtain the bold effect which is necessary for something so large (about 92 cm × 107 cm − 36 in. × 40 in.). Where there is a tradition of floral decoration, the canopy is usually without embroidery.

Joan H Koslan Schwartz, whose embroidery is well known in the US has said 'I consider myself bound by what is truly timeless in Judaism − the Laws of Torah (Pentateuch) − and not by anachronistic customs picked up at various times and places during the Diaspora.

'Much of my work is based on texts of Torah and other parts of the Bible − I want my stitcheries to express in design, colour, texture, and embroidery the essential meaning of the texts I use. It is important to me that these texts be interpreted anew for each generation, and be made fresh and alive again. This is especially necessary today, when the temptations of assimilation are so great. I want to capture the beauty and wisdom of the Bible in vital art.'

When planning her individually designed embroidery commissions, she stresses the importance of conferring with the rabbi or priest concerning the theme, and talking, not only with the client but with all those who are concerned in the project. Having derived her inspiration from the Bible, she makes sketch designs, drawings or models which, with patterns of materials, are submitted for approval. When the work is finished they have adopted the practice of billing and requiring payment before delivery.

CHAPTER VIII
Embroidery for ceremonial, regalia and badges

It is not surprising that during the sixteenth and seventeenth centuries in particular, the embroiderers who worked with purl and bullion were highly paid and esteemed. This specialised form of stitchery which is used for ceremonial Regalia, badges and Masonic work is mainly produced in professional workrooms. Margaret Forbes writes 'where many embroiderers are trained and employed to work together, apprenticeship schemes last from two to three years, which is necessary, as this type of embroidery is very precise and requires a high degree of technical skill and accuracy. As some of the pieces of work are large, several embroiderers work together, and there is no scope for individual interpretation; their work must be as nearly as possible alike and therefore anonymous, so that the whole approach is almost the opposite of embroiderers trained in art colleges where individuality is paramount.

If ceremonial embroidery is understood the interest is increased when the whole panoply of ceremonial can be seen, and detail examined at the Museum of London, National Army Museum, the Tower of London and in some of the National Trust properties.

This type of embroidery varies little, the designs are mainly traditional, though the drawing alters stylistically over the years. As the stitchery remains much the same this can lead to monotony and debasement. Such an example is the present Chancellor's Purse which is very similar to the one used in the late seventeenth century when stump work was the vogue.

Many of the designs are heraldic, the Royal Coat of Arms or the Royal Cypher and Crown are most frequently worked. All heraldic designs used for official purposes have to be passed by the College of Arms, to ensure that they are heraldically correct.

Ceremonial embroidery covers a wide field.

The Coronation robes

The design of these robes is almost Byzantine in origin, and is certainly ecclesiastical as well as temporal. The Colobium Sindonis is a long sleeveless robe made of white linen, open at the sides and edged with lace, and tied with a linen girdle at the waist. The Dalmatic is made of cloth of gold, with short wide sleeves and woven with a design of green palm trees between pink roses, green shamrocks and purple thistles. It is lined with rose-coloured silk.

The stole is made of cloth of gold, lined with rose pink and is about five feet long and fringed. At each end there is a panel embroidered with the red cross of St George on a silver ground. The Pall or Pallium (Imperial Mantle) is made of cloth of gold with a design of silver coronets, fleurs-de-lis, green leaves, shamrocks, purple thistle and silver eagles. It is shaped like a cope but has four corners instead of a rounded hemline. These garments are displayed at the Tower of London. The Imperial Robe of Royal Purple (red velvet trimmed with gold braids for the King) is worn for the procession out of the Abbey after the crowning. The robe is of purple velvet trimmed with ermine with satin ribbon bows, cords and tassels at the shoulders. The Queen's train is embroidered with gold and silver metal threads. Being individually designed each one is different and allows for inventive interpretation. The design of the dress for Queen Mary (220) is composed of scrolling leaves and flowers. Queen Elizabeth II's robe (221) has a design of sprays of olive branches and wheat, symbolising peace and plenty, and worked entirely in gold purl. On all three trains is incorporated the crown and royal cypher, the style of which varies from reign to reign. These are on view at the Museum of London.

Court dress and diplomatic uniforms

Examples of these lavishly embroidered uniforms can be seen at Windsor Castle. On state occasions, the eight Great Officers of the Realm and the Lord High Steward and Master of the Horse still wear uniforms richly embroidered in gold purl. The Livery of the Royal Coachmen, the postillions, grooms and footmen who accompany the coach consists of red cloth decorated with gold braids.

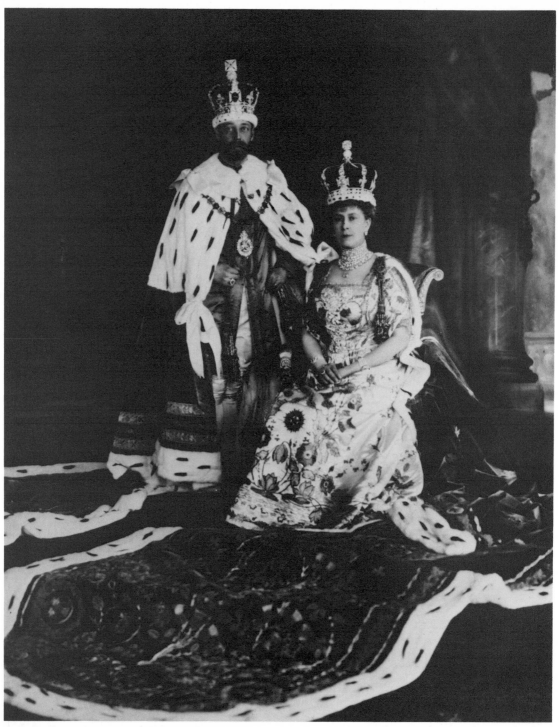

220A, B *Above and opposite* The Coronation dress of Queen
Mary, 1911. Cream satin embroidered with gold

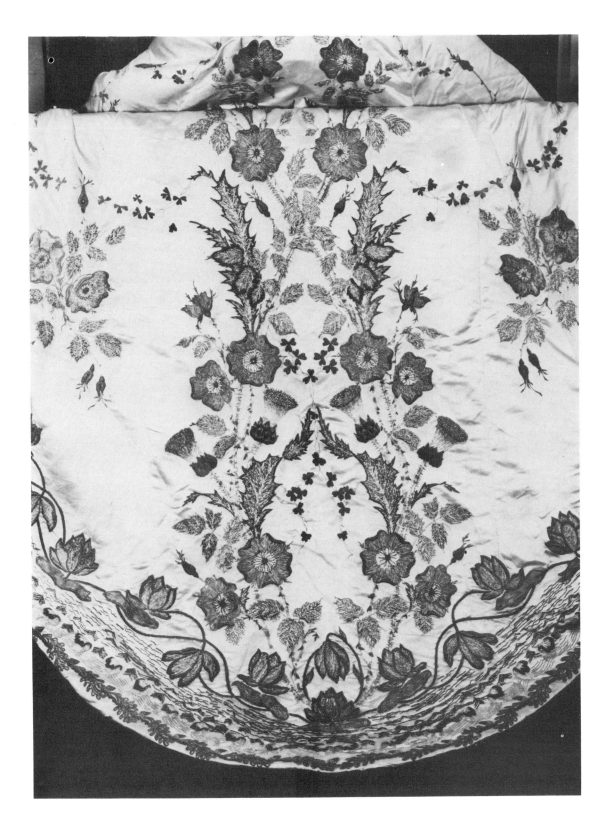

The Yeoman Warders' uniforms

Also known as the Beefeaters, they wear a uniform of Tudor design; it is red trimmed with black and gold braids with isolated motifs and an embroidered crown, royal cypher and emblems in coloured silk embroidery.

The Bargemaster and Watermen

The splendid Livery consists of a red coat and breeches with black caps (similar to jockey caps). On the back and the front of the coats is a crown, coat of arms and cypher in metal (not embroidered).

Heralds' tabards

The College of Arms is a body of officers of arms of the Royal Household. It consists of three Kings of arms, whose tabards are of velvet, six heralds of arms whose tabards are of satin and those of the four pursuivants are damask. They are subject to the jurisdiction of the Earl Marshall. The tabards are of medieval origin, the design consists of the Royal Coat of Arms on the back and front, and also on the sleeves which are loose and cape-like (**222**, **223**).

221 The Coronation Robe of Queen Elizabeth II. Gold metal thread embroidery on purple velvet. The picture shows the length of the train framed up and being embroidered in the workrooms of the Royal School of Needlework, London, 1953 *The Museum of London, Barbican*

Originally the tabards were embroidered with gold metal threads, but the more recent replacements have been carried out in appliqué outlined with cords.

The Lord Chancellor's robe and Judicial robes

These robes are of black damask with a wide band of gold braid down the front and round the hem. On the sleeves and continuing down the sides are bands of gold lace and gold purl embroidery. In about 1617 the same type of robe became the official dress of the Chancellors of the Universities of Oxford and Cambridge, with the addition of gold rosettes on the sleeves and in the centre of the train. In the same century it was also worn by the Privy Councillors and so is now worn by the Chanceller of the Exchequer at Coronation Ceremonies.

The Lord Chancellor's Purse

At one time this was known as the Bag of the Great Seal (**224**). (Today the bag is used to carry the Queen's Speech to the throne at the State Opening of Parliament.) It is embroidered in coloured silks with gold and silver threads upon red velvet. The cherubim heads are raised embroidery over wooden moulds, much else is heavily padded: this is a modified form of stump-work. The Royal Standard

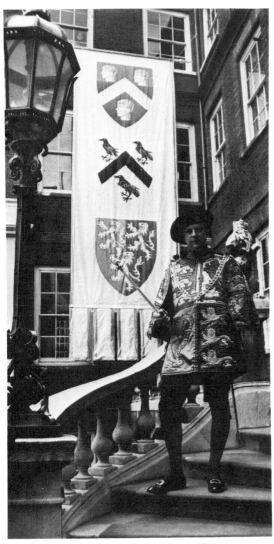

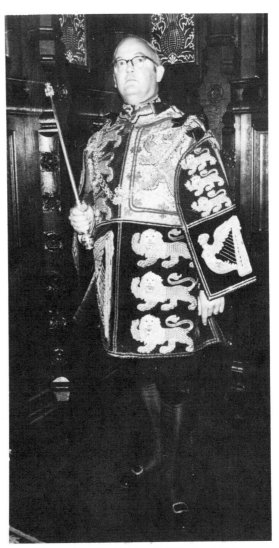

222 Windsor Herald wearing Tabard and holding the sceptre or wand carried when taking part in a State or Royal ceremonial. Pennant designed in the College of Arms and displayed at Caernarvon Castle during the Investiture of HRH The Prince of Wales

223 Richmond Herald, depicting the Tabard and Chain worn by Heralds, with ceremonial sceptre or wand, and breeches and stockings. Tabard carried out in appliqué and gold work

hangs in St George's Chapel, Windsor. It is very large, the Royal Coat of Arms is carried out in appliqué and cords, with details such as the claws and tongues, etc. in long and short and satin stitch. The lions and harp are padded with carpet felt underlay. The first and fourth quarters have a red velvet ground with cloth of gold appliqué: The second quarter has a red velvet lion with cloth of gold ground, and the third a blue velvet ground with cloth of gold appliqué for the harp. All the main shapes are outlined with cord, gold and red, the immediate details are delineated with finer cords.

One of the oldest extant examples of this type of heraldic embroidery is the Jupon of the Black Prince, which rests on his tomb in Canterbury Cathedral. The replica is of recent workmanship.

Military uniforms and accoutrements

In the past, military uniforms and accoutrements such as the Grenadier 'mitre' caps, sabretaches (for provisions) (225), pouches (for ammunition), sashes, epaulettes and horse furniture were richly embroidered, examples can be seen at the National

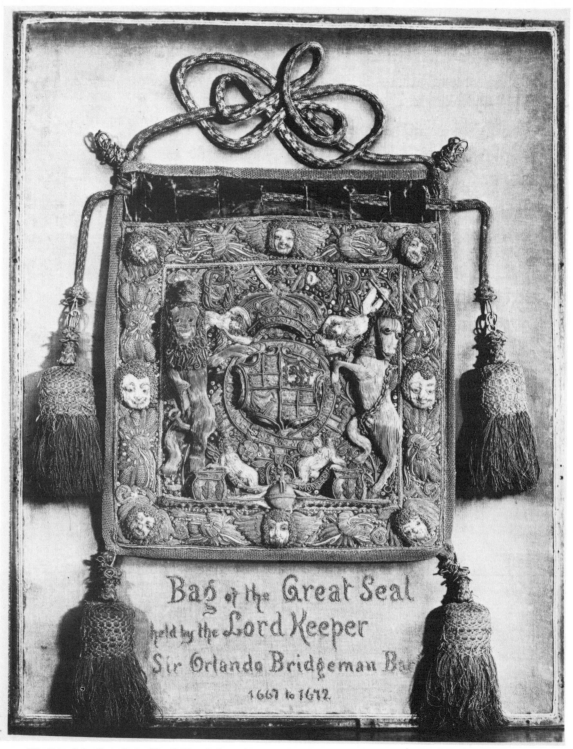

224 The Bag of the Great Seal, 1667. Gold and silver wire threads on velvet

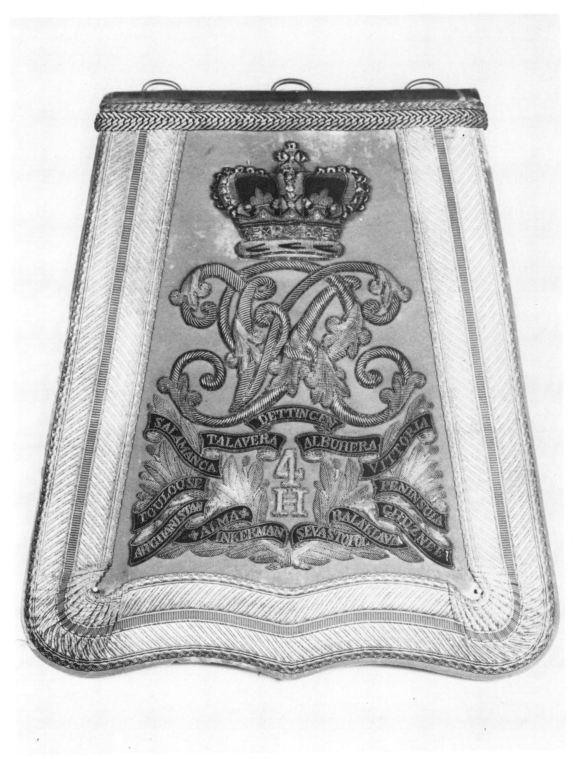

225 Sabretache 4th Hussars, 1860–1899. Scarlet ground, blue
honours, gold embroidery in rough and smooth purl.
Outlining in bead or pearl purl
National Army Museum, London

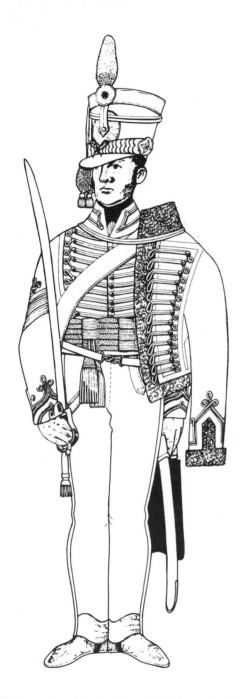

Army Museum, London. Today embroidery has been reduced to collars and badges on full-dress uniform with the addition of belts for high-ranking officers. Drum majors' and Trumpeters' uniforms consist of a red tunic heavily decorated with gold braids of various widths and embroidered with motifs of the crown and Royal cypher on both back and front.

The decoration on the ceremonial uniforms of the top-ranking of the Navy and Air Force is also embroidered in gold and silver purl work. The silk stitchery of some badges is machine embroidered.

Flags, which are distinguished as Standards, Guidons and Colours are made of a finely ribbed silk and embroidered with coloured twisted silks. The design is embroidered in long and short stitch and satin stitch through a single piece of silk, so that the design is identical on both sides. The battle honours, ie, the names of the principal battles of the regiment are embroidered on scrolls, and are worked in duplicate, one set on the front, and in order that it shall read correctly, the second set is applied to the reverse side. The edges of the scroll are then satin stitched simultaneously with the 'front'. The flags are fringed round three sides, the fourth having a slot to take the pole. Examples are displayed at the National Army Museum, London. When the Colours are replaced the old ones are laid up, usually in a church. Some of these old colours are preserved between two layers of net to keep the fragments in place.

Pipe, drum and trumpet banners have the design of the Royal Coat of Arms embroidered on them in coloured silks and gold thread.

226a Seargeant, 10th (or the Prince of Wales' Own Royal) Hussars, 1815. Blue jacket decorated with gold braiding. Pelisse, the jacket is braided in gold with brass buttons; it is blue trimmed with black fur, and is slung over the shoulder *National Army Museum, London*

226b Braids, cords and rat tail can be adapted for use in church embroidery

227 Royal College of Art. Academic robes designed by Joyce Conwy Evans, 1967. Weaving by Edinburgh Tapestry Company (Dovecot Weavers), embroidered by Elizabeth Geddes. Front view of Provost's robe. Also trumpet
Exhibited at the Victoria and Albert Museum, London

The Lord Mayor of London

The Lord Mayor has six gowns for different occasions, one of which is known as the Entertaining Gown in black and gold with a square collar; it resembles a chancellor's robe.

Badges

For blazer pockets and a variety of other uses, badges are usually carried out in the traditional methods of gold purl work and some silk; others are embroidered with cotton, in hand or machine embroidery.

Station masters' caps were embroidered with gold purl.

Masonic banners conform to traditional designs, and methods of work, these have been developed from the military banners, with the decoration on the front only. Some Masonic embroidery is worked with wire threads, passing, also Grecian and other cords, upon white kid.

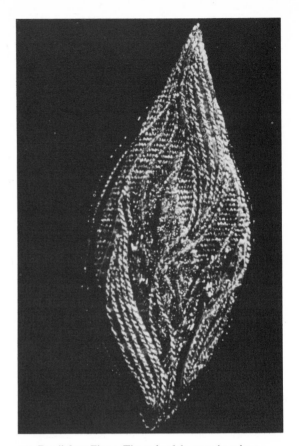

228 Detail showing the warp threads of the tapestry weaving

229 Detail from Flame. The ends of the warp have been turned in

Girl Guides' standards are carried out in methods adapted from those used for regimental colours. But instead of one layer of silk for the flag, there are two complete sides which are joined together. The larger motifs are in appliqué and the smaller are worked in long and short stitch.'

This traditional ceremonial embroidery continues to be made, renewed or repaired, but, so often, in the process it recedes a little further from its glorious origins in the age of chivalry.

We have seen that, with fewer people possessing the specialised skill and with the repetition of traditional designs, the scene might be considered unpromising. Yet, surprisingly this is not so. There is every sign of a revival – an injection of new life – stimulated, in part, by the commissioning of the ceremonial robes to be worn by the officers of the Royal College of Art in 1967, upon its elevation to University status, by the grant of a Royal Charter (**227**).

Academic robes

The set of four academic robes, for the Provost, Vice-Provost, Pro-Provost and Pro-Rector were designed by Joyce Conwy Evans. The theme is the phoenix resurgent, with the college emblem of a crowned phoenix represented heraldically on the Provost's hood (**232**), together with a symmetrical arrangement of flame motifs on the sleeves of all the robes, in number, colour and embellishment according to rank, and on their front panels (**230**) a continuous pattern of ascending flames. The method of decoration breaks with tradition in that it is carried out in tapestry weaving, with embroidery superimposed to lend extra definition, colour and texture.

The weaving is executed by the Dovecot Studios in Edinburgh, in gold, silver, aluminium and other wire and lurex threads at 12 warps to the inch (12 warps to 2.5 cm). The embroidery by Elisabeth Geddes assisted by Audrey Morris and Margaret

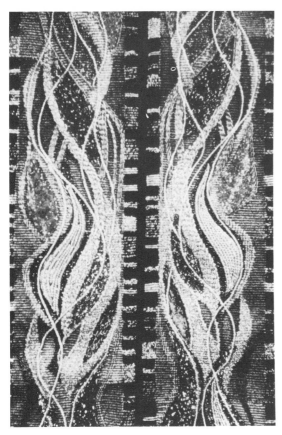

230 Detail of tapestry-woven orphrey, gold and black with superimposed embroidery mainly gold

Humfrey is couched jap gold, silver and aluminium cord, small areas of applied gold and silver kid and lurex fabrics, and in addition a little gold laid-work and black outlining for the Provost's collar.

The surplus fringe of warp threads which were left surrounding the flame motifs (228, 229) after being cut from the warps were turned to the back and fixed down before each flame was sewn in position. This procedure plus the combined weaving and embroidery raises the decoration in fairly high relief, which traditionally would be achieved by working over padding (232, 233B).

The importance of presentation has been noted elsewhere, here is a perfect example which shows the foresight necessary when submitting a scheme. Joyce Conwy Evans made a model which conveyed her idea more clearly than could any written description or countless sketches. This was supplemented by her designs and details worked to full size (231).

These robes and the trumpeter's banner (233) were

231 The model made by Joyce Conwy Evans to convey an impression of her design when realised

exhibited at the Victoria and Albert Museum, London. They must have a direct influence upon the development of contemporary ceremonial embroidery and its subsequent acceptance at the highest level. Gradually the emphasis has been shifting towards the well designed and imaginative work being produced by the Colleges and Schools of Art, also Polytechnics, where, in many instances, there is also the specialised background knowledge and the technical skill to carry out these lively designs with a matching degree of invention. Is it too optimistic to see in this undertaking the recognition of the fact that both the purpose of embroidery, and its practical application, may be returning to the importance and esteem in which it was once held?

Does this converging of the two streams, the direct development from the traditional academic gowns, and the adaptation of ancient skills to express twentieth-century inspired, creative design herald a resurgence of interest in, and an acceptance of, embroidery at a higher level?

The inception of the Open University is of the present day and the academic robes reflect the spirit of the arts of today in their design (234).

232 *Left* Detail from the hood of the provost's robe tapestry weaving and embroidery, in various golds, black and cream
233 The RCA college trumpet of silver parcel gilt with banner by Joyce Conwy Evans worked by Elizabeth Geddes, background tapestry woven. *Royal College of Art*

Metal thread and bullion work

Embroidery used for ceremonial purposes remains specialised and the method imposes its own characteristics. From the early sixteenth century gold work was in common use, as this later quotation shows: '. . . several sorts and manners of work wrought by the Needle with silk in Natures, Purles, Wyres, etc.' The wire purls from the basis of the technique, they were often twisted with coloured silks when combined with other stitchery upon household objects and dress, for example the gauntlets of gloves, which were important as presentation gifts, a custom which persists as a part of the Coronation ceremony. Being durable this method of embroidery was used for bookbindings. But in the eighteenth century in France and England much of this wire work was unpicked for the gold content, as a fashionable pastime, it was known as parfilage or drizzling.

Purls and bullion are made by spinning fine gold or silver covered wire into long, finely coiled tubes. Though variously named, the three qualities are usually known as Admiralty, best and gilt.

Types of technique are no longer isolated, so wire work can be found incorporated with other forms of stitchery in unexpected ways.

Individual embroiderers adapt traditional methods, using them freely and developing the virtues of all kinds of gold work by contrasting the colour of the metals and their textures: juxtaposing flat gold against raised, smooth with rough and dull with shiny surfaces.

The creative designer-embroiderer of today uses the purls and metallic threads with imagination, appreciating the textural quality and the adaptability of the line obtainable with pearl purl. As the necessary skill is mastered, the limitless interesting experimental variations of wire-work become apparent. The burse (237) shows heavily padded shapes and a contrasting texture produced with bullion in shades of gold.

Whatever the interpretation, the technique remains basically traditional, and for this reason, only the simple basic methods are given in the diagrams.

Technique

Most of the work on badges, uniforms, etc, is carried out in satin-stitch. To do this the pieces of purl are cut to the required lengths, and are threaded like beads which are stitched with waxed cotton or strong silk over a template cut to shape in card, parchment or thin leather or over a padding (235a). 238a,b,c,d are finished examples worked in this way (236). In the slanting satin-stitch shown at 235c the contrasting purls are stitched over a padding of string or felt sewn

234 Open University robes. *The Open University*

235 Diagram showing the stitching of various types of purl

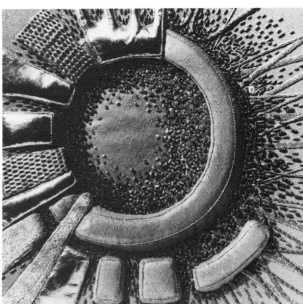

236 Crown, satin stitch in rough purl, worked on velvet, padded

237 *Right* Burse, part of a festal eucharistic set designed and worked by Beryl Dean 1969. Cloth of gold. The three-dimensional effect is achieved by padding with felt. Several kinds of gold braid and thread, including bullion
The Parish Church, Dorking, Surrey

down. Satin stitch can also be used for lettering.

For commercial work each motif may be carried out upon a foundation of card or buckram, which is, when complete, cut out and applied to the background material, or it is stitched directly on to the article (**235**b). The three kinds of purl (or perl) used for wire work are Rough purl, which has a matt finish, Smooth, which, as its name implies, has a smooth shiny surface, and Check purl is textured. These are spun in gold and silver: the sizes vary from no.8 fine, up to bullion which is thick, it is made in

lengths and sold by weight, (this applies also to Jaceron, obtainable in the States). Either Rough, Smooth or Check purl can be cut into short lengths and sewn to form little raised loops **235**d, or for working stem-stitch, lettering (**235**e) or for attaching spangles singly or as a row, as at **235**f; stem-stitch is an alternative. The formation of a chain (**235**g) is often seén in heraldry and long and short stitch, also many other stitches can be worked in purl. To sew very small pieces of Check purl (chips) closely together (**235**h) on to a padding gives an attractive texture. The cut lengths and the spacing can be varied to produce a contrasting surface texture, which is used in present-day embroidery (**237**).

Padding

To pass the purl or plate over a raised form gives an additional play of light (**238**g). This padding used to

be achieved with a thick linen thread. The padding was worked in split stitch or it could be formed by laying bunches of threads on the surface, these being couched down with a finer thread, which raises the top without adding bulk underneath. But it is now more often carried out with felt (235i). The first layer is the smallest, it is sewn or stuck in place, each subsequent layer is increased in size, and for the final padding the outline of the design is pounced on to the felt, so that it can be cut out accurately, and sewn with small stitches around the edges to the background fabric; this is important for intricate heraldic charges. When large-scale devices have to be raised away from the background, very thick carpet felt is modelled, as it is shaped and cut with the scissors. Substitutes, such as polystyrene, thicker card or balsa wood can be carved into three-dimensional forms, and attached to the background, but it is difficult to stitch through these materials.

In stump-work, as an alternative to the covered wooden moulds, another traditional method of padding was employed. The object, an animal for example, was worked in tent-stitch on linen, and cut out, then sewn around the outline to the background, leaving a gap through which the stuffing of wool or tow was pushed. In a simplified form this method is still used, as shown in **diagram 235j**. Here a circle of cotton fabric is sewn down on three sides, matching up the half and quarter marks with those of the background, and stitching these first, then poking in the wadding or wool through the gap with a stiletto, this is finally sewn down.

Another wire purl, used for outlining, is called pearl or bead purl. It is obtainable in several sizes, from superfine, which is excellent for intricate detail up to the thick heavier sizes. Each supplier has his own way of identifying these sizes. Before starting, this twisted wire has to be stretched, so that the sewing thread can slip between the twists (235k). When the pearl purl is cut it will be noticed that a little hook is formed; to start sewing, take a tiny stitch across this hook to secure it to the material (235k). The subsequent stitches are taken at intervals over the purl, the ending is the same as the beginning. When outlining a circle a perfect join can be made. A better line is kept if the outline is sewn in place before working the filling.

Also used for embroidery in ceremonial, regalia and badge work is passing thread (and tambour), it can be couched down in the same way as for Jap gold, or the passing thread can be threaded into the needle for stitchery (238e), and, for the foundation of burden stitch, worked with rough, smooth and check purl (238f), or silk.

Plate is a narrow flat strip of metal, it can be couched down flatly or crinkled, but more generally it is taken from side to side over a padding, being sewn at each folding (238g,h).

Combined with wire work are the sewn or clip-on jewels, studs and spangles, but sequins, unless used with discretion, can look cheap and flashy.

Conservation and restoration

In the conservation of embroidered fabric, nothing is taken away and nothing is added to the original beyond what is necessary to preserve it and, if

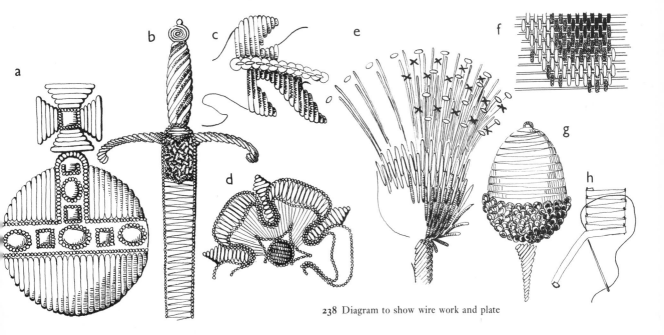

238 Diagram to show wire work and plate

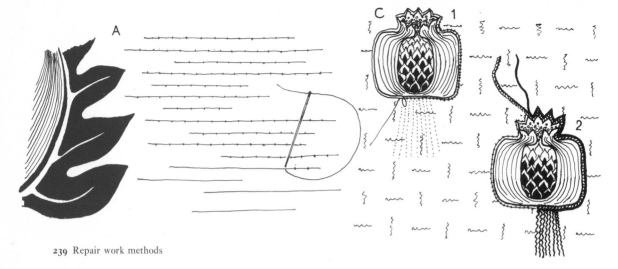

239 Repair work methods

possible restore the position of the remaining embroidery to its original composition. Anything done to the work should not be irreversible in case some better method is found in the future. Restoration means repairing or replacing worn out parts of embroidery so that it is renewed and strengthened for further use. The choice depends on the embroidery itself. If it has a rarity value or is of historical importance then it should be conserved, and preferably by a trained conservator. However, the conservation or restoration of most family heirlooms and some church embroideries can be safely undertaken by any skilled needlewoman.

A textile should be as clean as possible before receiving any treatment of conservation or restoration, and the pitfalls should be thoroughly understood before tackling any cleaning.* Dealing with old textiles is specialised, and is not like ordinary washing and cleaning, for instance some of the vegetable and early aniline dyes are not fast. To avoid irreparable damage the subject should first be studied. The whole matter is dealt with very comprehensively in chapter 4 of the book *Caring for Textiles* by Finch and Putnam.

The silk background fabrics of some embroideries, such as chair seats, hangings and frontals sometimes become badly worn although the embroidery may be intact. There are several ways of restoring or repairing such backgrounds. Method A by tramming; method B by covering with net and method C by replacing the old background with new

* NB For fabrics other than older and rarer examples, a fairly safe cleaning agent for removing certain marks is carbon tetrachloride, which can be gently rubbed on with cotton wool, the fabric being held over a clean cloth.

material.

The method decided upon will depend upon the degree of disintegration of the silk. If it is only slightly worn or frayed the first method, tramming, is used. To do this, remove the lining if it is a frontal or something similar, then, if the original was correctly made with a backing, frame the whole thing up in the usual way. But if there was no backing, frame up a piece of linen or unbleached calico, which is about 5 cm (2 in.) larger all round, wash, to shrink it, and remove any dressing. Frame it up (240) and with the frame kept at a fairly loose tension, apply the embroidered fabric, as already described. Then tighten up the frame and brace the sides so that it becomes taut. Using the finest matching silk threads, lay long parallel stitches on the surface and tie these down with short perpendicular stitches at about 6 mm ($\frac{1}{4}$ in.) intervals, alternating them with the next row, to give a bricked effect, the beginnings and endings are staggered (239A). When all the worn areas have been treated, remove the work from the frame and replace the lining.

As an alternative method, very fine nylon or terylene net can be placed over the whole embroidery. If a matching net is not available, it can be dyed. Frame up the work as before. Having covered the whole area with the net stitch lightly at intervals. Remove from the frame and replace the lining.

When the silk background is very badly worn and beyond repair, it can be replaced by new silk. This method is only feasible when the design consists of fairly large motifs which can easily be removed. First, cover the whole area of the work with Cello film, and trace the design with a fine felt-tip pen. Prick, pounce and transfer it on to the new

background (242). Prepare and frame up the backing as before, then apply to it the new silk background. Cut out the embroidered motifs and place them in position upon the new ground. The tension of the frame should be loose at this stage. Pin and stitch the embroidered motifs (239C1). When this is completed, tighten up the frame and cover the raw edges with fine cord or cords (239C2), or with couched silk. Complete as before.

If any part of the embroidery is worn or broken, match the threads as nearly as possible in colour and fibre and re-work the embroidery, using the same stitches as in the original. Sometimes the resulting appearance is rather hard; the effect can be softened by the addition of some fine couched patterning on the background as shown in the diagram.

Sometimes metal threads, especially those which are couched, become detached, because the silk used for tying down the metal threads gets broken or worn away. The gold or silver threads themselves are usually intact, though somewhat tangled. The original paint line or needle holes may still remain and can be re-used. Re-arrange the metal threads, pinning them in place, using fine lace pins, then couch the threads down again using a thread as near as possible to the original. This type of work must be framed up (see pages 214–217).

Chair seats, stools, cushions, handbags, etc, worked in canvas embroidery will have sustained hard wear and may require repairing. It is advisable to frame up, not only because the work remains flat, but it may not require stretching when completed. Should a backing be required for strength or to facilitate the making-up, a linen scrim is used. If there is a hole in the canvas, a patch of similar canvas is placed on the wrong side of the work, this is stitched in place before the whole piece of embroidery is backed with the scrim. But if there are only one or two threads of canvas missing, replacement threads are darned in, using linen button thread. This requires some care to prevent further damage. To replace worn or broken stitches, crewel wool – or stranded cotton for the silk areas – is used in appropriate colours and thickness. If it is a beaded piece, old beads should replace those missing, otherwise stitches worked with stranded cotton are a substitute. Obviously, the same stitches as used in the original are worked when doing the repair.

For smaller holes in tammy cloth or fine wool, bring the broken threads to the wrong side, and darn in the missing ones from the wrong side, using threads unravelled from the edges. The under and over of the weave must be matched up.

CHAPTER IX
Embroidery techniques

Equipment

The advantages of framing up for church embroidery are several.

1 It prevents puckering and keeps the work flat.

2 Both hands are free to manipulate threads, cords and materials. Increased speed results.

3 Some of the methods, such as laid-work and goldwork cannot be worked in the hand.

4 When there is a large area of material, creasing is avoided.

For embroidery, strong slate frames (four pieces, rectangular), with split pins or pegs, are recommended, the size is determined by the length of the webbing. A professional embroiderer will possess several in sizes up to a measurement of about 2.5 m or 3 m (8 ft or 9 ft) (if made with new wood they are apt to warp).

Trestles, as shown in **240.2**, support the frame and can be adjusted as the top bar is movable. Substitutes can be improvised.

Implements required for ecclesiastical embroidery include small, very sharp scissors with strong points, and a larger pair for cutting out; steel pins; a packing needle, large enough to take string; a ball or hank of string; reels of button thread (strong); measure, two thimbles (if used); crewel needles of good make (nos 8 and 9 are most used), also some sharps for making-up, Chenille needles nos 18, 20 and 22 are used for taking down the ends of gold thread. And for canvas work, tapestry needles nos 18, 20 and 22. A stiletto. Working threads are passed through bees-wax to give additional strength. Hammer, nails, drawing pins or thumb tacks. Weights.

Framing up or dressing the frame

It is almost always essential to have a backing for church embroidery, because the methods used pull upon the fabric (but for machine embroidery this does not often apply). White or unbleached linen or holland, or unbleached calico can be used for the backing; it must be thoroughly shrunk before use. The backing is framed up first.

Method 1

1 Cut the rectangle of backing material to the thread, and rather larger than the fabric to be embroidered. All materials must be cut with the selvedge running down.

2 At the top and bottom turn down a narrow turning.

3 At both sides fold back a turning, insert a string at the edge, and pin in place. Stitch using back-stitches at intervals (**240.1A**).

4 Mark permanently the exact centre of the webbing attached to both rollers of the frame.

5 Tack, or mark the centre of the backing; and place this to the centres of the webbing; when in position, pin keeping them at right angles to the edge, working outwards from the centre. Using strong thread, overcast, repeat for the second roller (**240B** and B). (If the work is large, a ridge can be avoided by placing the right side of the backing to the right side of the webbing, pinning and doing the overcasting on the wrong side.)

6 Slip the two side-pieces or slats through the slots in the rollers of the frame. (These flat laths have holes pierced at intervals along their length.)

7 Extend so that the backing is almost taut and insert the four pegs or split pins into the appropriate holes (**240.1D**). Check accuracy by measuring.

8 With string of sufficient length thread a packing needle – lace through the sides of the backing and over the side-pieces, as shown in the diagram (**240**). When some of the backing has been wound around the roller, leave extra string, and wind this round the ends, and tie off.

9 Cut by the thread, the piece of material to be embroidered (selvedge running down). Put a tack down the centre.

10 Place this fabric with the centre directly over the centre line on the backing.

11 Working outwards from the centre, pin with the head of the pins outside and pointing inwards.

12 Stitch with fairly long straight stitches as shown on the diagram, or use herringbone stitch. Complete the top and bottom, then the sides.

13 When complete – tighten up the frame and brace up the sides so that it is absolutely taut. It should always be tightened up when it becomes at all slack.

The diagram shows a frame set up for a small piece of work. For larger pieces, the width of the rollers must measure the width of the backing; longer side-arms are used to take the increased length, and to keep it all tight for stitching and painting-on to the outer fabric. This completed, the slats are withdrawn, the extra length rolled round one or both rollers, and the shorter sides put in. It is unrolled as the work proceeds.

Method 2

To frame up a large area of material.

This is a recurrent problem with hangings, copes, chasubles, etc, where the embroidery is surrounded by much embroidered fabric. A very large frame is not always the answer.

The drawing (**240**.2) shows one way of coping. The frame is of a size to take the area to be embroidered, and as it is not comfortable to have to stretch more than about 33 cm (13 in.), one starts with a width of 65 cm (26 in.), unrolling at both sides as required.

240. 1 and 2 Framing up

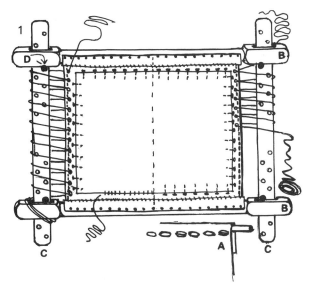

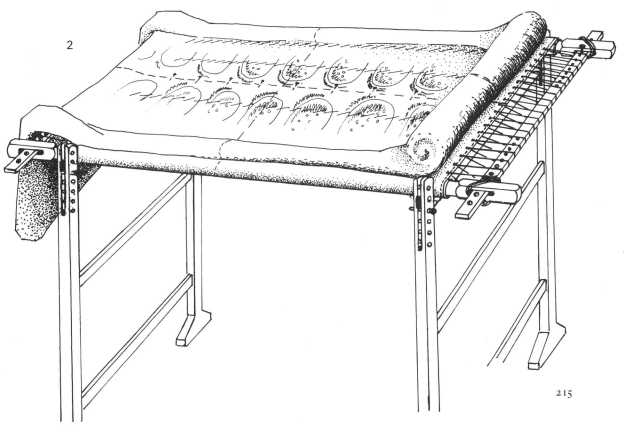

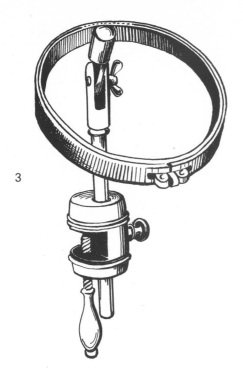

3

241. 3, 4 and 5 The tambour frame

Process

1 Cut the backing to the size of the embroidery plus a little extra. Prepare this and frame up as already described, allowing the backing to be very slightly slack.

2 Matching up the centres, place the fabric over the backing, smooth it out, pin, and tack.

Keep the tension of both materials the same.

Tighten up the frame by moving outwards the pegs and bracing up the string, it can now be very tight.

3 The design can be put on at this stage, or later (see Transferring and **242**).

4 Now, taking something soft, such as tissue paper, fold the surplus material over this, down the sides; then with more padding, roll the fabric over it at the ends. (Try not to lean on it whilst working, because deep creases will not always come out afterwards.)

First the backing, then the fabric is unrolled as the frame is extended. (It is not difficult to get longer side-arms made.)

Method 3

For speed and ease, units of the design can be worked separately and cut away close to the outline, then applied to the background; some units can be put over the joins. Details are worked in afterwards to

5

4

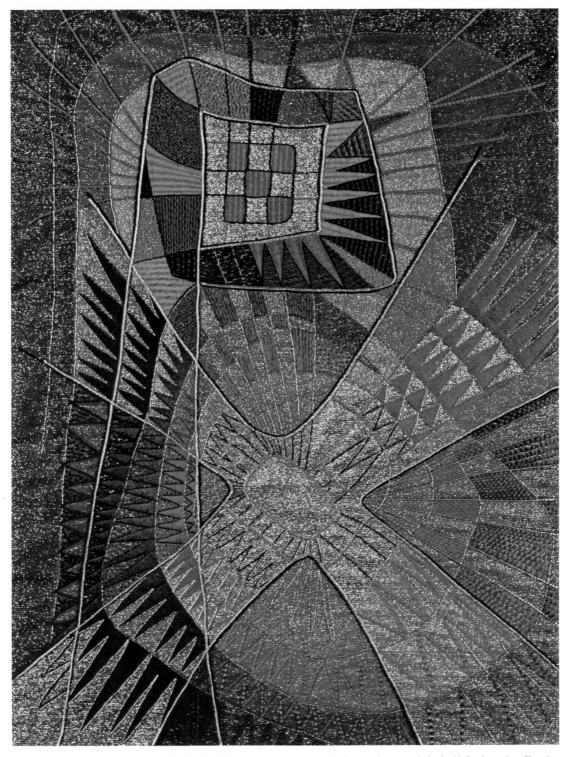

Plate I Pulpit fall, designed and embroidered by Beryl Dean, 1977. Surface stitchery upon the Chi Rho and background which is composed of layers of net over cloth of gold, for the ancient Church of St Mary, East Guldeford, Sussex

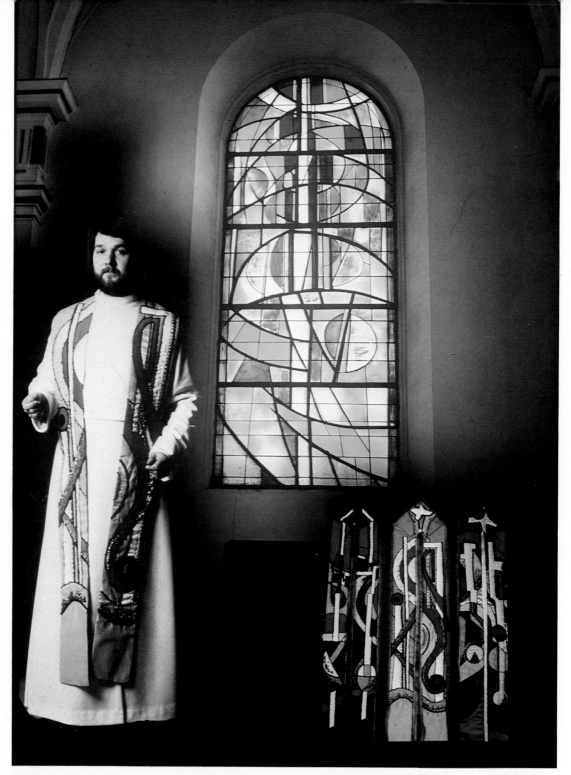

Plate II One of the cathedral windows by Ceri Richards which inspired the designs by the Reverend Leonard Childs for a set of wide stoles, 1977. The Celebrant's stole embroidered by Honor Redman and Pauline Morrison, appliqué in various textiles, wool cotton, silk and imitation raffia with wooden beads, worn with the white cassock-alb. Scapular for the Cross Bearer also designed by Leonard Childs, made by Grace Graham and Eileen Mills. Design based on the Cross as an implement of torture, flanked by candles; the Cross is a source of life, hence the egg shapes
Cathedral Workshop, Derby Cathedral

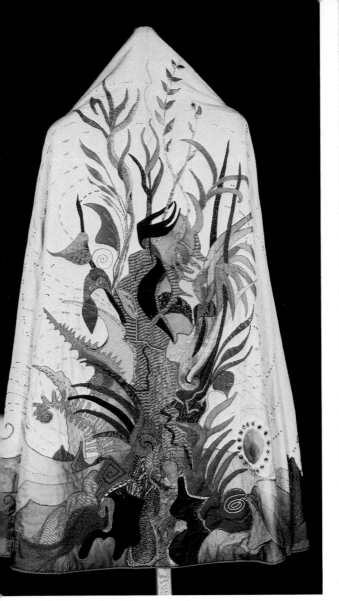

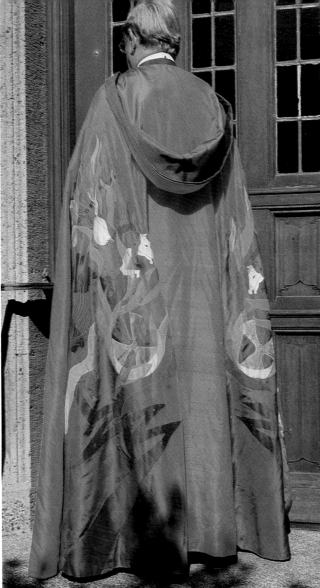

Plate IIIa Festal cope, designed by Marjory Morton and worked by Marjory Morton and Elizabeth Carpenter 1971 – The Tree of Life surrounded by the elements, worked on cream Italian silk chosen to go with the Bath stone of the chapel. Mainly applique with layers of organza with metallic bases, embroidery in metal threads, jewels and spangles
Eton College Chapel

Reproduced by courtesy of The Provost and Fellows of Eton and Chatto and Windus Ltd., from their title 'Treasures of Eton' by J D R McConnell, 1976. Photograph by Greville Studios, Slough

Plate IIIb Red cope, 'Behold the mountain and the horses with flames and chariots of fire', designed and embroidered by Anna Crossley. *San Francisco, California*

Above Trinity, *Below* Advent *Manchester Cathedral, Manchester*

Plates IVa and **b** Two of four sets of seasonal altar panels made to hang on the permanent Laudian altar cloth, designed and worked by Judy Barry and Beryl Patten, 1976. The panels are compositionally strong enough to read well from the back of the Cathedral, but also have sufficient detail to make them interesting when viewed from the communion rail.

They are worked in a variety of machine techniques with main features of the design achieved by appliqué

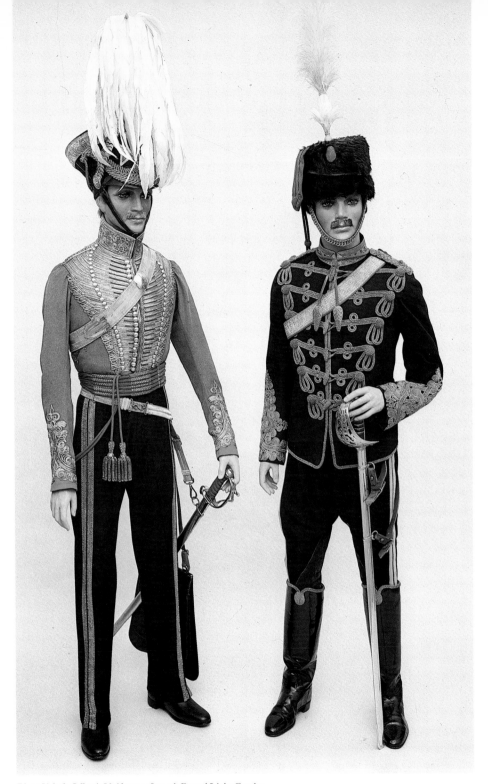

Plate V *Left* Officer's Uniform *c* 1832 4th Bengal Light Cavalry
Right Officer's Uniform *c* 1912 7th Hussars, Royal United Services Institution
National Army Museum, London
These and many other uniforms show an intricate use of gold and silver braiding

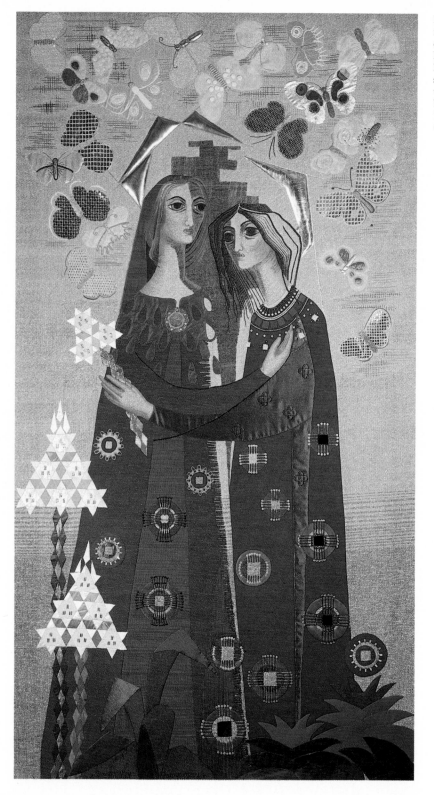

Plate VI 'The Visitation' 258 cm x 140 cm (8 ft 6 in. x 4 ft 8 in.), designed and embroidered by Beryl Dean, 1970. Background hand woven linen, features stitched in linen thread and fine wool, garments in appliqué, braids, cords, etc. and stitchery *The Rutland Chantry, St George's Chapel, Windsor Castle*

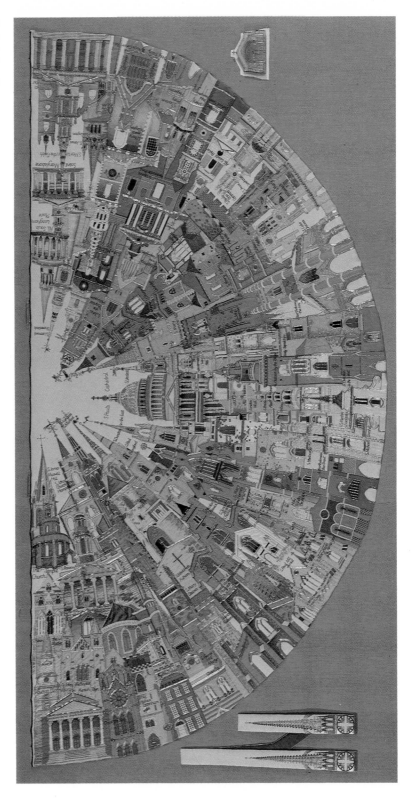

Plate VII Silver jubilee cope
designed and directed by Beryl Dean,
worked by members of her classes.
Presented to the Diocese of London, 1977.
Usually shown in the *Treasury,
St Paul's Cathedral, London*

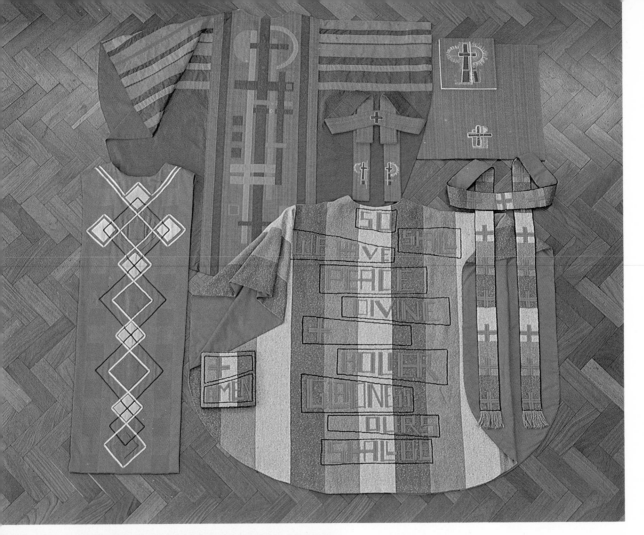

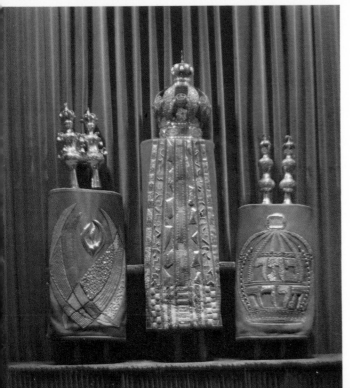

Plate VIIIa *Above* Red vestments and scapular, designed by Maureen Voisey, 1972, based on the Chi Rho. Silk and rayon fabrics with silver thread, mainly machine appliqué. Stole hand worked, a group project.

Vestments for Lent, designed by the Reverend Leonard Childs, 1978 upon the quotation from 'Forty Days and Forty Nights'. Loosely woven man-made fabric. Lettering embroidered in terra cotta and black anchor soft, satin stitch and twisted chain, by Dorothy Dixon
Cathedral Workshop, Derby Cathedral

Plate VIIIb Torah Mantles designed and worked by Dorothy E Wolken. Mantle on left represents the burning bush and the Twelve Tribes of Israel. The centre mantle is of ruby red ribbed silk worked in silver and on the right the crown of the Torah 'Keter Torah' is represented in a combination of gold metallic threads, cords, beads, etc.
Temple Israel, Canton, Ohio, USA

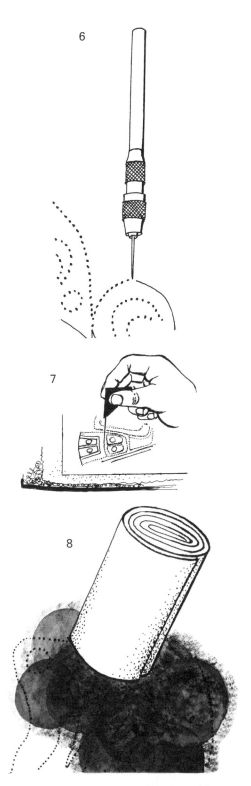

6

7

8

242. 6, 7 and 8 Transferring the design to material

soften the effect. One advantage is that several people can work simultaneously. For similar reasons large articles are divided into panels, and joined together after the embroidery has been completed. For an all-over pattern, long ends of thread are left along the joins so that they can be used for working over the seams. (These methods would not appeal to a designer.)

Method 4

When there is a powdering of small units, they can be embroidered separately using a table clamp-on tambour frame (241.3) or a small ordinary frame. Put a piece of backing between the hoops, be sure to pull with the grain of the material downwards and across, and not on the cross. Then place the unit of embroidery so that the direction of the grain corresponds with that of the backing, pin (if the material is delicate use needles as they will not leave a mark), then tack, and when the embroidery is complete, take it out of the frame and cut away the backing close to the back of the stitching. Repeat for each motif.

Method 5

There is an alternative method where the backing can be kept permanently ready and re-used many times. For this either a tambour or ordinary frame is suitable. Take a piece of good firm material, such as fine linen, mark out a circle or square of a useful size, say 15 cm (6 in.), stitch round this by machine or by hand, cut the hole away, leaving a narrow turning, fold this back, and buttonhole stitch round or machine stitch very strongly. Then frame up this piece of material (241.1).

Position the motif to be embroidered over this hole, pull it taut, pin and tack into place. When finished, simply unpin and take out the tacks, and provided that no stitches have gone into the backing it can be removed, ready for the next motif (241.5). The surrounding fabric must be carefully rolled up or folded to enable the worker to reach the embroidery.

For machine embroidery hoops are used, care has to be taken not to damage the basic fabric of the vestment.

Transferring the design

Decide the method to employ for transferring the individual design to the material. To preserve the spontaneity calls for a treatment very different from the accurate reproduction of an outline drawing.

For certain types of church embroidery the pricking and pouncing method is still the most satisfactory, in particular when the worker knows clearly what she wants to do, and is unlikely to make alterations.

1 Pricking and pouncing
Trace the design, thinking about the construction, trace as you would draw, rather than just going round the outline. The drawing can so easily get lost.

2 Mark in the centre lines down and across.

3 Mark in the outside corners or pattern line.

4 Over a piece of folded felt, put tissue paper, then place the tracing upon this.

Set a no 9 or 10 needle in a pin vice (**242**.6) (a thick needle allows through too much pounce). Or a holder can be made by folding, and re-folding into a triangle a small square of paper, and pushing the eye end of the needle up into it. Then perforate the tracing with little holes, close together all round every line (**242**.7). To check the pricking hold it up to the light.

The perforating can be done on either side of the tracing.

In the trade this is done mechanically.

At each stage it is most important to think about the construction behind a sensitive drawing.

Preferably carry out the next stage after the fabric has been framed up. But when this is not feasible, pin the material out flatly or keep it in position with weights.

5 With the framed up material lying on a table, build it up underneath with books, so that the surface is firm.

6 Put the perforated tracing upon the material, with centre lines corresponding. Keep it in place with weights.

7 Black pounce consists of powdered charcoal, and white is powdered cuttlefish; to each a little magnesia may be added to give weight; mix together for grey.

8 Make a pouncer by winding round a strip of felt (**242**.8). Dip the end into the pounce (black for a light or medium light fabric), shake away surplus, and rub the pounce through the perforations with small circular movements. Too much pounce will obscure the line.

9 Lift away the tracing very carefully (and clean it).

10 Using a previously tested pen or a fine watercolour brush, sable no 1 or 2 according to the size of the work, and water colour, usually black, white or grey, or blue upon white (a little gum Arabic can be added for permanence), outline with a very fine line over the lines composed of the dots of pounce; start at the part nearest the worker and cover with tissue paper where the hand rests on the surface. (For wool, use oil colour and terpentine.) It is important that this painting is done thoughtfully so that lines 'run through' and the drawing is accurate. Avoid jolting the frame.

Transparent Cello film, polythene or cellophane can be used instead of tracing paper, but it is apt to slip. And felt or fibre tipped or even biro pens make the transferring much quicker, the disadvantage is that the material is badly marked with a stain which spreads if there is any dampness.

11 When completed, flick away any surplus pounce with a clean cloth.

Alternative methods

1 Keeping the perforated tracing in position with weights, dampen a pad with petrol or benzene, rub on to a cobbler's heel ball, then with a circular movement rub over all the lines of the tracing.

2 Spray the fabric with methylated spirit, petrol or benzene, rub french chalk or pounce powder through the perforated tracing, then remove carefully and spray again. Some fixative sprays can safely be used on fabric. These are methods used commercially, as are various perforating appliances which can be plugged in.

3 The creative embroiderer may prefer to cut out and arrange the design shapes in paper, upon the fabric or paper, tacking or drawing round the shapes. This is suitable for large hangings. The paper forms can then be replaced by materials.

4 Another method is to trace out the design upon tissue paper (tracing paper is too stiff), tack through, following the lines, then tear away. This gives scope for a free development of the design.

5 Experienced designers may prefer to mark out guiding lines with tailor's chalk, or to draw directly upon the fabric, creating the design in terms of material.

Sometimes a suitable adhesive replaces stitchery. But it becomes collage without the addition of stitchery.

6 Dressmakers' carbon paper or some substitute, can also be used for marking in the outline.

Gold work

In the past gold work has been synonymous with

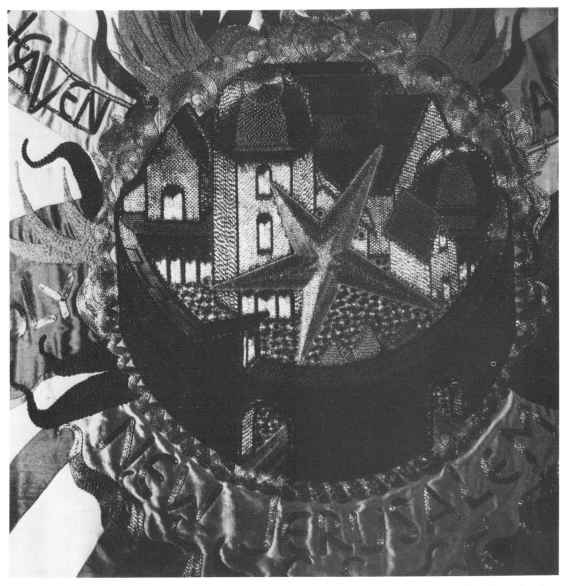

243 Detail from the chasuble, part of a set of festal vestments with the theme 'New Jerusalem'. Designed and executed by Anna Crossley. The central motif is a 36 cm (14 in.) rounded city with 'the glad and moving star in its midst'. Embroidered with various sizes of jap gold couched with red, purple and blue also filo floss. The direction of the thread is important

Emmanuel Church (Episcopalian), Rockford, Illinois, USA

embroidery for the church, because, as with the blue associated with the Virgin Mary, only the most precious metal and the costly lapis-lazuli were considered worthy of their sacred purpose.

The intention to give of the best to the church persists to some extent but the availability of substitutes and imitations has changed values.

Accustomed as we are to the invasion of artificial light, the importance of gold has diminished, the visual impact has lessened. The glory of gold and silver was enhanced by its power of reflection, in the mystery of a candle-lit sanctuary. Imagine how unearthly must have been the glint of light as it caught and reflected the shine of the metal during the movement of the vestments.

With the changed attitude it is accepted that the

braid used for tying up a chocolate box may also become an important part of the embroidery upon a frontal. The rarity and intrinsic value of materials is now less important than the impact made by a work of present day creativity.

Although most of the available threads are now synthetic, there is scope for inventiveness in their use, and an appreciation of the aesthetic potentialities can be explored endlessly, always provided that the result is restrained and fit for its purpose. The subtle nuances of colour and texture can be combined with textures such as wool or string. PVC and real gold kid both have a function. The coloured bullion (obtainable in America) is interesting when used in very small quantities, with thick wool on hessian (burlap) for example.

A frame is essential for gold work and a backing is also necessary.

Basically, most metal and Japanese gold or silver threads, whether synthetic or not, are couched down, that is, they are laid upon the surface of the material, double or singly, and are sewn over with a fine strong thread. The thread which replaces the now unobtainable Japanese gold, is generally made in about four thicknesses and is sold on reels. The new Maltese silk can be used for couching but even when waxed it is too fine and slippery to be pleasant to work with. Synthetic sewing threads of an old-gold colour can be found, some are satisfactory. Stranded cotton (waxed) is a possibility, but it does not wear very well. Nylon invisible thread double or single is an alternative, (recommended with reservations).

Technique

The characteristic play of light results from following the flow of the outline with rows of couched metal threads. The effect is accentuated by sewing with a darker thread, and regulating the spacing of the stitches, for an illustration see **243** and **245**.

To start, fold the gold thread, and take a small couching stitch over the bend. This can be seen at X (**244**.1). Traditionally, the threads are couched double. At the corner, stitch over each separately; to guide it with a stiletto helps to produce a sharper turn. For a very sharp angle take the outer thread a little beyond the point, cut it, and start again slightly lower down xx (**244**.2) pulling both ends through with a chenille needle (**244**.2).

To finish off almost all metal threads (and some others), also fine cords, make a sling with thick silk, by threading a short length, double, into the chenille needle, put the point of the needle through the fabric

and guide the gold ends into the loop of silk; then pull it all through to the reverse side. The gold ends which are about 2 cm ($\frac{3}{4}$ in.) long can be stuck down to the backing when the work is complete (**244**.2).

For thicker cords and narrow braids, at the start and finish, make a small hole through which the end is pulled to the reverse side (for a wider flat braid, make a tiny slit), unravel the ends and stick them down, on the reverse side.

When working a solid block of gold, the couching stitches are bricked (**243**). The neatest way to turn at the end of a row is shown in the diagram (**244**.3), where it will be seen that at the commencement one single thread is laid. Pair this with another twice the length, couch them down, at the end of the row turn the upper, longer thread, and bring in a new longer thread, put the two together and couch them down, leave a short end on the old thread, turn the other and bring in a new one. Take all the ends through afterwards.

To fill with couched gold a whole shape which varies in width, insert short threads at intervals. Retain the bricked stitches (**244**.4).

It is a temptation to follow round the outline, gradually filling up the area, but this probably leads to ugly and difficult turns towards the middle.

Plan the most straightforward way to work each shape. For example, to deal with a cross, start the thread at the centre of the top, work to the middle, with another thread start again from the base, bring the doubled thread to the centre, and divide them, pairing each with one from the top (**244**.5).

By sewing with colours and spacing the stitches, designs can be built up. (**243**) Self-colour is used for catching down the background. This was used in Chinese embroidery (**244**.6). It is a method which can be worked over a padding, for this the design would be traced on to the final layer of the felt.

Or Nué is a development of colour sewing (**244**.7). The design is traced on to a fairly fine linen background. The gold is laid double, starting at the bottom, a needle is threaded with each colour, stitches are worked over the gold, for the extent of each particular colour, bringing each needle up above the completed row, ready and in position for the next row. The spacing between the stitches can be varied according to the amount of gold to be obscured by the colour. Each row must be kept straight. The resultant effect is of gold one way, and colour when looking at it from the reverse direction. It is fascinating to do, but very slow and exacting. Hoods and orphreys of copes of Flemish origin are examples.

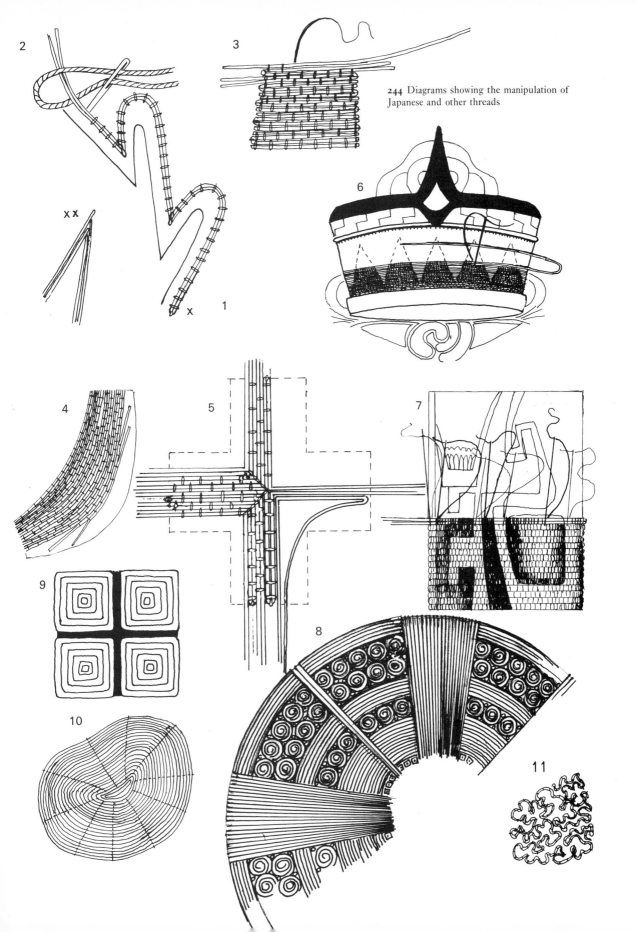

244 Diagrams showing the manipulation of Japanese and other threads

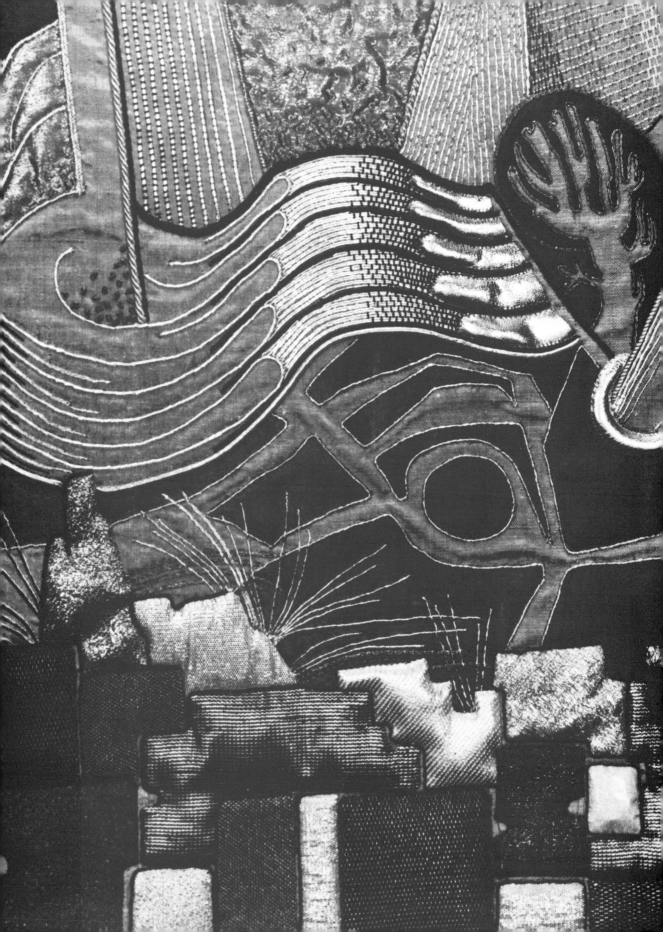

There are endless ways of using thicker Japanese gold (and other similar threads) couched down singly. If possible, the design should be adapted so that the lines are as continuous as possible; replacing concentric circles by spirals, for instance. The sheer repetition gives a lovely gleam. Examples are given at **244**.8.9.10.11.

These and many other metal thread methods can be found by studying **243** and **245, 247**.

Basket fillings are traditional techniques which can be included in modern embroidery (**193, 193**A). (In this example the ends of the string are bent round at the ends of the rows). All the variations will combine with contrasting stitchery or appliqué. Metal and other threads, narrow braids and stout floss work out well; and it is possible, instead of keeping the basket filling contained within a hard shape, to continue the rows of gold in uneven lengths beyond the area padded with string.

245 *Opposite* Bottom of the back panel of a cope designed and worked by Beryl Dean. Tones of gold obtained by various technical methods
St Giles Church, Northbrook, Illinois, USA
various technical methods *St Giles Church, Northbrook, Illinois, USA. Photograph: Mary Alice B Rich*

Method

First stitch down rows of string, across the shape, spaced rather more than the width of the string between each row. The stitches can be taken into or over the string, using a waxed thread. As shown at **246**A1. Then, taking two metal threads, they will lie over the two rows of string. Sew between the string (with waxed thread), pull the stitch tightly (a tiny back-stitch into the background will make it firmer); then bring the needle up, between the third and fourth row ahead, the metal threads are thus bent over the string, by repeating, the indentations are made with the subsequent stitches. The second pair of metal threads alternate with the first, this can be followed from the diagram (**246**.3).

A sloping edge can be more successfully manipulated by taking the ends down singly (**246**.7).

For the spacing which results in horizontal ridges, shown at **246**.2, take one pair of metal threads over two rows of string and stitch them, continue vertically, for the next two threads repeat, keeping the stitches close to those of the previous pair of metal threads.

246 The working of basket stitch filling and burden stitch

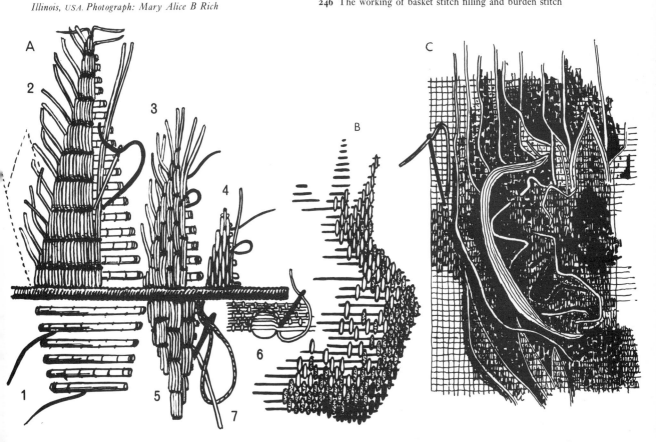

At **246**.5 two metal threads are taken over two rows of string, in the next vertical line the spacing is the same, but for the third pair the stitches come between those of the first two pairs. At **246**.4 the spacing is the same, but a single thread is used.

Many patterns can be contrived with different spacing, and if a thread of a darker colour is used for the stitching, the effect is increased.

Attractive patterns are produced by cutting out in felt, and sewing down or sticking, small circles, squares or other shapes on to the background, and couching down rows of metal threads which are not stitched where they cross the raised parts, again a darker colour helps (**246**.6).

An embroidery method which gives an elusive, gradated effect, is a form of brick stitch, worked over laid metal threads, it is often referred to as Burden stitch. It produces a broken edge, and broken colour can be introduced. One or more threads of silk, cotton, wool or even passing thread are stitched over two rows of passing thread (used because it can be threaded into the needle and is then easily taken from row to row.) It would be laborious to have to take down ends at the beginning and end of each row. This is shown at **246**B.

When two stitches, side by side are worked over threads in the background or over laid metal threads (**246**C) a broken colour effect results.

247 *Opposite* A section of the centre back panel of a festal cope designed and worked by Beryl Dean. Various methods and materials have been used, burden stitch can be seen at the top left and bottom right corners
St Giles Church, Northbrook, Illinois, USA. Photograph: Mary Alice B Rich

248 Working with metal threads

In the seventeenth and eighteenth centuries plate was frequently used, it is a thin narrow strip of gold or silver, the shine contrasts with textured threads. Longer narrower foundation shapes are more suitable, these are cut in parchment, thin leather or card, even felt, to give a raised effect, and are attached with tiny stitches. At the start, a little piece of plate is folded back to form a tiny hook. Bring the needle up ready to begin, and try to take the thread through this little hook, put the needle through to the back, so that the plate is attached to the fabric; bring the needle up, on the opposite side, stitch across the plate (**248**A), bend the plate over as at **248**B, and bring the needle up, on the opposite side and take a stitch over the plate, repeat. To finish, cut off, and bend back to form a little hook, shown at **248**C, the needle is taken through this, and a stitch over the plate strengthens the finish.

Passing thread is composed of fine metal wound round a silk, nylon or cotton core (**248**D). It can be threaded into the needle and used for stitchery. To do this, unwind the metal for rather more than the length of the needle, make a knot in the other end of the passing thread, thread the needle, pass the point into the silk core, and pull through. The object of this is to avoid having the metal thread actually going through the eye of the needle, because the roughness would cause a small tear in the material, and this is avoided, as only the core is threaded up. This is quicker as the passing can be slipped under threads already couched down (**248**E) and the taking down of single ends is avoided. For Burden stitch and buttonhole fillings, passing can be used for the actual stitching, also for detached buttonhole filling or ordinary buttonhole open fillings (**248**F), and as shown at **248**G, Ceylon stitch could be worked with

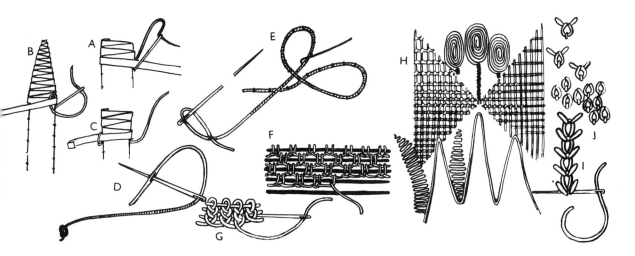

249 Crown, created with cords and braids, worked below each shoulder, gold on olive green, from a set of twelve Canons' mantles, designed by the Rev. Leonard Childs *Derby Cathedral*

250 Sewing cords

passing, as here, the thread only enters the fabric at the beginning and end of each row. And open laid fillings (248H) are much less rigid with a broken edge. There are many other stitches, for example wheatear and detached chain stitches (248I,J) for which this thread is suitable.

The most satisfactory way to sew down cords is to take a slanting stitch into the twist (250.1). For joining, starting and finishing, fray out an end of about 2 cm ($\frac{3}{4}$ in.), and take it through to the back with a sling; for a circle do not take all the strands through one hole, take down a few at a time (250.2). To sew a plait and some Russia braids, take a tiny stitch into the edge, alternately on each side (250.3).

Have a very fine needle and thread and pass the stitch through a tubular braid. If it is a thick one, pull out a short length of the inside cord and cut it off, before attempting to put the end through the hole previously made with a stiletto; use a sling to pull through the outside casing (250.4).

The circle (251A) shows another example of the combination of surface stitchery and gold work. On the perimeter can be seen the preparation for padding, ready for the gold work. It is shown in detail at 251.1. The first stage, a small square of felt is sewn or stuck in place, then a slightly larger square is put over it. At 251.2, the third and final layer is cut just a little smaller than the shape to be padded. Sew the centre of the top edge, then the centre of the lower edge, after that the sides, then complete the stitching; this care is really necessary for a complicated shape. When it is intended that the process of padding is in preparation for a covering of thin kid or fabric, the outline of the shape is traced on the reverse side, and cut out a fraction larger, again the first stitches are made at the centre top and bottom, then the centre of each side, the remainder of the stitches are then completed, as at 251.3.

At 251B rows of metal threads are shown, which are laid over the padding, progressing outwards from the centre of the circle; it will be seen that the metal is sewn down with small stitches, using a dark shade or contrasting colour. There are many variants of this method.

The texture of some stitches contrasts with the smooth surface of laid gold; sheaf stitch can look wonderful in conjunction with chunky metal threads; for working it, a thick wool, silk cotton or linen thread is required. To start, lay threads in pairs at regular intervals, for the variation shown within the circle (251C). They are further apart for conventional sheaf stitch (251F). Next, bring the working thread up at the point marked X.

226

It passes over two groups of foundation threads, then backwards and forwards about seven times. This is repeated over the second and third groups of foundation threads, as shown at 251D. They dovetail with the previous ones. This is the same as for the conventional method, and the next stage, the knotting, is the same for both and is shown at 251E. Bring the needle out at the point where the threads interlock. This knotted line is worked upon the transverse foundation threads: the working thread passes over the first pair of threads, then under the foundation stitches, the needle is then slipped under this loop and is drawn up tightly. It is repeated for the next pair and so on to the end of the row. Then, for the variation shown in the circle, it is worked at each pair of foundation threads, whereas in the conventional working, alternately they are sheathed together with two satin stitches (251F).

At 251G, the wheel in the centre of the circle is worked by making equally spaced foundation stitches to cross each other in the centre, where they are held in place with a little stitch. Then the needle is taken forward under two foundation threads, and pulled through, the thread is taken back over one and forward under two threads as shown.

Synthetic cords, braids, threads and studs

With the introduction of synthetic, metallic and plastic threads, braids, cords and studs there is an ever changing variety available to the embroiderer. Each has individual decorative characteristics which determine its purpose. The manipulation of most is similar, as the metal cord lies on the surface, and small stitches are sewn into it invisibly, using a fine needle and strong fine thread, the reason being, that the needle is apt to break the plastic, which then frays; so, when possible, the stitch is taken between the twist of the metal threads. Some of these braids, etc, can be couched down, that is, sewn over, with a matching or contrasting thread. For the beginning and the ending, a short length (rather more than 15 mm ($\frac{1}{2}$ in.)) is left on the surface. A small hole is made with the stiletto, through which the end is drawn with a sling (244.2). Some all-over patterns made by sewing down threads of varying thicknesses are illustrated (252).

The embroideries of Dorothy Wolken (USA) (204 and colour plate) for the synagogue show an imaginative understanding of this medium. From her practical experience she has made the following observations (which have been summarised):

'Some of the plastic and "metallic threads" are quite substantial to work with, but some are very

251 Padding for raised work and the working of sheaf stitch

fragile and will break with a slight pull or tear with the stab of a needle; it can burn and has a tendency to disintegrate. Certain woven fabrics ravel easily, they must be handled with care. There are imported, genuine metallic fabrics of magnificent prints and textures which are durable but costly.

'Gold beads which are usually electroplated are almost indestructible, they are made in many shapes and sizes, faceted, solid and pierced, they add richness and variety to gold work, and are available in craft and specialty shops. Real gold-plated beads can be obtained in some specialty shops.'

She uses the finest fabrics and selects them with care whether they are of upholstery weight or sheer, depending upon their purpose. Continuing she says: 'The design is traced on to the material with a gold drawing pencil. It is then backed with a closely woven piece of natural linen by stitching the linen to the area covered by the design. The entire piece of material is then stitched and lashed to a large standing frame before it is ready to embroider, when the design is completely worked a sizing consisting of half fabric glue and half water is brushed over the entire surface of the linen backing only, not until it is thoroughly dry is it unlashed and unstitched from the frame. The overall weight necessitates the reinforcement with the linen backing, this helps to maintain the shape of the article.' This is a different

252 Patterns made by sewing down threads and cords of varying sizes

253 Line stitches capable of variations in spacing

method for framing up and preparation.

With the mention of beads it might be noted that the durability lies in the strength of the thread used for sewing them. The edge of the hole in some beads and studs is rough, and cuts through the thread.

More embroidery stitches

Many of the line and filling stitches which are generally worked in the hand with cotton, linen, silk or wool threads possess a textural and visual quality which adds a unique character when combined with gold work, appliqué and machine embroidery. Worked in a thick cotton, a shiny silk, velvety chenille or very fine sewing cotton, a decorative stitch such as raised stem band gives distinction, so increasing the interest by introducing this contrasting depth and scale: the same applies to french knots and bullion-knots. It is not always appreciated that, when used imaginatively, these touches of hand stitchery add so much that is valuable to church embroidery today, especially to large pieces carried out almost entirely by machine. Diagrams for working some of these stitches are given in the following pages.

A successful result depends upon the correct spacing in relation to the thread, not all stitches are capable of being varied in width, those shown in **diagram 253** have this characteristic.

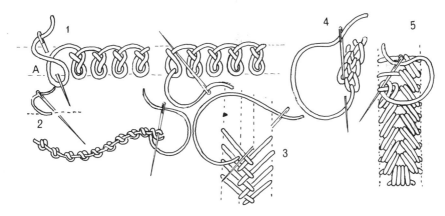

254 Decorative stitches

253A *Backstitch* is worked from right to left, the length of stitch can be regulated, if preferred whipping can be added as at (a).

253B For *Pekinese*, first work a row of backstitches. Beginning from the left, for the second stage, bring the needle out at the left, then, pointing the needle upwards, take it through one backstitch ahead, pull it, and with the needle pointing downwards go through one stitch back, as in the diagram, repeat.

253C *Open chain* stitch can be varied both in width and spacing.

253D *Cretan* is worked by pointing the needle from the outside inwards, keeping the working thread below the needle, from the opposite side insert the needle on the outside pointing inwards towards the centre. This can be followed from the diagram. The width can be regulated. And a variation is produced by stitching two parallel rows of alternating backstitches, which is shown at **253E**.

253F This is the effect obtained by taking a bunch of several threads, couched down with small stitches.

254A1 *Rosette* chain. Bring the needle up at the top right-hand end of the upper traced line. Pass the thread across to the left-hand side and hold it down loosely with the left thumb. Insert the needle as at A and pull the thread through, over the loop. Next pass it under the thread as in the second diagram. Then make another stitch a little further to the left, repeat the process.

254.2 *Double knot* stitch: bring the thread up on the left, make a small slanting stitch as shown at 2. Then slip the needle under the small stitch just made. For the second time the thread is slipped under the same stitch, worked as for a buttonhole stitch. This can be followed from the diagram. Pull up the thread at each stage.

Bring out the needle on the left of the centre to commence leaf stitch. Then insert the needle as at **254.3**, pull it through. Next, put the needle in upon the left-hand margin, and bring it through again below in the same way, but on the left side of the centre, continue alternately.

Double chain stitch. To start, make an open chain stitch, and into it another, to the left of the first (**254.4**). Then insert the needle a second time into the centre of the first chain loop, bring it out below, but on the right-hand side. Pull the needle through, over the working thread. For the fourth stitch, throw the thread across to the left and insert the needle in the centre of the second chain loop, to the left of the thread which is already emerging from this point, and pull it through immediately below: This is shown in the diagram **254.4**. Repeat the process.

Portuguese Border stitch. First make a foundation of transverse stitches laid evenly, (**254.5**). Begin by bringing the thread through below the lowest bar at the right-hand end. Then four stitches are worked around this and the next bar together (the thread does not enter the material). Next, bring the thread up just below the second bar and to the left of the last completed stitch. Two similar stitches are now worked over the second and third bars together, and then the thread is brought up in position for the next two. When completed the same process is carried out on the other side, it can be done more easily if the position of the fabric is reversed.

The following diagrams show a further selection of stitches which combine with other techniques, such as gold work, because the textures contrast with smooth surfaces. Thick threads give the best result.

The final stage of working raised stem band is given at **255A**. The underlay consists of long laid stitches, there being more towards the centre. Then at regular intervals single stitches are worked at right

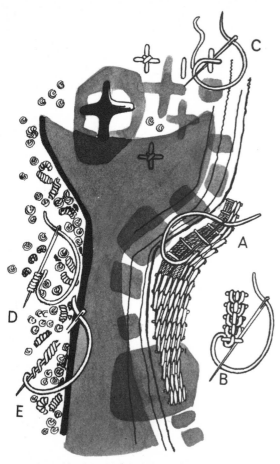

255 A combination of hand stitches and gold work

lengths of rough, smooth or bright check purl, then bringing the threaded needle up, pick up a length on the needle, in the same way as for a bead, and return the needle through the material close to the point at which it emerged. This forms little gold loops on the surface.

A fairly coarse thread, and a thick needle should be used for working *bullion knots* (255E). Bring the needle and thread through at one end of the stitch and put it down at the other end, bringing the point out again where it first entered the material, but do not pull it right through. Next, wind the thread seven or eight times around the needle, then place the thumb over this and draw the thread out, and pass the needle and thread over, so that they point in the opposite direction, and tighten up the thread, and put the needle down into the material at the point where it first emerged.

Additional stitches to give a broken texture are given at 256A where, at the top, the thread is shown twisted round the needle, the first stage in working a *french knot*. Next, keep the thumb over the twist as the thread is pulled through, and the point of the needle is taken down slightly behind the start, as shown at A.

256B *Detached chain* stitches, again the thumb is kept over the stitch as the thread is pulled through.

257C *Seeding* is worked by making a tiny back stitch covered by another.

Other ways of producing surface textures are given at 257. Shown at A are groups of a few split stitches which follow a rhythm, whereas at 257B long stitches are worked at random; for this wool is effective.

Running stitches either of uniform size as at 257C or of varied sizes will produce another texture.

Although this stitch belongs to another age, *Long and short* stitch (258.1) can still have its uses when gradation of colours and direction of stitch is required. A cleaner edge is obtained by first working a row of split stitches along. Then working a row over this of long and short stitches alternatively; repeat for the second and subsequent rows. Always bring the needle up through the previous stitches; and take long ones when they are intended to radiate, gradually eliminate a stitch here and there, retaining the up and down ending to the stitches.

258.2 For the foundation of *cloud filling* make small stitches, regularly spaced but alternating, then taking the needle from right to left, pass it through the little loops into the upper, then the lower row, fairly loosely.

258.3 *Detached* or *surface buttonhole* stitch. First

angles to the padding threads. Upon these stitches, rows of stem stitches are worked, each row being completed, (though in the diagram others have been started), and it shows how to increase the number.

At 255B raised chain band is given, first work the transverse threads, then make a single stitch to start and bring the needle out at the top left-hand side, and a loop stitch is made as shown in the diagram. This can be worked as a filling if the transverse threads are increased in length. Passing-thread or purl can be used as an alternative.

Four-legged knot stitch (255C) is worked by first making a vertical stitch, bringing the needle out on the right-hand side, then passing it under this stitch, with the thread under the point of the needle, and with the thumb over, pulling the thread through to form the knot, taking the needle down on the left side.

At 255D another way to obtain a detached, raised texture is given. This is done by cutting short

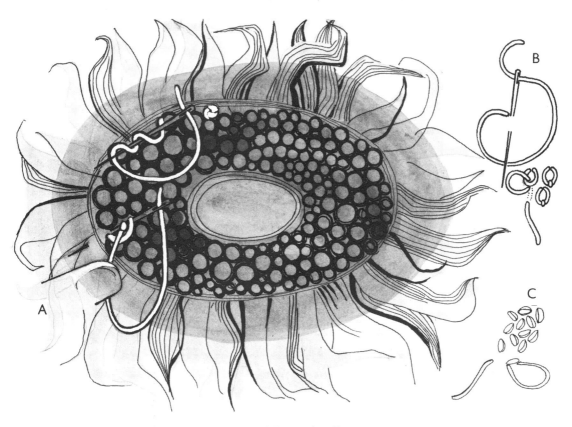

256 French knots and seeding

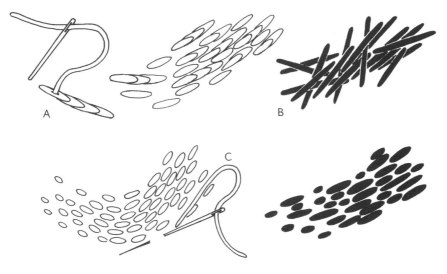

257 Broken textures

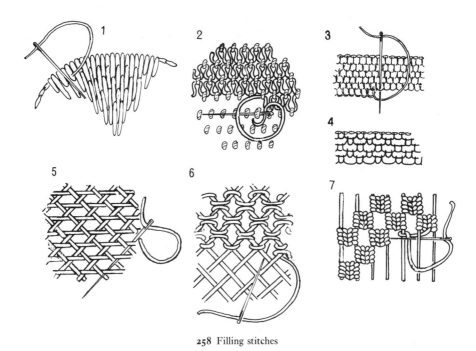

258 Filling stitches

work a row of small backstitches, into this from left to right make buttonhole stitches, close together. At the end and commencement of the row the needle can be taken through the fabric (or it may be returned without doing so, which results in making it detached, this has decorative possibilities). For *open buttonhole filling* the stitches are somewhat looser.

258.4 Here the stitches are spaced, they may be taken through the material, but if detached from it, the spacing would be closer together. There are many variations.

258.5 *Honeycomb filling*. First make the long, horizontal laid stitches, then the diagonal stitches are laid across, not darned, finally the last rows are darned through, passing under the horizontal and over the diagonal lines. This can be worked in passing thread.

258.6 *Twisted lattice*, used as a filling stitch. First lay stitches in rows diagonally one way, then diagonally in the other direction, darning the rows, over and under the first. Finally from right to left, the needle passes perpendicularly up under one transverse thread, then down under the next, repeat.

258.7 *Cretan open filling*. Lines of thread are first laid at regular intervals vertically. Then from right to left, diagonally downwards groups of Cretan stitches are worked upon the laid threads, this can be followed from the diagram.

Machine embroidery by Judy Barry

There are no longer any hard and fast rules dictating which methods of embroidery are suitable for church use. The major consideration is, rather, that the method be practical enough to withstand cleaning, handling and storage over a period of time.

Compared with hand embroidery, whose origins date back to the earliest civilisations, machine embroidery has only a very recent history. It is important to realise this before one can understand its place in church embroidery today.

The first machine which was invented to reproduce 'Hand Embroidery' was only conceived in 1820 and properly functioning by 1829. It was designed with a series of needles, pointed at either end and with the eye in the middle, which were threaded with lengths of embroidery thread. The needles were passed, by an arrangement of pincers, through fabric which was stretched taut on a framework. The method was connected with the movements associated with hand work, and was known as the 'Hand Embroidery Machine'.

Later, as the effect of the Industrial Revolution swept on, another machine was invented which utilized a continuous top thread, instead of the short lengths of embroidery thread, and which also made use of shuttles (or bobbins) at the back of the work, (similar to the sewing machine of today). This, the

259 Superfrontal by Judy Barry and Beryl Patten, 1975. Detail of a superfrontal for the Lady Chapel. Being permanently on the altar, the cloth is multiseasonal in colouring. It is entirely machine embroidered and illustrates some of the effects which can be achieved on a domestic sewing machine
St Stephen's Church, Elton, Bury, Lancashire

Schiffle machine, was still intended for embroidering lengths of cloth imitating the quality of hand embroidery. The lock stitch *Sewing Machine* was not fully developed until the 1850s and was to undergo many transformations before it became the tool we take for granted today.

Other, single-operator, embroidery machines of the 1900s were the Cornely chain stitch and the Singer machine, ultimately known as the 'Irish' machine. But both were designed for workshop rather than domestic use and could be termed (in the contemporary phrase) as Trade or Industrial machines.

Machine Embroidery was extensively used to embellish the countless articles of clothing fashionable in the 1880s and 1900s. Household items were also similarly decorated and most of the work was done in workshops and factories, by skilled women operators.

After the first infatuation with machine-made embroidered trimmings, there was, in the 1890s, a swing in fashion amongst the more discerning, towards a hand embroidered look. However, workrooms and factories still found a market for, and continued to pour forth, innumerable embroidered items. Despite the fact that many of these pieces were of an exceedingly high standard, it was perhaps their very number which led to the contempt with which machine-made embroidery came to be held, especially by hand embroiderers, at the turn of the century.

Some workrooms are known to have produced machine-decorated pieces for Church use; but, though the machine-embroidered ecclesiastical pieces may have been well designed and executed, they would, probably, have been considered very inferior to a hand worked design.

It was the advent of the *domestic sewing machine* which was to change the place of machine embroidery in the economic and artistic world.

The lock stitch sewing machine became available to most homes round about the 1860s and though infinitely less refined the basic principles were the same as the machine of to-day, and simple machine decoration was attempted on them. Manufacturers keen to promote sales brought out special attach-

260 *Above* Sample by Lynne Stokoe, Manchester Polytechnic, 1979. Machine 'bricking' and 'counted-thread' techniques worked on a Bernina 217 Industrial Machine in silver thread on silver fabric

261 *Below* Detail of a mitre by Dawn Garfitt. Machine stitching worked in gold thread zigzag blocks on a Bernina 807 machine. The detail illustrates the patience and skill required to work some techniques of machine embroidery. Moss stitch in floss and gold thread can also be seen

ments and devices to further facilitate machine decoration.

A great tradition of machine embroidery was developed in the 1920s and 1930s in the Singer Sewing Machine Company's workrooms. There, techniques were invented and developed by the machinists who carried out commissioned pieces and instructed the purchasers. So some of the workroom and factory skills were passed on to members of the public and machine embroidery became a domestic occupation.

The swing-needle domestic machine was brought out in the 1950s and there have been further design developments and advances. Our sewing machines today are so refined that innumerable surface effects and textures can be achieved. It is only lack of confidence, perseverence, and the fear of harming a costly piece of machinery which holds many people back.

Too often the machine is considered as a quick way of getting a result. Certain machine techniques demand as much patience and practice as the most arduous hand techniques and are almost as time-consuming. The pleasure in achievement can be infinitely satisfying whatever the method.

For ecclesiastical purposes zigzag 'blocks' and 'counted thread' techniques on the machine offer as much surface interest as many hand-stitches. Similarly, machine 'couching' and varied tension work give rich surface effects and directional changes, while machine 'rugging' methods can be worked which give all the qualities of a loom woven piece.

Appliqué work can be effective if well handled. Too often the machine is only used to zigzag one fabric on to another; then, the effect can be crude, and may earn machine work a bad name. Two fabrics placed side by side can, with the machine on 'darning', or by means of the forward/reverse lever, be subtly and harmoniously '*blended*' together – a technique which requires some practice and a clever use of colour.

262 *Above* Chasuble by Judy Barry and Beryl Patten, 1973. Festal chasuble made of a textured-weave fabric with a removable hood-like apparel. This enables the chasuble to be worn without decoration as a Lenten vestment, or with a matching, totally embroidered stole for baptisms, etc. The hood-like apparel may also be worn over other plain coloured chasubles and so becomes a multi-seasonal piece of embroidery
Bolton Parish Church, Bolton, Lancashire

263 *Below* The hood-like orphrey is completely machine embroidered, showing a variety of techniques which include cording, couching, zigzag blocks and some appliqué.
Symbolism is based on the 'Tree of Life' theme, this being a subject suitable to all seasons of the church year

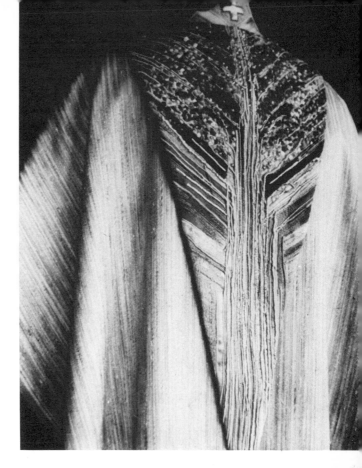

Laidwork is achieved by using the sewing machine manually to create long 'jump stitches' on the surface of the fabric. And if these are too fine when carried out in machine thread, then a thicker thread such as chenille or wool can be laid by running over only the points at which the yarn is turned.

All the possible effects are too numerous to mention. Each person must exploit the sewing machine to its limits and only by so doing will she achieve a personal technique.

The use of Industrial Embroidery and Sewing machines opens up even more scope for development in embroidery for ecclesiastical or domestic purposes. But Industrial machines are noisy and take much longer to master than the domestic machines.

Patience, perseverence and practice are required for the mastery of embroidery machines, many people trying to come to terms with machine embroidery are disappointed by the stages of depressing and seemingly irredeemable distortion which the work undergoes. All machine work tends to distort and pucker fabrics. For this reason it is important to 'sample' different techniques and types of fabric to see how they react to handling and to the stretching process so vital to machine work. Wools, cottons and other natural fabrics are always more obedient. They stretch and shrink until the work becomes flat.

Working for church use demands that the fabrics used be of a good quality, able to withstand the test of time and handling and not of a type which attracts

264 *Above* Detail of stole ends by Pauline Ainsworth, Manchester Polytechnic, 1979. A fine cream wool crêpe was used as the background for the baptismal stole, the ends of which are densely worked in machine embroidery. Colours grade subtly from white and gold through pale greens and blues to mauve. Brushed felt appliqué is used and also some Cornely moss stitching

265 *Left Tree of Life* sampler, in the technique used for the Cuna Indian Molas. By Joan Waring, Manchester Polytechnic, 1979. This form of decoration can be adapted for hangings, banners, etc

266 *Opposite* Machine-embroidered altar frontal by Beryl Patten, Manchester Polytechnic. Liturgical colours have been under-played in order to make this permanent altar cloth fit harmoniously into the interior for which it was designed. Symbolism is subtle and can be interpreted in many different ways to suit each onlooker. Designed to fit a very modern interior and altar, this frontal was worked entirely in machine embroidery on the Singer Irish machine. It makes subtle use of a variety of symbols and because the interior of the church is domestic in scale, the embroidery is extremely detailed

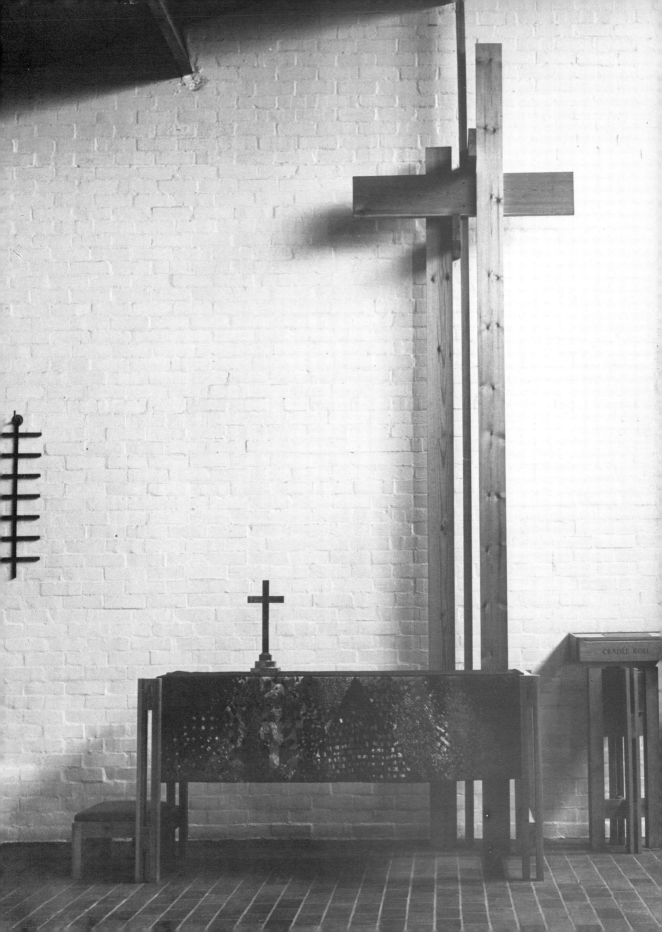

CRADLE ROLL

dirt to itself. Many man-made fabrics have this unfortunate tendency, but sometimes a synthetic is justified as being the only fabric 'right' for a particular job.

Some of the new synthetic gold and silver fabrics are more handleable in machine embroidery than leather or kid and because they *are* a fabric, can be worked into until they become a part of the background cloth. A leather, no matter how good, can, if subject to constant wear, crack and lose its surface.

Working with fabrics and leathers directly on to an iron-on backing helps to support frayable fabrics, thin fabrics, and non-woven structures like leather whilst machining. It also provides a strong base for machine embroidery and gives something to grip and pin into at the stretching stage. Work carried out in this way cuts out hours of tacking and means that the applied pieces of fabric are not excessively handled and picked at. Pulling out tacking threads can be as tedious as putting them in in the first place!

As with all new fabrics and methods, it is not enough to jump on the band-wagon of a new idea. Rigorous sampling and tests must be carried out to learn all there is to know about the reaction of methods and fabrics to wear, cleaning and varying humidities and temperatures, etc.

Adhesives and glues were used indiscriminately in the 1960s without thought as to how they would react to time and changing temperatures. Many go brittle and cause the fabric to crack and crumble away, others discolour and become black and sticky.

Some of the new heat-fusible gauzes can be used to bond fabrics in place whilst hems and edges are turned and secured. In making up banners, altar cloths and other large unwieldy pieces, they are invaluable in cutting down time and labour. Once their purpose is served they can be removed by steam and a little manipulation of the fabric. They are extremely useful in machine appliqué work, ensuring that a shape is securely held in place and that there is no distortion while sewing.

Sampling and trial tests are the best way to find out whether a technique is relevant to you. There are no hard and fast rules, but equally so, there are no short cuts without trial and practice.

Appliqué (hand)

The possibilities of this technique are many, by using differently textured materials, for example moss crêpe, organza and wild silk, interesting visual effects will result. The emphasis can be concentrated upon flat colour and surfaces, combined with hard outlines, or it may be indefinite and elusive by merging textured and patterned materials without contrasting outlines. The fashion of the time is usually reflected in the approach to appliqué for Ecclesiastical purposes. This method is one of the most widely used, as the broad effect is especially suited to the Church's needs, it is the quickest and most instantly rewarding way to create decoration large enough in scale to take its place in a building as big as a church.

Appliqué can be executed in the hand, or framed up or alternatively it may be entirely carried out by machine. Advantage can be taken of every sort of present day device for cutting corners, consistent with practical considerations. Sometimes the appliqué is a combination of hand and machine embroidery.

Before undertaking a large piece of work, experience should first be gained on a small example by mastering the conventional methods before experimenting with short cuts.

1 The method of framing up will depend upon the size of the work (**240, 241**). The nature of the background material will determine whether a backing is required, as it may be firm enough without. Having framed up, let it be slightly slack. For work in the hand spread the fabric out flatly, keeping it in place with weights.

2 The way in which the design is transferred (**242**) will depend upon its nature.

3 Next, on the background try out the previously collected scraps of material, deciding upon the colours and suitability; judge the whole scheme, with the pieces to be applied pinned in place, looking at it from a distance.

4 When a satisfactory arrangement has been found, one by one, pin out each piece on a board, taking care that the selvedge way of the material runs downwards, trace the outline and paint it on or fix it. Everything possible should be done to prevent puckering; for this reason the grain of each piece should correspond with that of the background.

5 For loosely woven material which might fray, iron on the thinnest *Vilene*, it can be used for other materials too, provided they are not too thin.

6 Decide which parts of the design are behind or underneath others, and which are on top. When cutting out, leave turnings on those parts of each piece which will be under another (**267**.1). Other edges are cut to the line.

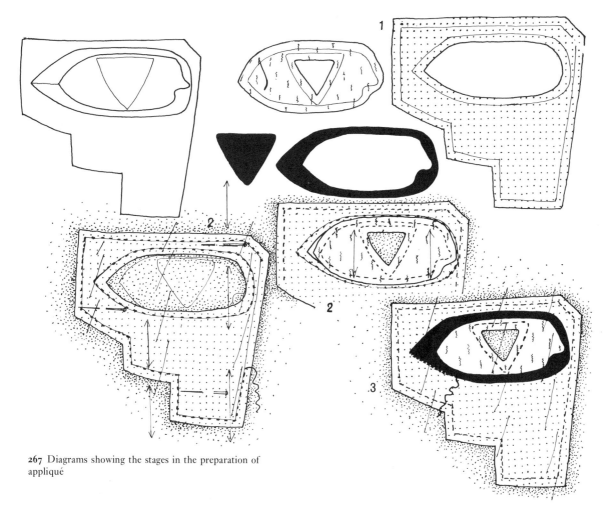

267 Diagrams showing the stages in the preparation of appliqué

7 Then, starting with the pieces which are underneath, and ending with those on top, pin them, tack in place, keeping the pins horizontal. With small stitches attach to the background along the design lines (**267.2**). When a frame is used it should have been slightly slack throughout this process. Now tighten it up.

8 Stitch the cut edges down (**267.3**).

9 Where parts of the outline need emphasising, use a decorative stitch, cord, braid, or couched thick threads. For a broken soft edge invisible thread or a light stitch or detached stitches can be used, and the whole thing developed in many different ways.

Embroidery for Ecclesiastical use will have to stand up to really hard wear, so for this purpose blind appliqué is really more durable and in many ways more attractive, but thick materials would be too clumsy to be suitable. The difference lies in the treatment of the edges of the applied pieces, they are cut allowing a turning which is folded over.

The method and preparation is the same as for basic appliqué, but instead of cutting along the outline of the pieces to be placed on top, a turning is added which is folded over and tacked, basted down to the background, and the edge slip-stitched (**268**A and B) or it may be hemmed with very small stitches (**268**C), to the background.

Or the actual shapes may be cut in either iron-on or ordinary *Vilene*, these are placed on the material, which is cut out, allowing turnings that are folded over on to the back and tacked down; these are then put in their appropriate places and attached with slip-stitch or hemming.

The diagram (**269.**1) shows iron-on *Vilene* cut to shape and attached to the fabric with turnings nicked, as for any convex curve. And at **269.2**, the shape is cut out in ordinary *Vilene*, with the turnings

239

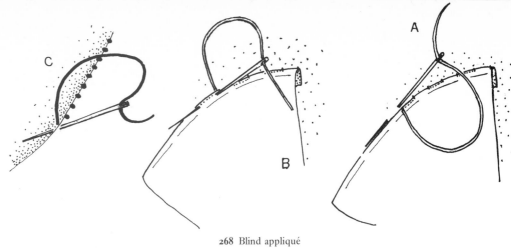

268 Blind appliqué

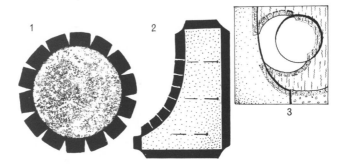

269 The use of vilene or other heat-fusible materials, for blind appliqué

270 Appliqué incorporating pieces of patterned textiles.

snipped as for a concave curve. At **269**.3 the turnings of the underneath piece are shown folded in to reveal a larger circle of background fabric, with pieces 1 and 2 on top.

The effect of hardness can be overcome with the addition of various kinds of free-hand stitchery.

Appliqué can be created spontaneously by cutting out the shapes in materials, and building up the design directly upon the background fabric.

Individuality can be added by finding pieces of printed or woven textiles which, when used for the right areas, add interest, an example is shown at **270**.

Laidwork

This is a technique of great variety which seems to convey the quality inherent in design today. It has in the past been used to fill shapes which could have been carried out in appliqué equally well and more speedily, but it is the ability to produce broken colour, and variation in the degree of density in the ground cover, which gives laidwork its advantages.

271 *Right* From the back of a cope designed and made by Barbara Dawson. Appliqué exploiting contrasting fabric textures
272 *Below* Festal frontal, detail, designed and executed by Nigel Wright
St Francis-in-the-Fields, Mooroolbank, Victoria, Australia

273 Panel for the back of the pulpit, designed by Maureen Voisey, 1977, embroidered by Grace Graham. Appliqué, raised, in dupion, silk, satin and superimposed silk embroidery
Derby Cathedral

An embroidery frame must be used, as it would be impossible to get a uniform tension without. Long threads are laid on the surface, with only a small stitch on the reverse side; as the needle is brought up at the edge, it crosses the shape, enters the material and is brought up again as close as possible by the side of the previous stitch, it then again crosses the surface and the process is repeated (274.1).

The direction can be vertical or horizontal, using both in the same piece of work gives a contrast in the play of light on the threads. This solid block of surface stitchery is caught down with long stitches, in a single thread of self colour, this in its turn is caught down with tiny stitches.

The effect of a broken edge is shown at 274.2 and gradation of the colours at 274.3.

Blocks of solid laid stitches can be caught down in various decorative ways, the effect of buttonhole stitch is given at 274.4.

There are endless open laid fillings, many are built upon a foundation of vertical, crossed by horizontal threads, which are sewn down at the intersections as at 274.5. This can be developed in many ways, as at 274.6, 7 and 8, where threads of different thicknesses are used, and at 274.9 where little pearls, sequins or beads are sewn.

Vertical stitches are worked with a thick thread, spaced fairly closely together as at 274.10. These are crossed with a finer one, which is stitched with a little cross at each intersection.

The variation of chequer filling shown has the usual foundation of laid threads, which are caught down. This is worked in four stages. First, bring the needle out at the top right-hand side of the outline, put it through each succeeding tying-down stitch from right to left downwards, following diagonally through, (275.1). Next complete this by crossing with stitches made with the needle pointing from left to right, 275.2; when the surface has once been covered, these lines of stitches are themselves crossed diagonally.

The rows of stitches (275.3 and 4) are done in the same way; but the diagonal is at right angles to the first two rows of stitching. Several changes in the spacing can give an entirely different effect, for instance, by working alternate lines, each way.

Another way of tying down a laid foundation is shown at 275.5. This is effective when passing thread and purl are used.

Various methods of couching silk or metal threads in decorative ways are shown in the diagram (276).

Patchwork

When stating that there is really no reason why all the embroidery techniques most usually associated with domestic use should not be adapted for ecclesiastical purposes, this must be qualified. The success of the result depends upon the way in which the idea has been carried through; whether everything unnecessary to the main idea has been discarded, leaving only the basic discipline and the characteristics of each needlework method; then and then only can a design of real worth emerge, having regard to its suitability for sacred purposes, and the practical considerations of the wearing of vestments.

If the strong association with domestic use intrudes between the intention of the designer and the visual reaction, then it needs to be re-inspired and re-thought, so that the limitations of the technique impose their individuality upon a design in a constructive way and to the furtherance of the spiritual import.

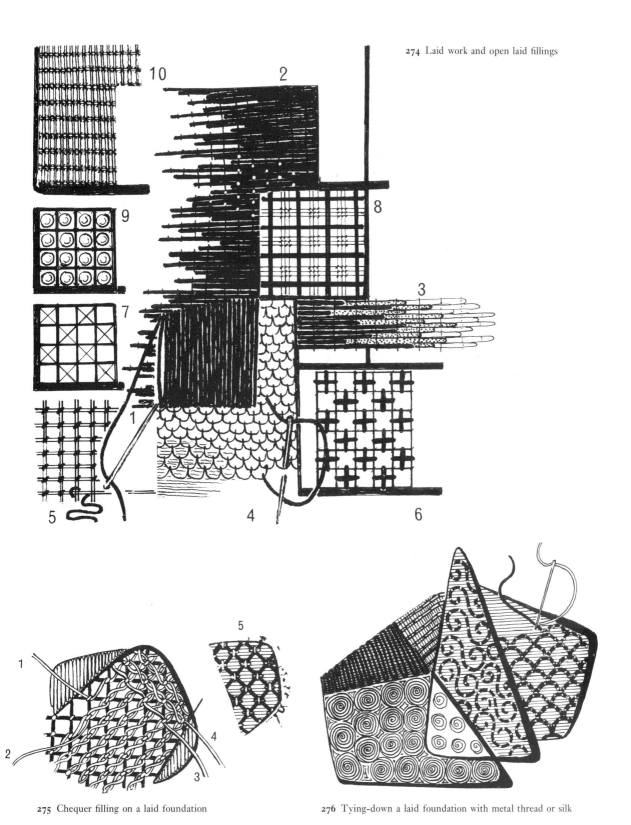

274 Laid work and open laid fillings

10

2

8

9

3

7

1

5

4

6

275 Chequer filling on a laid foundation

1

2

3

4

5

276 Tying-down a laid foundation with metal thread or silk

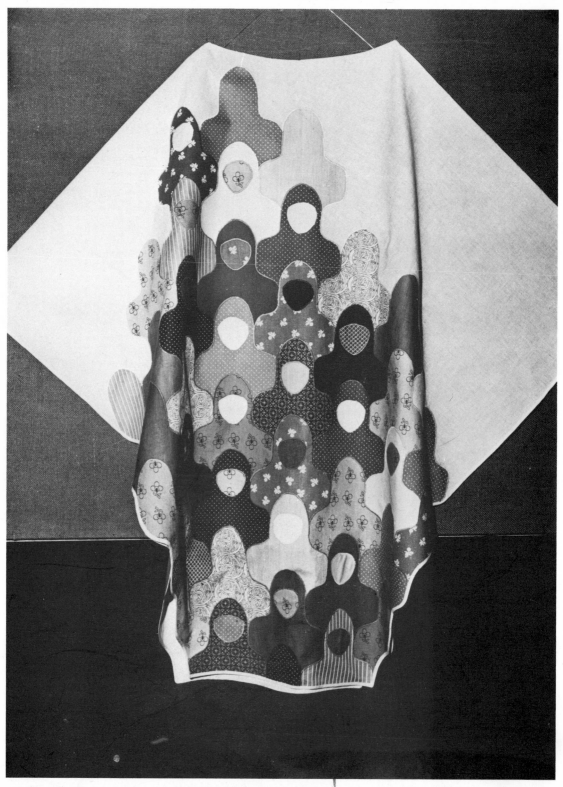

277 Chasuble, 'We being many are one body', designed and made by Julia Roberts

278 Alms bag made in patchwork by Beryl Dean

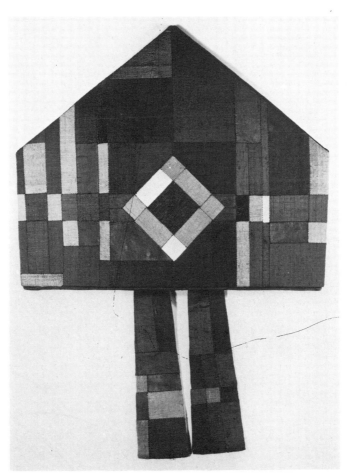

279 Mitre, designed and made by Helen Armstrong, Manchester Polytechnic, 1973. This patchwork of Thai and Indian silks is carried out in strong tones of blue, red, green and gold, the design is based on the keys of St Peter; the teeth of the key can be interpreted as crosses while the key stems form a band around the mitre, and the central motif is the head of the key

Some years ago Averil Colby pioneered the adaptation of patchwork for a cope and mitre for Burford Church, Oxfordshire. This work of great beauty was planned to fit the shape of the vestment, both decoratively and colour wise. But since then some travesties have been produced, which have failed to cross the divide between a bedspread and a sacred vestment.

Likewise, if the designer cannot get far enough away from traditional quilting, a cope can become a close relative of the dressing gown. When these and similar pitfalls can be satisfactorily overcome, then there is a whole area of interest ready to be developed in the service of the church. And works of sensitive artistry, integrity and imagination can be produced.

In the following pages suggestions for some of the traditional domestic techniques are given for the guidance of those who want to express their ideas in these ways.

To decide to employ patchwork as the medium in which to carry out a design for church use, one must be confident that it is absolutely right for that purpose and that each unit has been adapted to become an integral part of the idea for the design of the object as a whole, and not just an attractive all-over decoration. As a technique the full beauty of woven fabrics can be explored, as the light catches

the contrasting directions in the weave; and interesting designs can be created by arranging details from patterned materials, but these must form part of a well thought-out scheme for the whole cope, altar frontal, etc. The planning of the tones of the colour obtained by arranging the direction of the weave builds up to the central focal point, as can be seen (303) and this is emphasised by the introduction of gold. That the kneelers have been planned to become a part of the whole design, carried out in another technique (canvas) adds greatly to the total effect.

In another example (281) the approach was rather different. Here the chapel was fairly small, and dominated by a large Venetian painting above the altar. The frontal had to be planned to complement, rather than detract from the painting: so it seemed that a jewel-like quality was required, which picked out in its colours those of the painting. This could best be interpreted by using patchwork for the central panel, metallic gauzes, covered with coloured nets were used, and as a contrast, velvet and other materials were introduced. Such a combination requires experience in manipulation, and the differences in thickness had to be compensated by inserting templates of *Vilene* of varying weights, which were left in. The patches which formed the sides were of a different size and scale from the centre, this was intended to break and counteract the excessive length of the altar. It will be observed that the templates which combine to make the border patterns are not traditional, in fact very little of the whole process was! For this reason the design was

280 *Opposite* Altar frontal by the Rev John Bruno Healy. Cathedral window patchwork (in colour the interest is greatly enhanced)—detail

281 *Below* Altar frontal, designed and executed by Beryl Dean assisted by E Stevens and E Elvin, 1969. Patchwork in metallic fabrics, silks and velvet, embroidered in metal threads *Westminster Hospital, Interdenominational Chapel, London*

282 Diagram of traditional templates for patchwork

283 All over patterns planned in patchwork

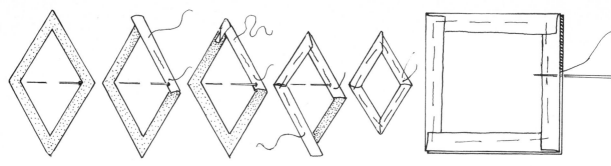

284 Diagram showing the preparation of the patches

first drawn out very carefully upon graph paper. In practice it was found that the templates which were to be covered with the thick materials had to be pared down to make them fit. To avoid disappointment, straight forward patchwork must be mastered before attempting to bend the rules to the extent necessitated by this combination of fabrics.

The following brief introduction to patchwork can be extended by referring to books for further study listed in the Bibliography. The present intention is to give just enough information to show the possibilities for creating original design themes developed from this traditional craft.

The most usual traditional template shapes are given in outline in **diagram 282**. The pentagon (constructed within a circle having sides at 36°), if used flatly, has one point extended, or it may be a diamond with one point removed (**1**). The equilateral pentagon (**2**) is used for making a ball. The diamond (**3**) can be used in very many ways, here at (**4**) it is combined with the pentagon, or forms a star as at (**5**). And the half diamond (**6**), pyramid, or long diamond, will make excellent borders (**7**), and many other patterns.

The hexagon (**8**) (an angle of 30° within a circle) is the characteristic shape, and the easiest to make. (**9**) is the long hexagon or church window, and these are shown as all-over patterns at (**10**) and (**11**). The coffin is another variation (**12**).

The square (**13**) and triangle (**14**) were used in early work, an example is given at (**283**.1).

A most satisfactory effect can be obtained by varying the direction of the weave, and introducing narrow rectangles. The square has been used with excellent results for the modern altar frontal (**306**) from Glasgow Cathedral.

(**15**) The octagon must be combined with some other shape, within a circle the sides are drawn at an angle of $22\frac{1}{2}°$. The eight-pointed star is made by joining the long or squat diamond (**16**).

The decorative value of printed or woven stripes and patterns, when combined to form designs on a much larger scale, is used in present day patchwork. Such an example is **283**.2, and the pattern formed with squares and rectangles could be quite large, and might incorporate a little striped material, with others which are plain (**283**.3).

Shown at **283**.4 is one of the patchwork border patterns from the altar frontal (**281**) for which a thin gilt tissue was used, over templates of *Vilene*.

A creative adaptation of a printed decorative detail is suggested at **283**.5. The shapes are large enough to be manageable, thin materials of contrasting textures, such as a little satin, vyella and cotton might be used and the superimposed embroidery forms an integral part.

Method

When a metal template is used, the paper patterns are each cut from it with absolute accuracy, and the paper should be of a uniform thickness. For a less conventional approach, the design is drawn out, a tracing is made for reference, and one copy is cut up into the shapes, again very accurately, marking each piece in relation to the master drawing.

The paper pattern is pinned on to the reverse side of the material, and cut out carefully, adding turnings. Where there are many similar shapes they may be cut two at a time, but not more. Certainly until sufficiently experienced, all the pieces should be cut from material of the same thickness, or it will not fit together accurately later, and with the experience gained, the pattern may be made a little smaller to allow for extra thickness. Have the grain running in the same way for as many patches as possible.

With the pattern pinned in place, fold over the turning of the first side, and tack (do not use a knot, as this makes the subsequent removal difficult), fold over the tip at the point of the angle, then turn over

the next turning, and tack, repeating until it is complete; this can be followed from the diagram (284), which shows the process for a diamond. When a batch of pieces are ready for sewing together, put the two right sides facing and overcast along the edge, avoid the use of a knot by sewing over the thread. Repeat.

It is easier to sew together groups of patches, and then to join these subsequently, as this makes it possible to keep the work flat.

To remove the tacking (basting) have the work laid out flatly, and snip the thread before withdrawing it, then take out the paper; if this is done carefully it may be re-used.

When adapted for ecclesiastical purposes it may be found an advantage (as has already been mentioned) to cut the pattern pieces in *Vilene*, again with extreme accuracy, so that they may be retained in the work; if so it may be necessary to use a little adhesive to stick down the turnings on to the *Vilene*. The tacks would already have been removed.

Quilting

If quilting is considered as the technique with which to interpret a design, fresh thought may result in a new creative approach, which will encapsulate some quality which could not be produced in any other way. Examine its characteristic – which is the three-dimensional raising of the pattern away from the background, so that parts of the design catch the light, whilst the other side is in shadow. This subtle effect is generally carried out in monotone. An additional feature is its suppleness, so allowing folds to form when hanging.

With imagination and skill the traditional approach may be varied in many ways.

Materials not generally associated with quilting can be used if sufficiently pliant: jersey, fine wool, most silks, and some cottons and mixtures, some real and simulated leathers or PVC, if thin enough and sufficiently supple. There are many ways in which these materials could be quilted and incorporated into embroidered decoration for church use. For example some types of cloth of gold possess a restrained richness when quilted. This can be seen in the detail from the hanging *Adoration* in St George's Chapel, Windsor Castle (294B). The garment worn by the kneeling king is composed of quilted patterns in various methods, on cloth-of-gold and other fabrics.

These suggestions can be developed in an imaginative way to interpret good designs of today –

but there are pitfalls, as has already been stated, because some of these embroidery methods are so much associated in people's minds with their domestic use, that it requires an entirely fresh approach before they can be translated for ecclesiastical embroidery. Every aspect must be thought out anew, then the result is possessed of a fresh and vital quality which the very characteristics of this and other specialised techniques will give.

Quilting has a long and almost universal history. Being both practical and economical, the decoration has grown out of necessity. Essentially the stitchery exists to keep in position the layer of soft wool or fabric padding placed between the lining and the outer material. An example of about AD 1400 is the Sicilian Quilt part of which is in the Victoria and Albert Museum, London (286). This method has been adapted for the altar frontal (285) for which pre-shrunk unbleached calico or fine linen was framed up. Over this was put the furnishing fabric which shows as the large cross, this was covered with thin gold tissue which was overlaid with layers of net which darken towards the edges. The cross shapes were outlined with couching which emphasised the gradation of colour. Layers of net were cut away from certain areas.

Then the work was turned over on to the reverse side, small slits were cut in the backing; through these the acrylic stuffing was pushed with the aid of a stiletto, then they were sewn up (287A). On the right side of the work the crosses are raised (287B). This method is a form of trapunto. For tracing the design special quilters' marker pens are obtainable.

The English quilts, coverlets and petticoats of the eighteenth century are varied in design and method. For the example from which the detail (288A) is taken, very soft wool would have formed the layer of padding between the linen and the outer satin, the outlines were stitched with fine running, (for this the needle stabs the material straight through, down, then upwards) (288B). The eight-pointed star (289A) is taken from a pillow, and is known as Italian quilting. For this the backing must be a loosely woven linen or muslin, to which the upper or outer fabric is tacked, the design having been traced on the front (with a line fine enough for the stitchery to cover it) or on to the reverse side, where, if worked with stem stitch, a backstitch will result upon the front. Then a large blunt needle is threaded with pre-shrunk wool or thick cotton, and it is pushed through, between the two parallel outlines; the needle is brought out at corners or points (289B) and at intervals around curves. The thread is cut at the ends (289C).

The detail from a nineteenth-century reproduction of an old Welsh quilt, would have had a layer of blanket or wool between the outside two layers, which were stitched together with backstitching (289D).

American quilts are delightful, the design being carried out in coloured appliqué, in both plain and patterned cotton prints, upon a ground usually consisting of two layers of linen with interlining. These were quilted in an all-over pattern. The example (290) is old, and shows the Tree of Life design applied in red on white cotton. The whole surface is quilted. There is a collection of quilts in the Smithsonian Institute, Washington, and further specimens are in many other museums.

Some of the welcome food parcels that were sent to Britain from America by generous benefactors during the Second World War, came wrapped in charming quilts which were greatly prized.

Ecclesiastical embroidery at the end of the nineteenth and into the twentieth centuries was synonymous with figure compositions carried out in long and short stitch in silk and couched gold. Because of this association it is still thought (even by the church itself) that it is in some way irreligious to interpret good present day design in an experimental medium. Should bead-work be suggested the idea might be unacceptable, because people 'like what

285 Altar frontal embroidered by Pamela Waterworth. Gold tissue over cream coloured fabric, the covering of net has been cut away from the cross forms which are quilted and outlined
St Andrews Church, Heddington, Wiltshire

286 *Opposite* The Sicilian Quilt, *c*1400. Scenes from the early life of Tristan are quilted in running stitches in natural thread and brown thread is used to backstitch the important parts of the design
Victoria and Albert Museum, London

they know', and would probably be unmoved if informed that, from as early as the thirteenth century, there are such examples. In the Victoria and Albert Museum there is a fragment of a German stole embroidered with beads of glass, coral and gold, seed pearls having been used for the faces of the figures. They are sewn onto a parchment foundation. There are other early examples, for example a frontal, dated 1698 from Weston Favell, Northamptonshire, which is interesting. Again, the Victorians used beads not only for their trivialities, but also incorporated them into embroideries which were worked for the church.

A technique which seems not to have been revived is inlay, yet the examples of Persian inlay of the eighteenth century from Resht, show how great are the possibilities for an inventive adaptation suitable for large hangings or for small alms bags. Then, there are many ways in which the Kuna (265) so-

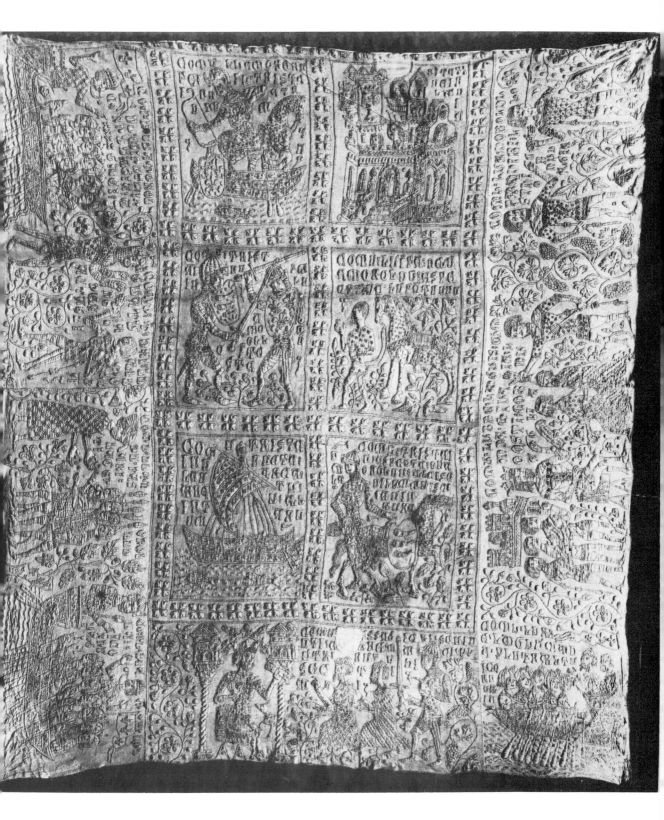

253

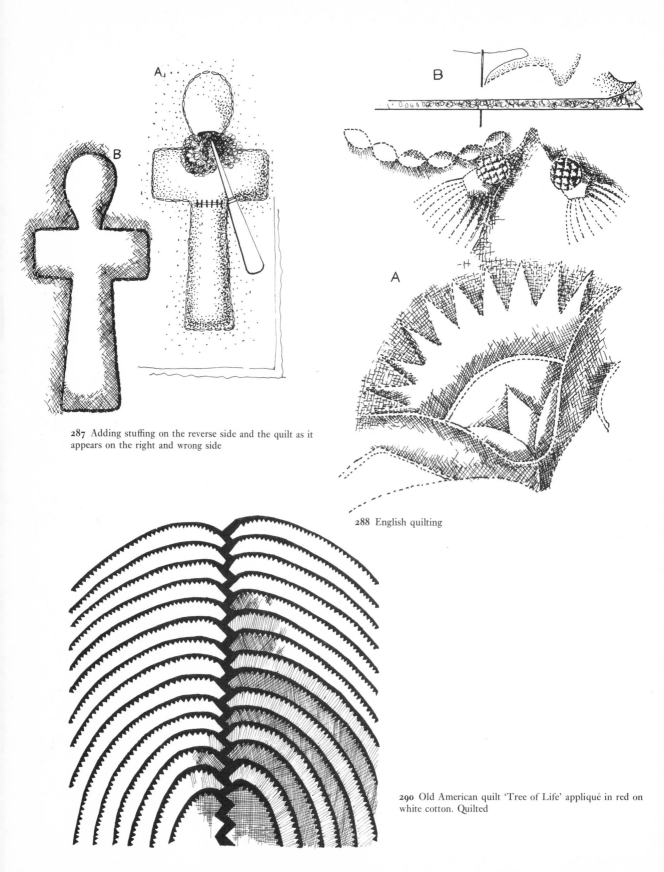

287 Adding stuffing on the reverse side and the quilt as it appears on the right and wrong side

288 English quilting

290 Old American quilt 'Tree of Life' appliqué in red on white cotton. Quilted

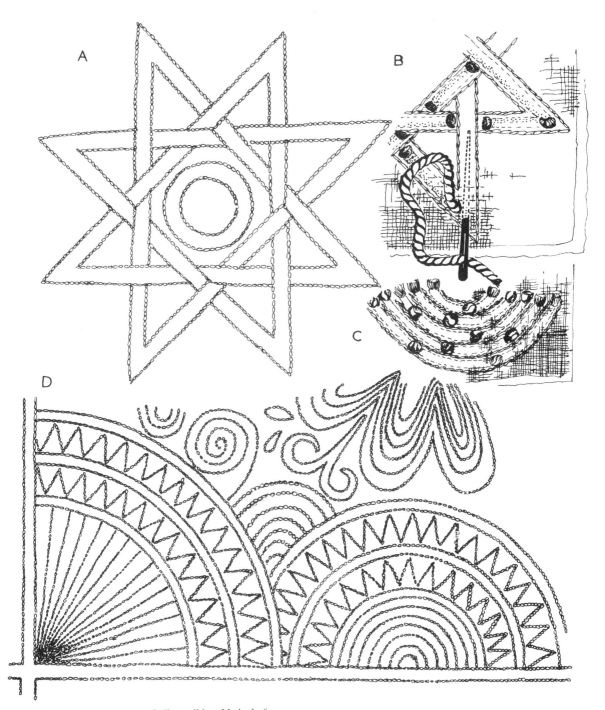

289A-C Eight-pointed star, Italian quilting. Method of stitching
289D Detail from a nineteenth-century reproduction of an old Welsh quilt

called 'appliqué' of the San Blas Indians could form the inspiration for most interesting pulpit falls or banners. This is done by tacking together layers of thin coloured cotton fabrics, and cutting away the upper ones to expose those underneath. The edges are turned in and hemmed.

There was a time when some prejudice was felt against machine embroidery for ecclesiastical purposes, but this has been almost overcome, due to the influence of the excellence of the works which have been produced in the medium. This form of expression has integrity in its own right, not as a substitute for hand embroidery nor for speed, but because it has a quality which cannot be produced in any other way, and many artists are thinking in terms of machine embroidery. *The Adoration of the Magi* by Susan Riley, a panel now in the Royal Scottish Museum was done at a time when there were few examples of machine embroidery for the church on such a large scale. The work of Pat Russell, to be seen in many cathedrals and churches is individual and important, especially for her use of decorative lettering which is mainly machine embroidered. Judy Barry and her partner Beryl Patten are outstanding for design and their forward looking approach to the technique and use of fabric for machine embroidery combined with hand work.

CHAPTER X
Commissioning ecclesiastical embroidery

It is generally the priest rather than the donor who approaches the designer-crafts person. He will want the very best for his church and a greater understanding of the way in which an artist works will help in its attainment. Upon his discernment in the choice of designs much depends; faced with the perpetual lack of funds it must be difficult for the priest to resist the temptation to accept the offer which costs least or nothing. This is to undervalue the power and importance of the very best of that which is visual. To some people it is the spoken word which communicates the Spirit of God, to some music, and upon others the impact of colour and the juxtaposition of shapes and forms makes a deep impression. Why else would the church have been (and to some extent, still is) a patron of the Arts?

These points were discussed by the Bishops' Committee on the Liturgy in 1978. The report stresses a zealous seeking out of the very best, and continues 'to restore respect for competence and expertise in all the arts and a desire for their best use in public worship. This means winning back to the service of the Church professional people whose places have long since been taken by "commercial" producers, or volunteers who do not have appropriate qualifications'.

As in any other sphere it is the trained professional who is more likely to succeed than the enthusiastic amateur, however naturally gifted. Is there not a difference between a long rambling talk given by a layman and the presentation of the sustained theme by the one whose vocation it is? Good exponents are in demand, sometimes they make big sacrifices, but the value of their inspiration is not always appreciated.

That visual design must be good design is as important to Protestants as to Catholics yet 'There has been a surfeit of poor and mediocre work done in the environmental arts. There has been a sort of acquiescence to the notion that everyone is an artist; that enthusiasm is a good enough substitute for skill, discipline and wisdom; that novelty is the same as creativity; and that there are no standards of taste except personal taste.' (Quoted from the Rev Ricardo Ramirez.)

Although the following reference is to the United States it applies equally to Britain. 'Many possibilities lie open for the future. There are skilled craftsmen and women who have proven their worth in such media as stone, metal, ceramic, glass, pottery, weaving, embroidery, silver, gold and bronze. Many artists who come to this country do not find a market or a ready appreciation for their crafts; soon they leave for more practical work which is remunerative. These people have to be convinced – concretely through adequate payment – that their skills are sorely needed in church.'

In preference to sacrificing the standard of design, economise by finding substitutes for expensive fabrics. Or, if absolutely necessary, the designer might, perhaps, agree to supervise the execution of the work by volunteers whose skill has been proved. But this is never as satisfactory as when the creator of the idea carries out the work. Untold damage can be done to a design by others who, with their heavy-handed approach and lack of sensitivity fail to appreciate its subtleties; sometimes this is because they are convinced that theirs *is* an informed opinion!

There are immense possibilities in designing for places of worship, and the reordering of the Liturgical space opens up chances for producing really stimulating new ideas through the introduction of colour and decoration. Yet it seems that comparatively few priests possess the visual imagination or have faith in advanced works of art, and still fewer are the Parochial Church Councils who would have the courage to support forward-looking schemes, and, to quote, there is 'the almost total inability of the audience to discriminate between what is good and bad'.

It may be that when contemplating the commissioning of an embroidery, the priest does not know of a qualified designer-crafts person. He could contact the local college or school of art, the polytechnic or perhaps the adult education institute

to enquire whether there is an embroidery instructor who is also a designer, and ask for advice, recommendations and suggestions from the Council for Places of Worship, or the Embroiderers' Guild or if it is an important job, the Crafts Advisory Committee.

If only the priest thought out what he wanted *before* briefing the designer, instead of waiting until seeing the designs to decide upon rejection, as being what is *not* wanted. Does he realise that with enthusiasm he can inspire, perhaps by chatting about possibilities of a new approach to the old symbols, references to the Scriptures, the architecture or special features of the church, etc, which may help to spark off ideas in the imagination of the designer, and would relate to that individual place of worship? Although emphasis upon limitations during briefing is not constructive, there may be some stimulus in overcoming difficulties. Freedom and latitude to develop ideas are to be encouraged, despite the fact that the vicar himself may be limited in his ability to envisage mentally a visual image. It is his understanding coupled with a good rapport with all concerned which will secure the best results.

The vicar may expect to receive from the designer three or four sketches or finished designs when commissioning work; and should ask for a provisional estimate of the approximate cost. If a limit has to be placed upon the expenditure, it is important that the designer be informed at the outset of the amount of money available.

Some clergy have probably never thought about the problems of finding the right coloured fabric at the right price, nor even imagined the days, months or even years of continuous hand stitching required to realise a design. So that it is not surprising when, through sheer thoughtlessness and dithering the time allowed for the completion of a commission may be unreasonably short. For example, five hand embroidered copes for an important occasion three months ahead!

Interesting developments in machine embroidery, and modern adhesives have introduced an approach which is alive to present day influences which replace traditional methods. We are not here concerned with the purely commercial aspect or with the output of the ecclesiastical supplier. Although the excellent products from West Germany, in particular, are inspiring and there are stimulating individual examples from other countries, this does not really indicate a generally improved standard in commercial goods. A look at the dull machine embroidered decoration offered in the catalogues from the USA throws into even stronger relief the freshness of outlook and pure artistry of certain individuals working in terms of the highly inventive use of the different types of machines for embroidery and the effective combinations of textiles and colours, for which Britain has become known. Yet the freelance artist is often caused anxiety through lack of understanding – a typical example which could arise when the artist has been asked to submit designs which have been dispatched: without acknowledgment being received (which causes difficulty when planning the time required for other commissions). Ultimately it may be discovered quite by chance, that the whole scheme had been abandoned! Was this failure to inform the artist due to the inability of those responsible to appreciate the value of the designs, and the working time and thought expended?

Many who work creatively are idealists and those who choose to express this instinct in terms of ecclesiastical embroidery recognise that they may have to accept far less than equal ability would command in some other sphere, such as commercial art, and that the interest of the job is to an extent its own reward.

Churchmen who are themselves artists and those with the knowledge and aesthetic discrimination do much to bring about the acquisition of works of art and encourage patronage and the co-operation of designer craftspersons. But even with very limited funds much can be done to bring about active participation in group projects. That hangings, etc, can be expendable is becoming acceptable, therefore the influence can be contemporary in feeling.

The priest becomes involved in many ways, because however brilliantly designed is a dossal, banner, fall, etc, its effect is absolutely destroyed, if, when it is put into the church, it is not properly lit. It is the responsibility of the designer to enquire about the lighting and to discuss with the priest and Parochial Church Council what is required, suggesting and advising, where applicable, movable spot lights, which, where banners are concerned, are projected from one pillar to another, thus throwing into relief the full effect of colour and texture of the fabric; this should be considered as a part of the project.

Another matter requiring collaboration is the care and storage of the vestments. The average parish needs to understand something about looking after the new large voluminous chasubles. The older chasubles fitted into a drawer, this is now impossible without folding, which spoils the vestment. It is

preferable to have big wooden hangers, padded, so that the chasuble will not slide off, and the whole thing can be put into a large zipped case, which is then hung upon the tall garment-racks on wheels which are used in the rag-trade.

To undertake a commission

Should you be a professional designer, specialising in ecclesiastical embroidery, and experienced in working for the church, or if you are an interested and gifted amateur – whether being paid or working partly or entirely as a labour of love – then the following suggestions apply: firstly, to quote the Rev Leonard Childs, 'Work with the priest, vicar, rector. It is his responsibility, find out what he likes or can be persuaded to like! He may have old fashioned ideas, or very modern ones, but he also has to work with other people and consult them: he will have a Church Council, and lay people often have even more conventional ideas than the clergy! The Church of England has an Advisory Committee of professionals and lay advisors in each diocese to comment on plans and designs. They are not usually asked about vestments, though they will give intelligent and informed comment if asked to do so, but they *must* be consulted about frontals and shown plans, drawings, samples, etc. Their advice *has* to be obeyed or the faculty (legal permission to install the work) will be withheld.'

The importance of equipping yourself with the required specialised knowledge cannot be overstressed, to be an established designer in one area does not automatically lead to success in another. Persuasion can be an adjunct to, but never a substitute for an informed opinion. Put simply, you must know what you are doing before attempting to be responsible for a work of importance in the field of embroidery.

As a designer/embroiderer imagine that you have been approached to undertake a piece of work, arrange to meet the priest to discuss the project, *and from him find out what is wanted*; if a vestment, what shape is preferred? If an altar frontal, what is the method of fixing? Look at the vestments and furnishings with which it will be used; have with you a tape or steel measure, and note all the measurements which you might need; to take along a collection of useful colour and fabric samples is a good idea. Ask about the financial arrangements, it is impossible to plan without knowing how much can be spent on materials. Make sure that you ascertain the other relevant information, for example, when do they

want it? Other practical advice is to be found in the section on design in Chapter II. Ideas will come as you absorb the ambience. It may be impossible to make even one return visit, so before you arrive, prepare a list of points requiring attention, and it would be wise to take larger patterns of material to judge the effect *in situ*. Draw out about four design ideas, making them look attractive and readable, remembering that most people cannot imagine anything beyond that which they can actually see, so, when submitting the designs take trouble with the presentation (a line drawing means little). You will probably not be there to explain your intentions, so add brief, clear notes. You may want the people to choose one of the designs in preference to the others, because in doing it you feel that you have more nearly captured what you were striving to express, consequently it is of more interest to you, so you want it accepted; you might add weight to your persuasion by carrying out the design in coloured cut paper collage, mounting it, and attaching patterns of possible materials, these can also be attractively presented, together with notes concerning the execution and perhaps a sketch of a detail to full size. An estimate will probably be required.

In some circumstances to submit a good modern, foward-looking design will require much well considered thought and carefully prepared argument, with rather larger samples of fabric to accompany the drawing; also an explanation of the meaning will help. Without an understanding of the religious requirements and the practical approach to the ultimate purpose one ought not to have the presumption to attempt to lay down the law, and even so equipped, persuasion and great tact are necessary. The prevalent attitude, 'I know what I like', more usually means 'I like what I know'. So, an attractively presented design will do much to prepare the way for the acceptance of new ideas into 'a church concerned with the past, by looking forward, through design, with hope and expectancy'. It is useful to remember that it is a part of a creative designer's training to envisage and plan in the mind, this is difficult for those who have no visual imagination.

To carry out a commission for a cathedral or church abroad presents additional problems, as one has to rely upon coloured photographs to get an impression of the interior. Further description helps, but to convey what is wanted entirely by correspondence is difficult, as one feels that their expectation is probably based upon something with which they are familiar, but about which you have no clue. It is

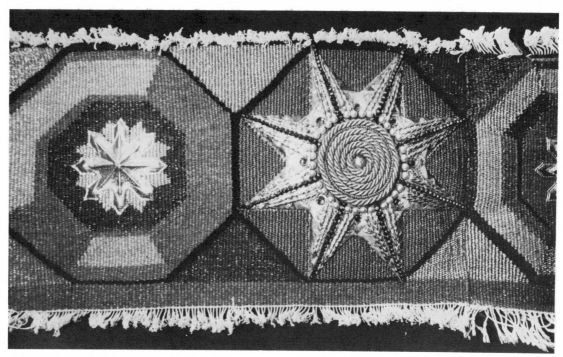

291 Detail from the frontal for King's College Chapel, Cambridge showing the woven background and 'some of the octagons contain relief ornamental motifs'

292 *Opposite* The preliminary sketch by Joyce Conwy Evans to convey scale and space of King's College Chapel, Cambridge, with which she was concerned when planning the design for the frontal

difficult to convey an elusive idea and for the recipient to comprehend exactly what is meant. It is however a stimulating and an interesting challenge when one is on the same wave-length, an understanding develops over the years and the appreciation is indeed rewarding. To avoid misunderstandings, anticipate difficulties by drawing details of construction clearly, and also make clear diagrams, asking for specific measurements to be supplied. They can then not only see the proposed shape but know where to take the measurement. When agreeing about the contemplated date for completion remember that there are hold-ups and delays whilst awaiting replies to queries. Estimating is much the same, except for the exchange rates, but responsibility for transportation, insurance and packing must be pre-determined.

Throughout these pages the importance of the ambience as a whole has been stressed; also the fact that the visual and practical aspects require consideration before any addition is planned.

The carrying out of the Royal College of Art robes has been described on pages 206–208; the following is a further example of the care and attention to detail and the lengthy preliminary preparation which has

to be undertaken even by the professional, either working alone or in conjunction with other experts in their particular field. This is illustrated by Joyce Conwy Evans, to whom the author is indebted for the following notes.

The altar frontal, King's College Chapel, Cambridge (293)

The frontal measures 4.10 m × 1.42 m (11 ft 3 in. × 3 ft 2 in.).

The design

The design is by Joyce Conwy Evans. Her first sketch roughs were submitted in 1964, and subsequently she made a full-scale mock-up of the frontal out of card, with the design recreated as a collage of paper-sculpture, cords, string, pipecleaners, gold and silver foil, pearls, beads, buttons, sequins, and sham Hepplewhite furniture mouldings of stamped plastic, coloured with paints, inks and metallic sprays. This mock-up was used in the chapel in lieu of a conventional frontal until 1967, but by 1966 items of the glued decoration had begun to fall off, and as major renovation plans for the chapel were beginning, under the direction of Sir

ings Colleae Chapel JCE

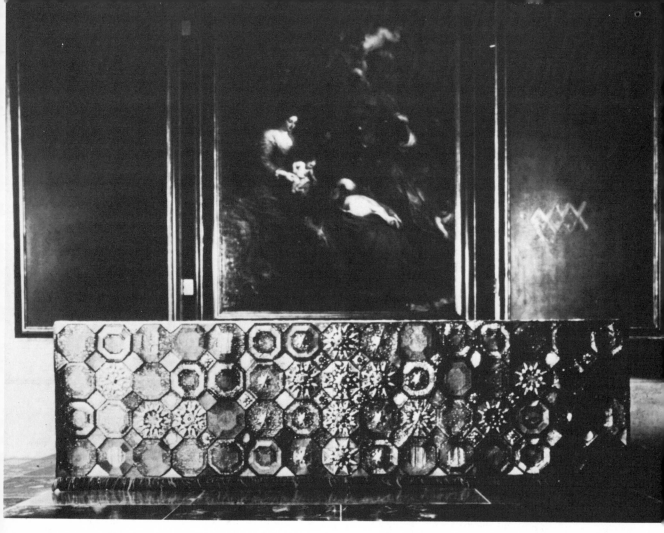

293 Altar frontal designed by Joyce Conwy Evans woven by Edinburgh Tapestry Company (Dovecot Weavers). Tones of gold, silver and black embroidered by Elizabeth Geddes *King's College Chapel, Cambridge*

Martyn Beckett, the chapel architect, it was decided that a permanent textile replacement should be included in the renovation scheme.

General description of the design

The frontal is designed as a geometric composition of sixty 23 cm (9 in.) diameter octagons, arranged in four horizontal rows of fifteen octagons to create a large patchwork. The colours consist of different golds, red-browns, ochre, sepia, and a little aluminium. Each octagon is subdivided within itself into areas of different tones and colours, an idea which was devised to avoid the risk of monotony from such a mathematical design by breaking up the ground into smaller units of pattern and colour, while keeping them subordinate to the main shapes.

Some of the octagons and the lozenge-shaped figures connecting them contain relief ornamental motifs which are distributed asymmetrically across the surface of the frontal, except in the centre, where they are concentrated most richly, and utilize the regular divisions of the ground to form a large cross.

The woven ground

This was produced in Scotland by the Edinburgh Tapestry Company at the Dovecot Studios, Edinburgh, under the direction of Archie Brennan. It took 115 days to make, and is woven at 8 warps per inch, with cotton warp and weft threads of wool, silk, metal and synthetic metal. This combination of different types and thicknesses of thread has created a varied surface texture, adding to the richness of the finished work, and helping to effect a successful partnership with the embroidery, much of which had to be raised away from the surface to a greater or lesser degree, some, in fact, having to be modelled in quite high relief, as a kind of fabric sculpture.

The embroidery

The embroidery was created by Elisabeth Geddes, assisted by Audrey Chaytor Morris, both of London, and took seven months to complete. It consists of appliqué, needleweaving, laid work, couching, and various raised methods, conventional and otherwise. The materials used are gold and copper kid, Orion cloth, lurex fabrics, Jap gold cords, metallic and lurex cords and threads, pearls, Austrian crystal beads, rocailles, diamanté, sequins, and filagree and hand-covered buttons. The fringe is hand-knotted with wools used in the weaving.

The design had first to be re-assembled, having been dismantled into five sections for greater ease of transport to Scotland. The task confronting the embroiderers was that of translating it into the medium of fabrics and threads and incorporating these effectively with the weaving so that embroidery and weaving became interdependent. In comparison with the RCA robes the concept was much bigger, the weaving coarser, and some of the decorative detail conceived on an elaborate scale. In these circumstances it was decided to avoid glitter and pursue subtlety, using threads in the ground colours, including some of the weaving threads, and incorporating needleweaving if possible.

The briefing given for each commission is different and depends upon individual circumstances and limitations. It is this factor that makes a job so interesting and challenging.

Whilst he was Dean of Windsor, the present Bishop of Worcester, Robin Woods had the idea that the worn-out damask hangings in the Rutland Chantry, St George's Chapel, Windsor Castle, should be replaced by one very large or five smaller embroidered panels.

This chapel, which is considered to be an outstanding example of Gothic architecture – the stonework soars up to the wonderful vaulting – is reserved for those who want to pray and meditate in quiet solitude.

To be offered this commission was both intimidating and immensely exciting; it was accepted with doubts and hesitation in 1969 by the author.

As stone veining divides the surface of the wall, it was decided to have five panels, each 2.59 m × 1.41 m (8 ft 6 in. × 4 ft 8 in.).

For the design, three main themes taken from the Old and New Testaments were suggested. The series dealing with events in the life of the Virgin Mary was chosen. At a time when most design was abstract in character, it proved difficult to adapt to the figurative approach required. Another problem was the large monument in the middle of the chapel which makes it impossible to view the panels as a whole. Yet, because each panel is separated by only 7.5 cm (3 in.), they must hang together as a complete unit. Pew-ends with 36 cm (14 in.) carved roundels further obscure parts of the panels.

It seemed important that the background fabric should integrate with the stone. This, together with the desire to include drawn thread and pulled work, determined the choice of hand-woven linen which was woven by Jack Peacock. The dark grey at the bottom graduated through medium to light grey at the top of each panel. As they were to be seen at very close range, it was decided to introduce techniques seldom combined, such as gold work, drawn thread work, quilting and appliqué, together with details using beads, studs and jewels.

The heads and hands were embroidered in coarse and fine Florentine wools and thick linen threads; the features were highlighted by leaving the ground fabric unworked.

A technical problem peculiar to large scale embroidery arose from having to keep the backing framed up throughout. Logically the whole thing would be put into an immense frame and worked from each side. But with a figure subject (though this may be a personal idiosyncrasy) it is essential to work out the heads with the embroidery the right way up, in order that the progress can be seen and the character developed. This leads to constant rolling and unrolling of the work on the frame, because it is only possible to stretch to stitch within a maximum of 33 cm (13 in.) from the worker, who will be using both hands.

With an unavoidable break of several months, this commission took under five years to complete, with some help on the first panel, by Elizabeth Elvin and Margaret Forbes.

In the first panel – *Annunciation* (294A) – the Virgin Mary was depicted as a simple girl of any country, with whom any young person might identify. The wings and the light at the top convey the impression of the Spirit descending to her.

With the second panel – *Visitation* (plate VI) – the problem was how to convey the happiness experienced by the two women, Mary and Elizabeth, on meeting. Sunshine symbolised by fluttering butterflies seemed the answer. Mary is identified by her emblem – lilies (carried out in patchwork).

In the third panel – *Adoration* (294B) – the whole gamut of embroidery techniques and materials were brought together in an endeavour to depict the rich raiment and gifts of the visiting Kings.

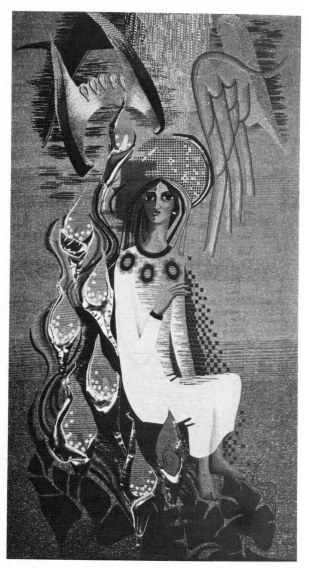

294 and **295** Panels 259 cm × 141 cm (8 ft 6 in. × 4 ft 8 in.)
for the Rutland Chantry, designed and embroidered by Beryl
Dean, commenced in 1969. Background is linen hand woven
in tones of fawn and gold, hand embroidered in gold work,
pulled and drawn thread work and appliqué
St Georges Chapel, Windsor Castle

294a 'Annunciation', 1969. White, dark green, orange and
gold. ('The Visitation', see colour plate VI)

The fourth panel represents the *Temptation*
(**295**A). In an attempt to convey the height of the
mountain, a sudden reduction in scale was used for
the drawing of the City and the Devil – the latter
being carried out in raised gold. So that any young
'hippie' of the time might relate, Christ's garment
shows this influence.

294b 'The Adoration', 1971. Various embroidery techniques
including quilting methods. Neutral colours with gold, some
mauve, black, brick red and pink

The symbolism of the grapes and the water-pots
suggests the miracle of *The Marriage at Cana*, which
is the subject of the fifth panel (**295**B). The figures in
this panel are treated decoratively. The panels were
stretched and mounted when completed.

Estimates

Circumstances vary so much that any ruling is
impossible, but the following suggestions may be a
guide. To prepare an estimate for a large commission,
consider these points:

295a 'The Temptation', 1972. Tones of purple, red browns, white, various golds, applied stitchery in wool, linen, chenille and silk also gold. Various embroidery methods

295b 'The Marriage at Cana', 1973. Tones of purple, cyclamen pink, dark blue, dark green, brown, a combination of appliqué, drawn thread and pulled work. Gold work, etc

1 Decide what proportion of the following outgoings are chargeable to the job. Overheads, such as rent, lighting, heating, insurance, phone, deterioration of equipment – also postage, travelling and other expenses.

2 The professional fee for the design (this is a personal evaluation of the creative factor + time).

3 The cost of the photographic blow-up or the time taken to enlarge the design. Cost of paper and tracing paper.

4 Cost of materials. This cannot be determined until

the design has been selected, but an approximate sum can be estimated.

5 Cost of packing and transporting the finished commission.

6 There may be the cost of a stretcher, banner-pole, etc.

7 VAT + inflation may have to be added.

8 Time! To foresee the amount of time which will be taken to carry out a design is almost impossible, but in a craft like embroidery the whole estimate

depends upon this element, so try to break it down into:

Time spent shopping, travelling, visits to site, preparation, transferring, framing-up, mounting or making-up. Time spent upon the actual embroidery – here is the difficulty, some sort of estimate can be obtained by covering the full-size design with cellofilm, and tracing on it the outline of the shapes. Then, using a contrasting colour, draw a grid over the whole area, the spacing of this will depend upon the scale of the design. Next, consider the squares, one at a time, trying to imagine how long each will take to work, write this down, then, having arrived at a total, it is bound to take considerably longer!

9 How to evaluate an hour of an individual's time? There is no standard rate for the job, so various factors have to be weighed up, and comparisons made.
(a) The more accomplished, experienced and skilful the embroiderer the less the time taken.
(b) Conversely the inexperienced worker will work more slowly, spending time unpicking, and will have to seek advice and directions, thus wasting the time of two people.
(c) The ability to design is fairly rare; the training, together with the practical knowledge takes several years.
(d) Technical skill and speed can be acquired with practice. This is where differentiation comes in.
(e) Some embroiderers are of the opinion that because the work is so pleasurable, and, in its creativity, so rewarding, they are willing to forego a proportion of the otherwise astronomically high real cost of hand embroidery for the church.
(f) That the church seldom has enough money to pay the real value may or may not be a consideration.
(g) It may help in estimating the rate to charge per hour to compare the work with that of other professions, this would apply to the designer-embroiderer capable of organising and directing the creation of a large project.

When there is a limited and definite sum of money available the amount will determine whether the project shall be undertaken as a commission, or if it shall be used to pay for the design, with the working being directed professionally, allocating the balance for the fee and purchase of materials, and depending upon skilful volunteers to execute the project. It is important that the organiser should discover the right person to undertake this project, and that the financial allocation is realistic. Dreams of Thai silk may have to be changed to Dupion, when the making-up and mounting are remembered.

It is important to estimate the probable cost before starting any piece of work as it is both humiliating and worrying to run out of money, and have to ask for more.

Upon the funds available the type of design and subsequently the amount of work and materials will depend. Complicated techniques may have to be replaced. From the start the extent of the embroidery must be disciplined.

It is perfectly possible, with proper planning, to execute a commission with the intention of showing a profit. But to do this it has to be efficiently organised, no time consuming techniques, small scale details and few expensive materials. Machine embroidery and appliqué, combined with the use of modern adhesives, etc, have to be employed. A predetermined schedule and time keeping is important.

In conclusion, although the professional has been addressed, much applies to the amateur, of whom high standards are expected. Additionally the amateur may be expected to aspire to judgements with which she is unfamiliar, and must be careful not to fall for the more popularly held opinions and standards of admiring friends.

CHAPTER XI
Group projects

Basically the aims activating corporate projects are 1) the production of vesture and soft furnishings for a place of worship, which will benefit by the acquisition of more, better designed, up-to-date and personalised works of art than could otherwise be afforded, and 2) the value to the participants, who, sharing a common interest are brought together to contribute skills according to capacity.

Any work introduced into a place of worship should be of the highest artistic integrity; unfortunately those in the positions to make decisions are not always themselves the best judges: they seem, so often, not to accept that contemporary art forms belong to liturgical expression as surely as the art forms of the past which were originally themselves contemporary. However, let us suppose that a group of embroiderers has got together and that someone has had the wisdom to insist that it is essential that the right leader should be appointed, he or she must be qualified as a designer, organiser and preferably as a teacher of the technique of the craft – one who will direct the realisation of the ideas. In many ways the decisions made by the leader are more easily accepted as being impersonal when he or she comes from outside the community. In any case very great tact and sympathetic understanding is necessary when dealing with a group of adults of mixed ability, who are all giving of their time and striving to do their best.

The leader forms the liaison between the group and the priest or Church Council, and others, and will probably have to use persuasion to get a good modern design and colour scheme accepted. Being able to use his or her imagination and seeing beyond the preferences of the present incumbent, this person must really know the job in order to overcome any preference for tradition and possible reaction against change.

The ideal is for the designer to direct the work and to teach, this is a job for the professional. Fortunate indeed is the church which can obtain the services of one so qualified and interested, although sometimes not only the priest but the amateurs too, in their own pleasurable enthusiasm fail to appreciate or properly evaluate the rare ability to design, and unwittingly take advantage of those who possess professional expertise.

When, possibly through lack of funds it is impossible for the designer personally to direct the working-out, an attempt should be made to arrange that the artist, as an understood part of the commission conveys the meaning and intention to the leader and the group, and sees how the work proceeds from time to time. This leader needs to be a trained and competent technician whose understanding is sufficiently developed to imagine what is required.

The people taking part in a corporate project are learning all the time and within the framework of the subject they begin to realise what it is that they are meant to be expressing and what the limitations of the media are, so, in gaining confidence the creative impulse is developed, but this can only be brought out by the trained and experienced person who uses that particular type of medium, understanding its technicalities; and because they possess that mastery they excel at doing what they are doing. Therefore through personal experience they can advise on technical matters, for example, that the hang of a chasuble depends upon the direction of the grain of the fabric, and can point out alternative working methods. And so step by step, the participants become confident enough to design individual parts. Because they are able to refer to the leader, who becomes the instrument through which they design, and have their questions answered, they feel secure enough to experiment. They gain much, realising that the design is only a part of the excitement of the project; as they learn to appreciate the nature of textures and how they are used, they can see the thing developing. To watch their satisfaction as the project gets under way, for themselves seeing it growing, this is the thrill and the interest for the leader – this the reward and the excitement. But the apparent ease is deceptive, it requires the professional experience to foresee mistakes and to prevent them happening; in embroidery, unlike painting it is

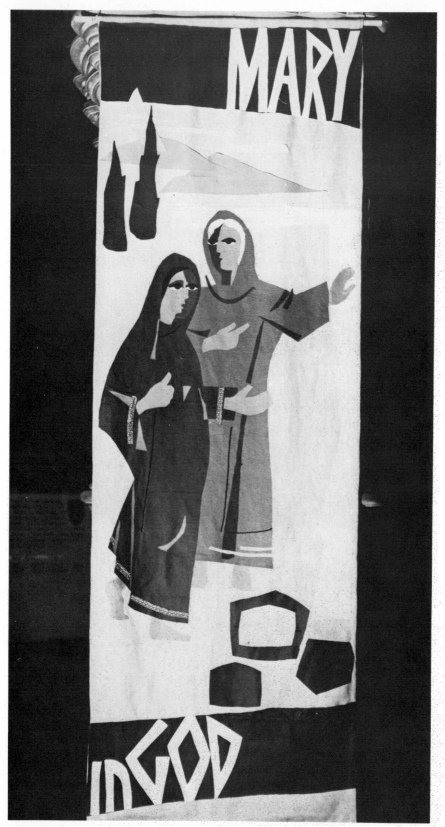

296a Christmas and Eastertide banners for the nave of
Southwark Cathedral, four from a set of fifteen, designed by
the Rev Peter Delaney and carried out in felt appliqué by a
corporate group

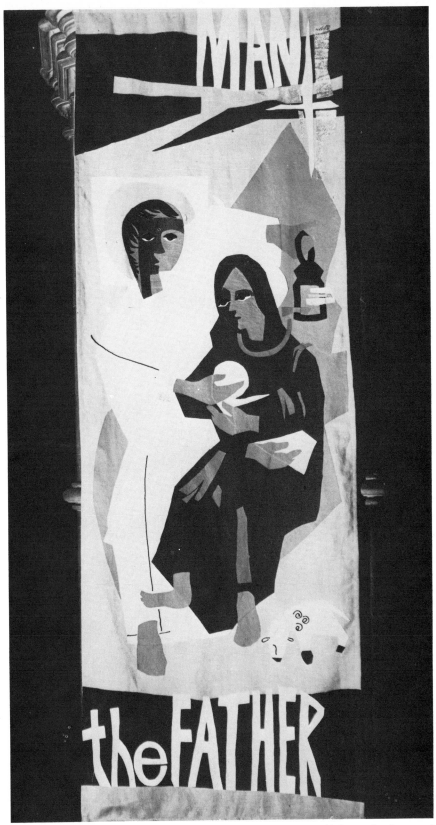

296b Christmas and Eastertide banner for the nave of Southwark Cathedral

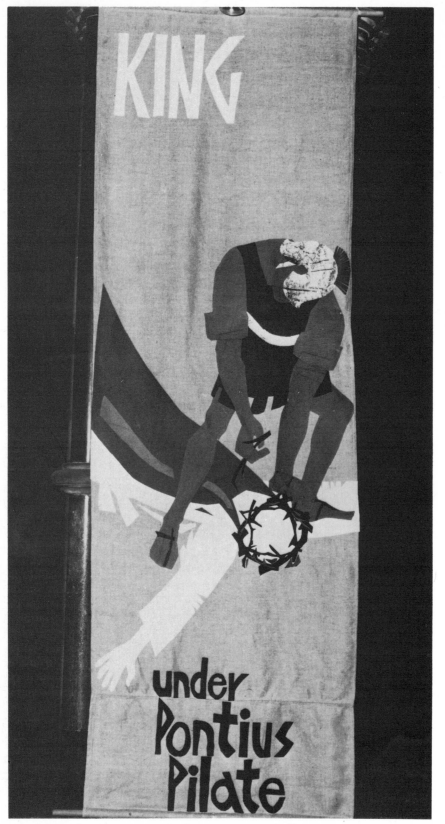

297a Christmas and Eastertide banner for the nave of
Southwark Cathedral

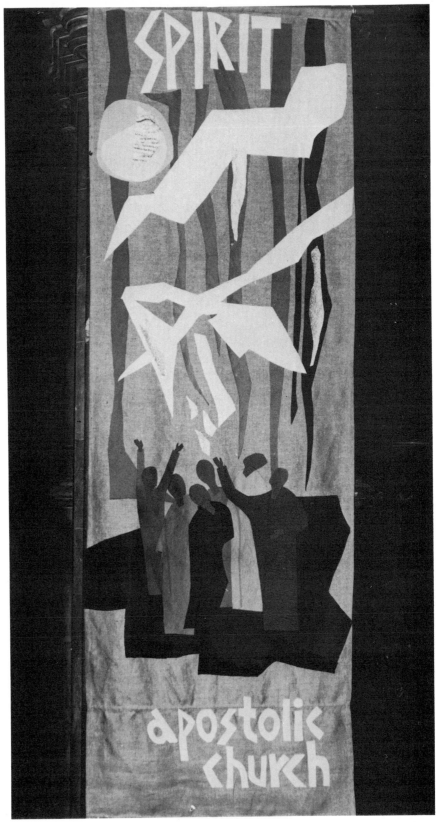

297b Christmas and Eastertide banner for the nave of Southwark Cathedral

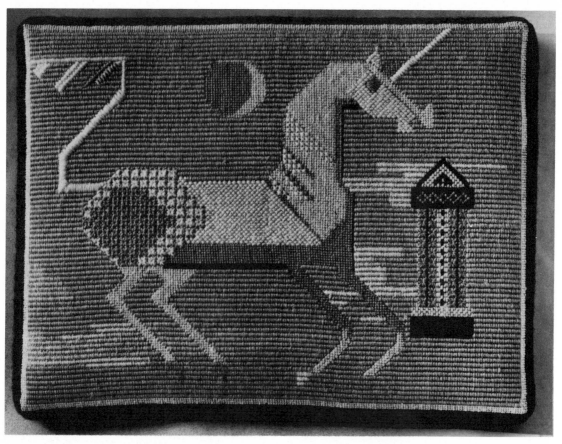

298 Bride's wedding kneeler in canvas embroidery designed
by Sylvia Green, embroidered by Norah Edwards. Worked in
white, light and dark blue with a touch of pale lime. The
unicorn signifies chastity, the moon is a feminine symbol, and
the small building represents the tabernacle of the body
St Michael's Embroidery Group, Highgate, London

difficult to rectify mistakes or make alterations. This
careful overall control by a professional of what is
going on is likely to result in a satisfactory project.

But leaders themselves have to beware of ignoring
the ideas contributed by other people, leaving no
freedom of expression. With such total domination
those taking part in the project are simply executing
or carrying out the design: although some em-
broiderers are quite content to do this it is not the
principal object of corporate work projects. To get
the right balance between sharing the interest, yet
enabling the leader to keep control, is essential to the
outcome – but difficult; and important if the work is
to be brought to a really satisfactory finish.

These very constructive observations were made
by the Rev Peter Delaney who designed and directed
the banner project undertaken for Southwark Cath-

edral, London (296A, B and 297A, B are examples).
They make a striking visual impact, at Easter-
tide and Christmas when the whole set is seen, and
the total effect is heightened by the lighting. Import-
ant also was the experience gained by the particip-
ants in the scheme, one result of which was that a
trained member who had taken part, went out and
helped another group with the work which they were
doing. But such a successful outcome does depend
upon professional people making themselves
available. The difference is observable in those
churches which try, in a minor way 'to have a go' at
creating banners on their own, without any advice at
all, and making an absolute mess of the whole
project. That people think they can do things on
their own, without advice, is a very real problem.

The whole subject of group leadership needs to be
studied, as people want to be able to ask questions
and to see for themselves the value of working
together. There are many approaches to this prob-
lem of leadership, each group has its own character.
The embroidery undertaken for York Minster is well
known. The very active and lively group who meet at

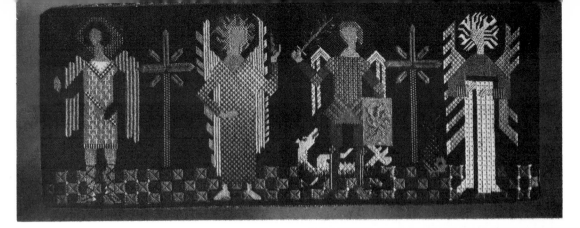

299A Four Archangels. St Gabriel, St Uriel, St Michael, and St Raphael, worked by Margaret Hill.
St Michaels, Highgate, London
299B Choir stall cushions. Designed by Sylvia Green. Canvas stitches in wool and metal threads. Lion, St Mark, worked by Mary Hall

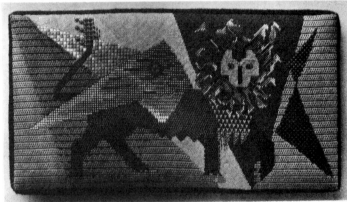

Derby Cathedral are fortunate to have as their designer and leader the Rev Leonard Childs who also directs and teaches the practical work.

At St Michael's, Highgate, London, the corporate projects have been designed and directed, and the members taught by Sylvia Green, who writes:

'The group of amateur embroiderers who have met together regularly to make embroidered choir stall cushions and other items for use in the parish church had little or no knowledge of canvas embroidery and no previous experience of working together on such a project, when we began. They were however, skilful and enthusiastic needlewomen with completely open minds and no more lofty ambitions at that time than the expressed wish to "learn about stitches". This was a most favourable basis on which to begin, for the kind of problems and difficulties which are often encountered among a group of people with mixed experience and ability, some of whom may hold fixed and opposing ideas about what is required and how it is to be arrived at, simply did not arise.

I had been asked to do this teaching, when planning it, my aim, from the beginning was to provide the maximum opportunity for all concerned to learn to work creatively with the stitches and technique and to develop individual ways of using them. A good deal of time was enjoyably spent in experimenting with stitches and textures and in getting to know the limitations and the possibilities of the technique. Confidence grew and it was soon discovered that it was not difficult to arrange stitches and shapes to make attractive border patterns and simple designs. The explorations and discoveries thus made were recorded on individual samplers and these provided a rich reservoir of inspiration upon which every member of the group could draw when the time came to begin work on the first embroidered cushions; in this way, an invaluable contribution which had been made by each member was put at the disposal of all. An example is shown (298).

The ten individual choir stall seats for which the first cushions were planned allowed each member the satisfaction of embroidering and making her own individual cushion. An outline drawing of a simple symbol with decorative possibilities such as a cock, loaves and fishes, a ship, was supplied and each person was encouraged to choose and use stitches to make pattern and texture and to develop the design as seemed to her appropriate, a carefully chosen overall colour scheme having first been agreed upon. It was not assumed that these first efforts would necessarily be of sufficient excellence to be placed in the church, although, as it happened, they were.

A set of eight cushions decorated with a continuous procession of saints, a subsequent undertaking, was a much more challenging enterprise. Each individually embroidered cushion carried the figures of four saints, and had to form an integral part of a scheme which had been designed as a whole. The problem for the embroiderer now was to accept the discipline imposed by the need for a degree of conformity while still preserving the distinctively personal and creative character of her work. The

273

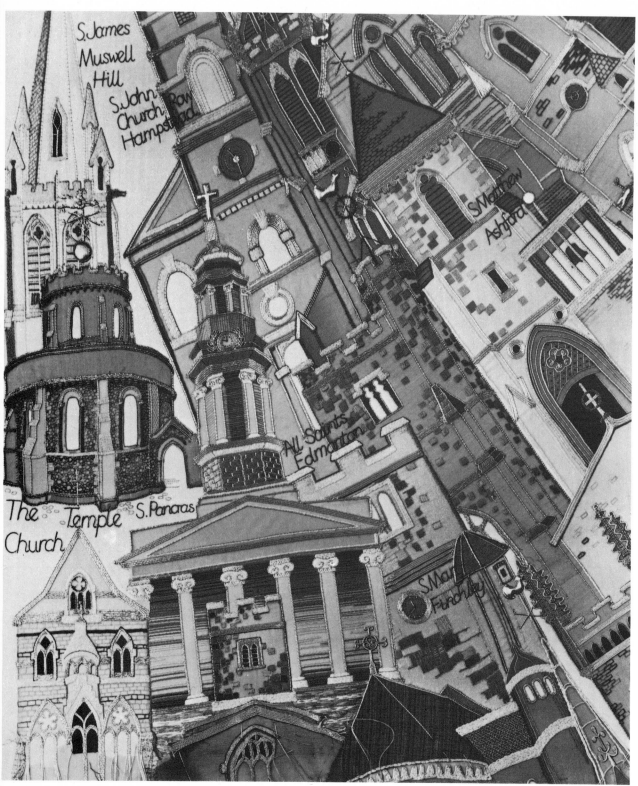

The labels embroidered within the image:

S. James Muswell Hill
S. John Church Row Hampstead
S. Matthew Ashford
All Saints Edmonton
The Temple Church
S. Pancras
S. Mary Finchley

300 Detail from Silver Jubilee cope, each church was embroidered with gold and silks upon a background of grey, fawn, honey colour, white ivory or light brown organza, and applied to the cream wool background. See plate VII.
Photograph: Country Life

willingness to learn and to share the knowledge and experience gained which had been such an important factor from the beginning made possible the success of this more exacting project.

Most people who enjoy working with needle and thread have the ability to think and work creatively and to make things of individual worth, given a little help and guidance. In many parishes there are those, both men and women, who are willing to use their time and their talents in the service of the parish church. It is sad to see so many instances of this skill and enthusiasm having been put to unworthy use in the making of articles of no personal character or merit in design and colour, because professional guidance has not been sought.'

Quite different was the motivation which led to the creation of the Silver Jubilee Cope and Mitre (300 and 302) in 1976–77, Undertaken by members of the class for Ecclesiastical Embroidery at the Stanhope Adult Education Institute, London. This group accepted the technical challenge for the joy derived from doing intricate embroidery and the

pleasure of working together towards the ultimate combination of their individual contributions. They aimed at producing the best possible result, and although each could exercise a certain amount of invention, they accepted overall control as necessary for the unity of the whole. It was explained that the scale, technique, colour and materials used for each separate church (worked on a ground of organza) must be uniform. The idea for the design and the entire project happened quite spontaneously during a class, the students were involved right from the start and helped with the research, details of drawing and the lettering, prior to the working.

The author designed the cope and mitre, directed the project and was responsible, with the assistance of a few of her more experienced class members for

301 Embroidered cloth and kneelers designed by Malcolm Lochead and worked as a group project by the members of the Glasgow and West of Scotland branch of the Embroiderer's Guild, 1973. The patchwork is carried out in shades of blue, orange and green with gold and silver superimposed. Every aspect of the design is symbolic
St Mungo's shrine, Glasgow Cathedral

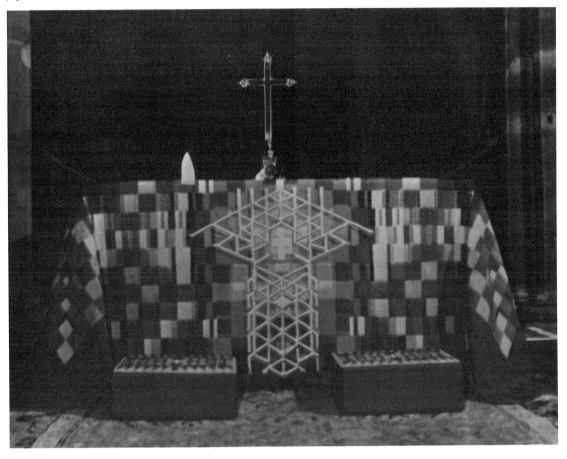

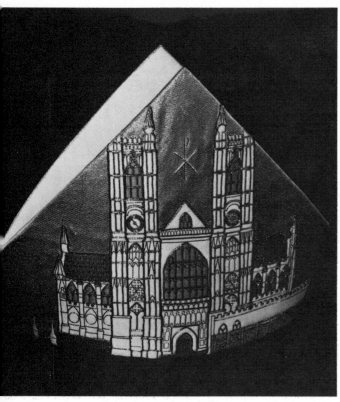

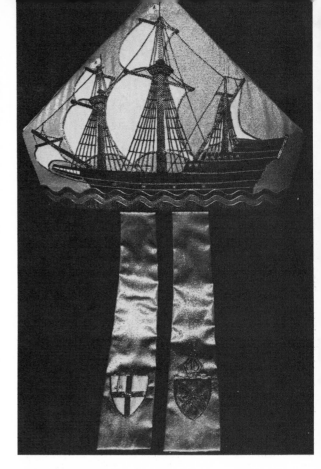

302a Mitre front worked by Pamela Waterworth, worn with the Silver Jubilee cope in Westminster Abbey, 1977. Cream woollen fabric applied to cloth of gold
302b *Right* Back of the Silver Jubilee mitre. The ship represents the Church
The Diocese of London for the Bishop of London

applying each separately completed church, as these had to be invisibly sewn to the fine woollen fabric of the cope, the whole of which was mounted on a 2.74 m (9 ft) slate frame.

In all large undertakings the problem is of organising a method whereby several people (in this instance 36) can work at the same time. This was overcome as each church was individually framed up and worked, then the surplus organza was cut away before being applied to the background. This method was possible because they were very light and added little to the total weight of the cope. When completed the cope, mitre and stole were given to the Diocese of London, and worn by the Bishop of London for the Queen's Jubilee Service at St Paul's Cathedral.

For another project, squares, individually designed and worked were sewn to a cope to form orphreys and a cross. To make a stole individually embroidered squares were joined together, with a

satisfactory result.

Patchwork can be worked by any number of people, so was the method selected by the members of the Glasgow and West of Scotland branch of the Embroiderers' Guild for the throw-over altar frontal which they carried out for St Kentigern's (Mungo's) tomb in Glasgow Cathedral. Designed by Malcolm Lochhead, the orange and gold of the centre is surrounded by tones of turquoise blue, the contrast between the sheen of the silks brings out the play of light most effectively. The superimposed raised design in gold is most interesting (301). The six kneelers in canvas work carry out a theme based on ships' rigging (303A,B).

Individual corporate projects are organised differently, and from each experience there is much to learn. Such a scheme was the 7.62 m × 4.87 m (25 ft × 16 ft) embroidery envisaged in 1971 and realised by a group of workers for the Plymouth Congregational Church, Guild Hall, Minneapolis, Minnesota (304). They have set out their aims and the practical approach, which, summarised are:

The importance of finding the best designer.

They decided that they wanted a narrative basis to the design, so, offered the results of their researches

303a Two of the six kneelers designed by Malcolm Lochead for St Mungo's shrine in the lower church
Glasgow Cathedral

303b *Below* The designs are based on ships' rigging and are worked in a variety of canvas stitches

304 Panel, 7.62 m × 4.87 m (25 ft × 16 ft) designed by Pauline Baynes, Surrey, England. Embroidered in crewel wools on linen. The project was completed in 1974
Guild Hall, Plymouth Congregational Church, Minneapolis, Minnesota, USA

305 *Opposite* Hanging designed and worked under the direction of Libby Edwards by members of the Congregation 1977–79. The format of this hanging works well in the interior for which it was designed. Most of the work is carried out in hand stitching, with some appliqué. The Chaplaincy is used by all denominations of the Christian church and by other sects as well. *University of Manchester, Chaplaincy, St Peter's House, University Precinct, Manchester*

to the designer (who appreciated the characteristics of the craft).

Group workers received instruction in the technique, a high standard was required, latent ability was discovered. They decided upon fabric and threads, estimating the amount required. With commendable insight they appreciated the importance of interpreting the 'spirit' of the design. Having raised the money they were offered two workrooms.

Deciding how to divide the area into manageable sizes for working, they planned the method of transferring the design to the Irish upholstery linen background; for this a grid was superimposed on to the original painting. Each square was photographed with a macro lens on the camera, and these were projected on to the linen. (The background fabric

was laid out flatly over a wooden pallet and the positions were marked out.)

The slide projector had to be the proper distance to magnify to the correct size. Care had to be taken to obtain a perfect register. The outline was drawn in with a black 'Sharpie' pen. On full size tracings from the slides, the deposition of the colours, threads and stitches was worked out and noted.

A small area can be meaningless, for this reason the interest of each worker was sustained by embroidering a complete unit, and other parts.

When finished this huge embroidery was held at the top with *Velcro* to a wooden frame attached to the wall. For protection from bright light the windows were covered with a special covering through which daylight is filtered.

In
the
begin
ning
God
crea
ted
the
heaven
and
the
earth

And
God
said
let
there
be a
firma
ment
in the
midst

And
God
saw
every
thing
that
he had
behold
it was
very
good

279

306 Hanging *in situ*

Whether the emphasis is upon the work of art as a whole, its design and workmanship, or the therapeutic value of the experience, it is the basic planning which requires organisation. Yet of overall importance is the community action, which is meant to be a shared experience by people, who in their different ways contribute to proclaiming the truth of God, but this must depend upon the leadership of the trained person, who knows how to understand the present progress of liturgical reform in which ever tradition they represent. It has been pointed out by the Rev P Delaney that our little groups of embroiderers are really a microcosm of what the believing community, of whatever faith, is meant to be! In the Anglican tradition the background book, *The Presentation of the Eucharist*, produced by the Liturgical Commission has suggested that it would seem that basically the idea of modern worship is for the leader to let people be totally involved – a controlled sharing – not a free for all, but an informed participation!

There is much work ahead for embroiderers and vestment makers because the main stream of Christianity is confined to the central action, the Eucharist, and the emphasis is on the collegiality, a college of priests sharing in the central action of breaking bread and blessing wine. Concelebration, as this is

known will become more and more widely used throughout the church. Not one chasuble, but a chasuble for each participating priest will be needed, instead of the dalmatic and tunicle and stole for a traditional High Mass. Or for simpler celebrations of the Eucharist the cassock-alb and new wide stoles for each priest celebrating can be used. And there are other changes.

With the ever changing fashions in wear and furnishing, the idea that vestments may become expendable consequent upon the impact of a design scheme being transient, may come to be accepted. If so, it will be a reversal of the established belief that ecclesiastical embroidery is intended to endure for posterity. This trend is on the way both in the Roman Catholic Church, the Anglican and Protestant Churches where simple, less expensive but still attractive materials are used. Even Japanese gold has been replaced by the imitation thread, and this is used very much less.

These trends in thought reflect not a projection of all traditional forms, but a real attempt on the part of the churches to express their common beliefs in a way understood by men and women today. Embroidery design can still fully participate in today's church by being the means through which the highest standards of creativity can be seen in regular constant use.

Demon-lion, a representation of evil. The twelfth century bronze door knocker at Durham Cathedral

Bibliography

Child, Heather and Colles, Dorothy *Christian Symbols*, Bell 1971

Flucke, Sr Augustina *Das Sakrale Gewand*, NZN Buchverlag

Christie, A G I *English Medieval Embroidery*, Oxford 1938

Ireland, Marion P *Textile Art in the Church*, Abingdon Press, Nashville and New York, 1966

Finch and Putnam, *Caring for Textiles*, Barrie and Jenkins 1977

Crafts Advisory Committee, *Conservation Sourcebook*, *1979* 12 Waterloo Place, London SW1Y 4AU

Russell, Pat *Lettering for Embroidery*, Batsford 1971

Bishop's Committee on the Liturgy, *Environment and Art in Catholic Worship*, National Conference of Catholic Bishops, 1978, Washington DC

Johnstone, Pauline *Byzantine Tradition in Church Embroidery*, Tiranti, 1967

Freehof Lillian S and King, Bucky *Embroideries and Fabrics for Synagogue and Home*, Hearthside 1966

Shafter, Mae *The Work of our Hands, Jewish Needlework Today*, Rockland Schocken Books, New York

Mathews, Sibyll *Needlemade Rugs*, Mills and Boon 1960

Heim, Bruno Berne *Heraldry in the Catholic Church*, Van Duren 1978

Milton, Roger *The English Ceremonial Book, A History of Robes, Insignia and Ceremonies still in use in England*, David & Charles 1972

Mackie, Albert *Scottish Pageantry*, Hutchinson 1967

Mollo, John *Military Fashion*, Barrie and Jenkins, 1972

Bridgement, Harriet, Drury, Elizabeth, Editors. *Needlework, An Illustrated History*, Paddington Press Limited

Whyte, Kathleen *Design in Embroidery*, Batsford 1969

Dawson, Barbara *Metal Thread Embroidery*, Batsford 1976

Roeder, Helen *Saints and their Attributes*, Longmans Green 1955

Milburn, RLP *Saints and their Emblems in English Churches*, Blackwell 1957

Lillow, Ira *Introducing Machine Embroidery*, Batsford 1967

Gray, Jennifer *Machine Embroidery*, Batsford 1973

Green, Sylvia *Canvas Embroidery for Beginners*, Studio Vista 1970

Green, Sylvia *Patchwork for Beginners*, Studio Vista 1971

Dean, Beryl *Creative Appliqué*, Studio Vista 1970

Rice, David Talbot *Art of the Byzantine Era*, Thames and Hudson 1963

Dean, Beryl *Ecclesiastical Embroidery*, Batsford 1958

Dean, Beryl *Church Needlework*, Batsford 1961

Dean, Beryl *Ideas for Church Embroidery*, Batsford 1968

Brooke-Little, John, *Royal Ceremonies of State*, Country Life 1980

Mayer-Thurman, Christian C *Raiment for the Lord's Service*, The Art Institute of Chicago 1975, Exhibition Catalogue

Opus Anglicanum, Exhibition Catalogue, Victoria and Albert Museum, London 1963

Coronation Costume 1685–1953, London Museum 1973. Her Majesty's Stationery Office

Liturgy, Journal of the Liturgical Conference, Washington DC, USA

L'Art d'Eglise, L'Abbaye de Sainte Andre, Bruges, Belgium

Liturgical Art, Liturgical Art Society, 7 East 42nd Street, New York 10017

Embroidery, Published by the Embroiderers' Guild (Articles on Church Embroidery from time to time and much interesting and useful information) Quarterly.

The Flying Needle, National Standards Council of America Embroideries. Published Quarterly – The Editor, 127 Lake Avenue, White Bear Lake M.N.55110. U.S.A.

Occasional publications by the New Churches Research Group, Architects' Journal Information Library

Suppliers of materials and equipment

Allans, 55–56 Duke Street, Grosvenor Square, London WIM 6HS. *Exclusive fabrics*

Danish Shop, 16 Sloane Street, London SWI. *DMC and other threads*

Embroiderers' Guild (members only), Apartment 41A, Hampton Court Palace, East Molesey, Surrey KT8 9AU. *Books, advice etc*

John, V D Kilbride and Joanna
Handwoven cloth 150 cm (60 in.) wide. Mixture of silk and Egyptian cotton
(These fabrics fall beautifully but are apt to drop slightly so allow to hang before completing)

MacCulloch and Wallis Ltd, 25–26 Dering Street, London WIR OBH. *Dowlas linen interlining etc*

Mace and Nairn, 89 Crane Street, Salisbury, Wiltshire, SPI 2PY. *Embroidery specialists, metal threads, cords and canvas, threads, linen etc.*

Liberty and Co Ltd, Regent Street, London WI. *Some Thai and Indian silks, fabrics*

Reeves–Dryad Limited, 178 Kensington High Street, London W8. *Felt, etc.*

Royal School of Needlework, 25 Princes Gate, London SW7. *Metal threads, gold and silver cords, cords, canvas etc*

Toynbee-Clarke Interiors Ltd, 95 Mount Street, London WI. *Thai silks*

Watts and Co Ltd, 7 Tufton Street, London SWI. *Church furnishers, cloth of gold and substitutes, braids, cords, etc*

Lilliman and Cox Ltd, 34 Bruton Place, London WI. *Specialists in dry cleaning all types of embroidery, vestments etc*

Tinsel Trading Co, 47 West 38th Street, New York NY 10018. *Metallic threads, braids and bullions, etc*

American Thread Corporation, 90 Park Avenue, New York. *All types of thread*

Index

Numerals in *italics* refer to pages on which illustrations occur